CHAOS & METAMORPHOSIS:
THE ART OF PIERO LERDA

CHAOS & METAMORPHOSIS:
THE ART OF PIERO LERDA

Georgia Museum of Art, University of Georgia
February 14–May 10, 2015

©2015 Georgia Museum of Art, University of Georgia

Published by the Georgia Museum of Art, University of Georgia.
All rights reserved. No part of this book may be reproduced without
the written consent of the publishers.

Printed in Korea in an edition of 750 by Four Colour Imports.

Design: MacFadden & Thorpe

Department of Publications: Hillary Brown and Anna Truszczynski

Library of Congress Cataloging-in-Publication Data

Chaos and Metamorphosis : The Art of Piero Lerda :
Georgia Museum of Art, University of Georgia, February 14, 2015/
May 10, 2015.
pages cm
Includes bibliographical references.
ISBN 978-0-915977-88-8
1. Lerda, Piero, 1927-2007—Exhibitions. I. Lerda, Piero, 1927-2007.
Works. Selections. II. Georgia Museum of Art.
N6923.L3424A4 2015
709.2—dc23

2014047102

Partial support for the exhibitions and programs at the Georgia
Museum of Art is provided by the Georgia Council for the Arts through
appropriations of the Georgia General Assembly. The council is a
partner agency of the National Endowment for the Arts. Individuals,
foundations, and corporations provide additional museum support
through their gifts to the University of Georgia Foundation.

Front cover: Piero Lerda, *untitled*, 1977
Back cover: Piero Lerda, *Città giostra visitata dagli aquiloni*, 1970

TABLE OF CONTENTS

PREFACE AND ACKNOWLEDGMENTS

By all accounts, Piero Lerda was as gracious and friendly as he was clever and warmhearted. Yet, as we learn from Laura Valeri's astute analysis of his art, he was distressed, if not tortured, by the existentialist dilemmas of post–World War II Europe. Lerda represents something of an enigma, like the French novelist and thinker he studied and admired, Georges Bernanos (1888–1948), whose hatred of materialism and fascism, whose humor and love of mankind are contrasting themes in his preoccupation with the struggle of good and evil for man's eternal soul. Just so, Lerda sought to resolve the oft-bloody contradictions he saw between order and chaos in his experiences and observations of wartime and mid-century Italy.

Lerda's cosmos is complex, sophisticated, at times distressing, and almost impenetrable without a guide. His universe requires a special language, a unique visual vocabulary—I use the word "unique" to emphasize the originality of his conceptual universe of symbol and allegory—to describe the play of irrational forces and counter-forces that govern humanity's behavior and fate. Lerda's words and pictures, the tools with which he presents his cosmography, depend on contradictory elements: static images and the flash of illumination; the screen that hides from view but that also organizes perception; the kite, meant to soar, but bound by string; the eternal *città*, a word that has multiple meanings for a European, especially an Italian habituated to the *campanilismo* of his countrymen, as an ever-changing, always swirling merry-go-round; and art itself, the private act of creation versus the urge toward exhibition.

Perhaps the most telling of Lerda's totems, the kite shows the tension between the irrational and the ordered, between the free and the bound, between the object's desperation to rise above an unruly world and its inevitable defeat by gravity. Such is humanity's fate in Lerda's polemic on good and evil, a pawn caught between an immutable past and an unpredictable future.

Lest we take his art and his thoughts as unbearably cynical or pessimistic—though those elements are present—if we look closer at the difficult ideas and images, an *oeuvre* at once objective yet self-referential, we find that Lerda's images of an imperfectly ordered universe are but reflections of his attempt to organize, study, and resolve chaos, both exterior and interior ("il caos che trova in sé," a quotation from

Nietzsche, appears in Lerda's papers). Thus, in bringing this remarkable thinker's work to an American audience, we are presenting a suite of works that illustrate the conflicts of philosophers and artists in mid-twentieth-century Europe as they grappled with the social, economic, and, yes, artistic after-effects of a horrendous war. As one such artist and aesthete, Piero Lerda may have obsessed over the battle between good and evil, between order and disorder, between stasis and metamorphosis, but behind that philosophical screen, his personal sweetness of character manifests in the one theme that underlies all his art and thought: hope. In a violent, materialistic age, he strove to describe the life of the spirit.

Without the loving assistance of Valeria Gennaro Lerda, Piero's wife, this exhibition would not have been possible or even initiated at the Georgia Museum of Art. Valeria is a scholar and thinker in her own right, illuminating and presenting new insights through her erudition and research into the complicated history of the American South. After her friends, especially Margie Spalding, introduced her to me here in Athens, Georgia, Valeria offered to show me Piero's work. I leapt at the chance, so struck was I by her explanations of her husband's lifetime of achievement. Devoted to his work, Valeria determinedly made it available for multiple exhibitions in Europe. Thanks to her generous gift of her husband's works to the museum, this, the first major exhibition in the United States, is also a prelude to the expansion of study of Lerda's career as well as of its contextualization in mid-century Western thought and art. Athens, her second home, and University of Georgia students, present and future, owe her a debt of gratitude, as we all owe to her beloved Torino, from where she and Piero sallied forth to enjoin us in serious reflection on life and art.

The curator of this exhibition, Laura Valeri, joins me in thanking the staff of the museum, especially our editorial team of Hillary Brown and Anna Truszczynski, deputy director Annelies Mondi and registrars Christy Sinksen and Sarina Rousso for coordinating shipping and photography, preparators Todd Rivers and Larry Forte for design and installation, and Pierre Daura Curator of European Art Lynn Boland for his initial interest in and inquiry into Lerda's works. We also thank Michael Lachowski and Taylor Little for their tireless efforts to achieve images faithful to Lerda's original works. We acknowledge with affection and admiration the indefatigable work and organizational ability of

Silvia Tritto Scaratti, whose cheerful assistance and commitment to our project brightened many a day for Laura and me, as well as the graciousness and hospitality afforded us by Maria Rosa Thea, who offered us delightful views of and tours through Torino during our study sojourns there. She helped us understand Lerda's sense of place through her explanation of Savoy's geography, cultural monuments, and history.

Finally, to Laura Valeri, whose own acknowledgments follow, I offer my gratitude for her taking on this project and pursuing it ruthlessly and intelligently. I know that Valeria joins me in admiration for Laura's sensitivity to Lerda's works as well as for her appreciation of his place in European, and now American, visual-arts history.

William Underwood Eiland
Director, Georgia Museum of Art

I add my wholehearted thanks to the museum staff and others mentioned above who made invaluable contributions to this project. I had the privilege of meeting Valeria Gennaro Lerda in February 2014 when she opened her home to me to study Piero's works and writing. It is rare to encounter someone so generous, warm, and enthusiastic, and I have never felt so welcomed. After my visit, as the exhibition and catalogue developed, we continued a lively correspondence, discussing everything from Piero's working methods and complex philosophy to the intricate subtleties of words and phrases as I translated many of his writings. Both during my visit and in our correspondence, Valeria continually thanked me, but I am the one who owes her a debt of gratitude. This catalogue would not exist without all of her efforts.

I would also like to thank Valeria's friends and family, including Maria Rosa Thea for her whirlwind tour of Torino, Silvia Tritto Scaratti for her indispensable help in navigating Piero's art and writings, Enrico and Mietta Gennaro and Anna Maria Rizzo for hosting me in their homes, and Marco and Alberto Gennaro for their kind assistance. I am so happy to know all of you; thank you for your generosity and kindness.

Laura Valeri
Associate Curator of European Art,
Georgia Museum of Art

CHAOS & METAMORPHOSIS:
THE ART OF PIERO LERDA

Laura Valeri

INTRODUCTION

"My poetics: art in free fall, global art, 360-degree art, art of the new caves, art of the end of the world, stratified art, upended art, asymmetric art, art of the mob, debated art, art of desolation, art of the crowd. The mob bursts into the narration, art [that is] crude, raw, coarse, deprived of decorum, of frills, of gimmicks, realistic disorganized art, art of order and of chaos (Koolhaas, the Dutch architect of chaos), art of dissonance (see music), scratched art, tortured art, art of incoherence, irrational art."[1]

Piero Lerda (1927–2007) drew upon his rich background as a student, writer, teacher, scriptwriter, and cultural director to create a vast body of work in diverse media, including India ink, tempera, and mixed-media collage. Lerda combined his experiences studying art and literature, teaching in France, and working in cultural fields in Torino with the shared global horror of World War II into a complex philosophy drawing on existentialism. He sought to balance contradictory concepts and feelings in his art, such as good and evil, order and chaos, optimism and pessimism, and childlike innocence and adult cynicism. At once cerebral and playful, Lerda's colorful abstraction incorporates symbols he developed—screens, flashes, kites, merry-go-round cities, and new geometries—to express those concepts, and it is unclear whether the world he depicts is changing for better or worse. His art centers on the common threads of chaos and metamorphosis, and he leaves space for the viewer to decide whether the works show a new beginning or an end.

BIOGRAPHY

Lerda, in his early twenties, in Nice, France.

Piero Lerda was born on April 29, 1927, in Caraglio, a small town in the Piedmont region of Italy. As a teenager, Lerda studied elementary education at the Istituto Magistrale Statale Edmondo De Amicis in the neighboring town of Cuneo. At the same time, he began his art training in Caraglio under the painter Vincenzo Alicandri. Alicandri had moved to Caraglio from Sulmona, Abruzzo, during World War II to escape the German army, which was retreating from the Allied advance into Italy in 1943. In the manner of a traditional apprenticeship, Alicandri introduced Lerda to a myriad of techniques and materials. Under his tutelage, Lerda experimented with oil painting, engraving, ceramics, and the use of wax resist with India ink, the latter eventually becoming one of the cornerstones of his early artistic practice.[2] After Alicandri's death, in 1955, Lerda fondly recalled his studies in Caraglio: "Over five years, I learned the craft of painting, every day seeing the artist from Abruzzo who raised me and taught me, with love, to use materials and techniques and to study the great masters of the past and the artists of our time."[3] It was under Alicandri that Lerda learned to harmonize tradition and innovation by synthesizing traditional methods with contemporary ideas and themes, an approach that would influence his later practice.

While beginning his artistic studies with Alicandri, Lerda witnessed the violence of World War II, as German soldiers passed through Caraglio and surrounding areas in their retreat, fighting against Italian *partigiani* (members of the resistance movement) who opposed the German occupation and the Fascist regime. The partigiani used guerrilla tactics against the German soldiers, and the Nazi regime decreed that it would execute ten Italian men for every German soldier killed. To take refuge from the fighting, Lerda often studied in the library of the Capuchin monastery. Lerda was also aware of the Allied bombing of northern Italian cities and saw its aftermath when he commuted from Caraglio to Torino as a university student. This awareness led Lerda to adopt much of the thinking of existentialist philosophers and incorporate themes of violence, philosophical chaos, and the hunting and trapping of men in his art. Elizabeth Hayes Turner, professor of history at the

University of North Texas, describes the formative nature of these terrible experiences: "Being a boy and being incapable of stopping the unjustified violence against his own city and his own country must have made an impression on him not much different from that which emerged in the thinking of the post-war existentialists."[4]

After the war, Lerda continued to practice art while pursuing a teaching career. Having passed the final comprehensive exam at the Liceo Artistico of the Accademia Albertina di Belle Arti in Torino in 1948, Lerda began the curriculum toward the *laurea* (a graduate degree) in French language and literature at the Università degli Studi di Torino. During his graduate studies, Lerda entered a competition held by the French Ministry of National Education and won a position as instructor of Italian language in Nice, France, from 1951 to 1953. While in Nice, Lerda cofounded the Club des Jeunes with other teachers of philosophy, music, and literature, in which he functioned as "critique d'art," giving lectures on the French and American avant-garde, the cave paintings at Lascaux, African sculpture, and other topics. The club was quite prestigious, with honorary members including literary giants Jean Cocteau and Jacques Prévert.

While teaching, Lerda continued to develop his expertise in French literature and philosophy, writing his thesis on the theme of good and evil in the works of French author Georges Bernanos. In it, Lerda describes how each person exists in the midst of the constant struggle between good and evil, playing his or her part without knowing the ultimate purpose. At the same time, Lerda recognizes the role of free will in Bernanos's works: "Human freedom is not absent, nor the experience of effort, of will, of the conquest of salvation by mankind in the face of the obscure game of destiny."[5] He concludes that humanity is prey to evil and may either endure it or try to escape it.[6] The conflict between good and evil—and other accompanying dualities, like order and chaos—as well as existential philosophy in general, fascinated Lerda for the rest of his life and became a major impetus for the majority of his works.

Following his graduation in 1953, Lerda served as a lieutenant in the Alpini (a corps of mountain troops in the Italian army) from 1954 to 1955. He then moved to Torino and, for the next two years, worked at Italy's national public broadcasting organization (RAI)

alongside other Torinese intellectuals, including Umberto Eco.[7] At RAI, Lerda was a co-organizer of television programs, including a program for young adults called *Orizzonti* (*Horizons*), and a script-writer for national children's radio programs. In the latter capacity, he adapted fiction and fairytales for the radio, including Ouida's *The Nürnberg Stove* (1895). Lerda's work with new broadcast technology—regular television service did not begin until 1954 in Italy—inspired him to think about new modes of representation and to incorporate his thoughts on technology's impact on humans into his art of this period. Lerda's former RAI coworker and renowned philosopher Gianni Vattimo describes the working atmosphere: "I do not believe that it was merely our age that made that period so exciting and rich. It was the period itself, the years in which television was born and we were all seeking new modes of expression and communication, and rethinking the inherited culture that we wanted to use to build the young Italian democracy."[8]

In 1957, Lerda became the director of the United States Information Service (USIS) library in Torino. The United States established USIS libraries in major cities throughout Europe during World War II to support its foreign policy and promote the American way of life. The library in Torino had 2,500 volumes and hundreds of periodicals, both American works in English and many translated into Italian, as well as recordings of folk music, prose, poetry, and English language audio courses, among other multimedia items.[9] Patrons could check out materials, and the library managed circulating collections in smaller towns, ensuring that the objects could reach a wide audience. The library also made available daily American newspapers and radio programs and hosted concerts, art exhibitions, documentary film screenings, and conferences and seminars on cultural topics. As director, Lerda was responsible for organizing these cultural initiatives and spoke at many of them. He lectured often on avant-garde American art and wrote reviews of books on American art and artists for the library's regional magazine, *Rassegna USIS*, which he oversaw beginning in 1958.[10] This wide range of materials and activities allowed Lerda to access his favorite French poets and writers from the Middle Ages through the twentieth century in tandem with the most up-to-date material on American culture. Lerda embraced his position and became

an important link to American visual art and culture for Torinese artists, teachers, and writers. As Vattimo recalled, "His position and his conversation were tied initially, for many of us, with the first discovery of American culture."[11]

Lerda also worked on his art and participated actively in exhibitions in Torino and surrounding regions from 1956 to 1963, including his first solo exhibition, *Pagine di diario* (*Pages of a Diary*), at gallery L'Immagine in 1962. Even though these exhibitions were a critical success and he won several prestigious prizes, Lerda preferred to work in isolation and receded from the public eye. When the USIS library closed in 1963 due to the United States' overall reduction of funding for cultural programs in Europe, Lerda largely stopped exhibiting his art. He became a professor of French language, offering courses at the Università degli Studi di Torino from 1969 to 1974, and continued to teach at several *licei* (secondary schools) in Torino until his retirement in 1990. Although he participated in few exhibitions after 1963, Lerda continued his research into existential themes and diligently refined his artistic theory and practice until his death, in 2007.

Lerda as director of the USIS library in Torino. He served as director from 1957 to 1963.

WRITING & PHILOSOPHY

To make art is, in my opinion, a way of knowing this tiny piece of the universe in which we must live. And to know it in its most fascinating part, that which hides enormous emotions as justification, perhaps, for a destiny that we did not choose ourselves.

And to carry out these tasks with the utmost freedom, in and of itself, [is the] highest reward for the artist. To make art is therefore to live, that is, to act with total freedom of intellect and perception, to work around an image of beauty to be continually renewed, with one eye on the future and the other on the tradition in which we have been forged.

Moravia says (see *The Time of Indifference*) that the only person of value is the bourgeois intellectual, because that is the man who acts, who puts himself forth. I am not an intellectual, or rather, I do not

Lerda in his office in the USIS library in Torino.

want to be one, nor am I a bourgeois, or rather, I do not want to be one, I want to be an artist, one that uses intelligence and perception, that is, not to put himself forth, to act, <u>only</u> on the level of "civil disputes," which are also noble, but for something higher, more ineffable, more aristocratic, in the ancient sense of the word.[12]

The passage above, which summarizes much of Lerda's philosophy, comes from a rich collection of his writing, notes, and sketches housed in the archives of the Georgia Museum of Art on the campus of the University of Georgia in Athens. Lerda's experience as a teacher and lifelong student comes through in his papers. Alongside sketches, lists of materials for artistic projects, and his musings on art appear a series of collected quotations, thoughts, and references from philosophers and authors such as Friedrich Nietzsche, Albert Camus, Jean-Paul Sartre, Franz Kafka, Stéphane Mallarmé, Charles Baudelaire, René Descartes, and many more. Lerda's writing, including the text of a slide lecture given at USIS in 1958 ("Cinquant'anni di pittura americana 1900–1950" ["Fifty Years of American Painting 1900–1950"]), gives insight into his philosophy by revealing the authors and artists he admired.

One of the most prevalent themes in Lerda's notes and in his art is irrationality in the existential sense—that is, the absurdity of existence, injustice, inequality, and the struggle between good and evil and order and chaos. Continuing his study of existentialist themes that began with his thesis on Bernanos, Lerda filled his notes with quotations by and interpretations of his favorite philosophers and writers. Camus figures prominently in Lerda's notes, which include two quotations from the *Myth of Sisyphus* (1942) that indicate the philosophical tension with which Lerda grappled: "What is called a reason for living is also an excellent reason for dying" and "I said that the world is absurd, but I was too hasty. This world in itself is not reasonable, that is all that can be said. But what is absurd is the confrontation of this irrational and the wild longing for clarity whose call echoes in the human heart."[13] These quotations illustrate the crux of the issue that most preoccupied Lerda: the irrationality, irony, and purposelessness of life and the futility and foolishness of seeking organization, clarity, or understanding in a fundamentally meaningless and chaotic universe.

The anxiety produced by living in such a world is apparent in the writing of many of the other authors Lerda quotes in his notes, such as André Gide, "In life nothing is resolved, everything continues. We remain in a state of uncertainty"; Jean Giraudoux on the fables of Jean de La Fontaine, "Injustice reigns in the world due to the maliciousness and inequality of mankind, as well as divine indifference"; and Jean-Michel Rey's discussion of Georges Bataille's *On Nietzsche*, "The integral man is one who does not have a purpose, but whose 'life is an unmotivated celebration.' His life is an unlimited desire, a desire to burn, an endless expenditure that is chosen against mutilation, against fragmentation. Yearning for totality leads 'to the desert,' it is a labyrinth, an 'enthusiastic torture.' The only human truth is to be 'an unanswered supplication.'"[14] All three of these quotations express a feeling of uncertainty in the face of the irrationality of existence and the accompanying sense of hopelessness at realizing that one is powerless to change one's destiny. To a degree, Lerda espouses this same feeling of futility; for instance, in the passage quoted at the beginning of this section, he uses phrases such as "the universe in which we must live" and "a destiny that we did not choose ourselves" to indicate the powerlessness inherent in the human condition.

Even though many of the quotations he records, as well as his own writing, convey the futility of confronting or trying to make sense of the absurd, unjust world, Lerda persisted in his artistic endeavors. He proposed artistic creation as an expression of hope in the face of a hopelessness that he fully acknowledged. Toward the end of his life, Lerda recorded a phrase from Nietzsche's "On the Use and Abuse of History for Life" (1874) on a document showing his blood test results: "Ognuno deve organizzare il caos che trova in sé" (Nietzsche's full sentence reads, "This is a parable for each one of us: he must organize the chaos within him by thinking back to his real needs").[15] For Nietzsche, this sentence formed part of a larger discussion of the function of history and culture and its interpretation, but for Lerda, as many critics have argued, the phrase embodies one of the main goals of his artistic practice—an attempt to make sense of or lend organization to the chaos of both the world around him and his inner world. As Hayes Turner summarizes, "His art-making is the answer to the chaotic world of his adolescence, his response to innocence and to evil."[16]

Lerda's writing makes clear that he believed that art had a high purpose and that the artist must transcend him or herself in order to express ineffable emotions and concepts and to gain understanding of the world in the face of chaos and uncertainty. As Hayes Turner argues, Lerda's work expresses "a deep desire for a spiritual progress of man," and as Linda Van Hart points out, there is a hopeful note to his work and writing that balances his tragic thoughts.[17] In his notes, Lerda adapts a sentence from Jean-Paul Sartre's essay "Introducing *Les Temps modernes*" (1945): "Man is no more than a situation; [a worker is not free to think and feel like a bourgeois.] But for that situation *to become human*, an integral man, it must be lived and transcended toward a specific aim."[18] Lerda's edited version of this quotation (he omitted the phrase represented in brackets) emphasizes a more optimistic worldview, one in which striving toward a particular goal is somewhat meaningful. In the passage quoted at the beginning of this section, Lerda asserts that to create art with absolute freedom of intellect and perception is the highest reward for an artist. It seems that within Lerda's "specific aim" of trying to know the universe through making art—even though he recognized the anxiety and hopelessness of a chaotic world—he sought to exercise the freedom Sartre describes by performing an act of creation.

For Lerda, in order to employ the freedom of perception and intellect necessary to accomplish these higher aims, the artist had to practice in solitude. In his slide lecture given at USIS, "Cinquant'anni di pittura americana 1900–1950," he praises certain artists for their individuality: Edward Hopper, "one of the most solitary, pensive, contemplative among American contemporary artists"; Franklin Watkins, "voluntarily far from schools and manifestos, he continues his experiments with great discipline"; Arthur Dove, "like [Alfred] Maurer, represents a true artist who leaves everything to pursue his creative dream"; and John Marin, "man of immense dignity, of profound talent [and] savagely independent, has always escaped the lure of movements and schools, working in depth in his preferred subject."[19] Describing his own practice and that of his contemporaries, Lerda wrote in a letter of 1966: "As for painting, the crisis that started three or four years ago continues. Almost all of the young Italian painters who do not seek easy

successes in accordance with current trends work in silence and in meditation seeking new ways. I do the same, waiting to have a sufficient number of works conceived seriously."[20]

In his solitary creative process, Lerda wove together a variety of techniques and influences in a careful balance. While working in the USIS library, Lerda had unlimited access to contemporary American art through print reproductions and periodicals; he also wrote reviews of new books on the subject.[21] From Lerda's lectures as USIS director, it is clear that he perceived a tension between Abstract Expressionism and the Northwest School. Speaking at the opening of an exhibition of American contemporary art in Verona, likely organized by USIS, Lerda defined the characteristics of the two movements:

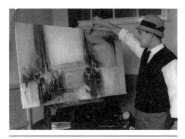

Lerda posing with one of his paintings before his solo exhibition at gallery L'Immagine, 1962. He is wearing his lucky hat, which belonged to his mother.

> I spoke a short time ago about a movement of Eastern inspiration located on the Pacific coast. Features of this trend are a refined technique, a spirituality of themes and content, a subtle play of images and forms alongside metaphysical abstraction and in contrast to expressionistic violence. That expressionistic violence, however, comprises the constants of the other movement, Abstract Expressionism, in which the canvas or sheet are covered with slashes of color on a non-figurative structure, in order to create a world in movement, in revolt, to represent an era that is not exactly calm and relaxing. It is not for nothing that this movement is also called "Action Painting," that is, painting in action, in movement.[22]

Thus, Lerda defined the Northwest School as calm and spiritual with a studied, refined technique in strong opposition to the violence of the Abstract Expressionists.

In his 1958 USIS lecture, Lerda further substantiates this division in his discussion of individual artists, contrasting the violence of the New York School Abstract Expressionists with the serenity of the Northwest School. Lerda describes members of the latter: Mark Tobey, "inspired by a mystical and religious fervor fueled by Eastern thought . . . is the inventor of the semi-automatic 'white writing' that, as [John I. H.] Baur said, 'weaves its hidden, evocative images in an infinite network of incredibly complicated lines,'" and Morris Graves, whose "hypersensitivity, specialization of subject, [and]

extreme refinement of technique" positions him as visionary in the symbolist tradition.[23] Lerda identifies a duality in the approach of the Northwest School; as its artists embrace undefined, mystical, evocative images, they employ a studied, refined technique that yields simplified, abstract symbols. In the same lecture, Lerda touches upon Willem de Kooning and Robert Motherwell, but focuses on Jackson Pollock: "Pollock is the creator of so-called Automatism, characterized by a completely free, tumultuous, intense technique. His paintings, in which the color organizes itself in a spider web, a labyrinth, almost chaotic, express the chaos of modern life in which emotions are in constant conflict with each other."[24] Lerda associates Abstract Expressionism with Automatism, that is, intuitive creation with an aim to access the subconscious, and even more so with chaotic violence. The dichotomy is overt when Lerda describes Arshile Gorky in the same lecture as "at equal distance from the expressionistic violence of the New York School, and from the formal refinement of the Pacific School."[25]

The hidden, evocative images and refined technique of the Northwest School and the Abstract Expressionists' violent representations of the chaos of modern life both appealed to Lerda, who incorporated aspects of these approaches into his own work. Lerda valued intuition and the mystery of the creative process and did not want to spoil the latter by explaining it away. He writes, "How hand, brain, and heart find the right equilibrium (when the painting succeeds), which is a prelude to the birth of the sought representation, is a great mystery. I do not think it is necessary to look for its most secret reasons, [as doing so would] diminish the charm of this creative act itself."[26] Like Lerda, the Abstract Expressionists valued intuition, but their aims and methods differed. The Abstract Expressionists looked inward, abandoning reason and pre-planning in favor of spontaneous, automatic creation in an effort to access their subconscious minds. By contrast, Lerda looked outward, using his intuition in an attempt to access a world of indefinable emotion beyond ordinary human struggles. Rather than attempting to access his subconscious, he sought to intuit concepts and emotions universal to human experience, an approach more aligned with the mystical tendencies of the Northwest School. Lerda describes his search for this universal world and his openness to surprises and hidden meanings while making art:

Why must a painting necessarily bring our message to others? How many times have I myself received the message after the last stroke of the palette knife, without my expecting it? How many times has the painting come out, unbeknownst to everyone, full of very strong emotions that spread to whomever views it? And yet, I follow a precise direction. I want to investigate a kind of world that is very specific in its contents and in its forms. Thus, I should not be surprised. I searched this universe for it all my life, consciously or unconsciously. And when finally it revealed itself to me, surrendered to me the strands of its ball of yarn so that I could slowly climb up to its distant point of departure (or arrival?) I believed I held the key to it. But no. Because every surface that I try to make vibrate with colors and forms has surprises in store for me.[27]

Lerda realizes that the world of emotions he seeks to know is in many ways unknowable, that some of its hidden messages can only be intuited. During his time working at RAI, Lerda wrote, "Man has the ability to give life to images, to suggest movement, to add a new life to natural life, that is, to create. All of this belongs to the life of the spirit."[28] Perhaps Lerda embraced intuition to confront the inescapable irrationality and absurdity of the world described by his favorite philosophers.

Lerda balanced this intuition and spirituality with careful thinking and planning. As art critic Renzo Guasco wrote in the catalogue for Lerda's solo exhibition *Pagine di diario*, Lerda's "desire to make painting a product, above all, of culture, of intelligence and of critical-experimental spirit ties Lerda to some painters of the most recent generation, who look to Abstract Expressionism and action painting . . . as important experiments, but already concluded and without possibility of development."[29] His work is both spontaneous and painstaking, lying between automatic, intuitive expression and deliberate planning, logic, and geometry. Referring to works in the same exhibition, Lerda emphasized the role of rationality over intuition: "My vision is not random (not merely gesture) but rational and ordered (a layout that derives from a mental clarification and defines the limits within which to move) and is certainly conditioned by other cultural experiences that I have lived and absorbed However, at the moment of making the first mark on the paper

or on the canvas, it is only intuition that determines the beginning (the first quality of the artist) followed by an almost obsessive participation in the world to be represented."[30]

Later, the two tendencies of intuition and rationality are on more equal footing, as Lerda describes his efforts to find the delicate balance between them in a piece of writing dated October 2, 1978:

I have been haunted for years by a technical problem that to me seemed insurmountable and now I think I have solved it. Every time I confronted a surface to paint, I always found myself up against an impassable screen: the temptation to act on impulse, in a gestural manner, implementing to the letter the . . . [illegible] surrealistic lesson of unconscious and totally automatic activity: gesture in and of itself, perhaps iterated, repeated obsessively until the surface to be covered is consumed and the inner illusion released. Afterwards, in the face of the result, the feeling one experiences after the gratuitous act of love, a feeling of emptiness, a sense of guilt, of futility. The *esprit de géometrie* that rises to the surface and demands your rational activity and lucid intellectual participation. I tried, needless to say, the opposite activity, starting from logical and predictable information where none, or almost none of the construction was left to chance. In this case as well I was inevitably prey to feelings of distress and rejection, as if my other disposition allied with the unconscious, because of the circumstances, wanted me to take all of the blame for an unequivocal failure. Then the gods must have taken pity on this poor wretch and they enlightened him through the mysterious ways of consciousness. The miracle happened again, because artists are entitled to the almost accidental discovery, certainly quintessential in its obviousness, of the solution to the enigma. One day, I was cutting patterns on a piece of paper with scissors and a blade. The half-meter was forcing me into a certain geometry of cuts. The operation excited me because I invented (discovered) forms, digging into the white of the paper, without a design in mind. When the paper was sufficiently tormented and the wounds gaping and open at each penetration, I left it instinctively as if I wanted to free myself of it, tear it from its "torturer," on top of some overlapping sheets that had prematurely received the aggression of

forms and colors and informal materials. Through the windows of geometric cuts, this informal magma took form, life, revealed itself to me with all of its evocative and magic power. The simple overlapping of two worlds revealed a third interpretive possibility that was the sum of the two plus the revelation of a new conquest of the pictorial space.[31]

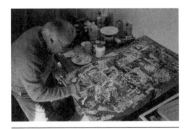

Lerda, in his late seventies, working in his studio in Oulx, Italy.

Lerda experienced a distinct tension within himself as an artist, described above as a battle between his two halves; his irrational side embraced automatic gestures, elements of chance, and playfulness, and his rational side utilized planned geometry, logical constructions, and a meticulous, studied process. From his trials, he realized that relying exclusively on one aspect or the other would result in failure and that he must balance the two to create a successful work of art.

Later in his life, Lerda wrote again about his goal of blending an intuitive approach with a rational one. In a note describing pictorial technique, Lerda advises his reader to combine geometric shapes with informal or random shapes, to mix planned elements with found elements of varying sizes, and to glue pieces down and tear them off at varying speeds to create a multicolored, distorted image resulting somewhat from chance.[32] Once the "ocean of 'confetti'" is arranged, and the work is largely finished, the artist "will begin to have an idea or several ideas about how to proceed further, depending on the things that have already been done, which will inevitably suggest (many) possible solutions."[33] Although this sentence indicates Lerda's trust in intuition, as does his recommendation to set aside a work temporarily when progress has stalled, he balances it by advocating rationality, or "rigorous mental choice": "The result is always different, the result is not always outstanding, but where you can, remove the unsuccessful or insignificant parts."[34]

The result of Lerda's inner battle is, in part, a blend of the styles he admired and studied. The coolness, rationality, and spirituality of some of Lerda's writings evoke the Northwest School, while others have a more violent, turbulent tone that calls to mind Abstract Expressionism (for instance, in his writing of October 2, 1978 [quoted above], he calls the cuts he has made into the paper "wounds").[35] In the summer of 1972, he acknowledges that a final work of art

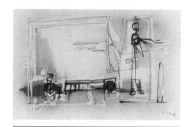

FIG. 01:
Uomini in trappola, 1961
(color plate 04)

FIG. 02
Personaggio Schermo, 1962 (plate 05)

encapsulates a secret violent battle: "Whoever views that canvas or that board or that drawn-upon sheet of paper put behind glass should know that behind that canvas, that board, or that sheet of paper, there was a secret, merciless battle between the painter and that surface to be covered and that, in the end, everything has been consumed."[36]

LERDA'S SYMBOLIC LANGUAGE

Lerda's painstaking mental process and ceaseless information-gathering and planning, paired with his spontaneity, intuition, and playfulness, resulted in lively works of art that convey a range of emotions in a variety of media, including India ink, tempera (which he preferred over oil paint), and collage using magazine and newspaper clippings, colored paper, and found materials.[37] His works are largely abstract but maintain a tie to figuration through recognizable symbols that playfully evoke his complex ideas, all the while leaving room for interpretation and engaging the viewer's imagination. Lerda developed his own abstract language, seeking in abstraction "the hidden implications of reality," as art critic Giovanni Cordero puts it.[38] In his notes, Lerda describes the intersection of reality and something ineffable: "Reality mixes with fantasy in an exaggerated way, because this is the most interesting thing: the revolutionary meeting point between that which is true in life and that which is magic."[39] This section examines four of Lerda's most important sets of symbols, which he employed in an effort to understand and organize the personal and philosophical chaos that plagued his thoughts. He investigates the central theme of chaos within four different frameworks that evolved as his artistic practice progressed.

Screens & Flashes

In the 1950s and 1960s, Lerda used India ink and wax resist to represent a world of violence, chaos, and confusion in which humans are hunted, trapped, or completely effaced. Two main symbols—the screen and the flash—recur in this series and originate largely from

his time at the RAI television studios. Lerda exhibited his India ink works for the first time during his solo exhibition *Pagine di diario*, in 1962. In its accompanying catalogue, Lerda explains:

> The screens and the *interni–flash* ["interiors–flash"] seem to me to be the equivalents of the lighting structures of the movie screens, of the television screens, of the magnesium lights, of the beams of the headlights on the highways at night, like the interiors of the movie studios, of the television sets, of the [photography and film] studios, of the scientific laboratories. It is a landscape that surrounds us and within which we live our daily lives. The theme has fascinated me for a long time, because in these tense, cold, hallucinatory, unreal atmospheres, I find a world of literary origin, already glimpsed, sensed, and breathed.[40]

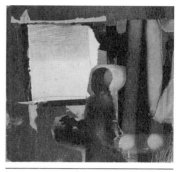

FIG. 03
Uomo e schermo, 1962 (plate 06)

While the screens and flashes are elements drawn from everyday life, they also serve as symbols that hearken to a world beyond reality, an intuited world tied to literature that mostly encompassed an existentialist perspective.

Elsewhere, discussing these same works, Lerda emphasizes that "the screens and the *interni–flash* . . . are the protagonists of the depicted world," and, in another version of the text, he calls them "the key to the world that I wish to represent."[41] The screens and flashes are indeed protagonists, with the human figures in the works featureless, unidentifiable, and washed out, functioning as supporting elements. Lerda emphasizes his screens using a variety of techniques, including broken ink or wax-resist contours (*Uomini in trappola* [*Trapped Men*] [fig. 01] and *Personaggio Schermo* [*Person Screen*] [fig. 02]), dark strips of torn magazine pages (*Uomo e schermo* [*Man and Screen*] [fig. 03]), and stark color contrasts (*Autoritratto–Flash* [*Self-Portrait–Flash*] [fig. 04]). The screen always appears blank, perhaps emitting or absorbing a powerful light, the flash, which overpowers the figure. As Cordero notes, Lerda urges the viewer to "look beyond reality to perceive what is evoked: the movie screen and the sequence of frames emphasize the blank geometry at the center of the stage while, in the background, disquieting visions of light receive the vanishing substance of characters and landscapes."[42] Critics Willy Darko and Ivana Mulatero have likened

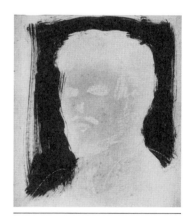

FIG. 04
Autoritratto–Flash, 1962 (plate 08)

the screens to traps, cages, and frames.[43] In fact, in Lerda's lists of concepts and titles for future projects, which he meticulously recorded on scraps of paper throughout his life as part of his brainstorming process, he often mentioned these elements in the same group as screens.[44] In all cases, the screen appears impenetrable by the human figures, which are merely organized around or placed within the confines of the frame.

Lerda's India ink works are perhaps his most overtly pessimistic with regard to humanity's ability to overcome the chaos and uncertainty of the world. The flash, which is so prevalent in Lerda's works of this period (in addition to the *interni–flash*, there are flash landscapes, screens, cities, and portraits), reduces human figures to nothing, indicating their powerlessness. Lerda doubtless observed how the flash of the magnesium lights in the television studios flattened and washed out details and translated this effect into his India ink works. In *Uomini in trappola*, the bright light that seems to be emanating from the screen at the center of the picture plane reduces the figure on the right to a few spindly contours. The expressive lines coming from the figure's torso suggest motion, as if the flash were accompanied by something physical, such as a blast of air or an explosion. In *Uomo e schermo*, Lerda cut a silhouetted figure from a magazine and drew on it in red, perhaps to obscure previously visible facial features. The light from the screen reduces the figure to a ghostly, anonymous silhouette. In *Autoritratto–Flash*, the flash of light reduces Lerda to a similar silhouette, with a few basic shapes in wax resist indicating his facial features.

The flash in Lerda's works is not solely an interpretation of a physical phenomenon observed in the television studios, but also a symbol of a world beyond daily struggles that fills humanity with false hope. Writing about the works in his 1962 solo exhibition, Lerda explains the symbolic significance of the light:

> The man involved in this world is subjected to the rules of the ongoing game remaining simultaneously trapped in it and fascinated by it. For him, these luminous openings represent something more than a mechanical event; they are, to an extent, myth–landscapes behind which lies a new promised land of happiness, fame, easy and immediate prosperity. I think that it is not difficult to assert that

this aspect of contemporary human behavior constitutes a social problem among the most typical of our era and among the strangest. Indeed, this type of adventure almost always ends tragically, just like the butterfly that burns its wings, fascinated by the candle or the incandescent lamp. Attempting to represent these realities graphically and pictorially in the form of an almost daily Diary, the pages or the canvases give from time to time a sense of condemnation or a pure statement, a participation or a refusal. It is my way of being socially engaged in my time.[45]

FIG. 05
Caccia all'uomo, 1956 (plate 02)

Considered in the context of his interest in existential philosophy and the overwhelming task of attempting to make sense of a postwar world, Lerda seems to indicate that striving for happiness is futile, further supporting his prior assertions that it is useless to confront or try to make sense of the absurd, unjust world. Indeed, *Uomo e schermo* conveys an image similar to Lerda's description of a butterfly fascinated by a candle, as the figure appears to walk toward the light source, transfixed. In his notes later in life, Lerda continued his fascination with screens—not only movie or television screens, but also decorative screens (*paraventi*)—and what lies behind and beyond them. He envisioned several projects (unrealized) in notes and sketches that involved old windows, writing about one in particular, "What does the triptych-window hide? What is behind? And behind still further? A way to be 'inside' the work of art, like the labyrinth."[46]

In these India ink works, the figure is not only metaphorically trapped, effaced by the powerful flash and unable to penetrate or transcend the screens with which he shares the picture plane, but he also appears physically trapped and hunted. Lerda's notes and plans for future works are rife with mentions of traps, cages, and hunting. Two works explicitly address these themes: *Uomini in trappola* and *Caccia all'uomo* (*Manhunt*) (fig. 05). In the first, the figure on the right is fully enclosed within the contours of a screen or frame, frozen in place and subjected to the flash of light (and also the accompanying physical blast, perhaps evoking the bombing in Torino). *Caccia all'uomo* features aggressive, frenetic contours drawn in wax resist with two figures in combat at the lower left, one appearing to throw his hands up in surrender. In the middle, a

red triangular shape suggests a flag on a battlefield, while the two shapes at bottom right appear to be explosions. The violence and chaos of these images in particular, along with the themes of being trapped or hunted, likely relate to the violence Lerda witnessed during World War II. Valeria Gennaro Lerda, the artist's wife, suggests that this theme may refer to Lerda feeling trapped when he took refuge in the library of the Capuchin Monastery from the clashing German troops and Italian partigiani.[47] The powerlessness of the human figures in these compositions, paired with their violent imagery, suggest humanity's inability to confront or transcend chaos and uncertainty.

Kites

In the 1960s and 1970s, Lerda continued to represent a world of personal and philosophical chaos but synthesized his ideas into a new protagonist: the kite. The basis of Lerda's work in this period remains the same (chaos, violence, and uncertainty), but he encapsulates these themes in a less threatening framework of toys, games, and childhood. In his notes, he adapts a quotation from author Valentino Bompiani's essay, "I giochi di Savinio" ("Savinio's Games"), which in turn quotes artist and author Alberto Savinio's "Fine dei modelli" ("End of Models"): "'A truly profound man is always light because he brings depth to the surface,' said SAVINIO, 'it is a good system, instead, to reduce things to objects, or better to toys, even the ineffable and perfectly spiritual things. It is the way of the Greeks, guarantee of the best result, CIVILIZATION IS A PATH THAT LEADS FROM NECESSITY TO THE GAME.'"[48] Lerda's distillation of complex concepts into toys and games indicates a shift in his reaction to the philosophical tension he perceives. Initially, his use of the screen and flash conveyed a total hopelessness: humans could not transcend or penetrate the screens or overcome the powerful flash. The kite, though still not fully able to overcome chaos, is a more optimistic, hopeful symbol.

For Lerda, the kite stands for freedom, both of the artist (as Lerda writes in his notes, "Art is a daily exercise toward freedom") and generally from personal and philosophical chaos.[49] As Cordero suggests, they are "perhaps a liberating beat of the wings in order to

FIG. 06
Aquilone, 1972 (plate 12)

invent a new reality, lighter and freer in the face of the heaviness of events of individual history. Kites: metaphor for life and the fragility of existence."[50] Indeed, many of Lerda's depictions of kites in collage and tempera show them striving toward the upper reaches of the picture plane, as two mixed-media works from 1972, both titled *Aquilone* (*Kite*) (figs. 06 and 07), demonstrate.[51] Gennaro Lerda writes about the optimism conveyed by his most precious symbol: "Piero created an imaginative universe of colors and techniques, giving body, light, life to the symbol most dear to him: freedom, expressed in the kites that for the artist assume the symbolic value of archetypal forms In each of these [kites], the will to fly, the anxiety of going beyond the boundary (the frame, the page, life?), the triumph of beauty."[52] Lerda's soaring, colorful kites invite the viewer to contemplate the upper limits or boundaries of the world, whether it is the edge of a picture plane, the ceiling of a room, or the sky, and convey a feeling of hopeful transcendence, an escape from the painful chaos and uncertainty at the base of human experience.[53]

Although Lerda's kites constitute a turn toward a more positive ideology than that conveyed in his previous works in India ink, they also carry distinct hallmarks of the hopelessness with which Lerda struggled. Even though the kites strive to surpass the upper reaches of their setting, they can never do so. Their freedom is an illusion, as they are tied to earth by the same string needed for flight. Lerda does not depict the string, only the colorful tails, but several scholars, including Cordero, Gennaro Lerda, and Ugo Cacace, have noted this limitation that confines the kite to earthly reality.[54] Cordero sees in Lerda's kites a "true yearning for spirituality," and the artist's up-close renderings in particular give the kites the almost desperate appearance of wishing to break free.[55] In all four up-close renderings in the exhibition—the two titled *Aquilone*, *Aquilone da combattimento* (*Combat Kite*) (fig. 08), and *Aquilone rosso* (*Red Kite*) (fig. 09)—the kites seem to be trapped in a frame that is too small, with their forms making at least one point of contact with the edge of the picture plane. The kites in the two images titled *Aquilone* particularly appear to be making an effort to break through the frame, both angled toward the upper left corner as if trying to take off. More sinister ideas for kites appear in Lerda's notes as well: "morte di un aquilone" ("death of a kite"), "funerali di un aquilone" ("kite

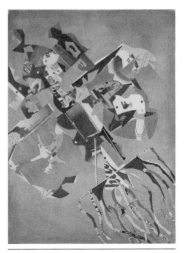

FIG. 07
Aquilone, 1972 (plate 13)

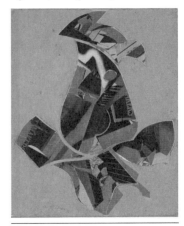

FIG. 08
Aquilone da combattimento, 1965 (plate 09)

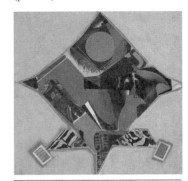

FIG. 09
Aquilone rosso, 1965 (plate 10)

funerals"), and a sketch of a kite, trapped, with the caption "gabbia con aquiloni" ("cage with kites") and the words "in trappola" ("trapped") appearing to the side.[56] Thus, the kite's limitations and fragility were not far from Lerda's mind, nor was the idea that this symbol of freedom and optimism could be overpowered and contained.

Some of Lerda's kites, such as *Aquilone da combattimento*, have a more combative tone, hearkening back to the violence of World War II. In addition to the work's aggressive title, the kite itself has the menacing appearance of a fierce bird with a sharp beak; in fact, in his notes, Lerda wrote "uccelli rapaci" ("birds of prey") among a list of possible titles for future works.[57] Lothar Hönnighausen, professor emeritus of American literary studies at the University of Bonn, determines that a similar kite Lerda made in 1972 "communicates an expressiveness through its wings, head, and beak that creates fear."[58] The two works titled *Aquilone* from 1972 also have an aggressive appearance—their sharp edges and symmetrical wings resemble warplanes more than children's toys, and the tails have sharp, jagged edges rather than the soft curves of ribbon or fabric. Hönnighausen agrees that wings such as these suggest "complicated and dangerous machines."[59] Lerda creates a truly ambiguous symbol by transforming harmless toys that engender feelings of hopefulness and optimism into instruments of destruction, which implies that humanity is capable of terrible things and perhaps can never really escape violence and injustice.

Merry-Go-Round Cities

Lerda also blended the optimistic, colorful world of childhood with the violent, chaotic world of adults in his *città giostre*, or "merry-go-round cities," his renderings of a world rebuilt by innocent children after its destruction by adults.[60] At the edges of the picture plane lie jumbles of forms that call to mind buildings, monuments, fountains, bridges, banners, and flags, all resembling colorful building blocks or toys (see figs. 10–13, 15, and 16 and color plates 14–20). For instance, some of the abstracted equestrian monuments in Lerda's merry-go-round cities have the appearance of carousel horses or rocking horses, as in the upper left and right of one work titled *Città*

giostra visitata dagli aquiloni (*Merry-Go-Round City Visited by Kites*) (fig. 11).[61] Similarly, in his lists of titles for prospective projects, Lerda places the distinct features of a city—fountains, monuments, gardens, flags—alongside childhood toys, games, and fairytales, such as seesaws (frequently mentioned), pinwheels, Pinocchio and Jiminy Cricket, and a comparison of his merry-go-round city to a game of Ring Around the Rosie.[62] As Mulatero argues, Lerda transforms these elements in an imaginative way, but some remain recognizable, yielding a semi-ordered chaos.[63]

Lerda did not limit the structure of his merry-go-round cities to the transformation of toys. He also took inspiration from traditional formats and reimagined them to suit modern themes, something he learned from his study with Alicandri. In a note from August 1972, he explains:

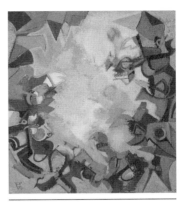

> The idea of filling the canvas along the edges rather than the center was born of a precise need for structure in the painting and not of a whim dictated by the desire for novelty. The recurring themes, merry-go-rounds and cities visited by kites, demand this type of layout. Furthermore it stimulates the desire for recovery of the space of the eighteenth-century vaults, especially [those by Giovanni Battista] Tiepolo (in any case Venetian) Revisiting this genre of painting entailed the reorganization of the space in a modern way, filtered through today's sensibility, and at the same time required my own substitution of eighteenth-century "themes" with contemporary "content."

> The space occupied by Madonnas and angels in a circle now becomes occupied by kites and merry-go-rounds and the interpretation of the canvases or of the ceilings remains influenced by this perspective.[64]

Although kites, the new protagonists of Lerda's compositions, often visited or inhabited the skies, the central spaces of the merry-go-round cities were not always occupied. Lerda often leaves the middle of the picture plane empty, which gives the impression of lying on one's back and looking up at the sky as city buildings lean in on all sides. In a passage written in English, he explains his use of empty space:

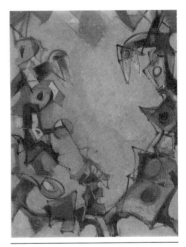

FIG. 11
Città giostra visitata dagli aquiloni, 1977 (plate 18)

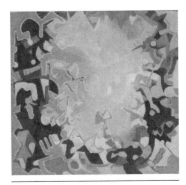

FIG. 12
Untitled, 1970 (plate 16)

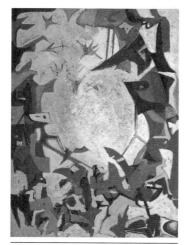

FIG. 13
Città giostra con aquiloni, n.d.
(plate 20)

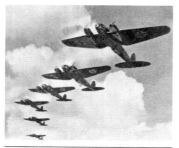

FIG. 14
Unidentified photographer. German
Heinkel He 111s, ca. 1939–42. Photo-
graph MH6547, part of the Foreign
Office Political Intelligence Depart-
ment Second World War Photograph
Library: Classified Print Collection.
© Imperial War Museums.

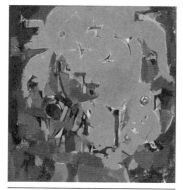

FIG. 15
Città giostra visitata dagli aquiloni,
1970 (plate 15)

The skies portrayed by Venetian painters like Tiepolo populated by
the Virgin, Saints and little Angels turn to a theatre stage.

The action takes place in an architectural space occupied by a struc-
ture of a town that looks like a mechanical fairly harmonious whole
formed by a series of toys, a kind of a merry-go-round-village over
which fly kites and other machines. Everything is painted along
the borders of the canvas—the center is empty. The normal place of
the protagonists is displaced. A change of scenery—an expedient to
attract the notice of the people. In any case these paintings never
show the presence of the humans. Mankind is absent—far, very far.[65]

The merry-go-round cities mark a departure from the India ink
works, which centered on human figures and the effect of screens
and flashes on them. By contrast, Lerda's merry-go-round cities
show a world without humans, lending them a haunted, post-apoc-
alyptic appearance that likely draws upon that of Torino and other
cities that suffered destruction during World War II.

Lerda makes this powerful connection clear in an unpublished
essay from 1970 titled "Le Scaglie per una poetica dell'ottimismo"
("Bits for a Poetic of Optimism"):

Now it will be up to him [mankind] to replace the destroyed species,
with his very own creations, with the help of technology and all of
the contraptions of "progress": this bestiary, driven by electronic
machinery or worse, will be given to children so that they can play
and to adults so that they can make wars. Who knows what these
new toys will be like, certainly made of very colorful metal. They will
move with feigned nonchalance, they will follow circular or ellipti-
cal trajectories, they will try to disguise themselves by assuming the
appearance of merry-go-rounds or toys of other times. And in the sky
kites will rise again, they too having developed with the times, half
birds and half flying machines, and, in their flight paths, they will find
other predatory enemies that will seek to destroy them. These false
hippogriffs, large dragonflies armed with deadly instruments, will
shoot down every kite they encounter and will not worry about the
reserve combat kites. Then they will attack the merry-go-round city,
the children's last hope, and will disseminate death and desolation.[66]

In this text, Lerda conveys a fear of the future and a pessimistic view of new technologies, such as the ones used in World War II for destructive purposes, which struck a powerful chord with him. The "false hippogriffs" in the passage are certainly helicopters, as he compared and interchanged the two countless times in his notes and sketches, including two vivid sketches showing helicopter–animal hybrids and comparisons (figs. 18 and 19). Even though hardly any of his large works feature helicopters, for Lerda they are perhaps the foremost symbol of evil and the enemies of kites, his ultimate symbol of good.

The conflict between good and evil that preoccupied Lerda throughout his life plays out symbolically in the fight between the fearsome helicopters and the fragile kites. The merry-go-round city is at once the playful world of childhood innocence, the "children's last hope," and the setting for this violent battle. Even though none of the merry-go-round cities explicitly show helicopters, many of the abstracted shapes flying in the sky could be interpreted as warplanes or helicopters instead of kites (see figs. 13, 15, and especially 16). In *Città giostra con aquiloni* (*Merry-Go-Round City with Kites*) (fig. 13), the six shapes in the sky have the colorful appearance of kites, but also the sharp angles of warplanes silhouetted against the sky (fig. 14). Lerda's notes are full of references to these aerial battles: in a list of future projects, under the heading "Cacce" ("Hunts"), Lerda lists "elicotteri (ippogrifi)" ("helicopters [hippogriffs]") and "aquiloni" ("kites"); a bit farther down, under the heading "Disegni in bianco e nero" ("Drawings in black and white") is "attachi aerei" ("aerial attacks"); and, on another sheet, "Elicotteri contro aquiloni: cieli con palloncini aquiloni, terra con scene di guerra" ("Helicopters against kites: skies with kite-balloons, land with war scenes").[67]

Lerda's merry-go-round cities embody the same duality that colors his previous works and his philosophy—a representation of the tension between good and evil, innocence and violence, chaos and organization. The juxtaposition of a ruined, post-apocalyptic world with the bright colors and shapes of children's toys gives the sense of innocence and optimism combatting terrifying violence and chaos—the world of children versus that of adults. In two different lists of concepts for potential projects, Lerda wrote the phrase, "Fondale

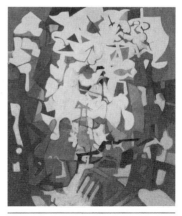

FIG. 16
Untitled, 1974 (plate 17)

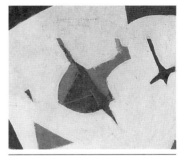

FIG. 17
Detail of figure 16. The abstracted object flying in the sky at the top center of the picture plane strongly resembles a helicopter: the triangle divided by a thin line has the appearance of a cockpit, the long line bisecting the entire shape could represent a propeller, and the tail looks similar to a helicopter's tail rotor.

FIG. 18
Lerda created *modelli minimi*, collections of sketches and drawings mounted on thick paper to illustrate his thought process throughout his career. He made several assemblages for each decade; these two examples are from the 1970s and are both in the collection of Valeria Gennaro Lerda.

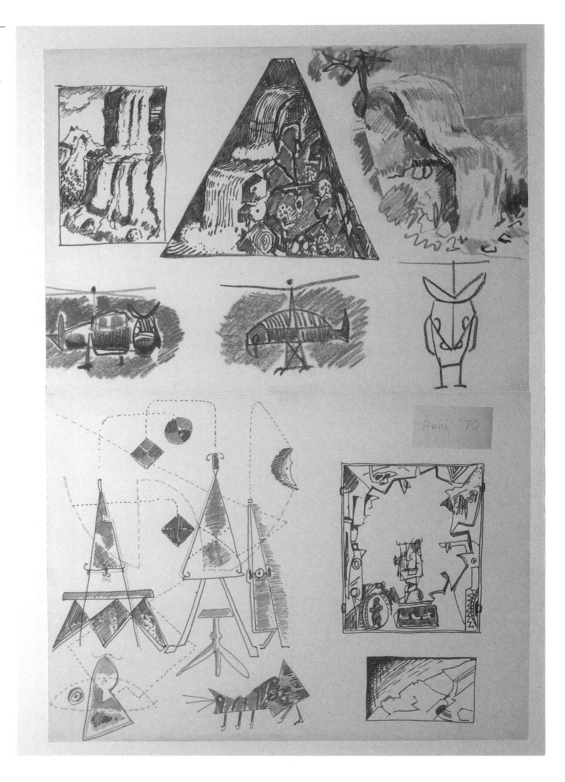

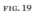

FIG. 19

per una favola per grandi" ("Backdrop for a fairytale for adults"); perhaps the merry-go-round cities are the setting in which adult innocence will be restored.[68] At the same time, the merry-go-round cities may be an ambiguous symbol, representing a false hope; in his study notes on La Fontaine, Lerda hinted at the potential ambiguity of fairytales, summarizing, "PAS DE PITIÉ DANS LA FONTAINE" ("No pity in La Fontaine").[69]

Primordial Chaos, Creation, & Metamorphosis

In Lerda's last group of works, dating from the 1990s to the 2000s, he continues to ponder chaos but now pertaining to the creation of the universe, the passage of time, and metamorphosis. His works of this period are a joyful explosion of color and appear to convey a more celebratory viewpoint, or at least one of curiosity. In one of his lists of concepts for new series of works, Lerda wrote, "la Creazione, le Metamorfosi, Ipotesi di un nuovo paradiso terrestre" ("Creation, Metamorphoses, Theories of a new earthly paradise"), perhaps indicating a fundamental sequence: creation followed by transformation, leading to a new world or beginning or perhaps to an end.[70] In this series, Lerda ponders the cause and progression of endings and new beginnings and contemplates the nature of time in general. In some works, he tries to address the problem by creating a geometrical order, while in others he observes and depicts metamorphosis with no clear resolution.

Lerda associated chaos with creation and believed that one could not exist without the other. Several of his notes evoke primordial chaos and Biblical creation, including one that stands apart on a separate sheet: "I primi versetti della Genesi con l'immagine del 'tohu–va–vohù,' il caos primordiale sul quale plana lo spirito di Dio" ("The first verses of Genesis with the image of 'tohu–va–vohù,' the primordial chaos over which hovers the spirit of God").[71] Other lists of titles and concepts for new projects encompass chaos, beginnings and endings, and some violent imagery: "Dalla serie la CREAZIONE: il giorno del giudizio, il Big Bang, l'Apocalisse" ("From the series the CREATION: the day of judgment, the Big Bang, the Apocalypse"); "Apocalisse tecnologica" ("technological Apocalypse"); "Dalla serie 'La Creazione: The Adam and Eve D day'" ("From the

series 'The Creation: The Adam and Eve D day'"); "'Come arriverà la fine del mondo?'" ("'How will the world end?'"); "Anno 2000 il nuovo caos" ("Year 2000 the new chaos"); "Alla scoperta del 'Nuovo Mondo,' il secondo Millennio" ("To the discovery of the 'New World,' the second Millennium"); and mentions of The Fall—that of Icarus and "the fall of the gods."[72] Gennaro Lerda says that she and Piero spoke about the Big Bang and black holes often and that it is important to note that Piero used the term "apocalypse" in the Biblical manner of rebirth, rather than to signify the end of the world.[73] Mulatero points out that it is impossible for one to contemplate the beginning and evolution of the universe without also contemplating chaos: Lerda "intended to make a personal and original contribution to a modern interpretation of the concept of cosmogony. We know that cosmogony concerns both the evolution of the universe and the origin and evolution of individual things in the universe (stars, galaxies). Indeed, the two words cosmo plus gonos/creation call to mind the creation of the world, likewise the word cosmo/kosmos comprises harmony and order as distinct from chaos. However, one cannot think of cosmogony without also referring to this other side, consisting of chaos."[74]

Grappling with the pairing of creation and chaos (an inevitable one, as Mulatero suggests) and the ambiguity of beginnings and endings, Lerda attempted to resolve this confusion in his art. According to Gennaro Lerda, Piero's works of these two decades mark an effort to reorganize philosophical chaos to arrive at a new vision of harmony.[75] She explains, "In each of his paintings, sketches, and drawings, in every fragment of his works, Piero tried to respond with reason and with his profound knowledge, part of his very being, to the great question of the Order of primordial, primitive, inescapable Chaos."[76] In the 1990s and early 2000s, Lerda tried to reorganize or find order in chaos and resolve some of the tension he felt by depicting a rational, basic geometry. Works such as *Triangolo blu e cerchio rosso* (*Blue Triangle and Red Circle*) (fig. 20) and *La nuova geometria* (*The New Geometry*) (fig. 21) are stripped down to essential shapes, which give the sense that Lerda is revealing the basic elements or building blocks of the universe (especially in the case of *Triangolo blu e cerchio rosso*, which uses striking primary colors).

FIG. 20
Triangolo blu e cerchio rosso, 1995
(plate 22)

FIG. 21
La nuova geometria, 1995 (plate 21)

Fundamental geometric shapes appear in Lerda's lists of titles as well: "Il quadrato è luce" ("The square is light"); "Il triangolo e Dio" ("The triangle and God"); "In quadratura del cerchio sbilenco" ("The squaring of the uneven circle"); and "Quattro piazze quadrate" ("Four squared squares").[77] While the last two reveal some of Lerda's sense of humor, "Il triangolo e Dio" is telling; Gennaro Lerda suggests that her husband thought the triangle was the most perfect shape, equating it to the Trinity.[78] Indeed, triangles feature prominently not only in *Triangolo blu e cerchio rosso* and *La nuova geometria*, but also in later works such as *Progetto e invenzione (Project and Idea)* (fig. 22) and *La creazione del mondo (The Creation of the World)* (fig. 23), in which red and blue triangles appear. Mulatero links the geometry present in Lerda's India ink works of the 1950s with that of the merry-go-round cities of the 1970s; in fact, a thread of geometric shapes runs through Lerda's entire body of work.[79] For example, the red circle that appears prominently in *Aquilone rosso* (fig. 09) shows up later in *Triangolo blu e cerchio rosso*.

Another unidentified shape appears even more consistently in Lerda's work of the 1990s and 2000s: an oblong shape with two rounded ends. In *La creazione del mondo*, it appears in the upper left against a red background and at center right against a dark background, both times outlined in white. Several other depictions of this shape show up throughout Lerda's work, including in five other works in the exhibition (figs. 21–24 and plate 27). Despite its importance in his art, Lerda never explains this shape in his notes. In many instances, it appears to be a keyhole or peephole, often cut out of the top layer in a collage and allowing the viewer to see a sliver of the layer behind it. This interpretation dovetails with Lerda's imagining his screens in the 1950s as portals to another world. The shape is also strikingly similar to the symbol for infinity, and it is highly likely that Lerda would have wanted to invoke this concept, given his strong interest in the passage of time. In 1960, he wrote a letter to a United States Cultural Affairs officer that reads, in part, "I hope to take advantage of the summer break to continue my absurd 'abstract' experiments in my painting. Watch out! One of these 'exhibitions' might find its way to Zagreb: it is only a question of time, but we agreed on the fact that time is infinite."[80] Lerda made several notes—often on the backs of calendar pages, clear markers of

the passage of time—regarding seasons, weather, times of day, and history.[81] Some of these notes refer to eternity and cyclical time; for instance, "storia circolare" ("circular history") appears in a list of Lerda's titles, and he saved a photograph of a painted sundial located on la Grande Gargouille in Briançon, France, copying down the accompanying inscription, "Qu'une certaine heure te trouve peignant l'éternité" ("May a certain hour find you painting eternity").[82]

Lerda's interest in the passage of time also manifested in his assembly of what he named "reliquaries." Lerda gathered everyday items, such as muselets (the wire cages from champagne bottles), the foil from wine bottles, strips of burlap, shavings of tree bark, and torn pieces of paper, in plastic bags, which he tied shut and hung on the walls of his studio. He preserved these common materials, not without irony, as a kind of shrine, never using them in his collages. In one note, he explains their purpose in English: "All the objects, the things closed in these plastic bags are like [a] reliquary, shrine— they are a token of a season of my life—they belong to my past, and my present time."[83] In a separate note, he elaborates, "Relics: archetypal, sheathed in plastic bags. Wide-ranging use as concrete example of overcoming the dichotomy of adolescence and old age."[84] In other words, Lerda's reliquaries symbolize the passage from past to present, uniting two seemingly separate stages (youth and old age) beneath a continuous arc of time. Gennaro Lerda suggests that the reliquaries convey the idea that, despite the inexorable march of time, some aspect of human beings (in this case, objects we produce) can be salvaged.[85]

In many works of this era, Lerda merged his thoughts on chaos, creation and destruction, and the passage of time with representations of metamorphosis. In these works, he appears to be less actively pursuing order through new geometry; instead, Lerda seems more content to observe or marvel at the effects of the passage of time. Three works from the exhibition show landscapes and kites in the midst of transformation: *Cronaca italiana: paesaggi stravolti ognuno deve organizzare il caos che trova in sé . . . (Italian History: Distorted Landscape Each One of Us Must Organize the Chaos within Himself . . .)* (fig. 24); *Metamorfosi di un aquilone (Metamorphosis of a Kite)* (fig. 25), and *Metamorfosi di un paesaggio con aquiloni (Metamorphosis of a Landscape with Kites)* (fig. 26). Lerda clearly

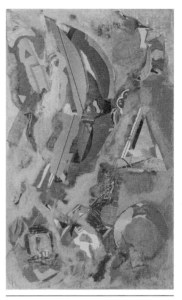

FIG. 22
Progetto e invenzione, 2003 (plate 28)

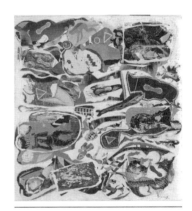

FIG. 23
La creazione del mondo, 2007 (plate 29)

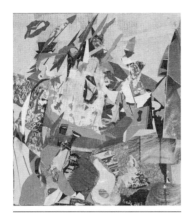

FIG. 24
Cronaca italiana: paesaggi stravolti ognuno deve organizzare il caos che trova in se . . ., 2002 (plate 25)

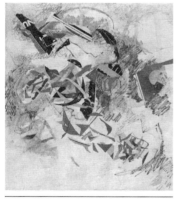

FIG. 25
Metamorfosi di un aquilone, 1987–2000 (plate 23)

associates metamorphosis with chaos, given the combination of the two concepts in the title of the first work and the overall chaotic appearance of all three. Lerda depicts landscapes and kites mid-transformation in explosions of color and abstract form. While the colors are joyful, and the forms sometimes have the appearance of confetti, the metamorphoses shown are far from gradual and peaceful.

For Lerda, metamorphosis also meant violence and destruction. Many of the titles in his notes convey violent change and chaos, such as "Metamorfosi di un paesaggio – lo Tsunami" ("Metamorphosis of a Landscape – The Tsunami") and landscapes described as "petrified," "ravaged," and "brutal," culminating in the phrase "un paesaggio non è mai innocente" ("a landscape is never innocent").[86] There is a certain violence in Lerda's working method as well—he used stiff-bristled brushes and metal tools to scrape and abrade the surfaces of his works, as seen in *Cronaca italiana*. This violence of metamorphosis likely refers to primordial chaos (especially the violence of the Big Bang) and to war and human violence (for instance, Lerda created a work titled *Metastasi metropolitana – La caduta delle Twin Towers* [*Metropolitan Metastasis – The Fall of the Twin Towers*], 2002). Hönnighausen identifies *Metamorfosi di un aquilone* as an example of warlike violence. He interprets the work as a depiction of a kite dissolving into the air "at an advanced stage of collapse" after being hit in an aerial battle such as the one Lerda described between kites and helicopters that took place over his merry-go-round cities.[87]

The creation and metamorphosis series once again encourages the viewer to contemplate the chaotic, irrational, and fragile world. Lerda's works of this period show that a sudden metamorphosis could occur at any moment, completely transforming our world. Although violence is not required for this transformation, Lerda contends that chaos is required for creation or rebirth. His metamorphosis works show a transformation not yet resolved, which leaves viewers in a place of ambiguity: they must decide whether Lerda depicts an end or a beginning.

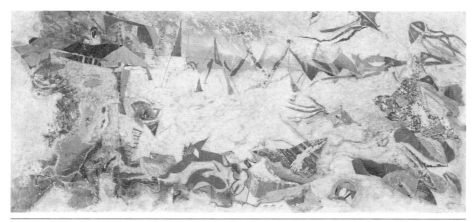

FIG. 26
Metamorfosi di un paesaggio con aquiloni, 2000 (plate 24)

CONCLUSION

Lerda was a prolific artist and thinker whose work conveys his ongoing self-reflection and efforts to resolve contradictions within his philosophy. He described his art as "in tension," and strove to achieve a balance in his working process between intuition and rationality and in his themes between order and chaos, good and evil, pessimism and optimism, and the innocence of children and the cynicism of adults. The theme of metamorphosis runs through his entire body of work—the flash overpowering and transforming the human figures in his early works, kites morphing from toys to instruments of combat, the battle between kites and helicopters that radically changes the merry-go-round city, the violent metamorphosis of landscapes and kites and his overall contemplation of creation and chaos in his later works. As he reevaluates and refines his philosophy in his art, the sense of ambiguity increases and his conception of the passage of time expands. In the compositions showing screens, the flash occurs in an instant and washes out or completely effaces the human figure with seemingly no hope for survival. In the merry-go-round cities, a battle and rebuilding takes place over a longer span of time, engendering an ambiguous hope for the future. In his final works, Lerda explores the concept of metamorphosis and the passage of time in itself. As he attempts to resolve the ambiguity of creation and chaos, beginnings and end-

ings, and good being born of evil and vice versa, it seems he has undergone a personal metamorphosis as well. Perhaps he felt he achieved the liberation of art (in his notes, he records a quotation from German philosopher Theodor W. Adorno: "Art is magic liberated from the lie of being truth") and of the artist ("Art is a daily exercise toward freedom") that he sought.[88] Days before he passed away, he added "Apochalisse [*sic*] please" to a list of titles for paintings, perhaps indicating that he was ready for a new beginning.[89]

Viewing Lerda's art simultaneously gives insight into the shared, global experience of a particular era and his unique, private world. On the one hand, Lerda's art did not adhere to popular trends— many Torinese critics felt that his work was too literary and would not fit in with the intuitive style of the dominant Abstract Expressionist movement.[90] At the same time, his art production is rooted in its era, embracing aspects of Abstract Expressionism, the Northwest School, and existentialism and, above all, coming to terms with the postwar world. The philosophical and at times traumatic basis of his art does not eclipse the hopeful, playful, and innocent side. As Hönnighausen states, "The philosophical dimension of his canvases does not contradict the precise sense of lightness and playfulness that characterizes his capacity to dominate forms and colors," and he terms this blend "metaphysical playfulness."[91] Lerda distills complex and often tragic concepts into colorful symbols steeped in chaos and metamorphosis, leaving room for the viewer to contemplate this tension and to decide whether they signal an end or a new beginning.

NOTES

1 Piero Lerda, papers, Georgia Museum of Art, Athens, Georgia. For all of Lerda's writings, emphases and ellipses appear in the original unless otherwise noted. All translations mine unless otherwise indicated.

2 See Ivana Mulatero, "L'indomesticabile caos," in *Piero Lerda: Dal caos al gioco, Opere dal 1948 al 2007*, exh. cat., ed. Ivana Mulatero (Caraglio: Marcovaldo, 2009), 21.

3 Piero Lerda, quoted in ibid., 19.

4 Elizabeth Hayes Turner, "Un ricordo di Piero," in *Piero Lerda: Dal caos al gioco*, 207.

5 Piero Lerda, "La Condition humaine dans les romans de Bernanos" (Thesis, Università degli Studi di Torino, 1952), 24.

6 See ibid., 25.

7 Other intellectuals working at RAI during this time included Gianni Vattimo, Furio Colombo, Vincenzo Incisa, Claudio Gorlier, Luciano Gallino, Folco Portinari, Michele Straniero, and Paolo Siniscalco. See Gianni Vattimo, "A Piero Lerda," in *Piero Lerda: Dal caos al gioco*, 213.

8 Ibid.

9 One of Lerda's notes shows that he, too, took advantage of the USIS library to improve his English: "English: listen to audio courses and translate French-English texts into Italian." Lerda, papers.

10 Lerda reviewed *Painting in America* and *Modern Art USA* in 1957, and also monographs on Albert Pinkham Ryder, Jackson Pollock, and Willem de Kooning. See Mulatero, "L'indomesticabile caos," 25.

11 Vattimo, 212.

12 Lerda, papers.

13 Ibid. Lerda recorded the first quotation in Italian and the second in the original French. These translations come from Albert Camus, *The Myth of Sisyphus and Other Essays*, trans. Justin O'Brien (New York: Knopf, 1955), 4 and 21.

14 Lerda, papers. See Jean Giraudoux, "Les cinq tentations de La Fontaine," in *Oeuvres littéraires diverses* (Paris: Grasset, 1958), 412. Essay first published 1938 by Grasset. Also see Jean-Michel Rey, "La Mise en jeu" in *Georges Bataille* (Paris: Éditions Inculte, 2007), 195–96. First published 1967 in *L'Arc* 32. Lerda saw the labyrinth as a symbol of no escape. He created one work on this theme, a circular composition titled *Il labirinto (The Labyrinth)*, ca. 1980. Among his papers are sketches of labyrinths, and, in a final list of titles written during the last days of his life, he wrote "Labyrinth and tunnel." Lerda, papers.

15 Lerda, papers. See Friedrich Nietzsche, "On the uses and disadvantages of history for life," in *Untimely Meditations*, ed. Daniel Breazeale, trans. R. J. Hollingdale (Cambridge: Cambridge University Press, 1997), 123.

16 Hayes Turner, 207.

17 Ibid.; and Linda Van Hart, "Conversazioni sul collage," in *Piero Lerda: Dal caos al gioco*, 212.

18 Lerda, papers. Lerda recorded the quotation in the original French, but left out the text that appears in brackets. This translation comes from Jean-Paul Sartre, "Introducing *Les Temps modernes*," in *We Have Only This Life to Live: The Selected Essays of Jean-Paul Sartre, 1939–1975*, ed. Ronald Aronson

and Adrian Van den Hoven, trans. Jeffrey Mehlman (New York: New York Review of Books, 2013), 143. Emphasis in the English translation of Sartre.

19 Piero Lerda, "Cinquant'anni di pittura americana 1900–1950," in *Piero Lerda: Dal caos al gioco*, 187–89.

20 Piero Lerda, quoted in Willy Darko, ed. *Piero Lerda: geometrie del caos: Opere dal 1955 al 1968*, exh. cat. (2011). Even though Lerda preferred to work in solitude, he was very outgoing, witty, and lighthearted. Friends were often surprised to learn of the underlying philosophy of his works. Lerda's friends often visited his studio, and he was forthcoming about discussing his art and theories. Personal communication with Valeria Gennaro Lerda, February 2014.

21 See Mulatero, "*L'indomesticabile* caos," 26. The list of artists that Lerda admired also includes Jasper Johns, Romare Bearden, Joan Miró, Wassily Kandinsky, and Paul Klee. In his studio, Lerda displayed silkscreened reproductions on canvas of Mark Tobey's *Gothic* (1943; Seattle Art Museum) and Arshile Gorky's *Betrothal* (1947; Museum of Contemporary Art, Los Angeles). Lerda also hung these reproductions in his office at USIS from 1958 to 1963.

22 Lerda, papers. Transcribed by Valeria Gennaro Lerda and Monica Ammirati.

23 Lerda, "Cinquant'anni di pittura americana 1900–1950," 189–90.

24 Ibid.

25 Ibid., 189.

26 Lerda, papers.

27 Ibid.

28 Piero Lerda, quoted in Mulatero, "*L'indomesticabile* caos," 31.

29 Renzo Guasco, *Lerda*, exh. broch. (Torino: L'Immagine, 1962), in Lerda, papers. Reprinted in *Piero Lerda: Dal caos al gioco*, 207.

30 Lerda, papers.

31 Ibid.

32 Ibid.

33 Ibid.

34 Ibid.

35 Ibid.

36 Ibid.

37 Lerda employed these three techniques (India ink and wax resist, tempera, and collage) most often, but his studio and notes show that he was interested in a wide variety of media and techniques. In a visit to his studio, I observed the following materials: magazines, books, and other collage material, inks, paints, palette knives, brushes, paint shavings (Lerda scraped into the painted surface of some of his works and often retained the paint that he removed for later use), candy wrappers, strips of yarn, fine-point markers, corrugated cardboard, crayons, pipettes, empty paint tubes, burlap, twine, netting, thin pieces of tree bark, leaves, and a blank jigsaw puzzle. His notes reveal plans for experimentation with batik, epoxy resin, armatures made of wood or painted metal, metal sculpture, tapestry, mosaic, Plexiglas, acrylic paint on unprimed linen, painting on glass, pastel, linocut, woodcut, and even underwater sculptures contained in glass or plastic boxes. Lerda, papers.

38 Giovanni Cordero, "Frammenti di infinito," in *Piero Lerda, Gianfranco*

Galizio, ed. Willy Darko. exh. broch. (2011).

39 Lerda, papers. Nearby, Lerda recorded the name of American author Jonathan Lethem and the title of his essay "The Disappointment Artist," published in *Harper's* in February 2003. It is unclear whether the two notes are connected.

40 Piero Lerda, quoted in Guasco.

41 Lerda, papers. The full quotations are as follows: "The screens and the *interni–flash* recurring in the titles are the protagonists of the depicted world and relate to a reality found in the external world: movies, television, photo journalism, also interiors of movie and television studios, an almost hallucinatory and artificial atmosphere, dominated by flashes from the lights, by the cold neon lights, by the silences and expectations measured in seconds." "The screens and the *interni–flash* that recur in the titles are the key to the world that I wish to represent. Not a real world (in the usual sense of the word) nor a surreal, metaphysical world, even if the general mood of these pages sometimes betrays some more or less emphasized trace of it (surrealism, on the other hand, is practically a constant in all of the modern trends, except maybe 'gesture' painting)."

42 Giovanni Cordero, "Piero Lerda: Teatri della mente," in *Piero Lerda: geometrie del caos.*

43 Darko, *Piero Lerda: geometrie del caos*; and Mulatero, "L'indomesticabile caos," 28.

44 A large part of Lerda's creative process comprises his lists of titles and concepts for future works, drawn from his reading of literature, poetry, and philosophy. Along with his original writing and his recording of philosophical and literary quotations, he kept endless lists of titles from the 1950s until the day before his death, in November 2007. The titles came to him before the works of art, which often did not come to fruition at all. He even conceptualized entire exhibitions in list form that never occurred. He referred to his lists repeatedly, keeping them for fifteen to twenty years or more. Lerda explained why he did not throw them out: "Maybe because these art projects and all of the others that you keep in that drawer are something more than a sign of your vitality: they are a summary of happiness, of emotions, of beginnings of creation." Lerda, papers. For more about Lerda's titles, see Valera Gennaro Lerda, "L'ipotesi di un Paradiso Terrestre: un percorso di arte e di pensiero di Piero Lerda," in *Piero Lerda: Dal caos al gioco*, 41–43.

45 Lerda, papers.

46 Ibid.

47 Personal communication, February 2014.

48 Lerda, papers. See Valentino Bompiani, "I giochi di Savinio," in *Dialoghi a distanza* (Milan: Arnoldo Mondadori, 1986), 55–56. Lerda changed the quotation; the original follows: "'Un uomo veramente profondo è sempre leggero' diceva 'perché porta la profondità in superficie. (Per questo io non credo alla Russia, che è l'Eleonora Duse della politica.)' Riduceva le cose e i fatti a oggetti, meglio a giocattoli, anche le ineffabili e perfettamenti [*sic*] spirituali. 'È il modo greco, garanzia di ottimità. La civiltà è un cammino che conduce dalla necessità al gioco.'"

49 Lerda, papers. Transcribed by Valeria Gennaro Lerda and Monica Ammirati.

50 Cordero, "Frammenti di infinito."

51 Lerda was preoccupied with kites. His notes contain plans for a multitude of unrealized projects focusing on kites—he wanted to make them out of wood, enamel, and metal, and had plans to create kinetic sculptures, kites mounted on rolling frameworks or assembled in mobiles. He thought the shadow cast by the sculpture was very important and wanted to allow it to change through movement. Some of these projects were site-specific: in one note, Lerda wrote that he would like to put a metal kite sculpture in a neglected corner of the room. Lerda, papers.

52 Gennaro Lerda, 43.

53 Lerda's notes reveal a general interest in flight and the sky, as well as the upper reaches of architectural settings. Alongside notes about kites appear several mentions of the sky, stars, constellations, and astronauts, as well as ceilings, vaults, and cupolas. Lerda, papers.

54 See Cordero, "Frammenti di infinito"; and Ugo Cacace, in *Armonie del caos di Piero Lerda*, exh. broch. (Bologna: Nuova Galleria d'Arte la Piccola, 2013), 4.

55 Cordero, "Frammenti di infinito."

56 Lerda, papers.

57 Ibid.

58 Lothar Hönnighausen, "La pittura metafisica di Piero Lerda," in *Piero Lerda: Dal caos al gioco*, 38.

59 Ibid.

60 Personal communication, February 2014.

61 For another depiction of a merry-go-round horse, see Lerda's untitled work from 1974 reproduced in Mulatero, "L'*indomesticabile* caos," 30.

62 Lerda, papers.

63 See Mulatero, "L'*indomesticabile* caos," 30.

64 Lerda, papers.

65 Ibid.

66 Ibid.

67 Ibid.

68 Ibid.

69 Ibid.

70 Ibid.

71 Ibid. "Tohu–va–vohù" or "Tohu wa bohu" is a Hebrew phrase in the Bible that connotes emptiness, formlessness, and the void, evoking the condition that preceded creation.

72 Ibid.

73 Personal communication, February 2014.

74 Mulatero, "L'*indomesticabile* caos," 33.

75 Personal communication, February 2014.

76 Gennaro Lerda, 41.

77 Lerda, papers.

78 Personal communication, February 2014.

79 See Mulatero, "L'*indomesticabile* caos," 22.

80 Piero Lerda, quoted in Darko, *Piero Lerda: geometrie del caos.*

81 See Gennaro Lerda, 41.

82 Lerda, papers.

83 Ibid.

84 Ibid.

85 Personal communication, August 2014. According to Gennaro Lerda, the reliquaries made up such an important part of Lerda's artistic practice that he included them in his lists of items to show in exhibitions. Lerda also indicated in his notes a possible series of reliquary sculptures. Lerda, papers.

86 Lerda, papers. The last title in this list comes from Lerda, papers, transcribed by Valeria Gennaro Lerda and Monica Ammirati.

87 Hönnighausen, 38.

88 Lerda, papers. Lerda recorded Adorno's phrase in Italian. The second phrase comes from Lerda, papers, transcribed by Valeria Gennaro Lerda and Monica Ammirati.

89 Lerda, papers.

90 See Ivana Mulatero, "Segni fluttuanti dietro le palpebre: Opere di Piero Lerda dal 1955 al 1968," in *Piero Lerda: geometrie del caos*.

91 Hönnighausen, 36.

PLATES

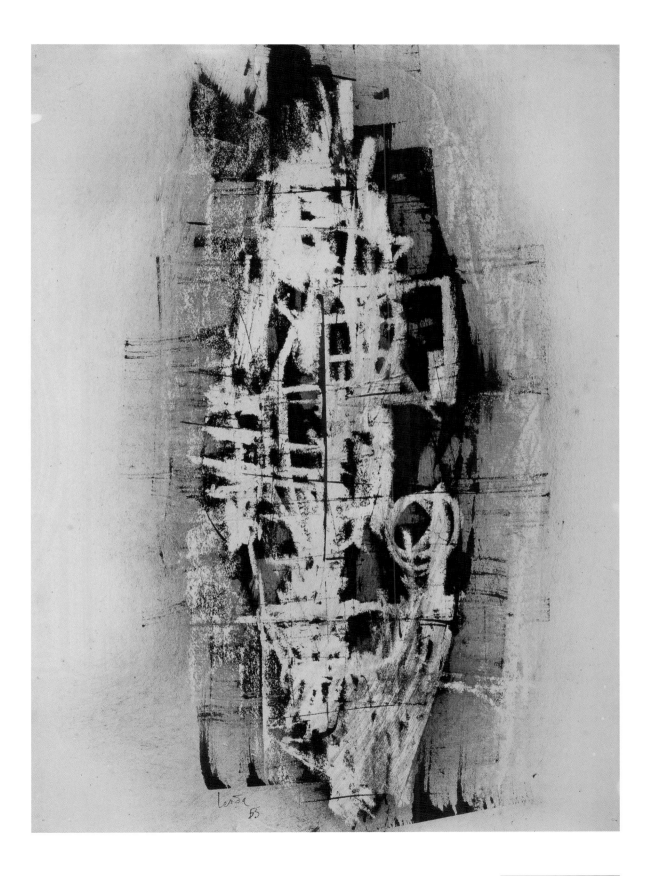

PLATE 01

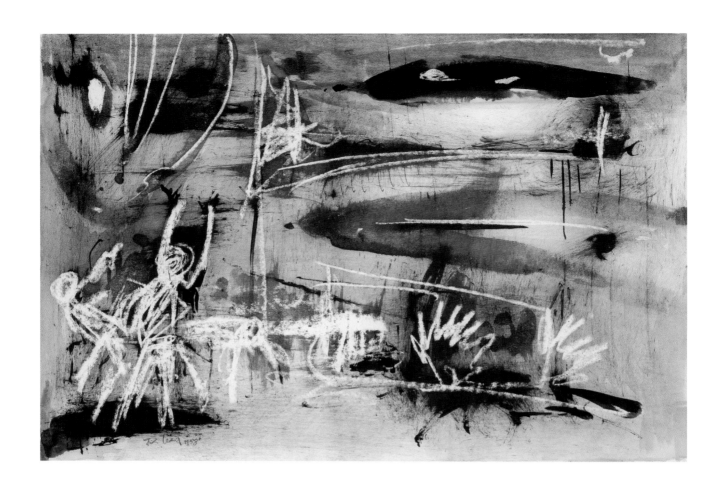

PLATE 02

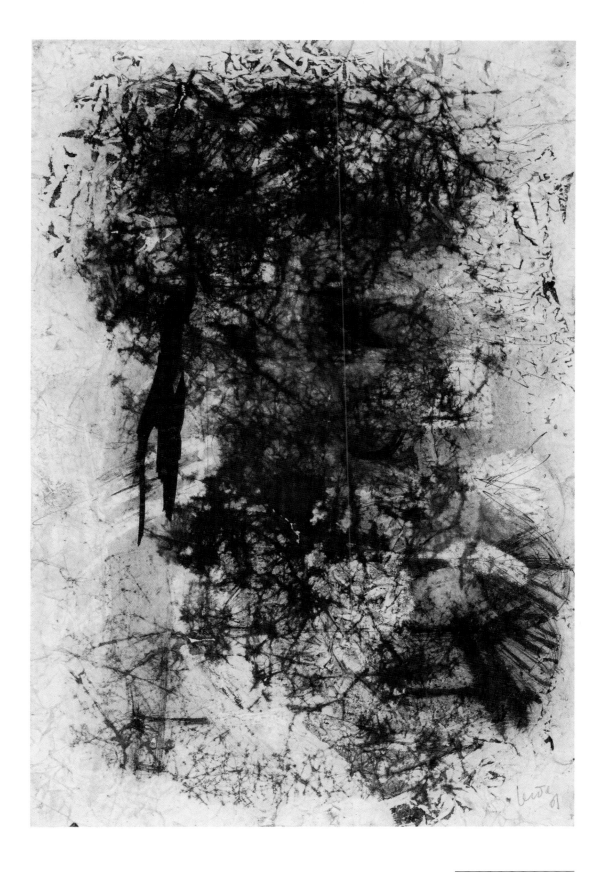

PLATE 03

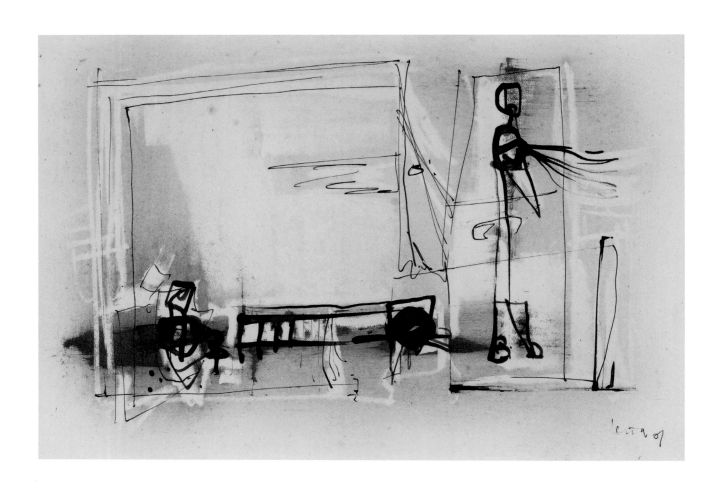

PLATE 04

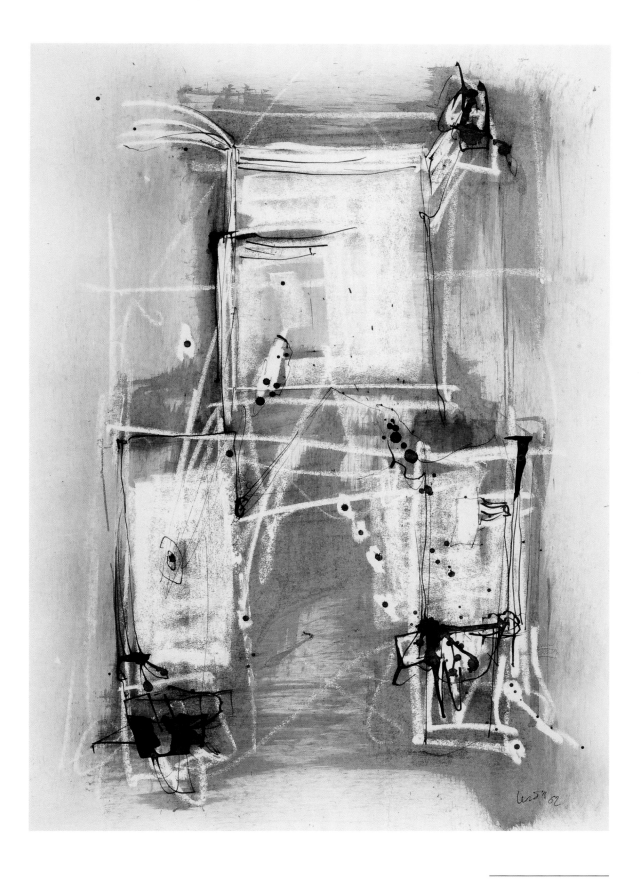

PLATE 05

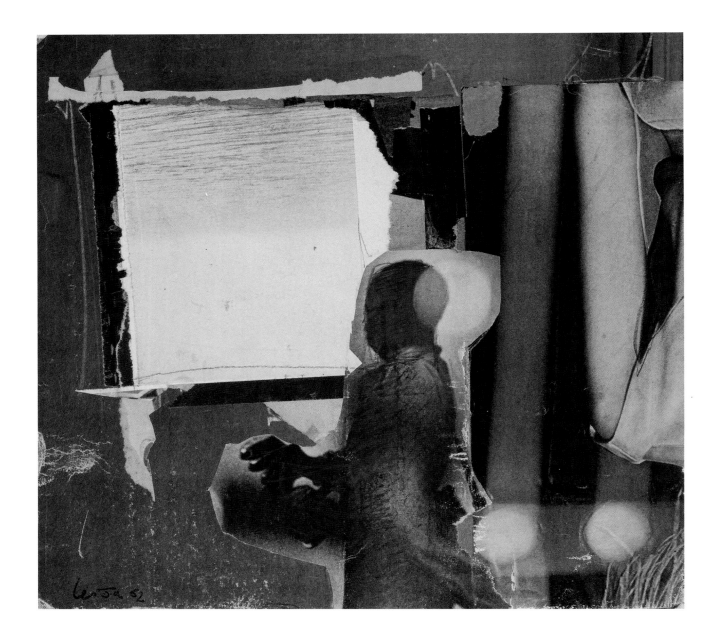

PLATE 06

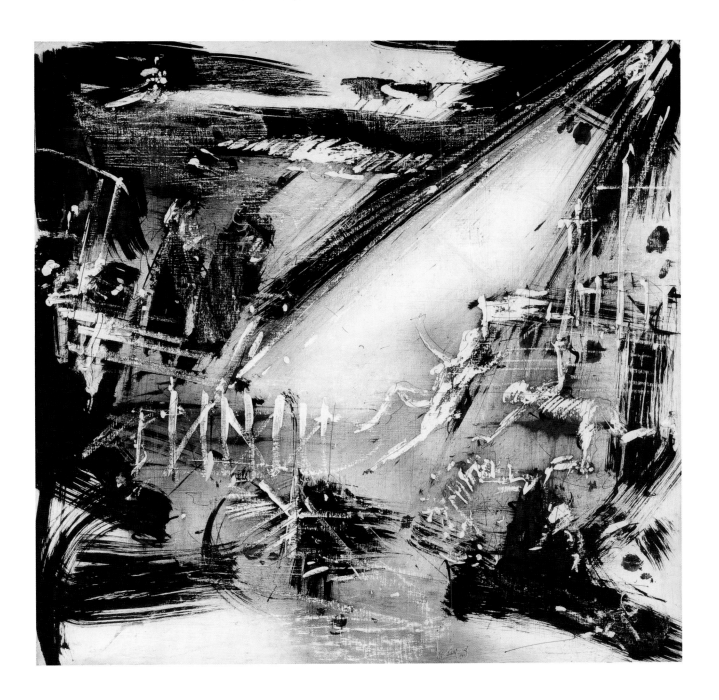

PLATE 07

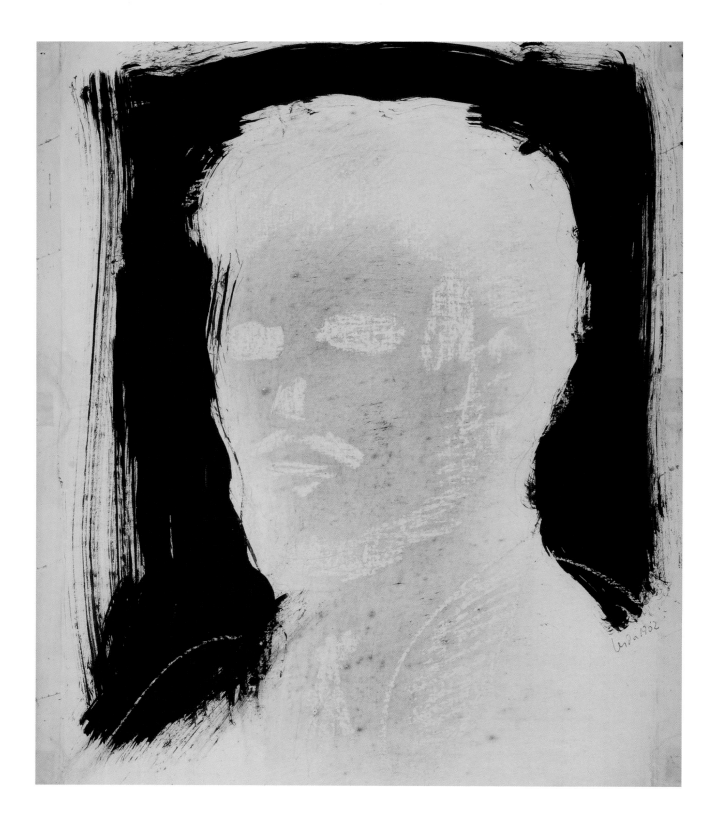

PLATE 08

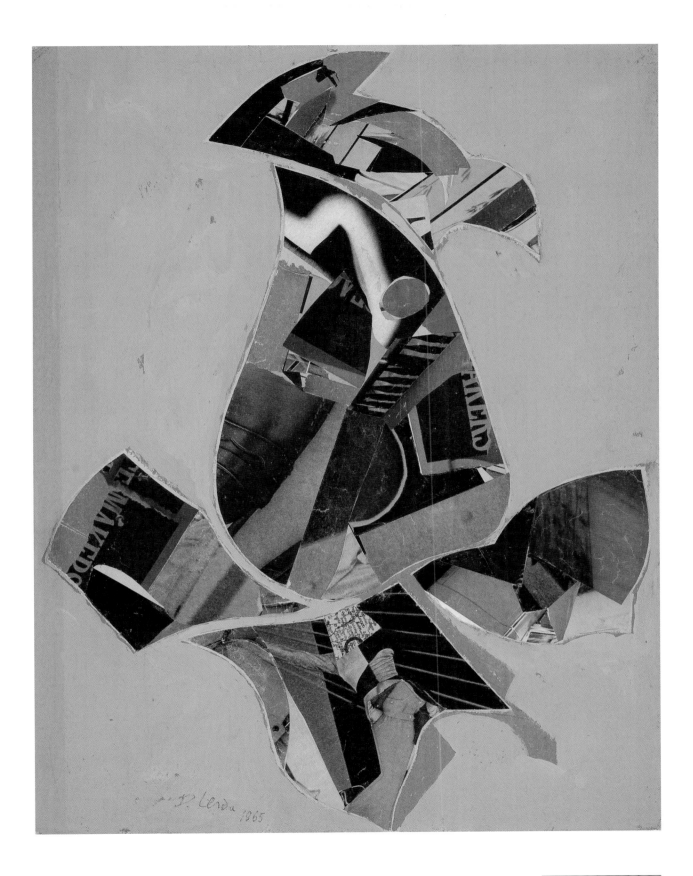

PLATE 09

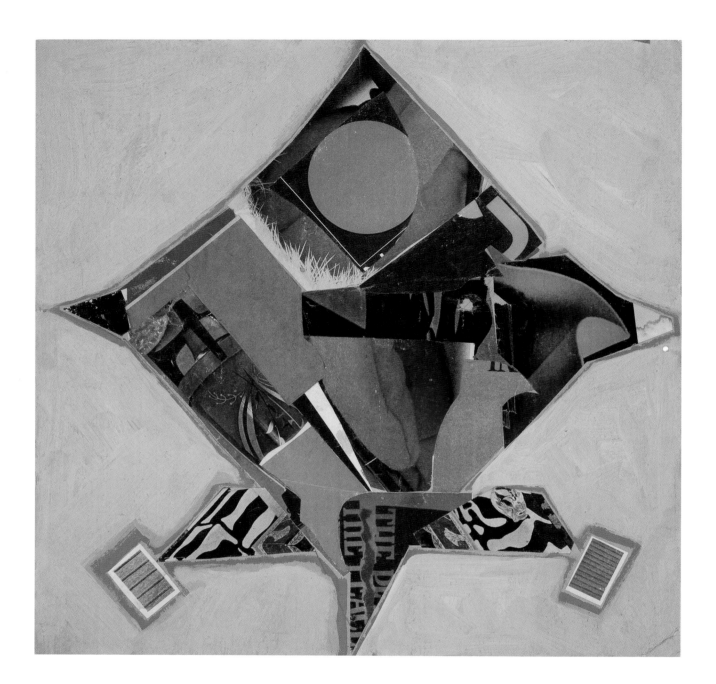

PLATE 10

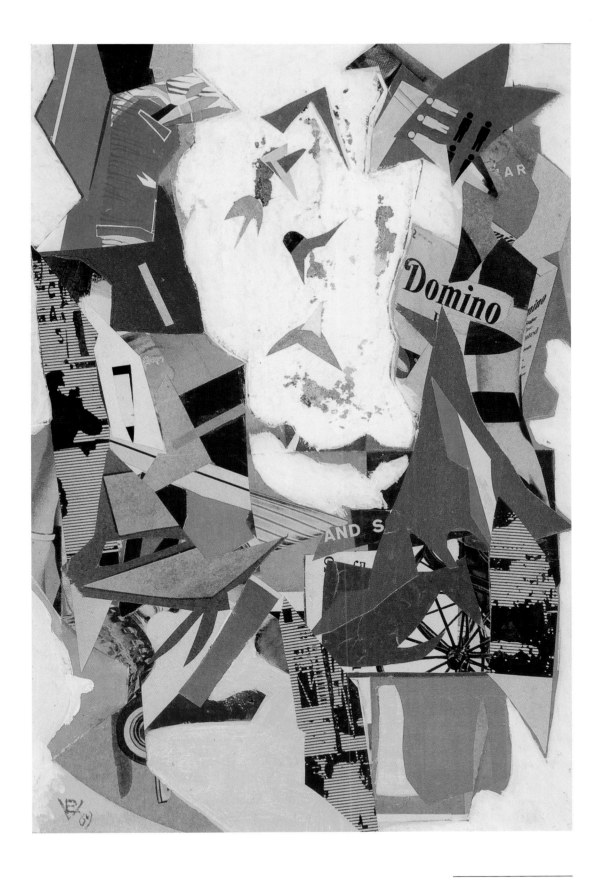

PLATE 11

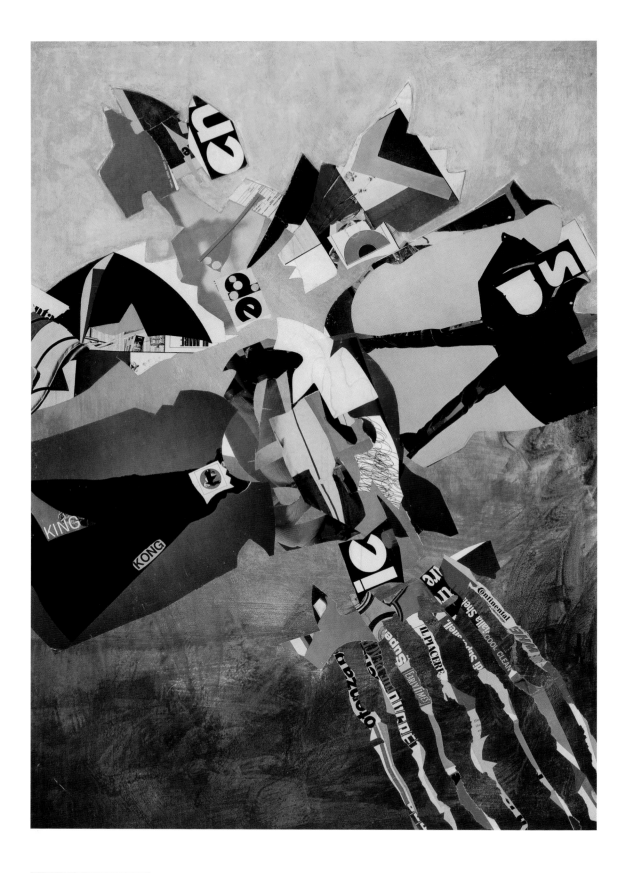

PLATE 12

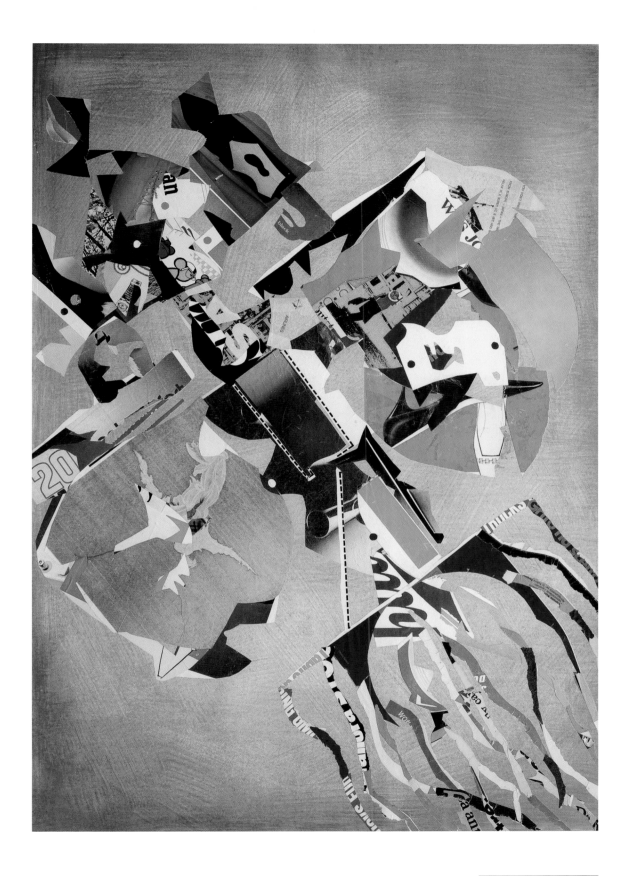

PLATE 13

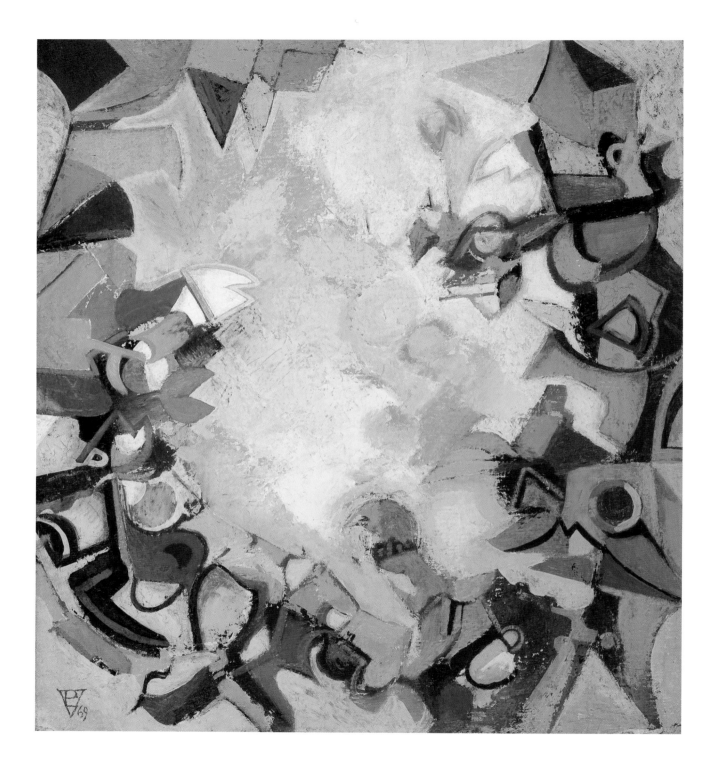

PLATE 14

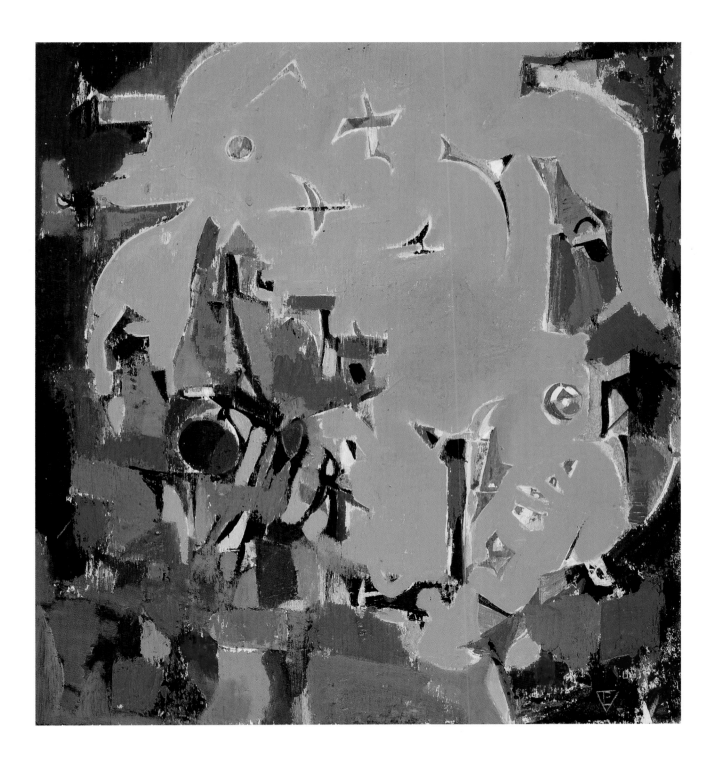

PLATE 15

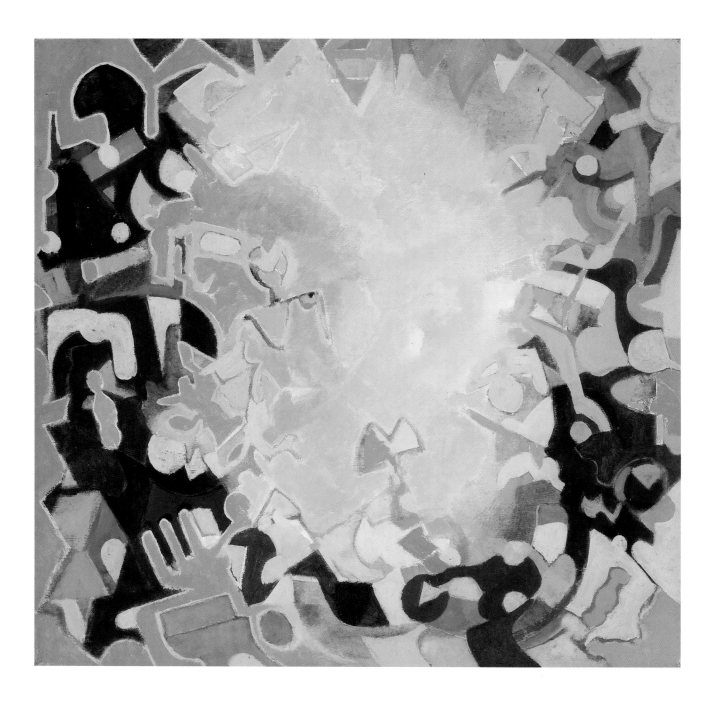

PLATE 16

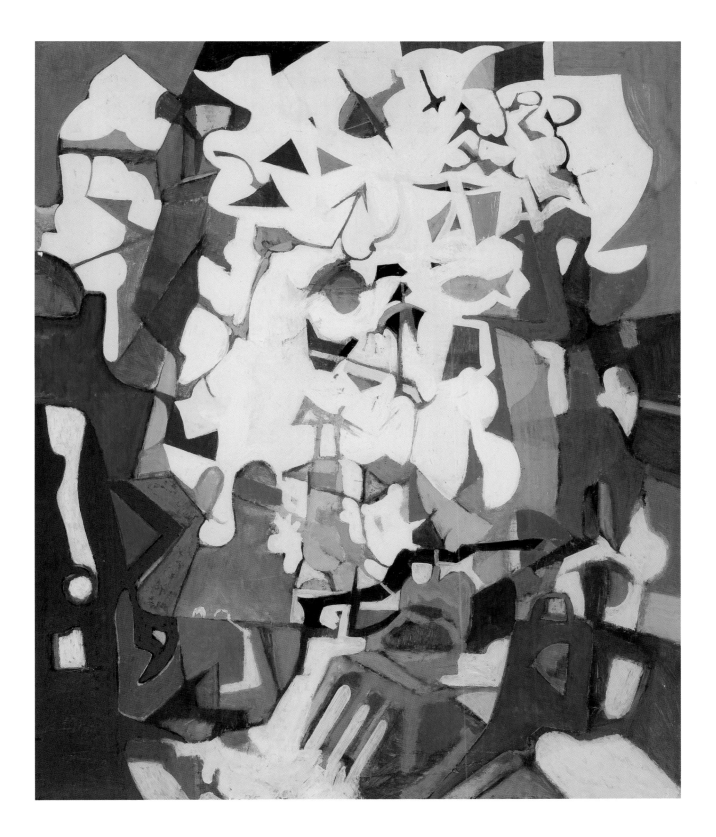

PLATE 17

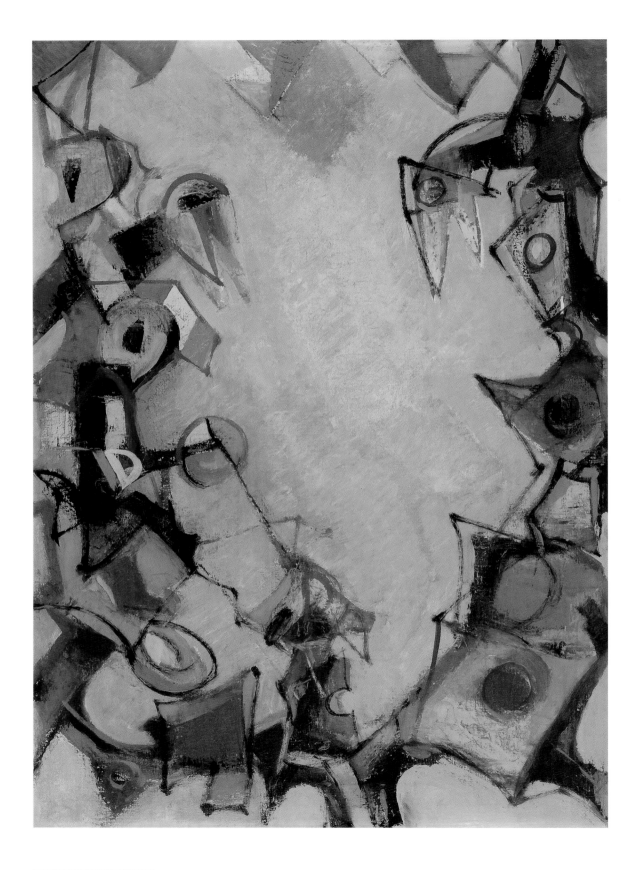

PLATE 18

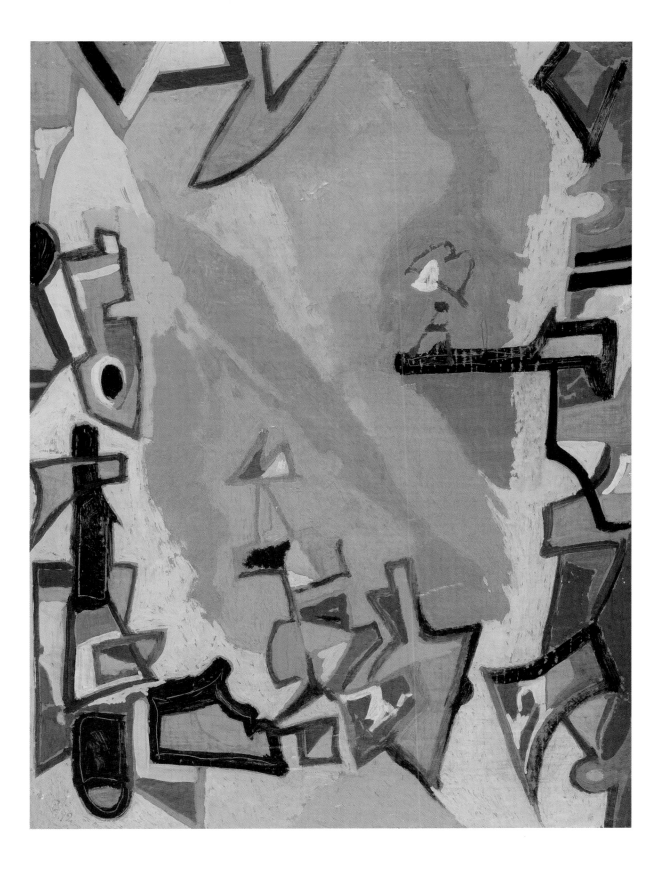

PLATE 19

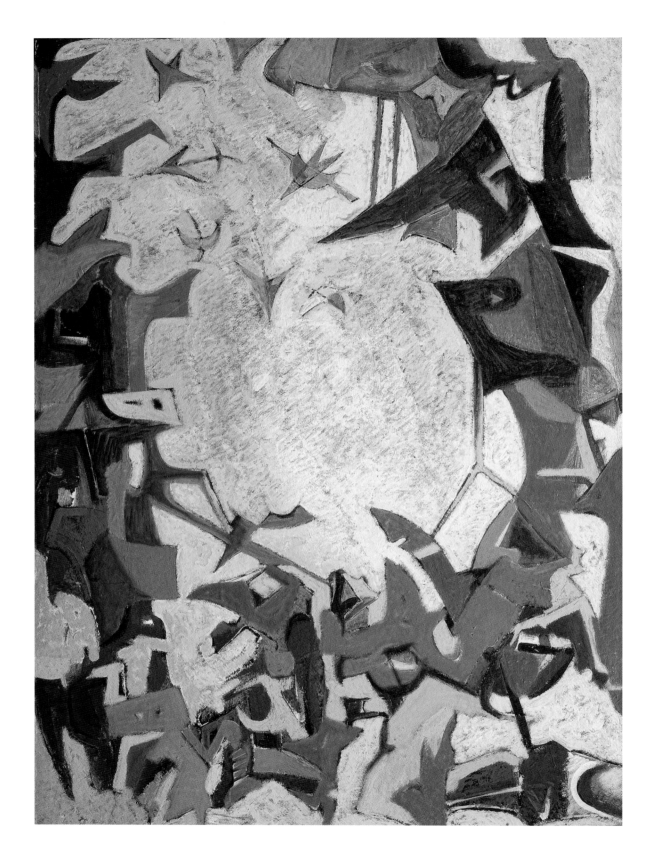

PLATE 20

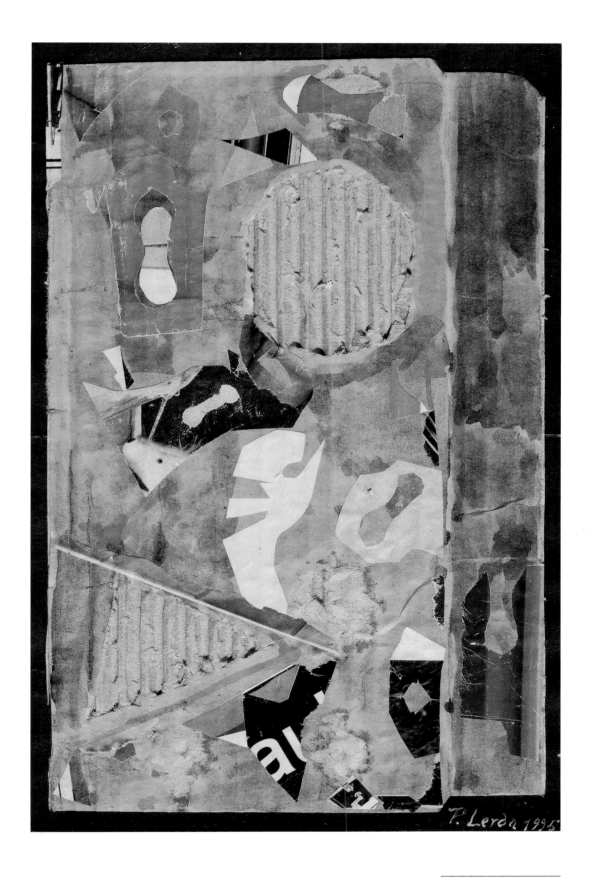

PLATE 21

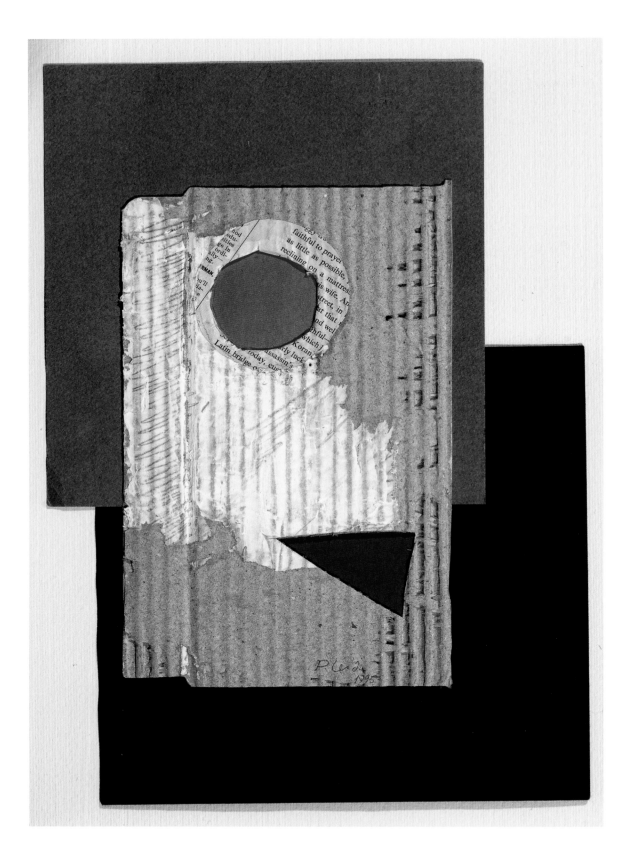

PLATE 22

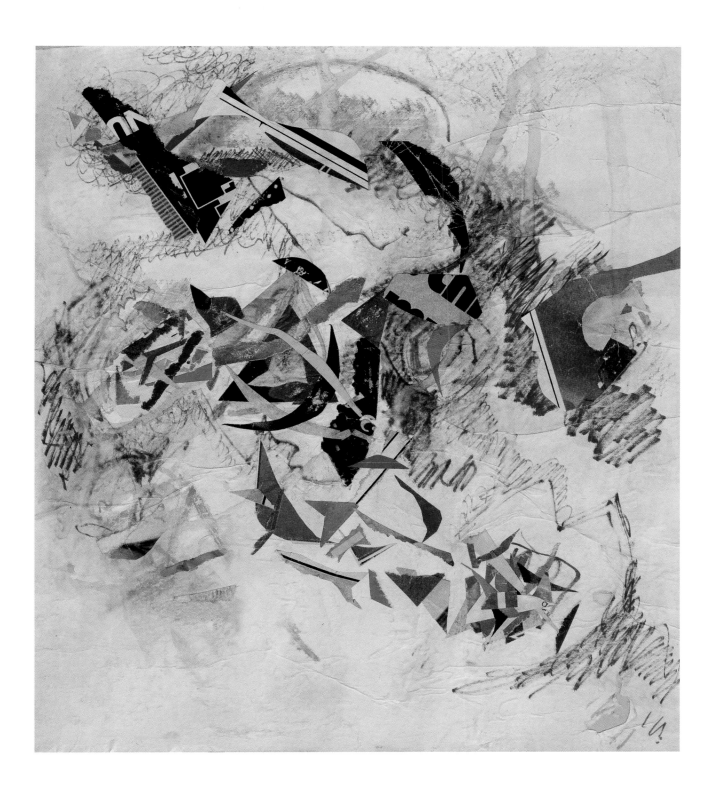

PLATE 23

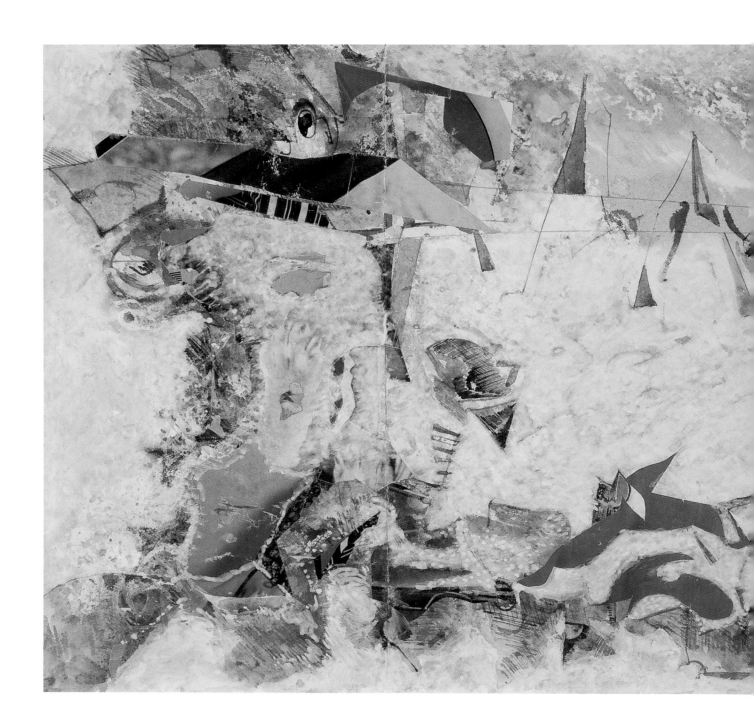

PLATE 24

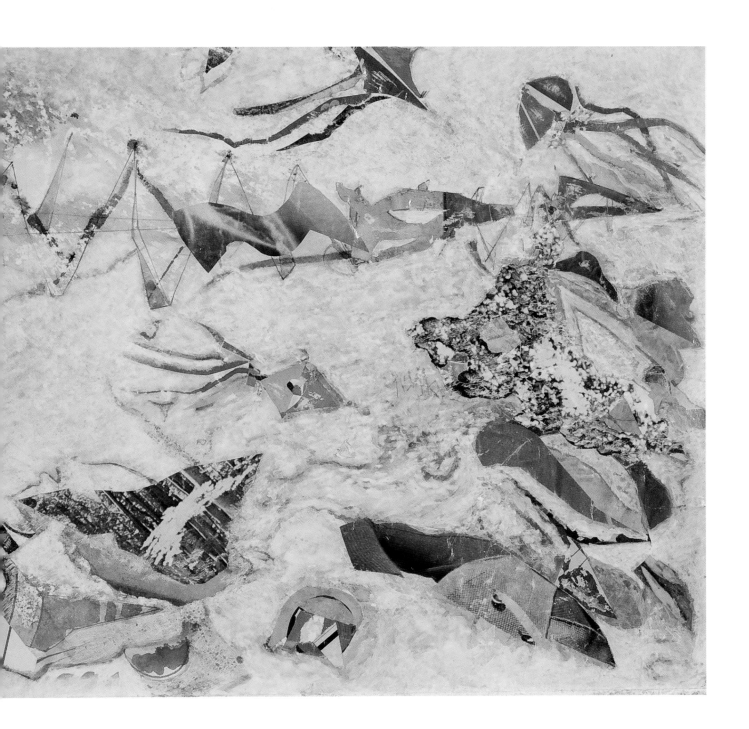

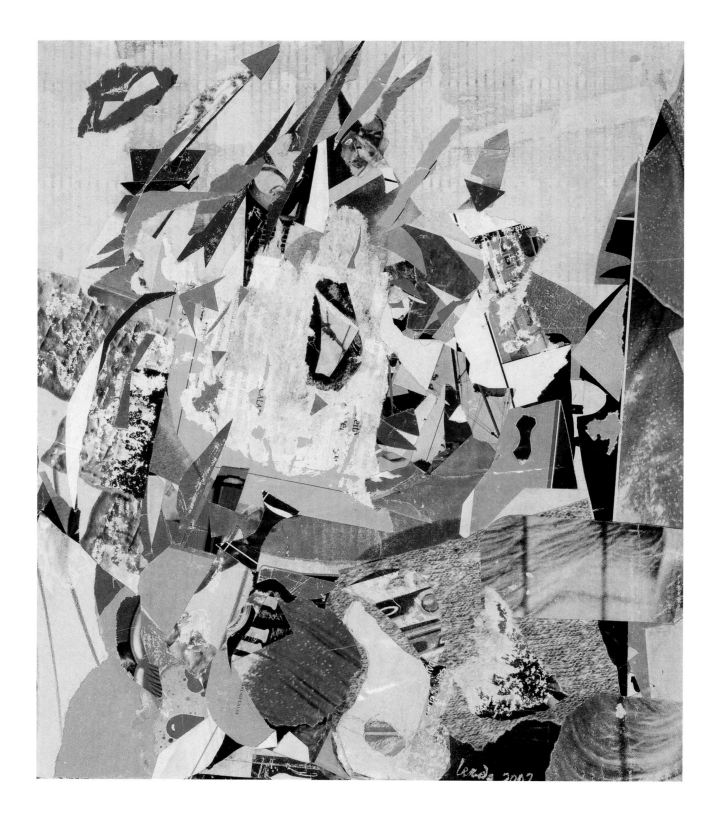

PLATE 25

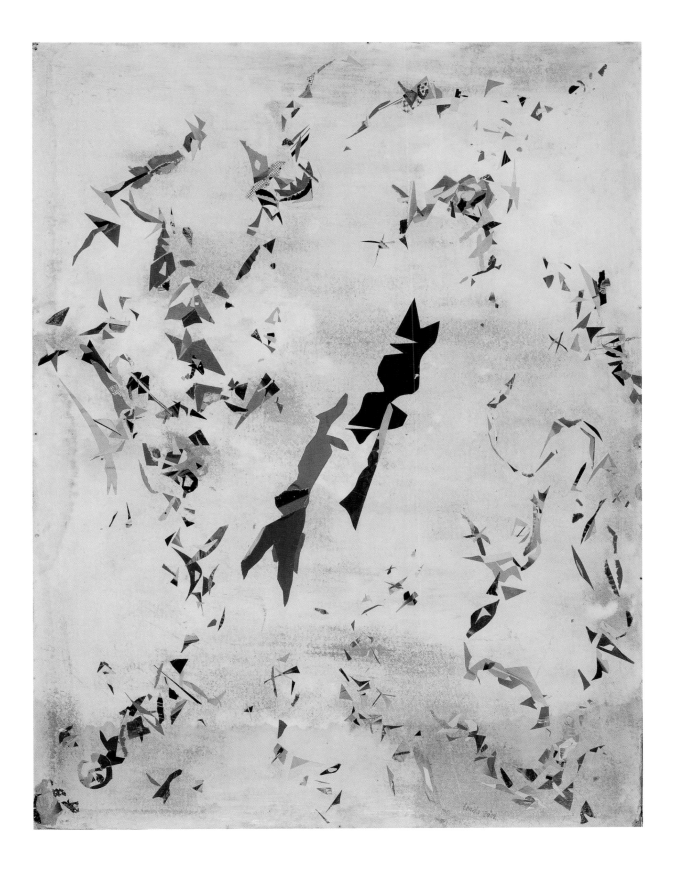

PLATE 26

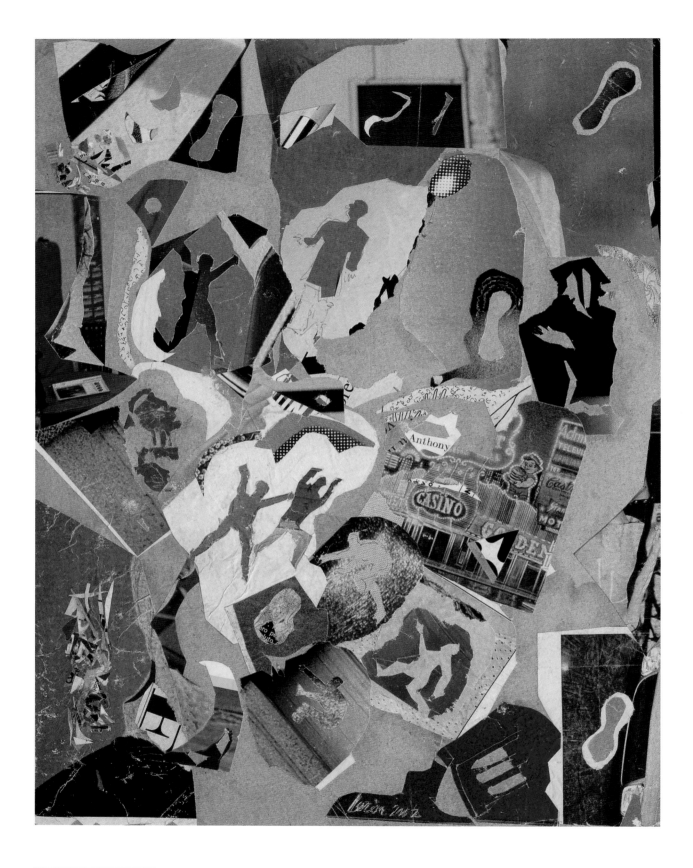

PLATE 27

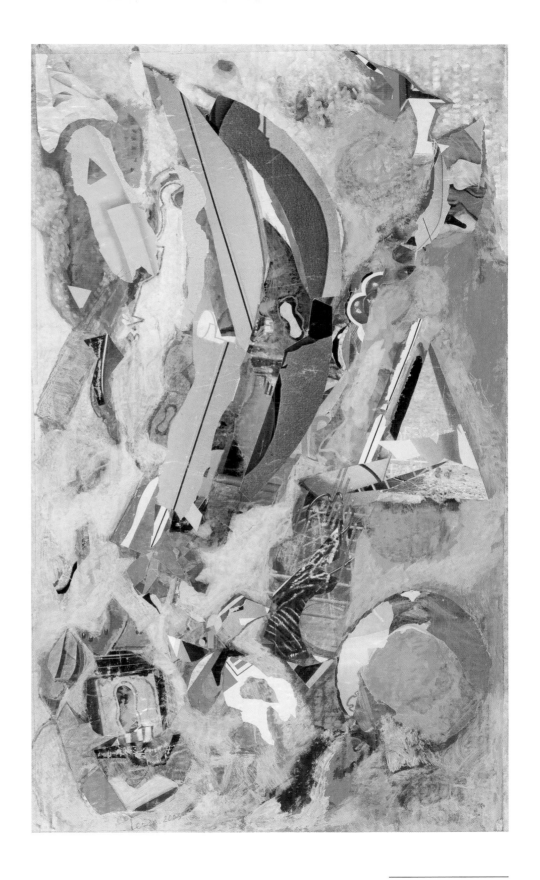

PLATE 28

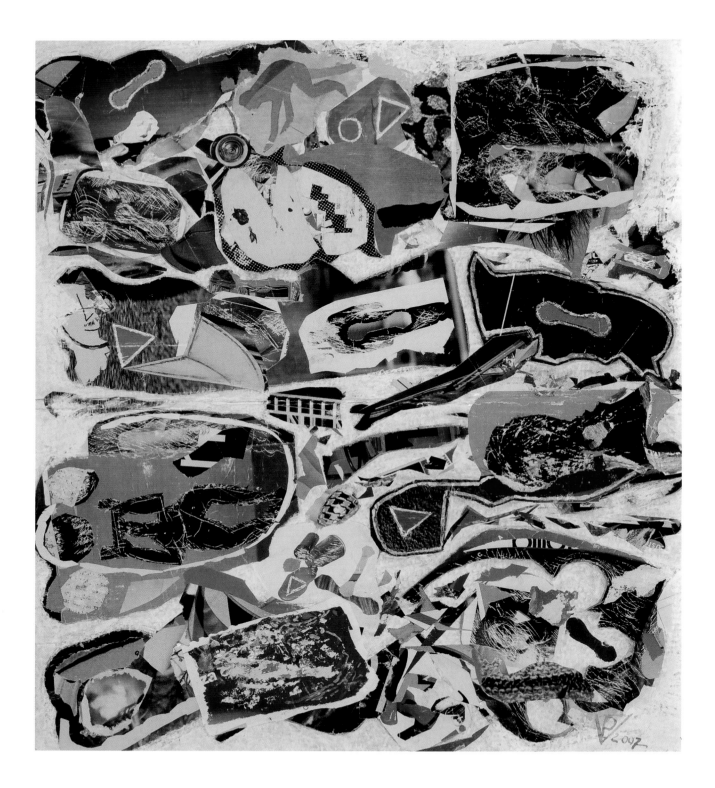

PLATE 29

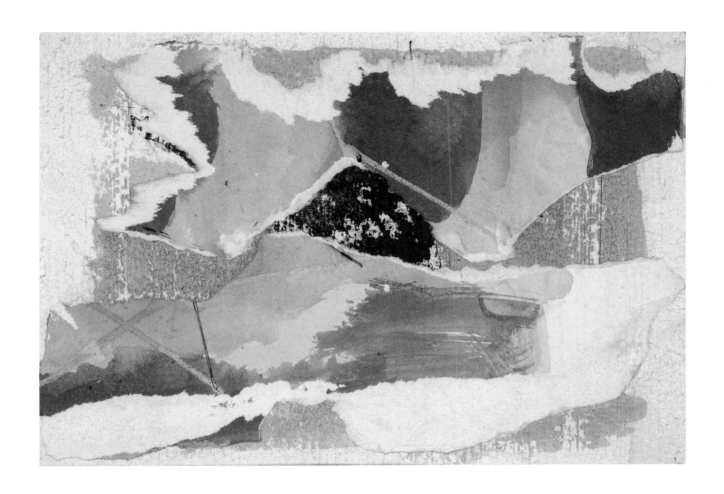

PLATE 30

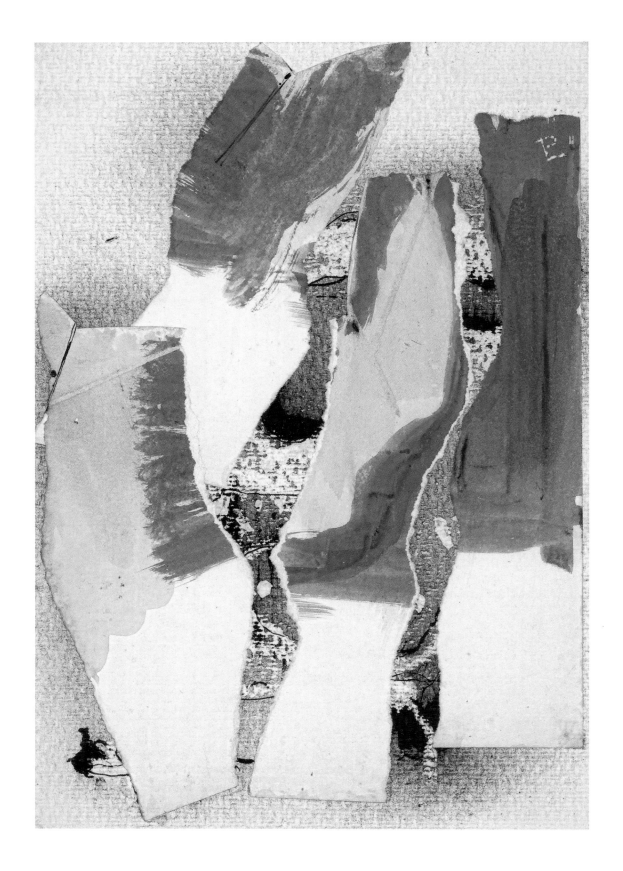

PLATE 31

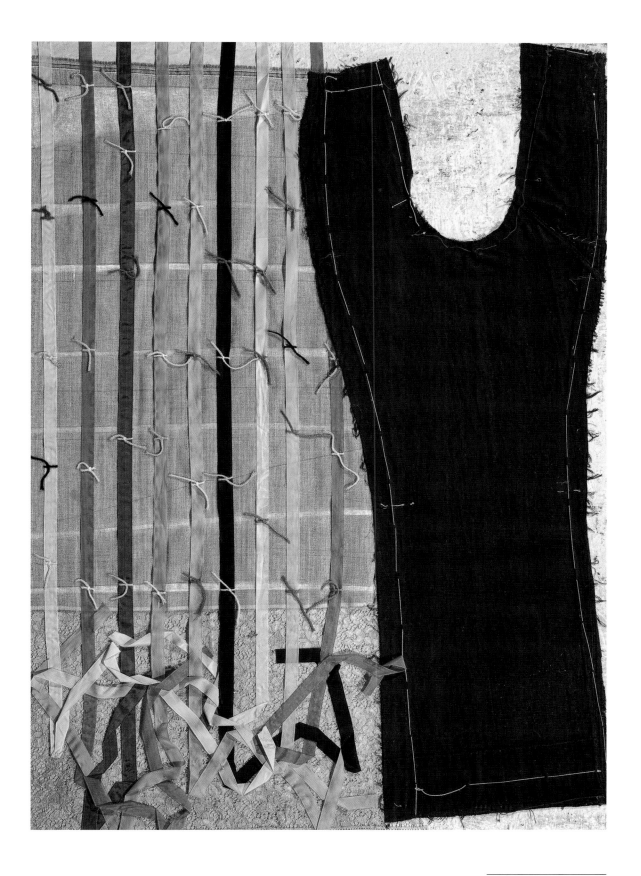

PLATE 32

PLATE 33

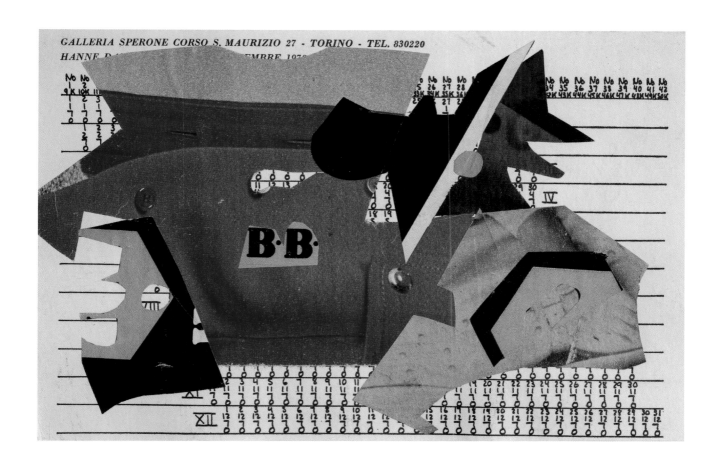

PLATE 34

PLATE 35

PLATE 36

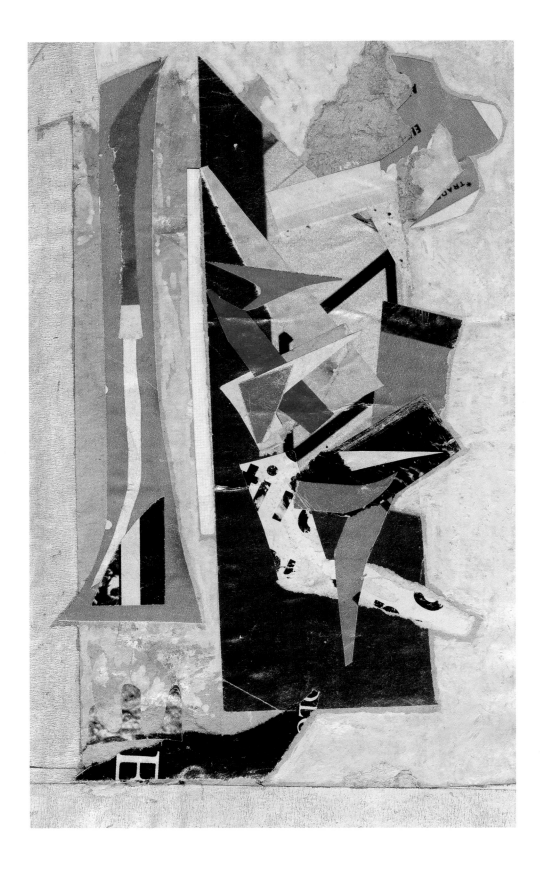

PLATE 37

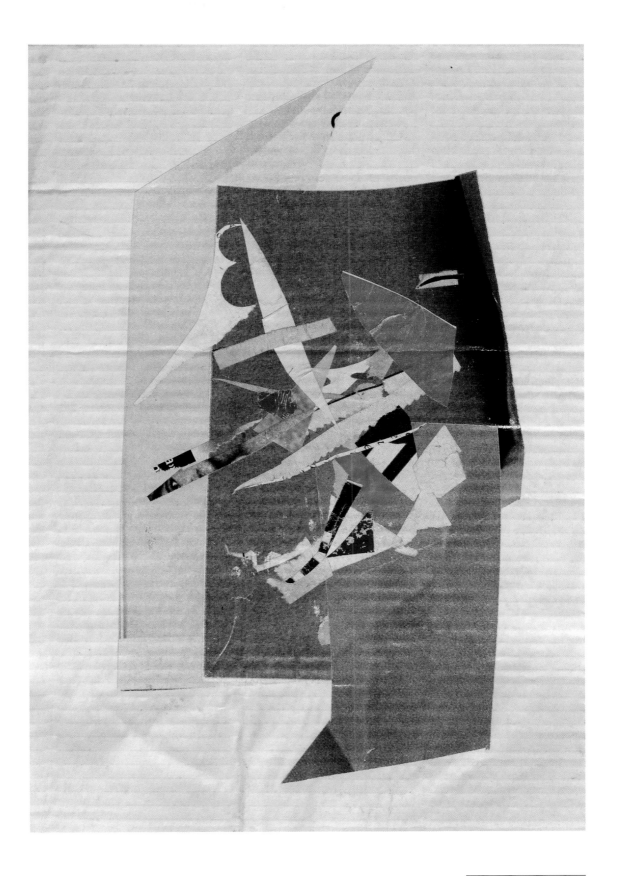

PLATE 38

CHECKLIST
OF THE
EXHIBITION

ALL WORKS BY PIERO LERDA.

**ALL WORKS GEORGIA MUSEUM OF
ART, UNIVERSITY OF GEORGIA;
GIFT OF VALERIA GENNARO LERDA.**

PLATE 1
Verticale, 1955
India ink and wax resist on paper
laid down on mat board
12 $\frac{5}{16}$ x 8 $\frac{1}{2}$ inches (image)
23 $\frac{5}{8}$ x 19 $\frac{1}{2}$ inches (sheet)

PLATE 2
Caccia all'uomo, 1956
Mixed media with wax resist on
paper
12 $\frac{15}{16}$ x 18 $\frac{13}{16}$ inches (sheet)

PLATE 3
Profili, 1961
Mixed media with wax resist on
paper laid down on paper
12 $\frac{1}{16}$ x 8 $\frac{1}{8}$ inches (image)
18 $\frac{13}{16}$ x 13 $\frac{1}{8}$ inches (sheet)

PLATE 4
Uomini in trappola, 1961
India ink and wax resist on paper
laid down on paper
8 $\frac{1}{2}$ x 12 $\frac{3}{8}$ inches (image)
12 $\frac{3}{4}$ x 18 $\frac{11}{16}$ inches (sheet)

PLATE 5
Personaggio Schermo, 1962
India ink and wax resist on paper
laid down on paper
19 x 13 $\frac{3}{4}$ inches (image)
25 $\frac{3}{4}$ x 18 $\frac{3}{4}$ inches (sheet)

PLATE 6
Uomo e schermo, 1962
Mixed media on board
9 $\frac{3}{8}$ x 9 $\frac{1}{2}$ inches (sheet)

PLATE 7
Untitled, 1968
India ink and wax resist on
Masonite
24 x 24 inches (sheet)

PLATE 8
Autoritratto–Flash, 1962
India ink and wax resist on paper
16 $\frac{5}{16}$ x 13 $\frac{3}{4}$ inches (sheet)

PLATE 9
Aquilone da combattimento, 1965
Mixed media on cardstock
16 $\frac{13}{16}$ x 13 inches (sheet)

PLATE 10
Aquilone rosso, 1965
Mixed media on cardstock laid
down on thick wove paper
12 $\frac{1}{2}$ x 12 $\frac{5}{8}$ inches (image)
19 $\frac{9}{16}$ x 15 $\frac{7}{8}$ inches (sheet)

PLATE 11
Piccolo alfabeto per aquiloni, 1969
Acrylic and collage on mat board
11 $\frac{1}{2}$ x 7 $\frac{11}{16}$ inches (image)
16 $\frac{7}{8}$ x 13 $\frac{3}{8}$ inches (sheet)

PLATE 12
Aquilone, 1972
Mixed media on board
39 $\frac{7}{8}$ x 28 inches (sheet)

PLATE 13
Aquilone, 1972
Mixed media on board
39 $\frac{3}{4}$ x 27 $\frac{3}{4}$ inches (sheet)

PLATE 14
Città giostra, 1969
Mixed media on canvas mounted
on board
18 1/8 x 16 3/8 inches (sheet)

PLATE 15
*Città giostra visitata dagli
aquiloni*, 1970
Tempera on wood panel
13 3/4 x 12 11/16 inches (sheet)

PLATE 16
Untitled, 1970
Tempera on Masonite
19 5/8 x 19 5/8 inches (actual)

PLATE 17
Untitled, 1974
Tempera on wood panel
19 3/4 x 16 1/8 inches (actual)

PLATE 18
*Città giostra visitata dagli
aquiloni*, 1977
Acrylic and tempera on canvas
27 3/4 x 19 3/4 inches (actual)

PLATE 19
Untitled, 1977
Tempera on wood panel
15 3/4 x 11 11/16 inches (sheet)

PLATE 20
Città giostra con aquiloni, n.d.
Mixed media on board
38 5/8 x 27 3/4 inches (sheet)

PLATE 21
La nuova geometria, 1995
Mixed media on cardboard laid
down on cardstock
8 9/16 x 5 1/2 inches (image)
10 3/8 x 7 3/16 inches (sheet)

PLATE 22
Triangolo blu e cerchio rosso, 1995
Mixed media on cardboard and
paper laid down on thick wove
paper
13 3/4 x 9 13/16 inches (sheet)

PLATE 23
Metamorfosi di un aquilone,
1987–2000
Mixed media on paper laid down
on cardstock
9 1/8 x 8 1/8 inches (sheet)

PLATE 24
*Metamorfosi di un paesaggio con
aquiloni*, 2000
Mixed media on cardstock
11 7/8 x 25 3/4 inches (sheet)

PLATE 25
*Cronaca italiana: paesaggi
stravolti ognuno deve organizzare
il caos che trova in se . . .* , 2002
Mixed media on cardboard
11 3/8 x 9 11/16 inches (sheet)

PLATE 26
*Quanto può valere un volo di
briciole di carta colorata in un
cielo tempestoso?*, 2002
Mixed media on board
23 5/16 x 17 1/2 inches (sheet)

PLATE 27
*Uomini che si arrampicano su
lastre di cristallo*, 2002
Mixed media on cardstock laid
down on thick wove paper
14 1/2 x 11 3/16 inches (image)
17 1/8 x 13 5/16 inches (sheet)

PLATE 28
Progetto e invenzione, 2003
Mixed media on cardboard
20 5/8 x 12 3/16 inches (sheet)

PLATE 29
La creazione del mondo, 2007
Mixed media on cardboard
16 1/2 x 14 11/16 inches (sheet)

PLATE 30
Collage, 1982
Mixed media on thick wove paper
8 3/8 x 11 15/16 inches (sheet)
GMOA 2014.104

PLATE 31
Collage, 1982
Mixed media on thick wove paper
12 1/4 x 8 3/8 inches (sheet)

PLATE 32
Untitled, 1983
Mixed media on board
40 9/16 x 28 3/4 inches (actual)

PLATE 33
*Art Blakey. On the Street Where
You Live*, 1995
Collage on paper
10 x 6 3/8 inches (sheet)

PLATE 34
Untitled, 1970
Collage on cardstock
5 1/16 x 7 9/16 inches (sheet)

PLATE 35
Predella, 2000
Collage on cardboard
7 3/4 x 5 3/8 inches (sheet)

PLATE 36
Predella, 2001
Collage on cardboard
7 3/4 x 5 3/8 inches (sheet)

PLATE 37
Predella, 2002
Acrylic and collage on cardboard
7 1/4 x 4 5/16 inches (sheet)

PLATE 38
Predella, 2002
Collage on cardboard
7 3/4 x 5 7/16 inches (sheet)

Labels Unlimited

1651-01

ROUGH TRADE

Rob Young

Black Dog Publishing

Above: Inside the first Rough Trade shop—a living collage of independent music. Photograph by Chris Ward (Sparks).

Right: Shop front at 202 Kensington Park Road. Photograph courtesy of Rough Trade Shop.

6 Introduction

In retrospect, 1978 shouldn't have been the ideal year to launch an independent record company in Britain. It was the year of national anticlimax: the grey depression after the manufactured high of the Queen's Silver Jubilee in 1977. For the nation's disaffected youth, the true national anthem of that year had been The Sex Pistols' irreverent, nihilistic "God Save The Queen"—a snarl of frustrated rage from the underbelly of the established order, which had scaled the top of the charts, albeit invisibly, as the single had been banned from national airplay by a toadying BBC.

One year later, much of punk's anger was turned in on itself. Musically and ethically, punk rock had passed its peak. Two years after The Pistols first let the establishment have it with both barrels, they had split up and a second wave of copyists were arriving with a diluted version of punk rock's first anarchic clarion call. The likes of The Exploited, Sham 69, UK Subs and the welter of Oi! bands were musically conservative—punk as lumpen, macho rant. Meanwhile, the old guard such as The Clash, The Damned, The Stranglers and Siouxsie & The Banshees were being bought up by major record labels and the sound was changing as a result. A sense of betrayal abounded when The Clash signed a deal with CBS to record their debut album. Punk sounded best when it was true to itself: recorded cheaply, on four or eight tracks, imprinted on cheap 7" vinyl. Transplanted to the kind of studios affordable to the big companies, its faults and structural/virtuosic weaknesses were revealed in higher fidelity than intended: the wrong music for the wrong medium. At the same time, a new vanguard was already breaking through whose music was more progressive and experimental— less concerned with making overt statements. This Heat, The Slits, X-Ray Spex, and even John Lydon's new group, Public Image Limited, threw a wide range of ingredients into the mix: dub, Krautrock, free jazz, irregular time signatures and abrasive instrumental configurations incuding 'non-punk' instruments such as saxophones and synthesizers. On an even lower level of visibility than these underground groups, a massive DIY movement bypassed the traditional route of signing to a record label, with groups instead self-releasing small editions of their own music, with the consequent total freedom of expression that is the vanity publisher's privilege.

Socially and politically, the UK was also under crisis management. The Labour government was grimly clutching onto power under prime minister Jim Callaghan, who would be dismissed in a vote of no-confidence the following year, ushering in the Thatcher Conservative party who dominated British politics throughout the 1980s. It was a time of crippling trade union strikes, with refuse uncollected in the streets, bodies unburied, the army standing by in lieu of the fire brigade. People feared more power cuts and oil price hikes, which the country had experienced in the mid-1970s, and unemployment was rising into millions.

In London, the divide between rich and poor was, as ever, blatantly visible on the streets. In west London, within a mile of Buckingham Palace, the area immediately to the north of Ladbroke Grove contained some of the country's highest density squatting zones: rows of terraced housing built for the working classes in the Victorian era, scheduled for demolition had been saved by a legal loophole that gave squatters legitimate rights to stay put provided the building remained occupied at all times. The micro-zone around Chippenham Road and Elgin Park, on the edge of affluent Maida Vale, was made up of a confluence of streets that had been reduced to rubble in the bombing runs of the Second World War, and had not yet been restored. Many streets were simply cordoned off with makeshift corrugated iron fencing, soon plastered with trenchant graffiti. Reading its urban landscape, you couldn't help but feel that Britain was a nation in terminal decline.

But Ladbroke Grove, Portobello and Notting Hill were at the same time the engine rooms of Britain's multicultural strengths. The Caribbean community had largely made its base here since immigration took off in the late 1940s, and the culture had, as so often in Britain, been enriched and diversified by the intermingling of cultures and languages. When the Rough Trade label started up, although on the surface things might not have looked auspicious, it had already spent two years entrenched in the centre of the area, carving out a niche for itself as a record shop and distributor of choice for any hip indie label wanting instant cred, a hotline to the crucial retailers in town, and a sympathetic set of ears that would at the very least subject any given piece of music to rigorous and enthusiastic critical debate.

'A great pair of ears': Rough Trade founder Geoff Travis, 1979.
Still taken from *The South Bank Show*.

Introduction

The history of Rough Trade, spanning more than a quarter of a century, can appear confusing at first glance. Geoff Travis, with business partner Jeannette Lee (former press assistant in Public Image Limited), currently runs Rough Trade Records as a successful operation, with offices in Golborne Road a few streets away from where the enterprise began. But the Rough Trade Records that exists in 2006, with high profile acts on its roster such as The Strokes, The Libertines, Belle & Sebastian, Babyshambles and Mercury Music Prize winners Antony & The Johnsons, is not technically the same company that released records by Swell Maps, The Raincoats, The Pop Group and Scritti Politti in the late 70s; nor is it the same company as that which runs the two London shops in Talbot Road and Covent Garden—both sporting the Rough Trade logo; neither is it the same company that put out records by Levitation, Disco Inferno, Giant Sand, Tom Verlaine and The Boo Radleys in the early 1990s; neither is it the same company that distributed records under the name RTM during the 90s. Yet all these ventures are distant cousins with a common ancestor; branches of a long-dispersed family—the lost tribes of indie. Like some form of persistent hardy and rugged plant that thrives in difficult soil, they all stem from the same seed—the one Travis planted in 1976. It has been a long and tortuous road to get there, and all the different incarnations of the Rough Trade brand, some of which still survive today, are testaments to the integrity and essential viability of his original vision for the company. In its heyday, the Rough Trade 'brand' could be found reaching far and wide around the world. As well as the two shops in London, there have been Rough Trade concessions in Paris, Tokyo and San Francisco; Rough Trade Publishing operations have existed in the UK, USA and Germany, and Rough Trade became one of the principal German independent label/ distributors during the 1990s. The Cartel and Chain With No Name, set up at Rough Trade's instigation to consolidate and improve the British independent distribution network, came to dictate the shape of UK indie music throughout the 1980s, the decade in which 'indie' itself became a term applied to a musical genre.

Certain record labels can be identified by a particular musical style. You could never say that about Rough Trade, even in its creative peak era, 1978–82, when it was associated with what's been dubbed the "scratchy-collapsy" sound of post-punk. Even in those first four years, the discography reveals an incredible diversity and open-mindedness, especially for an independent label of the time: polemical punk rock (Stiff Little Fingers, Zounds), post-punk amateur-experimentalism (Kleenex, Young Marble Giants), industrial noise/avant funk (Cabaret Voltaire, This Heat), electric free jazz (James 'Blood' Ulmer, Mofungo), dub reggae (Augustus Pablo, Jah Shaka), African pop and protest song (The Mighty Diamonds, Thomas Mapfumo), US hardcore (The Feelies, Pere Ubu), maverick singers (Robert Wyatt, Jonathan Richman), Mancunian post-punk (The Fall, Blue Orchids), No Wave (DNA), quirky spoken word (Ivor Cutler)... and that diversity increases dramatically over the whole catalogue: a total of 250 singles and 160 albums up until the company went bankrupt in 1991.

ROUGH TRADE

The Rough Trade logo has become an international brand.

This book will not go into detail on Rough Trade's outlying frontier posts; instead, I focus on the drama of the company's formation, its breezy first five years, the growing frictions at the centre of the operation between the distribution and label departments, how they moved from seamlessly complementing each other to inhibiting each other's progress. This tension gave Rough Trade its energy, but by the time Travis signed The Smiths in 1983, and entered a new arena, promoting an act into the charts and across world tours, the seeds were sown for the eventual collapse of the entire house of cards in 1991.

Rough Trade was a distributor before it was a label, and that notion—of getting important stuff out to the people—remained in its bloodstream. It began at exactly the right moment, in an explosion of underground music production and DIY culture in explicit opposition to the stifling world of major label business practice. In 1978, the year Rough Trade Records was formed, *Zigzag* magazine published a separate *Small Labels Catalogue*, which listed 231 independent labels. When the same magazine published an updated version two years later, the list had quadrupled to 800. It's fair to state that Rough Trade was *the* significant model for others to follow in creating this boom economy. At the same time, the model could not sustain itself over the long term. Its ideological and altruistic strengths were precisely the reasons for its failure. Open, non-binding 50-50 split deals where artist and label equally shared profits were beautiful and unprecedented—but in many cases they simply allowed artists a leg up with one of the hippest underground operations, placing them within scalping range of a major label who would then snap them up, with the serious A&R (Artist & Repertoire) spadework already done for free. In the early days, there were few distinctions and privileges extended to artists on the label—many musicians could be found working behind the shop counter, or stuffing 7" sleeves. Later the label found itself competing on different turf, playing the kind of games familiar to larger companies, as it tried to promote and plug the likes of Scritti Politti, The Smiths and The Sundays onto radio, TV and international press. The autonomy Rough Trade granted to its artists simply became harder and harder to control. There was also the confusion around the finances and he lack of clarity drawn between the distribution and the record label. A disproportionate amount of funds was being used by the label to promote its maverick portfolio of acts, when the bulk of those funds had been earned by the distribution.

Why did Rough Trade become the archetypal independent label? It had plenty of peer competitors in the post-punk era—Mute, Fast Product, Step Forward, New Hormones, Cherry Red, Kamera, Postcard...? In the end credit must be given to the quiet determination and ability to absorb sharp knocks of its founder. Geoff Travis has endured the stripping of his company ownership, estrangement within the organisation he founded, the bitter demise of many of his carefully nurtured groups, bankruptcy. All this he has survived, preserving an amazing amount of good will throughout the music industry. Persistence is all: his current Rough Trade Records is at last owned by himself again (in partnership with long-standing colleague Jeannette Lee), and profitable. The odyssey of Rough Trade, with its many twists and turns, peaks and nadirs, and its sprawling cast of characters, is firmly underpinned by this perverse doggedness.

Introduction

Introduction

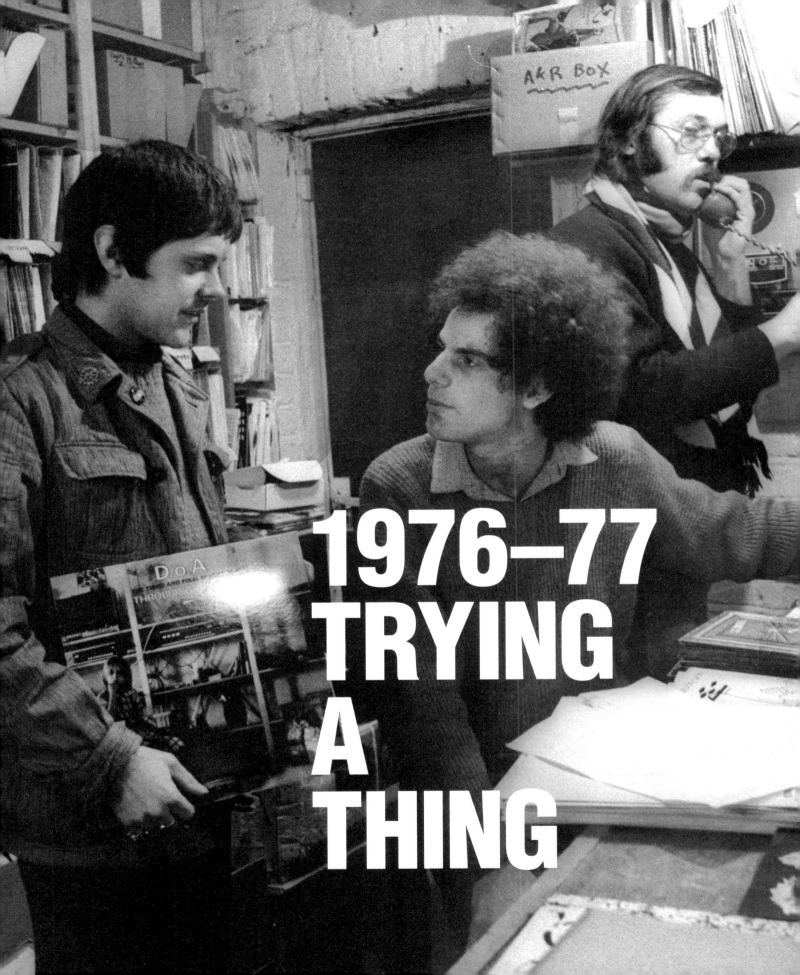

1976–77 TRYING A THING

Kensington Park Road lies at the heart of the crisscrossing streets and grand squares that make up west London's Portobello district. Its top end begins at a point almost equidistant between the long-standing reggae record shop, Dub Vendor, to the west, and Powis Square to the east. Dub Vendor was set up in the early 1970s catering to the large Caribbean community that had established itself in the surrounding area since the war, and was the principal port of call for anyone searching out the potent studio alchemy of Lee Perry, King Tubby, et al., freshly imported from Kingston, Jamaica. Powis Square is one of West London's tranquil, secluded Regency squares, just removed from the weekend hubbub of Portobello Market and the through traffic of Notting Hill Gate. It was in Powis Square that James Fox, Mick Jagger and Anita Pallenberg acted out the rock 'n' roll abjection of *Performance*, the 1970 movie directed by Donald Cammell and Nic Roeg, which immortalised a vision of bohemian rock chic. As a *mise-en-scène*, Ladbroke Grove was not chosen at random: in the late 60s and early 70s the area's spacious town houses, formerly the city residences of wealthy squires and of suitably mansion-like proportions, were the faded pads of London's bohemian, hippy squatting cults, and was particularly associated with psychedelic progressive rockers, such as Soft Machine, Hawkwind, Gong's Steve Hillage and others (the peeled-plaster squalor of the area was recreated in the 1988 film *Withnail And I*). Powis Square adjoins Talbot Road, a street off Portobello Road, which is strangely interrupted almost at the point where the square abuts it.

This is the heart of Rough Trade's 'manor': an area, which is intimately connected to Rough Trade in all its forms since the mid-70s. The shop front of Rough Trade has occupied its current location at 130 Talbot Road since 1983. Together with its sister branch in Covent Garden, it is still the first stop for anyone looking for alternative music, expertise, unbelievably capacious stock and a collage-like interior waywardness that forever throws up new wonders from its basement stockroom. Cross Portobello Road from here, and turn left into Kensington Park Road: number 202 was the site of the first shop to carry the Rough Trade sign. The premises now sells baby goods and toys, and its shop front has been painted a garish yellow, but the window still features the distinctive arch of diamond-leaded glass that it had when Rough Trade opened for business in 1976.

Previous page (left to right): Genesis P-Orridge of Industrial Records pays a call on Geoff Travis and Richard Scott at Rough Trade HQ, 1978. Photograph by Jill Furmanovsky.

Above: The Rough Trade shop, 202 Kensington Park Road. The shop is already a magnet for underground promotional posters and flyers. Photograph courtesy of Rough Trade shop.

Left: Preparing to hang the 'wagon wheel' sign above the shop front, 1976. Photograph by Chris Ward (Sparks).

Born in 1952, the son of an insurance loss adjuster, Geoff Travis was 18 when *Performance* was released, and it was one of his favourite films. As one who had already been seduced by the glamour of rock, he was part of its target market. While still a schoolboy in North London, turned on to music by a visiting Canadian cousin, Travis frequented many of the capital's rock venues watching groups such as The Who, Love, and The Rolling Stones, immersing himself in London's musical life. After spending his year off on an Israeli kibbutz, he studied philosophy and English at Churchill College, Cambridge. In 1973, while still a student, he attended a party at Warwick University, and ended up crashing on the floor of a female student there, Vivien Goldman. "He gave me tickets for The Who at the Roundhouse", she recalls. "He was just a really nice bloke and we were just gabbing and gabbing, and we became friends." They stayed in touch, and several years later, Goldman shared a house with Travis in West London, when she began writing for *Sounds* weekly magazine.

When Travis came down from Cambridge, he considered teaching or setting up a theatrical group that would educate teenagers in sexual politics. Instead, on a whim (he promised himself if a bus failed to appear in five minutes he would buy an airline ticket) he flew to Canada to visit his former drama teacher, and worked in a Toronto health food shop during the summer of 1974. A romantic interlude took him to Chicago, where he stayed for a while, before he and his girlfriend hitch-hiked from Illinois to San Francisco. It's a wonder anyone picked them up: by the time they cruised into the West Coast, Travis had accumulated a bulky luggage of 400 LPs, bought at thrift stores and boot sales across the country.

Once he had shipped his massive record collection home from San Francisco, and followed it himself on a separate plane, his friend Ken Davidson asked what he planned to do with all that vinyl. The only logical option was to set up a record shop, inspired by the small stores he had found in the States that were as much about community/scenester drop-ins as actually shifting product. Davidson and Travis took a lease on a premises in Dollis Hill, a north-west London suburb with a hipness cachet close to zero. "We started sanding down the walls and then we realised there was nothing there", remembers Travis. "We realised it when this rep from Polydor came round and said, 'What are you doing here? Who's your passing trade?' and we

Writer Vivien Goldman, photographed in Geoff Travis's bedsit at their shared house at 145A Ladbroke Grove. This image appeared on the sleeve of Goldman's 1981 single "Launderette"; the figure in the background is actor/poet Archie Poole.

said, 'What's passing trade?' We hadn't thought about it, the kind of customers that might come in the shop. So we packed it in and just drove around until we saw that wheel outside Kensington Park Road"— a reference to an old cartwheel that used to stand outside number 202, which ended up hanging outside Rough Trade—"and we investigated and we discovered a shop in an old print workshop, *the* big headshop during the hippy era in Ladbroke Grove, so it seemed appropriate."

Travis has variously said that the name Rough Trade was taken from a pulp S&M novel, or a moderately successful Canadian group featuring Carol Pope (a one time partner of Dusty Springfield). 'Rough trade' is also slang for vice or prostitution; it carries the sense of illicit, anti-establishment activity: a trade in unrefined commodities. A sign displaying those words was cut in curvaceous, Roger Dean-style lettering, the wagon wheel was hoisted onto a gable hook on the first floor, and Rough Trade opened at number 202 on 20 February 1976. "It was a West Indian area and the rent was cheap", says Travis. "We couldn't really afford to be on Portobello, so this was the next best thing, since it was kind of parallel. It took people quite a long time to realise we were there.... It was really empty for the first six or seven months. That was quite nice...."

The atmosphere of the shop was relaxed; a place for Travis and his small team to hang out, listen to reggae and punk singles blasting from their huge sound system, and to conduct their enthusiastic detective work in tracking down obscure records that no one else bothered to stock, such as Iggy Pop bootlegs, the first Talking Heads singles, and reggae and dub imports. This hard-to-get material soon marked Rough Trade out as unique, a hive for the city's specialist music fans and collectors.

"I started the shop on the basis that a record shop could be a lot more than just a place where you bought records, as though you were going to a chemist", said Travis in 1979. "The shop was set up in a way which would encourage people to stay for a while and talk, sit down, with a big table in the middle of the floor, and the shop was stocked with the kind of music that I personally really liked. It had a lot of reggae in it—that was one thing that differentiated it."

Travis and friend admire the newly installed wheel (above). Photographs by Chris Ward (Sparks).

"What a different location it was then to how people perceive it now", recalls Vivien Goldman. "It was really a shabby backwater, funky—not sleazy, but it certainly wasn't chic. All those shops with old dears, fairly surly, of a kind that you don't have any more. Where we were was the lowest point, and the lowest point is generally where the poor live—the richer people live on the hill. That was the grotty part, the borderline, where our house and Rough Trade were—the armpit of the area. There were so many dreads there, and people would come in wanting [reggae records], so there was market demand really. Because of where it was, on the Carnival route, and right at the heart of one of the biggest ex-pat West Indian communities.... And there was such a lot of great music at the time."

Notting Hill was the area of London associated with Caribbean immigration since the 1940s and was one of London's most racially mixed districts. Reggae and dub were the sounds most likely to be heard pumping out of open windows on a summer afternoon in Ladbroke Grove; Travis was effectively opening a local shop for the rich mix of local people, his punky reggae music policy attracting both Rastas and white punks. He would buy stock from various local underground dealers and importers, often forced to listen to just seconds of each track and make a decision to purchase or reject on the spot. The ordeal-by-audio forced his ears to mature fast—the perfect training for A&R duties.

"There were these records, 'prees' [i.e. pre-releases], that used to come from Jamaica", says Ana da Silva, who worked on the shop floor at the time, "and they used to have bits of sand on them. There were these guys that used to come in and listen to about two seconds of it: 'Oh yeah, I want that one', and two seconds of a different one: 'No, I don't want that one'. I could never understand how they could tell."

"I just remember it being very chaotic", recalls Ari Up, who would look in on the shop after her regular trip to Dub Vendor, a few streets away, before she became lead singer of The Slits. "A pile of records like a mountain, a mountainside. Piles and piles of records and shelves and everything thrown down on the ground and piles of papers and piles of scattered girls running around! That's what I remember walking in that shop—total chaos. I don't know how they sold records like that, they must have lost a lot of money. People coming in and stealing records...."

Above: Original shop employee Pete Donne. Photograph courtesy of Rough Trade shop.

Below: The Raincoats' Ana da Silva working at Rough Trade, 1979. Photograph by Chris Ward (Sparks).

Above left: The shop soon became the epicentre of London's punk scene. Photograph courtesy of Rough Trade shop.

Above right: Prolific bands such as The Ramones would frequent the premises. Photograph by Gerard Ruffin, courtesy of Rough Trade shop.

Travis's experience on the kibbutz had made him a passionate believer in the power of the co-operative as an alternative to conventional business practice. "A kibbutz is a utopia, isn't it?" affirms Goldman. "So he was trying to make a utopia there in the ghetto of Ladbroke Grove." Even though he was an owner of the company (along with his father, who contributed some of the start-up costs), no one remembers him acting like a normal 'boss'. All employees received the same wage no matter what their job was, and all took part in the regular meetings, which turned into discussions about music and the relative musical and ideological values of records. "The idealism was very real", confirms Goldman, "it wasn't a put-on, it wasn't pretentious or a façade. Geoff was giving it a go. He was very idealistic and he was a Marxist, and he wanted to shatter the paradigm. You could say it was an experiment, because nobody knew how it would turn out. Like they say in Jamaica, it was 'trying a thing'."

Rough Trade had some fledgling musicians working behind its counter. As well as Ana da Silva of The Raincoats, there were the two Godfrey brothers from the Midlands, nicknamed Nikki Sudden and Epic Soundtracks, who used to record DIY spacey punk tracks at their parents' house under the name Swell Maps. Drop-in visits from touring artists such as The Ramones and Patti Smith, and The Sex Pistols' Steve Jones, helped to cement the shop's cachet as the go-to centre of the independent universe. The shop's clientele signalled a market in transition: not hardcore punks, but not the Prog rock-centred white student audience of the early 70s either. In fact the customer base was hard to pin down, something between post-60s bohemia and 'conscious punk'. "It wasn't like what you imagine, punks, spiky hair kind of thing", recalls da Silva. "It's funny when you look at pictures of very early gigs at the Roxy, it was totally kind of student looking people in a way. A little bit scruffy... it wasn't the hardcore punks you sort of connect with that time."

Over the first couple of years, Travis found his role subtly changing from record shop manager to switchboard operator: Rough Trade had evolved into the main connection in a rapidly advancing network of bands, labels and nationwide record shops, facilitating each to get what they wanted. As is common with independent record shops, artists or entrepreneurs would visit the shop, leave several copies of their own self-manufactured record, and return at a later date to check on how many the shop had shifted. Retailers around the UK would ring up the shop when they were trying to obtain an item they had read a glowing review of in one of the weekly music papers. By 1977, this was happening so frequently that Rough Trade formally began to function as a distribution company, hooking the whole chain together for all these small scale releases, acting as a clearing house and supplier to other retailers around London—who very often couldn't get hold of the items via any other channels. If it was hot, hip or talked about, Rough Trade was the place to get it.

ROUGH TRADE

Geoff, Richard and Steve, directors of the Rough Trade Multi Million pound Conglomerate wish to announce that they are now trading in the best reggae records that can be found as well as the hardest core hard core glue stained sounds of the new wave.

Anyone interested in acquiring these records as a wholesale item, as a mail order customer or from the shop itself.....

Please write or call at ROUGH TRADE, 202, Kensington Park Road, London, W.11. phone 01-727-4312

Remember: This is the organisation that doesn't give a shit about Joe Public.

Shop flyer from 1977.

Richard Scott headed Rough Trade Distribution along with a handful of others, including Austin Palmer (a.k.a. reggae DJ Mighty Observer) and 'Little Steve' Montgomery, who used to sell reggae records from the back of a van. Scott was the former manager of Jamaican group Third World. He joined the company in the summer of 1977, introduced by Viv Goldman, who was then press officer at Island Records. Scott's original remit was to broaden the shop's range of stock, especially to increase the amount of reggae releases, and to get the shop's mail order business up and running. But in a short space of time he was handling the distribution arm of the business, which he continued to do for the next decade. Like Travis, he had altruistic notions of what a music company could be, and was an enthusiastic proponent of Rough Trade's function as a facilitating resource for artists. One of his lasting contributions was producing a booklet with advice for bands on how to press records, the best way to submit material to Rough Trade, etc.—practical information that so many acts learn over several years by repetitious failure.

Clockwise from top left: The first
generation of employees: Jude Crighton;
a customer being served; view of back
of shop (note reggae sound system);
Pete Donne; Nigel House. Photographs
by Chris Ward (Sparks).

Shirley O'Loughlin was an early Rough Trade employee; first in the shop, then behind the scenes in promotion, eventually running a concert booking agency and at the same time managing The Raincoats. She recalls the excitement of the on-the-hoof methods of those early days: "I'd been going to the shop since 1976, pretty much since it first opened, and it was really just an exciting place to be, all the records coming out, and a lot of people used to hang out there on Saturdays as well, and talk to people, and exchange numbers, because it seemed like everybody was forming bands and stuff at the time. One day I was standing talking to Ana at the corner of Portobello Road, and Steve who used to work at Rough Trade came along in a van, and said, 'Hey Shirley, can you drive?' I said, 'Yeah', got in the van and that was it. Basically, they bought this van, and he'd lost his licence or something, and I drove him around for about a month, and we went selling records out the back of the van, in London, all over the place."

Vivien Goldman, who by now had moved into a communal house at nearby 145A Ladbroke Grove, along with Travis and several others, points out, "Rough Trade was there before punk, and I believe Rough Trade and its ideology, its revolutionary business model, had a huge part to play in the birth and spread of punk—I think that's undeniable. Bob Last of Fast, and Daniel Miller, all these people would come in. There's a photo of me in the back yard with Mark P from *Sniffin' Glue* [fanzine]. These were all people who flocked to Geoff, because he was making something happen."

THE DESPERATE BICYCLES

The medium was tedium Don't back the Front

Danny Wigley (voice) Roger Stephens (bass) Dave Papworth (drums)
Nicky Stephens (organ)
© Office Music Refill records RR2 SLIGHTLY STEREO

The Desperate Bicycles were formed in March 1977 specifically for the purpose of recording and releasing a single on their own label. They booked a studio in Dalston for three hours and with a lot of courage and a little rehearsal they recorded 'Smokescreen' and 'Handlebars'. It subsequently leapt at the throat. Three months later and The Desperate Bicycles were back in a studio to record their second single and this is the result. "No more time for spectating" they sing and who knows? they may be right. They'd really like to know why you haven't made your single yet. "It was easy , it was cheap , go and do it " (the complete cost of "Smokescreen" was £153) The medium may very well have been tedium but it's changing fast. So if you can understand, go and join a band. Now it's your turn.............

sleeve design by Ingram Pinn

David Fox	D. B. Furness	Paul Bartlett	Judy & Dave Steele
P. W. Blakey	Helen Reid	Stephen Pulsford	J. Bradley
Arthur Baiely	Richard Hall	Peter Holmes	Bob Pritchard
Derek Laburn	John Bailey	Martin Preuss	Ron Curd
Nigel Broad	Jim Stacey	Chris Jones	Arnold McDowell
Simon Hicks	Malcolm Thrupp	Michael Meredith	Brian McCubbin
Mart Robinson	William Stone	Ken Baker	S. Swift
Simon Clegg	Alan Garvey	Martin Frisher	Tom Prentice
Craig Macadam	Jim Divers	Bob Clarkson	Paul Stavrakis
Steven Fyfe	David Finlay	Tim Ford	
Steven Hall	Martyn Higg	David Cobb	

Opposite: Blacked-out shop with stencilled logo, 1982. Photograph courtesy of Rough Trade shop.

Above and right: Sleevenotes on The Desperate Bicycles' "The Medium Was Tedium" 7" (Refill) espouse DIY culture.

In 1977, certain records had been passing through the Rough Trade Distribution system that were clearly the product of a total 'do it yourself' mentality—recorded, pressed and manufactured entirely at the group's expense. These included The Buzzcocks' *Spiral Scratch* EP, on New Hormones (run by Richard Boon), and The Desperate Bicycles' "Smokescreen"/ "Handlebars" 7", both of which described the process of recording and manufacturing, stating the costs incurred. Further pushing the DIY creed, the lyrics of the Bicycles' second single's B side, "Don't Back The Front", declared, "Cut it, press it, distribute it/Xerox music's here at last". It was the beginning of an entirely new perception of records: not as a mass produced commodity from a large, established manufacturing base, but as a kind of audio pamphlet, a subcultural bullet(in) recorded quickly and cheaply, handed out among a core of willing listeners, not aimed at scattershot radio exposure but targeted among like-minded communities who were aware of the contradictions inherent in producing an art object that espoused revolutionary values but which was also for sale.

Travis would strike deals with artists or labels that involved Rough Trade paying for the recording, and/or manufacturing costs, and taking on the liability of distributing the release, for a 50-50 share of any profits made. Little media promotion was undertaken at this stage, but the arrangement was exactly what many small scale operations needed in order to survive— a leg up from a 'big brother' to get some product out, perhaps grab the attention of influential journalists or DJs such as John Peel, plant the seeds of a grassroots following. Deals of this nature were struck with Industrial Records, influential home of Throbbing Gristle; Factory Records; and The Normal, the electronic project of Daniel Miller, whose "Warm Leatherette" single became the first on Mute Records, eventually selling 16,000 copies and launching a venture that would continue to become one of the world's most successful international independents.

By the end of 1977, it had taken less than two years for Travis's team to establish Rough Trade as a highly efficient and effective retailer and distributor that actively nurtured musicians and provided the resources to make the step up to getting their music out to the public. In addition it had set up a model of a collective, co-operative operation in which workers' and artists' roles intermingled, reducing the hierarchies that traditionally divide those roles. At some point, though, it must have struck Travis that, in all but name, Rough Trade was doing the work of a record label.

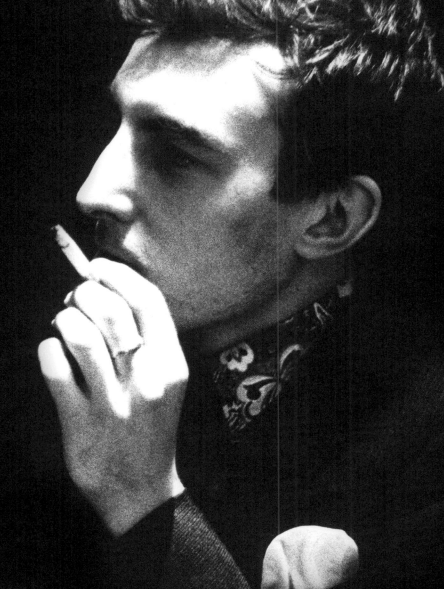

1978
SILENT
COMMAND

Previous page: Vic Godard of Subway Sect.

Above: French punks Metal Urbain, the
Rough Trade label's first signing,
brandish the picture they want to use on
their next single. It never happened.
Photograph courtesy of Rough Trade shop.

"We're gonna do it our way
 We're gonna make it on our own
 Because we've found people to trust
 People who put music first"
 — Stiff Little Fingers, "Rough Trade"

"There was the shop, then there was a scrubby back yard behind it, then there was a shed", remembers Vivien Goldman. "Then there was a bigger shed that was more like a small house, and then somehow there was an upstairs, and it was really a focus for the building of a community—a lot of journalists from all over the world would gravitate there, and a lot of the musicians would hang out. That is how you got this exchange of ideas, and, you might say, a new wave—he fostered that environment there."

It took a car-load of French punks to push Travis into setting out his stall as a label. Metal Urbain were four Parisians with a handful of attitude and a prototype drum machine who had already shipped over a few hundred copies of their single "Lady Coca Cola"/"Panik" to be sold at Rough Trade. "They all came over from Paris one day, the whole group", says Travis. "They gave me a tape of what they'd just recorded, which was "Paris Maquis", and said, 'Can you help us do anything with this?' So that was really the moment—it was them asking us that made us do it, really. I don't think we were hatching a master plan to run a label. It was a natural thing to do, like, why aren't we already doing it?"

As scores of bedroom punk rockers had already proved, setting up a record label hardly required a degree in economics. To put out a 7″ single, you needed to arrange a day in a recording studio (more than a couple of takes would destroy the aura of inspired amateurism many groups sought to achieve); a session with an engineer in a cutting room to produce the master lathe from which the vinyl would be cut; the pressing itself, in an edition of 500 to 5000, depending on your confidence and budget; and printing of your (self-designed) sleeve, in black and white or one colour. Once you had your boxes of records, stuffed into their sleeves in a few afternoons of intra-band bonding, there was the question of how you placed them in the public's hands. Usually this was where the hard slog began: driving around individual record shops, persuading the managers to take a consignment there and then, for cash. A small distributor might handle this part on your behalf, but their cut would make the group's proceeds negligible.

As a distributor, Rough Trade was already undertaking and funding most of these aspects of the process. To become a label simply entailed moving beyond just offering logistical and financial support, and adding a stronger curatorial dimension, principally driven by the tastes and instincts of Geoff Travis. Once the record had been made, it was then simply a matter of stamping the Rough Trade logo on the records instead of whatever the artists had decided to call their 'label'.

Metal Urbain's "Paris Maquis", with its distinctive bellowed *"Fasciste!"* kiss-off line, overdriven guitar, and one-man rhythm section (Eric Debris) playing EMS synth and Linn drum machine, was the first record to bear the Rough Trade imprint. Apart from later spin-off solo projects (Dr Mix, Metal Boys), Metal Urbain never appeared again on the label, after the porn centrefold they had proposed as the sleeve of their next record failed to amuse the feminists at one of the regular company meetings. But the momentum had begun: 1978 saw the release of a dozen 7" singles from the first wave of Rough Trade artists, in hindsight representing the wide stylistic diversity that endured throughout the label's existence, from French and Northern Irish punk rock to classic Jamaican dub. "People would just keep arriving with their records, which they'd just recorded", says Travis. "They would just come into the shop with what they'd done and say, 'Listen to this'. I suppose once they'd recorded it, they'd think, 'What shall I do with it? Go down to Rough Trade and see if they like it'. It was pretty exciting, and when people come and see you as an A&R outfit then you're in a really lucky position. It's almost an embarrassment of riches really."

From the beginning, the vibe of Rough Trade Records was communal: a small family. Literally so: Geoff Travis's father lent his son £4,000 to cover the startup cost of buying new stock and equipping the office. Goldman recalls that Travis Senior, the insurance man, "was often in there helping with the accounts. He certainly invested a lot of time and energy and was extremely supportive." With the label run from one of the desks shoehorned into the shed behind the shop, the whole Rough Trade business was becoming increasingly cluttered: the distribution arm was handling its roster of small indie labels like Fast Product, Postcard, Factory, etc. while Travis selected a clutch of acts to kick off the label's fortunes.

Opposite: Metal Urbain. Photograph by Gerard Ruffin, courtesy of Rough Trade shop.

Above (from top left): Metal Boys' "Sweet Marilyn"; Dr Mix "No Fun" and Dr Mix & The Remix's "I Can't Control Myself".

Rough Trade's relationships with its artists marked it out as very different from most other labels. The most significant innovation, which reflected the company's internal ethics, was the 50–50 deal. Following the example Rough Trade had already set in their distribution business, the artist would receive equal shares of any profit, after manufacturing, distribution and promotional costs had been met. Coupled with the fact that no groups were signed to long term binding contracts, this added up to an attractive offer compared to the smaller percentages—typically ten to 12 per cent—offered by the majors, and the negligible budgets of other small independent labels. Still, in the economy of independent music, it was sales of 10,000 and above—not so unusual in the late 70s—which would begin to generate modest incomes; low sales would still leave the artist with nothing. But Rough Trade imparted an instant integrity which was more valuable to some acts than the ready chequebooks of bigger organisations. This arrangement, believed Travis, created the psychological conditions for artists to produce their best work. It was a formula with huge appeal for underground musicians, and a largely effective policy in the first five years of Rough Trade Records, before the label began competing on a much larger scale and adopting more ambitious marketing strategies. On major labels, the marketing division beat the drum: regular release schedules meant groups were forced into writing songs when they had nothing to say, leading to an inevitable dilution of quality. In these early years of the label Rough Trade adopted a hands-off approach to the music, trusting the artists to develop at their own speed.

Stephen Mallinder of Sheffield experimental trio Cabaret Voltaire describes the experience from a musician's perspective. "The whole thing with the deal was it was very equitable; the idea that after costs the split was 50–50, which was unheard of then as I'm sure it is now. Also, at that time, the idea of being entrepreneurial about making music and being involved wasn't a consideration: we weren't Thatcher's children, we didn't have a business plan—you just did it. The ability to release something had greater value in the pre-digital age—to get a record out at that time was vindication in itself. The Rough Trade ethos was in sync with where we were at, it was the only alternative to a corporate contract, which wasn't us. The deal was very informal, and we were down to earth but still a bit naive with regard to the process of negotiation. Trust was a major factor.

Hard corps: Cabaret Voltaire (left to right: Richard H Kirk, Stephen Mallinder, Chris Watson). Photograph by Peter Anderson.

Clockwise (from top left): Selected
Cabaret Voltaire releases, 1979—81:
"Extended Play" 7"; "Seconds Too Late" 7"
(front & back); *Red Mecca*; "Jazz The Glass"
7"; *The Voice Of America*; *Three Mantras* EP.

ALTERNATIVES on Broadway

CLARENDON HOTEL
On the roundabout. Hammersmith

ROUGH TRADE GOODIES

FRIDAY 26TH SEPTEMBER

cabaret voltaire

ERIC RANDOM + Take It

7.30 - 12.00 LATE BAR

TICKETS £1.75 IN ADVANCE £2 ON DOOR

FROM ROUGH TRADE, TICKET MACHINE, PREMIER,
LTB, BEGGARS BANQUET (EARLS CT), HONKY TONK.

Opposite: Flyer for Cabaret Voltaire
gig, 1979.

Above: Mallinder and Kirk. Photograph
by Janette Beckman.

"I do remember Richard [Kirk] and I", continues Mallinder, "coming down to
London to cut the first EP and spending the entire time trying to get around,
dossing in parks and trying to avoid going on the Tube—the myth at the
time was the Underground's magnetic field had the capacity to wipe out the
tape. We met up with Geoff and the first thing he did was jump on the Tube
to the cutting room in Soho. We shat ourselves but didn't say anything. The
tape was fine." Cabaret Voltaire already had close links with Manchester's
Factory Records, regularly appearing at the label's showcases at the Russell
Club, and had even had two tracks on the first *Factory Sampler*. When it
came to putting out their first album, "we weren't sure where to go", says
Mallinder. "But in the end Geoff was willing and able to fund it and Factory
weren't able to at that time, so in the end it wasn't a difficult decision."
The album *Mix Up* came out in the following year. Cabaret Voltaire had
been cooking up their distinctive cocktail of cut-up tape loops, distorted
electronics and paranoid refrains since 1974, so their lineage stretched further
back than the earliest punk outfits, and their music, created in comparative
isolation in a Sheffield loft, far from the fashion-driven movements of
London, was far less reliant on conventional rock tropes than the likes of
the Pistols and the Clash. In fact none of the first four singles Rough Trade
released were by London artists, showing that the label's ears were open
to unorthodox sounds coming from disparate directions.

"You were just asked to be part of Geoff's adventure", says Mallinder,
"I remember hooking up with Geoff and Vivien Goldman in Ladbroke
Grove a few times. He came across as a very sincere bloke, music was his
passion and that was enough. Whenever people mentioned his name,
it was followed by, 'Geoff? Great pair of ears'. To this day I have a mental
picture—false—of him with unfeasibly large ears."

Stiff Little Fingers

ROBERT RENTAL & THE NORMAL

ESSENTIAL LOGIC

BENN MEMORIAL HALL, RUGBY.

on Monday 26th, February.

7.30 p.m. — Doors 7.00 p.m.

Admit 1 —— £1.80

No admission/Re-admission after 10.00 pm.

A 'VICKYS' — 'ROUGH TRADE' PROMOTION

STIFF LITTLE FINGERS

Clockwise (from top left): Rough Trade
tour concert ticket; "Gotta Gettaway" 7";
Stiff Little Fingers (left to right):
Jake Burns, Brian Faloon, Ali McMordie,
Henry Cluney; *Alternative Ulster* badge.
Photograph by Shirley O'Loughlin.

The Monochrome Set (top right) and their
records. Photograph by Janette Beckman.

Belfast agit-punks Stiff Little Fingers and art rock ensemble The
Monochrome Set each released three singles during their time on Rough
Trade. Stylistically they couldn't have been further apart. SLF's "Alternative
Ulster" and "Suspect Device" were blazing Molotov cocktails lobbed
from the front line of the Anglo-Irish armed struggle. The Monochrome
Set's apolitical, angular and somewhat opaque pop was a world away. Chief
songwriter Bid, with colleagues Lester Square and Andy Warren, typified
an emerging sound of London's outer suburban ring: their *milieu* too
peaceful to have been much affected by punk's inner city howl, they turned
instead to literate, oblique lyrics and arch presentation that involved odd
publicity photos and performances reminiscent of the surrealists or Monty
Python. They would end up releasing three singles with Rough Trade before
moving to Dindisc for their first album in late 1979. Despite many line-up
changes and a dedicated following, their often oblique stance and erratic
musical swerves have never managed to sustain a constant larger audience.

Subway Sect

Name: PAUL MYERS
Age: 20
Birthsign: Gemini
Eye Colour: Green
Hair Colour: Light Brown
Domicile: Mortlake
Hobbies: Golf, walking, Climbing
Favourite Fish: Tench
Likes: Haddock and Cod
Dislikes: Plaice and Eels
Favourite Area: Richmond Park
Favourite Actress: Phyllis Diller
Ambition: To ride a motor-bike around Wentworth
Worst Memory: Missing a 3 footer on the 18th.
Favourite Golfer: Dave Hill
Favourite Film: Seven Samurai
Happiest Memory: Hearing Bing Crosby singing "White Christmas"

Name: VICTOR GODDARD
Age: 20
Birthsign: Virgo
Colour of Eyes: Grey
Colour of Hair: Mousey
Domicile: Barnes, S.E.13.
Hobbies: Cinema and Tennis
Favourite Country: Albania, Bulgaria
Favourite Singers: Francoise Hardy, Annette Peacock
Favourite Composers: David Bowie, Claude Debussy
Favourite Groups: Velvet Underground, Abba
Various Likes: Songwriting and learning guitar
Various Dislikes: Rich people. False people
Favourite Motto: "Do it now on"
Favourite Actor: Todd Slaughter, Laszlo Szabo
Favourite Actress: Ingrid Bergman, Anna Karina
Ambition: To Die

Name: ROBERT WARD
Age: 20
Birth sign: Gemini
Eye Colour: Grey
Hair Colour: Blonde
Domicile: Bethnal Green
Hobbies: Fishing, Football, Paris
Favourite Fish: Pike
Favourite Drummer: Ian Paice
Favourite Group: Montrose
Various Likes: Girls
Various Dislikes: Captain Sensible
Favourite Motto: "Fishing is fun"
Favourite City: Bethnal Green
Favourite Country: Bethnal Green
Favourite Food: Pie & mash from Kelly's
Ambition: To own a lake

ROBERT SIMMONS
Robert was born in Fulham, South London on April 2nd 1957. He is 5ft 11ins tall, and weighs 10st 6lbs. The colour of his eyes are brown/green, and his hair is dark brown. He lives at home with his parents. He is the Rhythm guitarist in the group and also joins Paul with backing vocals. His favourite guitarists are Lou Reed and Jonathan Richman on their respective 1st L.P.s and also Bo Diddley. He detests all sports including the ones in which the rest of the group indulge. He likes watching T.V. during the daytime **only**, especially 'Bosscat' and 'Bewitched'. He hates transport and going to crowded places such as High Streets on his own, although he likes being alone. He also dislikes all social occasions and two-faced people. HIs favourite season is the Autumn. He also enjoys being in bed and reading.

Vic Godard was one of Rough Trade's more colourful characters. His group
Subway Sect, formed in 1976, took part in the original Punk Fest in Central
London's 100 Club, and went on tour as part of The Clash's *White Riot* tour of
1977, alongside The Buzzcocks and The Slits. Bernie Rhodes, The Clash's
legendary manager, took them under his umbrella but had a strange attitude
to releasing their music. "Ambition"/"Different Story", their second single
and their first for Rough Trade, was sat on for a while by Rhodes, who
also doctored the master tape of "Ambition" by speeding it up and adding
a Wurlitzer organ line. That swirling, fairground-style addition made the
tune memorable, along with Godard's vocal delivery, halfway between John
Lydon's snarl and Frankie Howerd's curled-lip camp. Subway Sect only
made one other record for Rough Trade, 1981's "Stop That Girl", but by that
time Godard had entered a wholly other phase, dressing his group like
Second World War spivs and making an insouciant jazz-inflected pop with
Gallic accordions.

swell maps

Opposite (clockwise from top left):
Selection of Swell Maps releases:
"Let's Build A Car" 7"; *Whatever Happens Next*; Epic Soundtracks's "Popular Classical" 7"; "Real Shocks" 7"; Cult Figures' "Zip Nolan" 7" (featuring Swell Maps as backing band to two Birmingham teenagers); "Read About Seymour" 7"; *Jane From Occupied Europe.*

Above: Who left the gas on? Swell Maps' *A Trip To Marineville.*

In Subway Sect and many of the other early Rough Trade acts, the 'angry energy' expressed by the likes of The Sex Pistols seemed to have dissipated down narrower tributaries. This was not the pure nihilism of the Pistols, neither was it the agitprop hectoring of The Clash. Swell Maps' *Boy's Own* boisterous enthusiasm, Subway Sect's weird, noirish, accusatory lyrics, Cabaret Voltaire's Burroughs-inspired sonic collage and The Monochrome Set's intellectual aloofness signposted subtly different routes out of complacency than the one indicated by 'straight' punk rock: already, the era of post-punk had arrived. Now it was Rough Trade's job to capitalise on it.

Swell Maps in the shop. Photograph
courtesy of Swell Maps.

RT001

Metal Urbain "Paris Maquis"
The Parisian punk outfit blustered
their way into the history books by
descending on the Rough Trade shop
en masse and playing Geoff Travis
this guttural belch of a song.
Tinny drum machine akimbo, rasping
electric guitar, and an accusatory
war cry of *"Fasciste!"*

RT002

Augustus Pablo
"Pablo Meets Mr Bassie"
The presence of one of the most
famous masters of Jamaican reggae
on Rough Trade clearly pays dues to
the shop's close connections with
the West London dub scene. This
warm, melodica-driven rocker, which
made the reggae Top Ten in October
1978, has become a classic Pablo dub.

RT003

Cabaret Voltaire
"Do The Mussolini (Headkick)"
The Sheffield experimental trio had
been recommended to Rough Trade
by journalist Jon Savage, an early
champion of the group. This lump of
gangrenous electronic chant creeps
like a slug, enacting the fascistic
death-dances itemised in Stephen
Mallinder's lyric.

RT004

Stiff Little Fingers
"Alternative Ulster"
Jake Burns and Co's punk battle
hymn reflected a longing to be
free of the crippling limitations
that existed from both sides of
the Loyalist/Republican divide in
Northern Ireland. The song imagines
a new beginning for Ulster as a
reformed utopia.

Opposite: Belfast punks Stiff Little Fingers released Rough Trade's first album. The group go wild in the shop. Photograph by Mike Layo, courtesy of Rough Trade shop.

RT005
The Monochrome Set
"Alphaville"/"He's Frank"
With its angular three-chord lyricism, and character sketch of a sleazy outsider, Bid's song looked back to the chug of The Velvet Underground's "What Goes On", took a swig from the heady guitar brew of contemporaries like Television, and looked forward to the arrowhead riffs of Josef K and even Franz Ferdinand.

RT006
Stiff Little Fingers
"Suspect Device"
Burns's larynx is reduced to a wail of anguish on this single, urging resistance to mind control and political lies. *"I'm a suspect device the Army can't defuse"*, he warns, before careering into a jagged-edged chorus with neat *"suss—suss—suspect device"* transition.

RT007
Subway Sect "Ambition"
One of the great punk singles owes its organ hook to a later overdub by manager Bernie Rhodes. The title is ironic. Far from ambitious, Vic Godard's verses celebrate inertia: *"I'm a dried up seed that can't be restored/I hope no one notices the sleep on me"* ...

RT008
Electric Eels "Agitated"
Recorded in 1975, "Agitated" showed this Ohio trio at their rawest and most disturbed and spoiling for a brawl. Brian McMahon and John Morton came out of the same locale as label-mates Pere Ubu, toughened on the kind of blue collar macho drinking joints where they used to provoke fights by pretending to be gay.

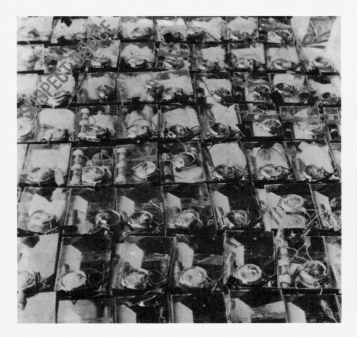

RT009
Kleenex "Ain't You"/"Hedi's Head"
Feral call-and-response yelps from vocalist Marlene Marder, metronomic drumming, stop-start and careering time signatures, all add up to a classic of post-punk primitivism from the female Swiss quartet before they were persuaded to change name to Liliput.

RT010
Swell Maps "Read About Seymour"
Brothers Nikki Sudden and Epic Soundtracks (aka Nicholas and Kevin Paul Godfrey), with schoolmates/co-conspirators Jowe Head (aka Stephen Bird) and Richard Earl (who used the names Biggles Books and Dikki Mint), turn in one and half minutes of post-punk frenzy with a subtle ska twist. The song is a tribute to an imaginary piratical hero, *"All cutlass and alone, at last/The spirit sank like mourning glass"*.

RT011
File Under Pop "Heathrow"
Edited from manipulated field recordings made at Heathrow Airport, this slab of post-punk musique concrète has become one of the most obscure records in the whole Rough Trade catalogue. The perpetrator was Simon Leonard of the Industrial units AK Process and AK 47, and later a member of electro groups Start Counting and Fortran 5.

RT012
Swell Maps "Dresden Style"
Swell Maps' second single, an adaptation of a previous song called "City Boys", bursts at the seams with propulsive energy courtesy of Epic Soundtracks's Ramones-style drumming, while Nikki Sudden slurs, heroically out of tune, from somewhere deep in the mix.

1979
MESSTHETICS

UPSTAIRS AT THE
CHIPPENHAM

SCRITTI
POLITTI
+
THE
RAINCOATS

THURSDAY - 8TH MARCH
8:30 - 11:00

"Oh we know what we're doing
What we know how it sounds
yes we know how it sounds
We know how this sounds"
— Scritti Politti, "Messthetics"

After a year of trading as a label, distributor, shop and mail order outlet, Rough Trade found itself swelling uncontrollably. The distribution arm had become the central node in an informal network of UK independent wholesalers and record shops, all eager to purchase stock from the flood of records that were now arriving at Rough Trade's door from the USA, Australia, Europe and the West Indies. The 'warehouse' had already outgrown the second, larger shed they had built in the back yard behind the shop to house the distribution operation, while the label's offices had spilled over into rooms above the shop, where some of the staff were also living. The throughput of stock, correspondence, demo tapes and mail order requests was beginning to back up. If the persistent rumours are to be believed, one reason there was such a backlog was because the employees were always in a meeting.

"We used to have weekly meetings", remembers Shirley O'Loughlin. "Geoff's role was very much to do with the A&R side of Rough Trade, but we would have meetings and we would discuss things rather a lot, you know. I think that was really important. Some people have attitudes about these meetings that we had, as if they were some form of political activism or something, but I think it was just really important that people had that kind of space, and could feel they could speak about the bands and the music that we were taking on. Sometimes, somebody wouldn't agree with putting out a certain record, and we would talk about it.... And then a couple of times they had people who came in to do the cooking, which made it feel like a kind of brown rice, hippy kind of thing.... That's where that myth comes from. It didn't last long."

Travis's memory is slightly different: "There was some discussion, probably a lot more musical discussion than you'd find in most places. But it wasn't really that caricature of every single hour having a debate. Often, I would just be very autocratic and say, 'This is great'. I mean, it was kind of common sense. But there weren't really big debates about anything—or if there were, I wasn't aware of them. Maybe they were having debates when I wasn't there—it's quite possible!"

Previous page: Geoff Travis in percussion discussion with Green Gartside, recording Scritti Politti's *4 A Sides* EP, 1979. Photograph courtesy of Tom Morley.

Opposite: Handwritten poster for gig at the Chippenham pub in West London, 1979.

Above: Scritti Politti's *2nd Peel Session* EP.

Opposite: The back of the album, with detailed breakdown of costs and methods.

All this talk reinforced Rough Trade's reputation as a community that engaged with—even kickstarted—the arguments of the day, a boiler room of ideas. Employees were all encouraged to toss opinions into the debate, about music, politics, the ethical dimension of every aspect of the business. Visiting musicians also fed the debate: Green Gartside of Scritti Politti remembers a noticeboard where staff and visitors were requested to pin up a list of their current top ten favourite records. Vivien Goldman recalls "Meetings, meetings, meetings. People were jamming conceptually, you could say, with the ideas. Geoff is a very serious minded man—he takes things very seriously, he thinks things through. He was ambitious in an unconventional way, because he was ambitious to see a different approach. He was ambitious in attempting to weld ideology to commerce."

No one who worked at Rough Trade at the time would admit to having an official business plan, or any kind of longer-term vision. To this collective of young socialists whose minds had been expanded and activated by punk's revolutionary cause, the notion of 'growing' the business, of profit margins and detailed accounting, was part of the problem, not the solution. At the same time, the company had come along at exactly the right time to capitalise on the rush of interest in the fallout from the punk explosion, and whether by luck or good judgment, Travis's A&R decisions created a long string of releases that were selling in comfortable numbers and generating critical interest. And all this was achieved by an improvisatory ability to learn on the hoof and react quickly to unfolding events and musical micro-trends. As David Cavanagh has put it, Rough Trade "centralised the anarchic indie hurly-burly and gave underground music a spine".[1]

There was too much diversity to call it a 'Rough Trade sound', but common values could be detected across the 20 singles and seven albums the label released in 1979. The DIY attitude that had trickled in from the fringes in 1977–78 was now the defining quality of post-punk, summed up in the title "Messthetics", a track on Scritti Politti's *2nd Peel Session* EP. The word encapsulates Rough Trade's visionary fusion of ethics with lo-fi aesthetics, and the improvisatory business model that ensured the one was reflected in the other.

1. Cavanagh, David, *The Creation Records Story: My Magpie Eyes Are Hungry For The Prize*, London: Virgin Books 2000.

JOHN PEEL SHOW
Rec: a/b) 20th June 1979
a) ⁰TA203J064
b) ⁰TA203P075

for SCRITTI POLITTI

ed copy would you please attach

CUTTING - £40+vat
I.B.C.Sound Recording Studios
35 Portland Place, London W1
(01)637 2111

LABELS approx. £30 per printing plat
£13 per thousnd pairs
Peter Gray, Wellington Rd.
Bromley, Kent. (01)464 0828

During a broadcast Peel invited the group
to do a session.
Our "organiser" phoned Peel's secretary and
spoke to John Walters who offered a choice
of dates within the next month.
A date was agreed on, a contract arrived a
few days later (for a group member to sign
and return) detailing time,place,wage etc.
The session was recorded at the BBC's
Maida Vale Studios with the excellent
assistance of the enginneers and producer.
Peel and Walters didn't attend.
From 2.00pm we spent about 4½hrs. setting
up and recording backing tracks, 2½hrs.
recording vocals, and 3½hrs. mixing. But
we weren't allowed a copy of the songs.
The BBC prohibits our negotiations being
made public on this sleeve as we are unable
to print the full production costs. However...

PROCESSING - £14+vat per side
PRESSING - 13p each + vat, for
5,000.
Allied Records Ltd.
326 Kensal Rd. London W10
(01)969 6651

PLASTIC COVERS - £65 inc. vat
for 5,000.
West 4 Tapes & Records,
100 Chiswick High Rd.
London W4. (01)994 5879

INSERTS - printed cheap by
Beattie.

Where the first wave of punk strove for authenticity through the three-chord strut, a structure largely derived from previous forms of blues-influenced rock 'n' roll, post-punk threw more complex structures into the mix. Lower recording budgets meant short spells in the studio and necessitated speedy mixdowns. These were contributory factors to the slightly coarse, 'shambolic' sound of many post-punk records. A singer who wobbled off key, or a drum beat that occasionally departed from the metronome, represented grassroots authenticity, lack of 'classical' training, and refreshing, street-level spontaneity.

Rough Trade might have been largely staffed by middle class bohemians and intellectuals prone to collectively analysing the political ramifications of where they bought their teabags from, but all that mattered in the end, for Travis, was whether or not the record gave you a thrill. Many of the label's 1979 signings made music that sounded as though the building blocks of song had been broken apart and rearranged to make its mechanics transparent. With no single instrument fleshing out the sound, and with the rhythm section's drums and bass pushed to unconventionally high levels in the mix, post-punk often sounded scrawny and undernourished rather than slick and EQ-fattened (a quality which reflected the starved squat/dole culture many of the players often lived in). This sonic transparency reinforced the often self-reflexive nature of the music— Scritti Politti's "28/8/78" played a long instrumental passage over that night's BBC News, reporting a riot at the Notting Hill Carnival that had taken place only hours before. Kleenex's "You" transformed a housewife/ girlfriend's henpecking nag into a wider meditation on the expectations of the sexes within a partnership. A common preoccupation was the fragility of personal integrity in the face of the state or corporate machine; the notion of being a social 'prostitute' arose in songs by both Vic Godard ("Everyone is a prostitute", intones the opening line of "Nobody's Scared"),

Above: Scritti Politti in concert.

Opposite: Full time punk baiters: Television Personalities (Dan Treacy, left, and Jowe Head) and their 1981 LP, *And Don't The Kids Just Love It*. Photograph courtesy of Jowe Head.

and the song "We Are All Prostitutes" by The Pop Group. As a flipside, the antics of Swell Maps addressed war and law enforcement with a spirit of high jinks derived from adventures stories, pulp fiction, Gerry Anderson animations and B movies. Chelsea schoolboys the Television Personalities' "Part Time Punks" (reissued by Rough Trade at the beginning of 1980 following its appearance on 1978's *Where's Bill Grundy Now?* EP, on their own King's Road label), reflected a transference of the earnest imperatives behind punk rock into pastiche, satirising the cartoon-mohican punk rockers that had taken over the King's Road as helpless fashion victims, ignorant of the founding spirit of punk rock. The song testified to the presence of the shop in the scheme of things:

```
Here they come
La la la la laaa la
La la la la laaa la
The part time punks
Then they go to Rough Trade
To buy Siouxsie & The Banshees
They heard John Peel play it
Just the other night

They like to buy the O Level single
Or "Read About Seymour"
But they're not pressed in red
So they buy The Lurkers instead

They play their records very loud
They pogo in the bedroom
In front of the mirror
But only when their mum's gone out
```

Top: Mayo Thompson with his reformed
The Red Crayola, drawn from the ranks of
Rough Trade (from left): Epic Soundtracks,
Gina Birch, Lora Logic and Mayo Thompson.
Photograph by Janette Beckman.

Bottom: The Red Crayola, post-punk
vintage (from left): *Micro-Chips & Fish*
EP; *Soldier-Talk* (Radar Records 1979);
"Born In Flames" 7".

In 1979, Thames Television produced a half hour documentary on Rough Trade as part of the long running cultural series *The South Bank Show*. Introduced by Melvyn Bragg and narrated by music critic Simon Frith, the programme shows footage inside the Rough Trade shop, The Raincoats recording their *Fairytale In The Supermarket* EP at Cambridge's Spaceward Studios, and live shots of Stiff Little Fingers, The Normal & Robert Rental, and Essential Logic. "We like to make records in someone's living room", Travis comments in the film. "Because if you take people that haven't previously existed in a very luxurious environment, and put them in a very expensive studio surrounded by huge amounts of technology and professional people, they're intimidated by it." It was a clear statement of the attitude behind Rough Trade's recording budgets and methodology. Leaving aside the limited resources available, the idea was to tap the creativity of groups at a rawer stage in the process, in an environment that seemed more naturally suited to the musical aesthetics. How much sense did it make to record the wayward sounds of a Raincoats or Young Marble Giants in a 24 track high end studio setting? It would serve neither the music nor the requirements of the label.

A new face appeared in the documentary, filmed behind the mixing desk at Spaceward. Mayo Thompson would prove to be a crucial addition to Rough Trade's floating collective of associates. Born in 1944 in Houston, Texas, Thompson was already a veteran of the music business, from his cult leftfield rock ensemble The Red Crayola, whose late 60s albums such as *Hazel* and *The Parable Of Arable Land*, and his own solo *Corky's Debt To His Father*, 1970, had foxed listeners expecting more psychedelic mayhem in the vein of United Artists labelmates The 13th Floor Elevators. In hindsight, Crayola's eccentric, stripped down simplicity and intelligent, caustic lyrics make them a rarely acknowledged precursor of punk, along with The Velvet Underground.

In the late 70s, Thompson moved to New York, worked as studio assistant to the artist Robert Rauschenberg, and fell in with the New York branch of conceptual art provocateurs Art & Language, a politicised collective begun in Britain in the mid-60s with such artists as Terry Atkinson, David Bainbridge and Michael Baldwin, who were later joined by a larger coterie including Joseph Kosuth and Preston Heller. The output of Art & Language involved theoretical writings as well as 'artworks', but as the 70s progressed the group was racked with the kind of tensions that afflicted many such underground collectivist groups at the time, including the London Musicians Collective and avant garde composer Cornelius Cardew: whether direct political action should replace cultural production. Thompson has called the group "the baddest bastards on the block",[2] and his connections with them resulted in records like *Corrected Slogans*, 1976, in which a revived Crayola were teamed up with Art & Language for some rather arch neo-pop (sample titles: "Ergastulum", "The Mistakes Of Trotsky... Thesmorphoriazusae", "An Harangue").

When the American branch of Art & Language was liquidated, Thompson relocated to the UK to join the collective there, but fell out with them after a dispute, and "wound up having to get back into the music business".

In 1978, having recorded a single, "Wives In Orbit"/"Yik Yak", for Jake Riviera's Radar label, he found himself wandering into the Rough Trade shop, which he had read about in the *New Musical Express*, hoping they would buy up his remaining copies of *Corrected Slogans*. Travis "took 25, and put them in the browser bin right there", recalls Thompson. "I got talking to Geoff and we struck up a natural alliance. I got offered to produce The Monochrome Set's first single." Travis had been asked by Stiff Little Fingers to produce their debut album for Rough Trade, but he had no experience of working in a studio. "We pooled our resources", says Thompson, "his ears and my know-how." Through his work on The Monochrome Set's "He's Frank", and the label's first album, Stiff Little Fingers' *Inflammable Material*, Thompson became an indispensable part of the Rough Trade team, his experience as a producer and musician eventually bringing him the role of label manager in the mid-80s, and his dry, erudite wit furnishing the weekly meetings with a much needed injection of levity.

"The intensity with which Stiff Little Fingers played", says Thompson, "and the depth and craftsmanship, showed that those guys were yeoman performers, and that they'd been a band for ever. The quality of that stuff, and the fact that they spoke the language of the street, to the people who wanted to be talked to in that way and wanted to hear that stuff, and they wanted other people to know they cared, and because they cared, you're gonna have to care about it too—how do you feel about that? We mixed it in Deep Purple's studio. That was a lot of fun. "Smoke On The Water"? You bet there was smoke coming out of that desk."

Thompson was impressed at punk's "political force at the cash register"—the distribution of anti-establishment sentiments in units of tens of thousands was certainly in contrast to the single-unit economy of avant-garde art he had encountered in the early 70s. But there was another quality, exemplified by The Monochrome Set's detached intellectual pop and role-playing, that convinced him he was in the right place. "I've always been an admirer of British pop, it's superior, fooling around with guises and masks and faces and style—British music has always been able to knock spots off anyone else. On one side you had your hardcore authenticist punks, who would kick your motherfuckin' ass if you didn't agree with them about your music, and on the other side you had the arty types—people with pretensions, people like me—who had some idea about having some fun and stirring the shit. Opportunists, fellow travellers, lumpen proletariats, the usual cultural riffraff. And The Monochrome Set was a really good reflection of all that was interesting about that gravy."

In 1979 Thompson and Travis worked as an informal production team, attending many of the recording sessions for Rough Trade releases and guiding and shaping the creation of the sound. Admittedly this began in more of an aesthetic advisory capacity than hands-on technical work, but it channelled the 'holistic' energy of Rough Trade directly into the studio, meaning that the label's ideology could be applied in real time at the point where the artefact was being shaped. "Usually you're confronted with a situation where the engineer plonks himself in the middle", Thompson complained to the *South Bank Show*'s camera. "You don't have access to it,

Opposite: The Rough Trade production team of Geoff Travis and Mayo Thompson tweaking the mix during the recording of The Raincoats' "Fairytale In The Supermarket", Spaceward Studios, Cambridge, 1979. Stills taken from *The South Bank Show*.

2. Keenan, David, "The Merry Prankster" in *The Wire* no. 258 August 2005.

you can't check things, can't change the way things sound—you have to ask. There's a whole chain of command, a whole set of relationships that are very difficult to break. And here it's easier to get at it. The access is greater."

Thompson went on to become a fully fledged professional producer, working throughout the 1980s on many sessions—Rough Trade acts like Scritti Politti, The Fall, Blue Orchids, James 'Blood' Ulmer, and other indie groups of the 1980s, including Primal Scream, Felt, and The Chills, becoming adept at getting the most value out of low-budget recording dates. "In productive terms, it's a good straitjacket to put on", he comments. "Focuses the mind wonderfully, to know that you've got X amount of pounds and you really ought not to spend more than that. The constraints made it a great deal of fun."

The Raincoats' Ana da Silva recalls the *Fairytale In The Supermarket* session: "I could hardly play the guitar, we could hardly do anything, in terms of knowing what's what about recording. When we started the band we didn't know anything about PAs or how it's organised, and what you need on stage—we just did it. We used to rehearse with tiny little practice amps—put the vocals and the bass and guitars through these tiny little amps. And Geoff and Mayo were a bit of the same thing, they didn't know about production—or at least Geoff didn't know about production. There was an engineer, and they just went, 'That sounds good ...'."

"The first thing I did was mix [Stiff Little Fingers'] "Alternative Ulster"", confirms Travis. "I didn't really do very much. I mean, the engineer inevitably did most of it, I was pointing my finger at the faders. And then Mayo and I produced Stiff Little Fingers' first album in Spaceward's basement in about 12 days, and that was a really good experience—just a matter of making sure we got down the energy of their live performance, really."

Stiff Little Fingers interviewed on *The South Bank Show* documentary about Rough Trade, 1979.

Sing no evil: Mayo Thompson with Green
Gartside recording Scritti Politti's
4 A-Sides EP.

The film proves that Thompson and Travis were on a very similar
wavelength regarding the politics of production. Thompson managed to
squeeze in a dig at the expense of producer Sandy Pearlman, who had given
The Clash's *Give 'Em Enough Rope* a hefty rock acoustic aimed squarely at
CBS's international market. "Sandy Pearlman has said plainly that the
reason he produced The Clash the way that he did was because he wanted
them to be heard in America. And if they were not produced in a certain
way, then the American ears would not hear it—they're closed… and I think
that's wrong. It is a mistaken way of approaching the problem."

"We're not Luddites", insisted a softly spoken Travis in the same interview,
"we don't want to mash up machinery and go back to the seventeenth
century. But we feel happier learning about the technical process with the
technical means that we can understand, that we can learn on. Being a
producer, all it means is that you give your musical ideas: you say, well,
I hear it like this, it would sound better as so-and-so. It's a job that anyone
who's listening to music seriously could do …."

Travis's appearance on *The South Bank Show* concluded with a succinct
statement of his current label management policy: "We are saying the
marketplace is a false creation, and has very little to do with what people
might want, given the options. I suppose in a way we are incredibly
egotistical about it, we measure the success of a Rough Trade record by
how happy the bands are with what's been produced in the recording

studio, and how happy everyone at Rough Trade is. I mean, if we were all convinced it was good and the rest of the world thought it was lousy, we'd probably be quite happy to stay in our insane asylum, alone."

Later that year, Rough Trade found a new venue for its asylum. The shop continued at Kensington Park Road, but the rest of Rough Trade—the label's office and distribution system—uprooted from the overflowing sheds and installed itself at new premises about ten minutes' walk away.

Blenheim Crescent's grand, white-fronted, three-storey terraced townhouses curve elegantly away from Portobello Road in a south-westerly direction. Just before the street dissolves into a cluster of 1960s council housing stands number 137, the very last building. The house is the odd one out: detached and just two storeys high, it's set strangely far back from the road, shielded behind tall iron railings.

137 Blenheim Crescent has passed into the legend of independent music. Almost instantly it became far more than just a company headquarters: more of a drop-in centre for musicians, journalists and record business hipsters. It was an informal hotel for touring artists; a poste restante for independent labels, subcultural fanzines and group fan clubs; a cutting edge noticeboard; storage facility for instruments and equipment; shrine of pilgrimage for fans from all over the world. It was even a free restaurant: visitors arriving in the foyer could help themselves to a tasty vegetarian buffet that was often brought in, ostensibly to feed the staff.

Coming from the collectivist ethos of Art & Language, Mayo Thompson found the set-up familiar but with a refreshing twist: "Even in Texas people were living in communes, having 20 dogs and 50 families and stuff like that. That was never really my cup of tea. I preferred the English approach to it, which was: I went home to my own house at night. That collective activity in respect of a *business* made sense to me. By that time I had read [Al Morton's] *People's History Of England* and knew about the co-op movement, and thought, if there is anything worthy of the name 'progressive', that's some kind of progressive idea in there. That was a strong selling point for me: the possibility of doing what I felt like doing, and at the same time expressing my commitments and my attitudes to the universe. That was pretty handy."

Thompson recalls that early on the day scheduled for the release of Stiff Little Fingers' *Inflammable Material* LP, a sudden flurry of couriers and taxis appeared outside the office to collect promotional copies. They had been sent by various bigger record companies, and it was in effect the beginning of a bidding war to sign the independent sector's hottest punk group. It raised questions that the label would soon have to address with greater frequency: how much obligation should Rough Trade place on their artists to remain with them; or should they be content to act as an interim talent scout and provide a raft of underground-endorsed acts to be cherrypicked by major labels? As Simon Frith commented in the 1979 documentary, "[Stiff Little] Fingers seem better prepared to cope with the dilemmas of success than Rough Trade's intellectuals. The danger is that Rough Trade will merely service the record business, take the musical risks that the

KLEENEX

SLOT REGULA MARLENE

KLAUDIA

Opposite: Threat of legal action from
the tissue-manufacturing Kimberley-Clark
corporation forced Kleenex to change
their name in 1981. Rechristened Liliput,
they released *Liliput*, 1982, and *Some
Songs*, 1983.

Left: Homemade artwork by the Swiss
foursome. Courtesy of Klaudia Schifferle.

Above: Kleenex's Marlene Mardi and
Klaudia Schifferle mop it up. Courtesy
of Klaudia Schifferle.

established companies will cash in on. An even greater danger is that
they will go the way of other small labels before them, and become an
established company themselves."

Inflammable Material quickly reached number 14 in the national album
charts—an impressive feat for an independent label at the time, and a
vindication of Rough Trade's commitment so far. Many in the industry
were surprised at the pulling power of an organisation that had previously
been seen as marginal and underground.

As it expanded into Blenheim Crescent, the company added divisions that
increased its self-sufficiency. Anne Clarke set up Rough Trade Music to
handle publishing, copyright and royalties. Shirley O'Loughlin, meanwhile,
found herself fielding most of the calls regarding live bookings for many
of the artists, and arranging a Rough Trade tour featuring Kleenex, The
Raincoats and Spizz Energi (replacing Cabaret Voltaire, whose girlfriends
didn't fancy them going on tour with two girl bands). "Around 1980 I just
became completely busy with people ringing up to book bands, so I turned
into a booking agency", recalls O'Loughlin. "We sat down, me and Sue
Johnson, and figured out that actually, we should formalise that, because I
ended up doing that most of the time, and obviously the label was growing as
well—there was Essential Logic, Delta 5, Red Crayola, Young Marble Giants,
The Swell Maps and so on." The agency continued through to the mid-80s,

and also booked shows for other bands who were under the umbrella of Rough Trade distribution, eventually establishing a connection with a sister operation in the United States so that international tours could be arranged.

Despite the success of Stiff Little Fingers, and the unusually extensive market penetration of many of their singles—thanks to Richard Scott's cultivation of the nationwide distribution network—Rough Trade was not equipped to promote hit records, and its small staff was not used to the sudden increase in workload. Trying to keep on top of the distribution in a climate where a record like the Television Personalities' *Where's Bill Grundy Now?* EP could achieve sales of well over 20,000, was becoming increasingly taxing. In addition, a backstage drama had slowly started to unfold. Certain emerging differences of opinion between the distribution and the label were turning messthetics into messy ethics.

The economics of distribution require products that will generate income in the short term: records that retailers will want to snap up in large quantities, backed up with effective, wide ranging promotional campaigns. Travis, handling the label side, was focused on the needs and requirements of his artists. He explicitly tried to protect them from the kind of short-termism that he perceived was the biggest problem with the major labels, and allow them the freedom and space to make music on their own terms. "If we don't respond in some sense to the growth of our bands", he says in the television documentary, "all it means is that we will be a nursery ground for every major label that exists in this country. And it doesn't seem in the long run as though that's a very good idea, because all it means is that you give a band the chance to live out their ideals for a few years, and then they go and join a corporation. It's very debatable whether that's good or bad—we think it's bad."

The faultline was opening up between Richard Scott and his distribution team on the one hand, and Travis, Pete Walmsley and Mayo Thompson in the A&R department. It was still at a low simmering point; Rough Trade's initial critical success had just been translated into commercial success with its first albums. Travis had accumulated plenty of cultural capital, and now he intended to spend it.

Left: Richard Scott, the lynchpin of Rough Trade Distribution. Still taken from *The South Bank Show*, 1979.

Opposite: Mark Stewart, emotionally naked. Photograph by Janette Beckman.

Formed at the beginning of 1978, Bristol's The Pop Group roared out of the traps with the ferocity of a flamethrower. The five-piece were all still in their teens when they cut their first single, "She Is Beyond Good And Evil", for the Radar label shortly after touring with Radar act Pere Ubu in spring 78, which eventually came out in March 1979. Fronted by the possessed vocalist Mark Stewart and the guitar/sax of Gareth Sager, with Bruce Smith (drums), John Waddington (guitar), Simon Underwood (bass, soon replaced by Dan Catsis), and produced by British dub legend Dennis Bovell, their music was simultaneously more fauvist-primitive than previous punk rock, and more sophisticated in its points of departure. The group had immersed themselves in early 70s funk, dub and free jazz, thanks to regular sorties into the clubs in Bristol's predominantly black St Paul's district, but their feral, transgressive sound was the paranoiac hangover following the 'punky reggae party'. *"Capitalism is the most barbaric of all religions"*, Stewart sang on "We Are All Prostitutes", which appeared on a Rough Trade 7" in 1979: The Pop Group attempted to find a sound that would match this 'Western barbarity', looking for inspiration in the return to the primitive in the writings of Arthur 'Primal Scream' Janov, Wilhelm Reich and Antonin Artaud's Theatre of Cruelty; the post-colonial phantoms in the surrealist literature of Michel Leiris and Alfred Jarry, and broken narrative departures of the Beat writers and William S Burroughs. *"We're the new explorers"*, run the lyrics of "Savage Sea" (from *Y*, Radar 1979), *"With the spirit of Dr Livingston/We'll talk to the savage sea/It's the only direction for you and me"*. Their steamy brew of splatter-jazz, the strange dislocated reverb that set Stewart's voice far back in the mix, and the ferocity with which the whole thing was delivered on stage, made visceral the brutal after-effects of imperialist expansion—torture, genocide—that remained always implicit in their propagandist lyrics.

"He was an extreme idealist", says Vivien Goldman, who went out with Stewart for a time. "He really believed in all that stuff. That was a group with a load of talent, where the egos were too big. Mark and Gareth both wanted to be the lion of the pack, the alpha male, and in the end this band wasn't big enough for the both of them.

"The whole thing about The Pop Group was getting naked. The idea was to be completely naked, emotionally, and the boldness of allowing yourself to be so vulnerable, stressing your vulnerability and your inner turmoil. Wearing as unconventional clothing as you possibly could. I got a lot of gear from the Morris Angel [theatrical] costumier on Shaftesbury Avenue: Bruce had a big stovepipe hat... it was very theatrical, very emotional, sometimes to the point of hysteria. Once we had to peel Mark out, he was gibbering, hiding under the sink in the kitchen, screaming. He would spraypaint things on the wall, angry graffiti... there was always a lot of drama and passion and fire and rage. It was all very extreme and intense."

```
WE ARE ALL PROSTITUTES

EVERYONE HAS THEIR PRICE
AND YOU TOO WILL LEARN
    TO LIVE THE LIE
AGGRESSION
COMPETITION
AMBITION        CONSUMER FASCISM

CAPITALISM IS THE MOST BARBARIC OF ALL RELIGIONS

DEPARTMENT STORES ARE OUR NEW CATHEDRALS
OUR CARS ARE MARTYRS TO THE CAUSE

WE ARE ALL PROSTITUTES
OUR CHILDREN SHALL RISE UP AGAINST US
BECAUSE WE ARE THE ONES TO BLAME
    WE ARE THE ONES THEY'LL BLAME
THEY WILL GIVE US A NEW NAME
WE SHALL BE

HYPOCRITES      HYPOCRITES      HYPOCRITES

at this moment despair ends and tactics begin.
```

<u>Opposite:</u> The Pop Group (left to right):
Gareth Sager, Mark Stewart, Dan Catsis.
Photograph by Janette Beckman.

<u>Clockwise (from top left):</u> "Where There's A
Will" split 7" with The Slits; *For How Much
Longer Do We Tolerate Mass Murder?*; The Pop
Group's "We Are All Prostitutes" 7".

Perhaps inevitably, The Pop Group burnt out quickly: by early 1981 they had been extinguished, but their short life added an important new dimension to the already broad church of Rough Trade music policy. Goldman recalls being "dragged off" with the group to the North Sea Jazz Festival in The Netherlands, where they met trumpeter Don Cherry, a long time associate of saxophonist Ornette Coleman. It was the jazz connection that marked The Pop Group out from their contemporaries, and they talked confidently about these influences in their interviews of the period. "Don't Call Me Pain" uses a spiky funk drum riff that could have been sampled from Miles Davis's 1972 *On The Corner*. "Savage Sea" added an amateur violin part that brought to mind Ornette Coleman's occasional ventures onto this unfamiliar instrument in an attempt to free his mind from the instrument that he had trained on.

In fact, Coleman's notion of 'harmolodics' was not unlike The Pop Group's methodology. Harmolodics, which has never had a single convincing definition but has been endlessly debated since its coinage in the mid-70s, is fundamentally a highly intuitive system of playing, with much wider limits—not fixed melodies or keys, but multiple tonal centres and tempo changes; what the player interprets as the overall harmonic structure of a song. Ideas develop out of individual/collective ways of hearing and interpreting each note or phrase. It has been called looking at a musical unit three-dimensionally. Beyond the strictly musical, though, harmolodics is a utopian system whose qualities can be applied to the social and political dimension as a model of communality: everybody plays individually and the whole finds its equilibrium between individual and collective playing. Like a vision of collectivity, the hierarchy of 'lead' and 'backing' instruments is broken down; no one has the lead at any time but anyone is free to take it at any time; music making becomes an endless succession of conversations, revised statements and arguments.

Such musical values would have appealed to the staff of Rough Trade, and in 1980 the label released *Are You Glad To Be In America?* by guitarist James 'Blood' Ulmer. Ulmer was a member of Prime Time, the electric jazz group set up by Ornette Coleman in 1975, following his visit to Morocco in 1973 to study the polyrhythmic drumming of the Master Musicians of Joujouka. *Are You Glad*'s sextet features David Murray, Oliver Lake and Olu Dara, and includes Ulmer's best known track, "Jazz Is The Teacher ... Funk Is The Preacher", a title that speaks for itself. Ulmer was at home in the American post-punk universe of his New York hometown: he claimed his favourite rock outfits at the time were The Contortions, Richard Hell's Voidoids, and The Feelies (another Rough Trade group), and his addition to the label further added to Rough Trade's eclectic cachet.

Harmolodic guitarist James 'Blood' Ulmer's 1980 LP *Are You Glad To Be In America?*

Messing with your head: Scritti Politti on stage, 1979 (clockwise from above): Tom Morley, Niall Jinks, Matthew Kay, Green Gartside. Photographs courtesy of Tom Morley.

Scritti Politti were the quintessential Rough Trade group. Valuing inspired amateurism and spontaneous composition over musicianship and technical accomplishment, their songs enacted a process of constant scepticism, a contrarian questioning of the consensus, including an interrogation of the conditions and assumptions that went into making music itself. Green Gartside (born Paul Julian Strohmeyer in Cardiff) formed the group with his art student friends Niall Jinks, Tom Morley and Matthew Kay in 1977, while they were still attending Leeds University. By 1978 they were living in squats in the Camden Town area of north London, surrounded by an anarchistic 'politburo' of musicians, writers, journalists and activists, all of whom were allowed input into the group, whose name was a tribute to the 'political writings' of Italian Marxist Antonio Gramsci. Their first single, "Skank Bloc Bologna", issued on their own St Pancras Records, finds Gartside's guitar constantly changing direction, ploughing forward and reeling back, jumping from 4/4 beat to reggae skank, as his lyrics obliquely contrast a mundane shopping trip in London with the post-revolutionary dreams of Italian Communist collectives in Bologna. Political pop marching to the shambling drums of a "Doubt Beat" (a track from their first Rough Trade EP, *4 A Sides*). "28/8/78" used a tape of a BBC news report of riot that had happened at the Notting Hill Carnival on the day of recording.

Scritti Politti followed the example of DIY group The Desperate Bicycles (see page 23), by printing an itemised breakdown of costs on the sleeves of all their singles, bringing a transparency to the process of self-releasing music. However, they were not unashamed apologists for DIY methods. "Messthetics", one of four tracks on their 1979 *Peel Session* EP, was a typically double edged, unstable song, partly a post-punk manifesto, equally a critique of the unfocused messages being sent out via DIY culture. But the music was still

Above left: Scritti Politti as Marxist collective, 1979. Photograph courtesy of Tom Morley.

From top to bottom and left to right: A strange trajectory took them from the lo-fi visionaries of the 4 *A Sides* EP towards the deconstructionist pop of "The 'Sweetest Girl'" and *Songs To Remember*.

couched in a form that paid no heed to the conventional verse-chorus structures of pop, granting the group permission to use a palette of chord colours that seemed to exist somewhere in between the standard chromatic range. "Hegemony", from the same EP, has Gartside wrestling with the stranglehold of language and its abuses by controlling powers—a conundrum that increasingly obsessed him, to the point where he wrote a song entitled "Jacques Derrida" in 1982 as a homage to the French god of the deconstructionist movement. The self-reflexive, self-questioning restlessness of Scritti Politti in this early phase epitomised Geoff Travis's interest in capturing a group's incubation stage. In 1979 he claimed to be more interested in artistic expression in the evolving stage before self-awareness as an artist set in; before musicians were surrounded by marketing strategies, image refiners, media representation, etc. "After that, as far as I can see, the way they're set up, they're treated as artists—separate from society. And when they do that, they start to find themselves in a very unreal world. And what we want to try is to put our ideas into practice in real society."[3]

But with the growth of Rough Trade in the early 80s, the strategy changed. Gartside, always a nervous performer, spent most of 1980 recuperating at his parents' home in Wales, after becoming ill while on tour with Gang Of Four. During that sabbatical he listened to wall-to-wall soul and reggae records and developed a love of black music which he became determined to explore in a sleeker, more 'professional' version of Scritti Politti—in which there was eventually no place for Jinks and Morley. "The 'Sweetest Girl'" (featuring Robert Wyatt on keyboards)

and "Asylums In Jerusalem" took them close to the national Top 40—they almost made *Top Of The Pops* with the latter, but it peaked at number 43. But the album *Songs To Remember*, 1982, made the top of the independent chart, and number 12 nationally.

Rough Trade facilitated and funded this change of direction, but the singles prefacing *Songs To Remember* consumed a large chunk of the company's budget, and Travis was disappointed at what he saw as the distribution's failure to make them hits (this was one of the crucial factors in the bad relations between Travis and Richard Scott). For the company at large, there were high hopes riding on Scritti's success, but it didn't happen— Gartside's increasingly opaque linguistic knot gardens proving too rugged for frequent playlist rotation on Radio 1.

Ironically, Scritti's departure in 1984 for Virgin Records—which had seemed so unlikely in 1979— was precipitated by Rough Trade. Producer David Gamson had been an engineer in a small New York studio that specialised in recording sound effects. In his spare time he had made a "terrible cover" of The Archies' bubblegum hit "Sugar Sugar", which ended up on a Rough Trade single, and he was introduced as Gartside's label-mate during a trip to Blenheim Crescent in London. Together with Fred Maher of Material, Gamson and Gartside formed the core of the studio-bound, funked-up Scritti Politti that had international hits with the meta-pop singles "Wood Beez", "Absolute" and "The Word 'Girl'" in 1984—85.

Scritti Politti's rigorous fragmentation of certainties

3. Geoff Travis interviewed on *The South Bank Show*, Thames Television, 1979.

crystallised a moment in Rough Trade's evolution, and their radicalism has become more apparent in hindsight (in 2005, Gartside re-signed to Travis's new Rough Trade imprint and issued all the original tracks on the *Early* compilation). Among the hundreds of DIY groups of the period, their music occupies a unique place. As Jon Savage put it: "Despite the apparent liberation of their rhetoric, many of these groups painted themselves into a corner: there were so many things you could not be—sexist, racist, entryist, Rockist—that the negatives overpowered any potential *jouissance*. Apart from brief bursts of Scritti Politti, the music was no fun at all."[4]

4. Savage, Jon, *England's Dreaming: Sex Pistols And Punk Rock*, London: Faber and Faber, 1991.

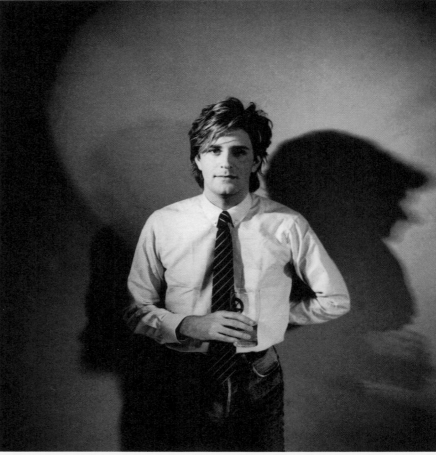

David Gamson's "Sugar Sugar" 7" (bottom left) drew the producer to the attention of an ambitious Green (top). But his new commercial direction was already underway on the "Faithless" single (bottom right). Photograph by Peter Anderson.

Photo: Michael Hohmann

ROUGH TRADE DISTRIBUTION CATALOGUE
137 BLENHEIM CRESCENT LONDON W.11. U.K.

Previous page: Cover of distribution
catalogue from 1979.

Above: A sample of the inner pages gives
a sense of the breadth of material and
activities undertaken by Rough Trade
in its early years.

1980–82
CREDIT
IN
THE
STRAIGHT
WORLD

"I got some credit in the straight world
 I lost a leg, I lost an eye
 Go for credit in the real world
 You won't die"
— Young Marble Giants, "Credit In The Straight World"

Rough Trade's culture of collectivist meetings at Blenheim Crescent quickly earned them the stereotype of a 'loony leftie' label, munching on brown rice as they discussed which international oppressed workers' groups should receive a charitable donation from the company profits. While many of the stories were undoubtedly exaggerated and apocryphal, there were certainly cases where Rough Trade's culture of political correctness had a direct influence on its products—in the mid-80s, for instance, Rough Trade Distribution refused to handle *Two Nuns And A Pack Mule* by Steve Albini's group Rapeman because of objections to the name by various female members of staff.

With Rough Trade's roster swelling at the beginning of the 1980s, not every artist was happy with the house rules. One such artist was Mark E Smith of The Fall, the Mancunian heavyweights and favourites of Radio 1's John Peel show, who were signed to Rough Trade in mid-1980. "They'd go, 'Er, the tea boy doesn't like the fact that you've slagged off Wah! Heat on this number'", Smith recalled in 1992. "The girl who cooks the fucking rice in the canteen doesn't like the fact that you've used the word 'slags'. They had a whole meeting over the fact that we mentioned guns in one song. Y'know ... 'it is not the policy of Rough Trade to be supporting fuckin'...' And I'd go, 'What the fuck has it got to do with you? Just fuckin' sell the fuckin' record you fuckin' hippy.'" [5]

Previous page: Mark E Smith of The Fall. Photograph by Janette Beckman.

Above: Young Marble Giants' *Colossal Youth*.

5. Cavanagh, David "The Fall" in Volume, #4, September 1992.

The Fall

'TOTALE'S TURNS'
('It's Now or Never')

IN: Doncaster!
Bradford! 79 Oct - Feb 80
Preston!
Prestwich!

The Fall's Rough Trade debut: the lavishly
packaged live album *Totale's Turns (It's
Now Or Never)*.

Clockwise (from top left): Fall releases
"Totally Wired"; "How I Wrote Elastic
Man"/"City Hobgoblins"; *Grotesque (After
The Gramme)*; Mark E Smith in contemplation.
Photograph by Peter Anderson.

"I don't think Mark E Smith liked the idea that anybody could have anything to say about anything he did", says Geoff Travis, "And I think on the one hand, that's fair enough, and then on the other hand it's really good for him to be challenged as well. So, you know, I think people have the right to say what they want to say, but they can be wrong."

Travis had first encountered The Fall as record producer with Mayo Thompson, when they jointly produced "Fiery Jack", which came out in January 1980 on Miles Copeland's Step Forward label. Formed in the environs of Prestwich, Manchester, The Fall already had their LP *Dragnet* behind them, which had won them fans via its curious, sinister blend of dirty realist observation and Northern Gothic surrealism rooted in the decayed Victoriana of their city at the dawn of the Thatcher era. Copeland had been managing them but his attentions were increasingly occupied by his other groups, Squeeze and The Police, who were just moving into a new gear with their sights on mainstream success. The Fall were in a different category, and after some persuasion by Travis, accepted—for now—that Rough Trade's world was more suited to the requirements of The Fall. With his sights now trained on Manchester, where Tony Wilson's Factory Records stable was hitting its stride with landmark records by Joy Division and A Certain Ratio, Travis also signed up The Blue Orchids, who shared common roots with The Fall, featuring two of the group's founder members, guitarist/vocalist Martin Bramah and keyboardist Una Baines.

The Blue Orchids' "The Flood" 7" and *Agents Of Change* EP.

Totale's Turns (It's Now Or Never) was the first fruit of The Fall's Rough Trade contract, in May 1980: a live and lo-fi mini-album recorded in various small clubs in the north-east of England ("Doncaster! Bradford! Preston! Prestwich!", announced the sleeve's felt-tip scrawl). The Fall's star was still rising thanks to the influence of perennial fan John Peel, and the record reached the number one spot in the independent chart. But the honeymoon would not last. Despite several of The Fall's most celebrated albums— *Slates, Grotesque (After The Gramme)*, both 1981, and *Perverted By Language*, 1984—being issued on Rough Trade and produced by Travis and Thompson, it was a rocky marriage. Rough Trade's communitarian liberalism was at odds with the uncompromising Smith. In a 1980 radio interview he described himself as "pretty fascist" in his expectations of group members, going on to say that he refused to run The Fall as a democracy because that resulted only in "a mediocre average".[6]

6. Smith interviewed on *Dave Fanning* radio show, RTE (Ireland), 18 October 1980. Quoted in Ford, Simon, *Hip Priest: The Story Of Mark E Smith And The Fall*, London: Quartet 2003.

It was only a matter of time before these distinct outlooks would founder on irretrievable differences.

"You have to run a benign dictatorship", says Travis, "same as a group. You have to be able to include everybody, and you have to be rational. But at the end of the day, somebody's got to take responsibility.... It was common sense: I mean, you don't have to be a genius to realise *Spiral Scratch* is great—everybody liked it. It was a time of debate and talking, and I think that's good."

The Fall already had established a reputation and following by the time they signed with Rough Trade. The same was true of Pere Ubu, the 'avant garage' group from Cleveland, Ohio, led by David Thomas that formed out of the ashes of proto-punk outfit Rocket From The Tombs in 1975. The connection came through Mayo Thompson, who was temporarily playing guitar with the group, and in 1980 and 81 Rough Trade put out two new Ubu records, *The Art Of Walking* and the live *390 Degrees Of Simulated Stereo*, and reissued their 1978 debut *The Modern Dance*. David Thomas also initiated what would become a string of extra-Ubu projects on Rough Trade in 1981, with his Pedestrians LP *The Sound Of The Sand*.

This was a new situation for the label, requiring an increased focus on promotion. Prior to 1981, Rough Trade's liaisons with the press had been tentative, to say the least. Rather than sending out free review copies to journalists, recalls Travis, "we used to think, 'why can't they just come and buy the records?' And quite often they did. We liked that thing that Stiff Records did: making major label A&Rs from EMI pay to get into their gigs. Lots of good ideas like that. They should pay twice really, double the amount the audience does."

Several newcomers helped boost the Rough Trade promotional department. Scott Piering, originally from San Francisco and previously the PR for Island in the USA, proved to be a crucial member of the Rough Trade team. When he arrived at Rough Trade in 1981, he managed the information flow out of the company HQ, acting as a radio plugger and producing mail-out sheets and small booklets with information on all the new releases from the independent sector. These, in time, grew into a more formal publication, first entitled *Masterbag*, then *The Catalogue*, which was edited by Richard Boon (onetime Buzzcocks manager) and former *Smash Hits* journalist Simon Cranna. Claude Bessy was another of Rough Trade's spokespeople. A Frenchman by birth but a long-term resident of Los Angeles, Bessy was a journalist (using the *nom de plume* Kickboy Face) who had co-founded *Slash* magazine in LA in 1977. When Ronald Reagan was elected president in 1980, he bailed out and wound up in the UK, one of the many kicking ideas around the Rough Trade meeting table and turning his iconoclastic prose into press bulletins.

The Raincoats manager Shirley O'Loughlin was also involved in PR: "Scott Piering came to work with us in the same room and he started dealing with the promotion. Every Wednesday, if we had new records out, I'd go down to all the music papers with copies for reviews and drop off at John Peel on the way down. If you had a really good record, it would be so exciting to take it in.

Opposite: Pere Ubu's David Thomas shipped his group across the water from Cleveland, Ohio. Rough Trade issued *The Art Of Walking* and *390 Degrees Of Simulated Stereo*, plus a string of Thomas's solo work including *The Sound Of The Sand*, with The Pedestrians. Photograph by Peter Anderson.

390 DEGREES
OF
SIMULATED STEREO.

Pere Ubu
In
Cleveland,
London,
& Brussels.

UBU LIVE:
Volume One.

I'd go in there and say, 'Who's doing the singles this week?' and I'd just give the singles to whoever it was, Chris Bohn or Paul Morley or whoever. It's only later we thought, 'Perhaps that wasn't such a good idea, to give that person that record...' We didn't know anything at that point, and then got a bit smarter. Certainly when Scott came in, he had ideas about things like that."

In the first couple of years of the new decade, as well as new groups like The Television Personalities, This Heat and Cardiff trio Young Marble Giants, the 'Blenheim Crescent effect' kicked in, as groups began to intermingle and collaborate. Mayo Thompson's Red Crayola was reconstituted, with a line-up that featured The Raincoats' Gina Birch on bass, Essential Logic's Lora Logic on sax, Allen Ravenstine from Pere Ubu on keyboards, and The Swell Maps' Epic Soundtracks on guitar. *Kangaroo?*, released in 1981, renewed Thompson's acquaintance with Art & Language on a series of songs, such as "Portrait Of VI Lenin In The Style Of Jackson Pollock, Parts I & II" and "The Mistakes Of Trotsky", that were intended as fantasy pop-songs-that-might-have-been in the Soviet Union. Mischievous lyrics were enhanced by intentionally shambolic playing and off-pitch vocals—many of the songs sounded like a rehearsal or a hastily convened rally. But Thompson's laconic presence ensured that an air of mockery prevailed through the whole proceedings, and that this was not simply a gritted-teeth, earnest political protest. For Thompson, this freedom with the notion of the 'political' in pop was a liberation compared with his experiences in the USA. "There's something that's referred to in my country as 'left culture': if you get tarred with that brush, it's hard to get that stuff off. In Britain in the 70s, it was part of the terrain of contradiction, as we say. And therefore because it was part of the fabric of social life—because [the UK] is a highly politicised country—it could be part of the referential apparatus you could deploy, when you were trying to get this stuff in play. Whereas in the States that gets partitioned off as a certain kind of music. In America we have a conflict of ideas, like 'winning space', but there's not really any arguments over there, because there's not really a coherent cultural background against which to argue. But in Britain I enjoyed it, because there's this social seamlessness, you could see how things are connected up."

Below: Young Marble Giants' *Testcard* EP; Red Crayola with Art & Language's *Kangaroo?*.

Opposite: Zounds' "Demystification" 7".

The Rough Trade umbrella had given shelter to a variety of artists that were trading in politicised music, most notably distributing the north London anarchist outfit Crass, whose sprawling collective gave rise to a group called Zounds, who released their one and only album with Rough Trade in 1981. Throbbing Gristle's Industrial Records, also handled by Rough Trade, spewed out a harsh and uncompromising electronic sound that implicitly stabbed at systems of political and social control; like The Pop Group, TG communicated an awareness of Western civilisation's barbarity, adding a dalliance with neo-fascist imagery.

But a political pop of a very different stripe was served up by the label's greatest and most surprising find during this period. Since tumbling out of a window at a party in 1973, drummer and vocalist Robert Wyatt had been lying low for much of the remaining decade. A founding member of Soft Machine in 1966, Wyatt had been at the epicentre of London's psychedelic revolution, as Soft Machine toured with the first visit of the Jimi Hendrix Experience, held a regular slot at Central London's UFO Club alongside Pink Floyd during 1967, and were regularly championed by John Peel on his flowery *Perfumed Garden* radio show. Wyatt's nasal falsetto was one of the distinctive elements of Soft Machine, counterpointing the group's muggy fusion of electric jazz and ornamented experimental rock with lyrics that occasionally veered into comical self-referentiality. In the early 70s, though, Wyatt was deliberately edged out of the group, as keyboardist Mike Ratledge wanted to take the band in a more abstract fusion direction, ejecting the songs and the whimsical humour. Wyatt's next group, Matching Mole, included wry references to Maoism and the Communist International on their second album, *The Little Red Record*, 1972. The accident the following year left him in a wheelchair and after his hit version of The

Monkees' "I'm A Believer" and the album *Rock Bottom* in 1974, for Virgin Records, plus a few guest appearances with Brian Eno, his own music making dried up, and he and his wife, artist Alfreda Benge, moved into a flat in Twickenham, on the outskirts of London, thanks to the generosity of their friend, the actress Julie Christie.

In 1980, when Brian Eno was about to depart for a trip to Africa, he asked his friend, Vivien Goldman, to "look out for" Wyatt while he was away. Since he lived so far outside Central London, Goldman asked Geoff Travis for a lift in his car, which aroused Travis's A&R instincts. "Geoff had this thing in mind", says Goldman, "that maybe he could encourage Robert to record again, because it had been a very long dry spell. And of course it was another terrific marriage, because they shared political viewpoints.... We all became really tight, I used to hang out there a lot with Geoff. I seem to remember that at first he was not up for it. He was studio-shy. But I think that finding this situation that was so appropriate made so much sense, it got his juices flowing again and he returned to recording. He felt at ease, it was an appropriate context for him."

Wyatt himself recalls events slightly differently: that Goldman introduced him to Travis at the opening of an exhibition by Eno and Peter Schmidt. "I didn't know what 'indie' was", he says, "I thought it was something to do with Bombay film music, having not read the papers apart from the *Morning Star* for the last five years." As it turned out, Wyatt had become an ardent socialist, and had kept his ears wrapped around a huge range of music, from free jazz and bebop to disco, soul music, and Chilean folk songs. Rough Trade eased him out of his existing contract with Virgin, with the one proviso that he could not immediately make a new album-length work. Instead, it was decided that Wyatt would make a series of singles for the label, featuring mostly cover versions. The first of these was "Arauco", by the Chilean activist and songwriter Violetta Parra. Wyatt was particularly interested in the 'mass songs' from Chile, whose democratically elected government had been violently ousted by General Pinochet, with the connivance of the CIA, in 1973. Two further singles were released during 1980, a version of the 1940s barbershop quartet song "Stalin Wasn't Stallin'", a patriotic, rousing chorus from a brief, blissful pre-Cold War era when America and the Soviet Union were united against Nazism. On "At Last I Am Free", he covered the funk number by Chic, turning it into a subdued anthem of self-liberation. These songs — later collected on the LP *Nothing Can Stop Us* — were political tracts with a human dimension, not so much a tirade as melancholic meditations in solitude. "I never associated shouting at people with making the world a better place", agrees Wyatt. "You couldn't not be acutely aware of street politics at the time, and not feel a solidarity in the face of hostility from the state, whether it's miners or Rastas or anybody else. I felt that was very much the dark side of the punk moon, if you like, the whole black experience — which is sort of ignored internationally when punk is discussed. 'Nothing Can Stop Us' was a quote from an American, Ludwell Denny, in 1930. The full quote was, 'We shall not make Britain's mistake. Too wise to try to govern the world, we shall merely own it. Nothing can stop us.'"

Opposite (clockwise from top): Thanks to Rough Trade, the career of former Soft Machine member Robert Wyatt was revived in the late 70s; "At Last I am Free"/ "Strange Fruit"; "Arauco"/"Caimanera". Photograph by Janette Beckman.

Wyatt's quietly revolutionary music reached its high point—musically and critically—with 1982's "Shipbuilding", a song written especially for him by Elvis Costello and Clive Langer. A lugubrious and unsentimental sketch of a downtrodden British port living in perpetual hope of a renewal of its shipyard industry that never quite happens, it caught the mood of the nation under the Conservative government, which sent a task force steaming to the Falklands War and set about dismantling the trade unions. "I got a cassette through the post from one of them", he remembers. "They said they'd done this song they thought might suit my voice more than the groups they were working with at the moment, would I have a go at it? And I thought, blimey, what an honour. Because one of the things I expected was to be hardly allowed in, because of the expected hostility to long haired people of the previous musical generation. I was surprised how friendly and welcoming they were to me, compared with the subsequent generation.

"Anyway, I learnt it. Went to the studio with Costello, and recorded it. He made me do it right. It was one of those oases where I wasn't smoking, so my voice was more on top of it than it might have been." At first the single was intended to come out on a new label venture set up by Costello. "Then I said it wouldn't be fair on Geoff, to put it on Costello's label, because we weren't selling anything, and so using it as a launch for another record label wouldn't be right. Because Geoff didn't do that sort of exclusive contract thing, which he lost out on a lot. He would get people on the road and then they would get snapped up by the big labels and wouldn't reap the reward that he was due—you can be too nice. And I thought it would be dishonourable to put this on another label, so I said to Costello and Langer, 'If we put this out, do you mind if we do it on Rough Trade?'" What with Costello's involvement, and a beautiful understated keyboard arrangement, this should have been a huge commercial success. Unfortunately, as Wyatt remembers, "Everyone got too excited and then made a video that cost more than the records sold. So in fact it's my least successful record."

Wyatt went on to release a further two albums with Rough Trade, and joined in the family activities by guesting on The Raincoats' *Odyshape* album, and on the Scritti Politti single "The 'Sweetest Girl'".

Above (left to right): Robert Wyatt's "Shipbuilding" 7": exquisitely understated political pop; "Trade Union" was the product of a collaboration with Bengali group, Disharhi, and called for Bengali workers in England to unite under the trade union banner.

Opposite: Chris & Cosey's first album as a duo, *Heartbeat*.

Another act whose career was resurrected with Rough Trade's help was Chris & Cosey. Chris Carter and Cosey Fanny Tutti were founding members of the influential Throbbing Gristle with Genesis P-Orridge and Peter 'Sleazy' Christopherson. Their label, Industrial Records, had been one of the key clients of Rough Trade distribution since mid-1977, but when TG split in 1981, Chris & Cosey, who had become a couple, formed a splinter group and began making their own electronic music almost immediately. "Industrial was basically the four of us, a few unpaid dogsbodies and a couple of lowly paid office/mail order workers", recalls Cosey. "Industrial was in no way a collective—democratic maybe, as long as everyone working there agreed with us." "Once we made it known we were going to carry on as Chris & Cosey we were getting offers from all over the place", adds Carter. "But Rough Trade was the obvious choice. They weren't offering us an advance, and the deal was done on a handshake, but we knew and trusted them implicitly. Our time with them was very productive, in terms of releases and performances, and although we had the odd minor disagreement, they were very supportive and it was great to be a part of it."

Heartbeat, their first duo album, came out in 1981. It sounds like a group still finding its feet, but 1982's *Trance* is far more assured. "It was a pleasure to make, and seemed to flow almost effortlessly", says Cosey. "I can remember our son Nick was only about six weeks old, just out of shot when we took the photo for the cover at Highgate Cemetery. So the album has good feelings associated with it other than the music. "October (Love Song)", 1984, is very special because it's about our beginning and was recorded as if it were a song for the two of us. Kitsch, but genuine sentiment, and a different direction for us again. I guess these two are both about beginnings, really."

Chris & Cosey's proto-Techno releases ensured a healthy strand of electronic music stayed on the Rough Trade roster during the early 80s. The end came, though, in 1985, when the label gave a lukewarm response to the tapes for what became their *Techno Primitiv* LP. "It went down a storm live", recalls Carter. "But on our return we had a message saying they weren't happy with the final mixes. This was the first time anything like this had happened between us. We spent a week tweaking the tracks and sent them a remastered album. They just didn't seem to push it as much as

Chris & Cosey October (love song)

Chris & Cosey found a home for their
electronic experimentation at Rough Trade
after the break-up of Throbbing Gristle.
Clockwise (from top left): *Songs Of Love
And Lust*; "October (Love Song)" 12";
Techno Primitiv; *Trance*.

Songs Of Love And Lust, which had done really well. We knew it was a good album but they just seemed to sit on it." C&C followed up an offer from Play It Again Sam, but the arrangement seemed mutually satisfying, and there's no lingering bad blood: "Being with Rough Trade offered us a lot of opportunities and allowed us the freedom to record and release almost whatever we wanted—we definitely wouldn't be where we are now without them", states Carter.

Chris & Cosey's experience with a flagging promotional department highlights a growing problem for the company in the early 80s: sheer volume of workload was putting resources and manpower under intense pressure—and this applied not only to Rough Trade, but to the wider independent music industry. In 1982, one of the largest indie distributors, Pinnacle, went into receivership, leaving scores of small labels with their stock impounded in the warehouse. Some of these companies, sent into freefall, fetched up in Rough Trade's distribution arms. Although Pinnacle was refloated after three months, it was a salutary lesson that the growing independent sector depended upon a pretty fragile cashflow economy. In part swelled by the fallout from the Pinnacle debacle, Rough Trade Distribution's turnover began to overheat during 1982, far outstripping that of Rough Trade Records. The requirements of the two parts of the company were rapidly diverging and becoming increasingly distinct. Richard Scott's distribution team had found that one way of decreasing the workload was to foster connections with a regional network of smaller local distributors (which were often local equivalents of Rough Trade, based in a record shop). They could send a large batch delivery to this regional node, which would then distribute stock to the shops within its own catchment area. In 1982, this network was formalised as the Cartel, an organisation which transformed and empowered the spread and availability of independent releases in the UK throughout the 1980s. Rough Trade effectively became a central warehouse servicing six outlying branches: Fast Forward in Edinburgh, Revolver in Bristol, Red Rhino (two branches, in York and Leamington Spa), Backs in Norwich, and Probe in Liverpool.

As soon as the Cartel was initiated, though, serious problems set in. Scott and Travis found themselves on different planets in terms of their day-to-day job descriptions and cashflow requirements, and relations between them quickly turned sour. Rough Trade's non-hierarchical, non-management style, which had made its birth years such a hippyish idyll, were utterly inadequate for the massive surge in productivity the Cartel demanded, which was, as Scott Piering once put it, "too much money for a bunch of amateurs to handle".[7] The accounting and credit control system was rudimentary at best, and the division of funds between label and distribution was a financial blur. In desperation, Scott appointed a new company administrator, Richard Powell, a 30 year old who came from a background in a chain of DIY superstores. Powell immediately embarked on a wholesale restructuring of Rough Trade, effectively forcing it to grow up fast in order to avoid disaster. Powell converted Rough Trade into a trust, which meant that Travis lost his outright ownership of the company and, as head of A&R, became answerable to an altered power structure in a way that had never been part of the company's original ethos.

7. Cavanagh, David, *The Creation Records Story*.

Top: Cartoon flyer features artwork by
Savage Pencil. Image courtesy of Rough
Trade shop.

Bottom (from left): Rough Trade shop staff
members Pete Donne, Nigel House and Jude
Crighton, shortly before they bought it
out in 1982; the shop as it is today in
Talbot Road. Photograph courtesy of Rough
Trade shop.

Above left: Signs of lean times ahead on this note pinned to the shop door, late 1982. Photograph courtesy of Rough Trade shop.

Above right: Rough Trade's great white hope: Aztec Camera's Roddy Frame. Photograph by Peter Anderson.

The most immediate effect this had upon Geoff Travis was to focus his efforts on searching for an act that would make a viable bid on the national charts, to avoid the possible outcome that Rough Trade Records would become a tiny boutique specialist label, just a kooky footnote to the company's great leap forward towards a monopolised distribution. The Fall, who enjoyed Rough Trade's best critical success, were becoming too truculent with Travis personally, and refused to play the kind of compromising games that would take them to that level. So Travis looked to his old friends Scritti Politti and a new signing, the jangly Scottish guitar group Aztec Camera, who had come to the label via Glasgow's Postcard. Scritti's Green had cast off most of his original group and was in the process of reinventing himself, after a nervous breakdown, as a postmodern white soul artist with a helium voicebox on singles like "The 'Sweetest Girl'" and "Faithless". They were getting something right: the single "Asylums In Jerusalem" narrowly missed getting on *Top Of The Pops* in 1982. Aztec Camera's leader, a James Dean-quiffed singer named Roddy Frame, had written the infectious song "Oblivious", which was Travis's great white hope as 1982 gave way to 1983. But at the end of such a turbulent year, he had no idea that his salvation was close at hand. In December 1982, in a tiny, cheap Manchester studio called Drone, a quartet of young men cut a demo of a song called "Hand In Glove". That song, which would find its way into Travis's hands within a couple of months, was credited to two songwriters, one named Morrissey, the other named Marr.

On 4 April 1978, Patti Smith
appeared live on the BBC's *The Old
Grey Whistle Test* in what remains
one of the show's most searing
performances, fading out over the
credits with Smith doubled on
the studio floor, kissing the sky
with her electric guitar during
the extended improvised coda to
"Gloria". Ana da Silva and Gina
Birch were astonished by Smith's
performances, and her live shows
in London at the same time. She was
a punk rocker, but not as the UK
knew it. She sang in dream images
and rhapsodic soliloquies; her idols
were visionary poets such as
William Blake, Jack Kerouac, Allen
Ginsberg and personal friend William
S Burroughs, looking beyond the
surface of everyday life to the
hidden realities and forces that
lay behind, with a romantic streak
and a wistful, forceful, no-bullshit
delivery. Although her group was

made up of skilled musicians,
Smith herself was unashamedly an
instrumental amateur, often holding
a Fender Telecaster all the way
through songs without striking a
note, or occasionally blasting chunks
of freeform skronk on her clarinet.

It's easy to see why Smith might
have been a powerful influence
on a younger generation of female
musicians. Here was a woman, leading
a powerful rock group, who was in
a parallel universe to the kind of
schlock peddled by disco divas or
hit-factory no-brainers. In fact,
a glance at the top 40 lists for the
mid-1970s shows a marked absence
of female solo artists, and no all-
female groups at all. Aside from
rockers Suzi Quatro and Joan Jett,
soul/disco singers such as Aretha
Franklin, Diana Ross and Donna
Summer, and folkies like Joan Baez,
Carole King and Joni Mitchell, you

Every wardrobe should have one: A gallery of Raincoats records (clockwise from top left): *Moving* (front & back), *Fairytale In The Supermarket* EP, *Odyshape*, *The Raincoats*.

EMPIRE STATE BUILDING
NEW YORK CITY

This giant shaft of masonry and steel piercing the sky over New York can be seen fifty miles away on a clear day. In the evening, huge searchlights flash their lights from the towering observation roof of the building. The height of the Empire State Building is an overwhelming 1472 ft. to the tip of the TV tower.

Hi!

Even monsters are gigantic here. Wow!

This is weird and special. New York new york — high and low, grey and yellow, hot and humid. Just had a west india meal. Well, high there! we've been up and down and round and round, and things are really spinning. Some really nice people & places, and some horrors. But generally having lots of fun.

It gets better all the time, but I'm looking forward to getting home too, as always. We're keeping funny hours — going to bed in the morning and getting up in the evening ready to hit the town again!

This is Vicky's bit.

See ya all back in Blighty.

30908-C

post card

Steve, Judy and Pete
Rough Trade
202 Kensington Park Rd
London W-11
England

The warmth of the florida sunshine and the touch of a chocolate from the land of gods chosen — with a postcard ending

a commercial form

This is Ana Poo.

THIS CARD IS SENT COURTESY OF ANA GINA INGRID SIMON + VICKY TO ALL OF YOU OUT THERE

(SILDERNESS, JUST EXTEND OUR HANDS OF FRIENDSHIP ACROSS THE WATER. LORD NEED A FRIEND AND LIKE TO FEEL A HAND REACHING OUT TO THEM FROM...

Postcard from New York sent by The Raincoats to the staff at Rough Trade shop, 1980.

had to look to the pop and easy listening end of the market to find women in lead roles, offering unchallenging views of romance through songs usually written by male hit factory squads. In the musical underground, The Slits (formerly The Castrators), formed in 1976, were almost the only exclusively girl group; others, including X-Ray Spex, Penetration and The Rezillos featured a mix of female and male personnel.

Ana da Silva and Gina Birch started The Raincoats in 1977, while studying at Hornsey College of Art in North London. They aired their primitive songs, written on guitar and bass, at a handful of student gigs, but quickly ran through a succession of male drummers and guitarists (including The Barracudas' Nick Turner, The 101ers' Richard Dudanski, and future filmmaker Patrick Keiller).

By late 1978, The Raincoats had found two women to fill the vacancies: Vicky Aspinall, a classically trained violinist, and Palmolive

(a.k.a. Paloma Romera), an energetic drummer who had just left The Slits. By this time, da Silva was working at the Rough Trade shop, and The Raincoats made their first recording in extra studio time left over after Stiff Little Fingers had completed their *Inflammable Material* LP. In the way they wrote, recorded and performed, The Raincoats were a model of collective activity in a similar way to Rough Trade itself. Da Silva or Birch might create the seed of a song idea, but then it was brought to the group. Da Silva recalls: "We'd just have an idea and try it, never be afraid of just trying something that was maybe unacceptable. Everybody would put their parts on and then we would collectively work on it and get to a certain point. It never seemed final. If one of us hadn't been there, the song would have been totally different." Raincoats songs sound slightly unfinished: semi-carved blocks that still have the potential to be finished off in a number of different possible outcomes. Played with an infectious good humour, they nevertheless

<u>Above:</u> At home with Kleenex. Photograph courtesy of Klaudia Schifferle.

<u>Middle and right:</u> Kleenex's later incarnation, Liliput. Photographs courtesy of Klaudia Schifferle.

Delta 5 and their single "Anticipation".

tackle themes common to many post-punk groups: emotional alienation; the disparity between expectations, market-force aspirations, and the reality of daily experience; the inadequacy of language to express emotion, and the struggle against political and gender disempowerment. The shared process of composition threw up quirky, eccentric structures, melodies and, especially, rhythmic patterns. After Palmolive departed in 1980, they could never comfortably re-fill the drum stool, going through about 20 replacements, including Charles Hayward of This Heat, Robert Wyatt, and Tom Morley of Scritti Politti. "If we finished singing on the first beat of the bar, then why bother having a bar of four beats?", explains da Silva of their construction method. "It's hard when a new drummer joins, and they have to learn '1-2-3', or '1-2-3-4-5', but certain people coped very well." The songs on their landmark album, 1980's *Odyshape*, were worked out without a drummer in Gina Birch's flat, "that's why it sounds a little bit more organic and less like a band", as da Silva explains.

The Raincoats fell apart after 1984's *Moving*, exhausted by spending too much time together touring, and

pulling in too many different musical directions. Birch and da Silva reformed the group after Nirvana's Kurt Cobain made a pilgrimage to the Rough Trade shop in the early 90s and wrote glowing sleevenotes to a reissue of their debut LP. The way the group broke down accepted structures and found practical, logical solutions with honesty, raw intuition and uncompromising singlemindedness made a deep impression on Cobain and was a beacon for the Riot Grrrl movement, which emerged in parallel with Grunge.

Several other groups partially or solely comprising women signed up with Rough Trade in 1979. Delta 5, from Leeds, built their big-boned sound around the twin basses of Ros Allen and Bethan Peters, achieving a gutsiness approaching that of fellow Leeds artists Gang Of Four. As fervent socialists, Delta 5 joined the front line of the late 1970s Rock Against Racism movement and encountered a good deal of "verbal abuse and skirmishes", according to Allen. "There was a lot of BNP activity in Leeds at the time we lived there and they often tried to disrupt gigs at the F Club, as well as known student pubs. I remember a group of idiots

goose-stepping towards the stage at a Mekons gig. It was very much us and them, but there was always more of us!"

Like The Raincoats, Delta 5 had no illusions about their musical prowess and followed their instincts. "The atmosphere at that time was so encouraging to anyone regardless of gender or musical capabilities to get up on stage and perform, play and create—it seemed very liberating", affirms Allen. "But I do remember feeling at the time that in comparison to some of the bands [on Rough Trade], we were a tad lightweight and poppy."

While she was still at school, teenager Susan Whitby changed her name to Lora Logic and began playing saxophone alongside vocalist Poly Styrene in punk outfit X-Ray Spex. In 1978, she formed her own group, Essential Logic, releasing one album on Virgin before finding a more sympathetic home with Rough Trade in 1979. As well as releasing four singles, the LP *Beat Rhythm News— Whaddle Ya Play?*, and a solo album *Pedigree Charm* in 1980, Logic also joined Mayo Thompson's reformed Red Crayola, recast as a Rough Trade supergroup which also included The Raincoats' Gina Birch.

For its time, Rough Trade Records was unusually welcoming to female musicians and employees. "It was a really brilliant thing working with Geoff, because of the way he kind of embraced and respected women—that's something that I really valued", says Shirley O'Loughlin, The Raincoats' manager. "I found Geoff to be more genuine than anyone else I had previously encountered in the music business", testifies Lora Logic. "That's part of why people like me used to like hanging around there", adds Vivien Goldman. "Geoff's not a sexist guy, and that's rare in the music industry. So he wasn't trying to shag every girl who walked in the door, unlike other head of independent labels. Instead, he created a community."

At the same time, it's easy to overplay the idea that all the female musicians on Rough Trade were aggressively feminist. "I never found Rough Trade to be more sympathetic to female artists than male", says Logic. "I think Geoff signed up music he liked regardless of bodily identification." "They didn't have a preconceived notion of 'we should be a certain way'", confirms Ari Up of The Slits. "That's why women were able to express themselves properly on there. We weren't feminist, that's the problem, that's a big point. Later on, you suddenly had to be political, you had to be Women's Lib, you had to be all these things, uniform dressing, you had to wear certain clothes, look a certain way, sound a certain way, have political issues.... Where did that come from? That has nothing to do with punk in our time. All these women were just being girls expressing themselves. Feminism was 'ism', and 'ism' didn't go well with reggae fans, because it was said, 'we don't deal with 'ism' and 'schism'.'"

Above: The Slits' Ari Up with Viv Albertine and Tessa Pollitt in the group's notorious cover shoot for *Cut*, 1979. Photograph courtesy of Rough Trade shop.

Opposite: Poster advertising a night out with the girls, 1980.

FINAL SOLUTION PRESENT
THE SLITS
THE RAINCOATS
PLUS GUESTS AND SOUND SYSTEM
7·30PM THURS 21st FEB, ELECTRIC BALLROOM,
184 CAMDEN HIGH ST. NW1.
PRICE £2·50

ESSential LoGic

WADDLE YA PLAY?

beat
rhythm
news

essential
logic

<u>Above:</u> Lora Logic (playing sax). Her group Essential Logic's records included "Aerosol Burns" (above left) and *Beat Rhythm News—Whaddle Ya Play?* (left). Photograph by Shirley O'Loughlin.

1983–86
MONEY
CHANGES
EVERYTHING

"I tremble at the power we have, that's how I feel
 about the Smiths. It's there and it's going to happen...
 What we want to achieve CAN be achieved on Rough
 Trade. Obviously we wouldn't say no to Warners,
 but RT can do it too."
— Morrissey[8]

John Martin Maher was 15 when he first met the reclusive Steven Patrick
Morrissey, who was known as the singer and lyricist in a shortlived group
called The Nosebleeds in the Wythenshawe district of Manchester.
The encounter, at a Patti Smith gig in 1979, lasted barely longer than a
handshake, but Morrissey had made enough of an impression for Maher to
seek him out three years later, when, as a guitarist and songwriter, he had
developed grand ambitions to forge a British, post-punk equivalent of the
writing partnership Leiber & Stoller. Like the legend of Jerry Leiber turning
up on Mike Stoller's doorstep with a proposal to work together, Maher beat
a path to Morrissey's house, chaperoned by a mutual friend. The chemistry
was clearly right; Morrissey, who had skirted the fringes of the local punk
scene, tried and failed to become a music journalist and produced two
fanboy pamphlets on his heroes James Dean and The New York Dolls,
dropped his first name almost immediately following that meeting; Maher
became Johnny Marr (avoiding confusion with John Maher, drummer with
local punk heroes The Buzzcocks); and the name The Smiths was selected
by Morrissey not long after.

This took place in the middle of 1982. By the end of that year they had written
a handful of songs and recorded two demo sessions, and had settled
upon their definitive rhythm section, Andy Rourke (bass) and Mike Joyce
(drums). Within three months, The Smiths would have their first record
deal. Within a year and a half, they would achieve a UK Top Ten hit, their
highest chart placing. And within four and a half years they would have
split up, with five albums behind them. Their initial success was down to
Rough Trade's enthusiasm, but by the end of their run they would have
tested the limits of what the company was capable of, transforming it in the
process. Furthermore, it was arguably their commercial success while on
Rough Trade that set the company in motion towards its great cataclysm in
the early 90s, which had a huge knock-on effect on the Cartel, effectively
breaking the backbone of the independent music industry.

8. Morrissey quoted in McCullough,
 Dave, "Dave McCullough Is
 Smitten By The Smiths", *Sounds*,
 4 June 1983.

Previous page: Golden boy, Morrissey tucks
into a packet of crisps. Photograph by
Peter Anderson.

Above: The Smiths. England was theirs,
and it owed them a living, (left to right):
Morrissey, Johnny Marr, Mike Joyce,
Andy Rourke. Photograph by Paul Slattery.

Money Changes Everything

Oscillating wildly: The Smiths on
The Queen Is Dead tour, 1986.

Weekend's "Past Meets Present" 7", featuring Young Marble Giants' Alison Statton.

When Johnny Marr and Andy Rourke pushed open the doors of Rough Trade's Blenheim Crescent offices in April 1983, they were entering a company still coping with change and licking its wounds after the ructions of the previous year. The first big casualty of Richard Powell's recovery programme had happened just before Christmas 1982: the severing of ties with the record shop. The move to Blenheim Crescent had opened up a chasm between those two branches of the company, and Richard Powell's team viewed the shop and the in-house publishing company, Rough Trade Music as loss-makers — wrongly, as it turned out. Three of the shop's core staff, Pete Donne, Jude Crighton and Nigel House, offered to buy out the business and keep it running, and the new separate company was incorporated on 15 December. It continued running at Kensington Park Road until July 1983, when the landlord of the premises forced them out, and they moved the operation to nearby 130 Talbot Road, where the shop has remained ever since.

Geoff Travis was personally coming to terms with no longer owning the company he had started seven years before — in other words, no longer being his own boss. On top of this, his enthusiasm for releasing the music that inspired him had gradually changed into a desire to sell it to a much larger audience. The hits he had bargained on with a series of Scritti Politti singles had not transpired, which had caused bitterness between himself and the man he faced daily across a communal desk, Richard Scott. And it was hits he now wanted. The critical acclaim garnered by singles by the likes of The Go-Betweens, Virgin Prunes, Weekend, TV Personalities, Konk and Aztec Camera had not translated into the kind of sales needed to propel them into the charts or onto radio playlists, but from the label's point of view, the blame always lay with distribution. Scott, meanwhile, found Travis's new desire for chart success to be at odds with what he saw as the culture of the Rough Trade company. "I didn't like hits. I thought Rough Trade should service a different area of the market", he said.[9]

"When our first album went into the charts", says Travis in hindsight, "we were very excited about that. So we were quickly seduced by the idea. I think you want things that you think are great to be heard."

Travis was certainly seduced by The Smiths. On 23 March 1983 he had followed up their invitation to watch their first London gig, at the Rock Garden in Covent Garden. "I see Morrissey on stage as pretty much a revelation at the Rock Garden", recalls Travis. "Because he was fully formed... dancing about, it was great. Then again, I remember some people were going, 'I'm not sure about this lot'. But you have to have that kind of ridiculous belief. If you take a consensus of opinion, you've had it — you end up signing Shed Seven!" When the group's delegation of two visited again, a month later, they were kept waiting to meet an overworked Travis for several hours, after which they buttonholed him in the kitchen and pressed the tape into his hand with an exhortation to treat it as more than just another demo. He lived with the two songs over the weekend, "Hand In Glove" and a live version of "Handsome Devil", and by Monday he was phoning Marr in Manchester and inviting him back to London the next day to witness the two tracks being cut as a single. The whole quartet leapt onto a train on the Tuesday morning, and, with Morrissey meeting Travis for the first time,

9. Cavanagh, David, *The Creation Records Story: My Magpie Eyes Are Hungry For The Prize*, London: Virgin, 2000.

agreed on a trial one-single deal. In fact, the group had already been turned down by several labels including EMI, and had taken a collective decision not to sign to the iconic local label Factory, as they felt that the label's strong visual identity and association with a certain strain of Northern post-punk music would distort the public's reception of their own sound.

"Hand In Glove" never breached the network charts, but it did sell well for the 18 months after its May 1983 release, and at one point the following year, it occupied the number two slot in the independent Top Three between subsequent Smiths singles "What Difference Does It Make?" and "This Charming Man". The track's emotional awkwardness—a veneer of public arrogance faintly masking deep inner turmoil and sexual confusion—sums up many of Morrissey's later lyrical concerns, and its punching beat and acrid harmonica punctuation made it a continual live favourite—usually a set-closer or encore.

Two sessions for BBC Radio 1's David Jensen and John Peel shows in the summer of 1983 substantially boosted The Smiths' fanbase, which in turn gave Travis the confidence to commission further singles and an album. A third Jensen session, in August, sparked a media furore when the song "Reel Around The Fountain" was banned due to the BBC interpreting Morrissey's lyrics—"It's time the tale was told / Of how you took a child and made him old"—as references to paedophilia. The producer of that session, John Porter, had heard the 14 tracks the group had already recorded for their album. These had been made with producer Troy Tate, a former member of The Teardrop Explodes whom Travis had introduced to the group, after Tate had put out a solo single on Rough Trade. But now Porter alerted Travis to what he considered the poor quality of Tate's production, and offered to take on the job himself. Tate's version—available as a rare bootleg—has a roughness that would have placed The Smiths more firmly in the lineage of earlier lo-fi pop, while Porter cleaned up the sound and gave it a sharper edge. Both Travis and Morrissey agreed that Porter's higher definition and multitracked Marr guitars should become the signature sound unveiled on 1984's debut LP, *The Smiths*, much to Tate's dismay.

Such on the hoof decision-making was to become typical of the way the band and label would interact during the relationship that ensued. The Smiths gave Travis a renewed vigour, and a taste for popular recognition that he hadn't experienced before. Rough Trade's former short-term deals with its artists now looked like one night stands, while The Smiths was its first serious relationship. "They were our first long-term signing, our first serious commitment to making a commercial project work", agrees Travis, "and to see how far we could take somebody, as opposed to just putting out a record. There was a different mindset. We were going to commit all our resources to The Smiths and we wanted to have some kind of security. We don't often think like that—we would still make stupid one-off deals all the time. But it just seemed obvious that this was a pretty special thing."

Like most serious relationships, this one involved an inordinate amount of friction and communication between the various parties. Throughout their career, one of The Smiths' biggest unresolved problems was the lack of a

permanent manager they could rely on to handle the day-to-day running of a group. In the beginning, Johnny Marr's old friend Joe Moss had taken on the task, but didn't last long: it seems by mutual consent the friendship would have suffered if he had remained at The Smiths' helm. "I think he felt they became unmanageable", comments Travis. The precarious group dynamic, centred upon the relationship between Marr and Morrissey, was usually under threat of destabilisation every time a manager came in whom Marr became friendly with. "I don't think they ever found that perfect manager who was able to balance the two together", says Travis, "which is part of their tragedy really. Had they done that, they would have probably lasted." For much of the group's peak period, they were effectively their own managers—Marr often having to talk to lawyers, accountants, even booking taxis and tour vans; while Morrissey would take obsessive interest in the interactions with Rough Trade, conceiving the record artwork in collaboration with the label's Jo Slee. "Morrissey would do everything, talk to us almost every day", Travis recalls. "Morrissey was awake in the daytime and Johnny was awake at night. For a record label, it was a dream, because they were so fully formed, and they knew what they wanted to do, and they were so fast. If they had a John Peel session to do on Tuesday, they'd write four songs over the weekend. They saw it very much in the same way that a working person would see it: that's their job. It's a wonderful attitude."

Without a strong manager, there was no one to negotiate and mediate in the intra-band dispute that flared up during the sessions for the single "What Difference Does It Make?" in autumn 1983. One of their oldest songs, it was begun at Manchester's Pluto Studios with John Porter producing. Morrissey disappeared from the studio without explanation, keeping the rest of the group waiting around until they received a phone call five hours later from Geoff Travis at Rough Trade, informing them that the singer was now sitting in his office in London having walked straight from the studio onto a train. Morrissey wanted to clarify and formalise the group's financial arrangements, believing that he and Marr should receive ten per cent of the group's earnings—a higher percentage than Rourke and Joyce—but was unable to confront the rest of the group directly about it, so his way of dealing with it was to go straight to 'the boss'. This uneven division of The Smiths' royalties would eventually boil over into a case at the high court in 1996, in which Mike Joyce denied that he and Rourke had ever formally agreed to this arrangement.

In the face of such unpredictable behaviour, Rough Trade became a kind of surrogate manager to The Smiths, providing them with emotional, logistical and financial support. It was Travis, for instance, who brokered their deal in the US with Sire Records. Shirley O'Loughlin recalls "spending a whole week trying to figure out this problem of how to get the band from *Top Of The Pops* to the airport to get a flight to Glasgow in time to play, and I booked this helicopter to land behind the place, got permission from the council in Shepherd's Bush... and two days before, Morrissey didn't want to go in a helicopter—I never thought about that!"

Handling The Smiths necessitated a steep learning curve for Rough Trade. The label had initially advanced the group £4,000. It might have made sense

Opposite (top to bottom): The Smiths' *The Smiths*; their Peel Sessions compilation, *Hatful Of Hollow*.

Above: On a roadside desolate: Morrissey. Photograph by Peter Anderson.

to sign the publishing rights to Rough Trade Music, the in-house publishing company, which had been taken on by Cathi Gibson in 1981. But, to avoid having to pay out large lump sums, the group's publishing rights were sold to Warner Chappell, with the label receiving what's known in the trade as an override—an 'agent's fee'. Recording *The Smiths*, which came out in February 1984, had racked up £60,000. A vast sum, especially given that Morrissey and Marr ended up disgruntled about the sound quality achieved by John Porter. The truth was that the culture of Rough Trade, in respect of promotion, meant they were slow off the mark in the eyes of The Smiths. Morrissey was usually disappointed with their chart placings—the highest they achieved was with "Heaven Knows I'm Miserable Now", a number ten in May 1984—and increasingly blamed a sluggish promotional department for failing to do basic tasks such as printing posters. The distribution struggled to fulfil orders of a magnitude they had never experienced before. In March 1984, even the wide open doors of Blenheim Crescent had become untenable, and Rough Trade moved its operations across Central London to a warehouse in Collier Street, near King's Cross. The move coincided with the release of the re-recorded "Hand In Glove" with Morrissey's heroine Sandie Shaw—a record that by all rights should have gone higher than its 27 chart placing, but thousands of copies simply became invisible, packed up in cardboard boxes for the move, and were not rediscovered until after the single had peaked.

The label's character was shifting in other ways, too. The Fall's Mark E Smith took his group off the label, apparently rankling over the favoured treatment of a come-lately, younger set of clean-cut Mancunians. His bitterness came out in a Christmas article he wrote for the *NME* at the close of 1983: "A good laugh ... was seeing all the serious/literal musicians go 'Lite' (in wake of lager and cigarettes) as the scrambling for market position heated up.... Competition fierce, and groups as clean and accommodating as never before!" [10]

10. Mark E Smith in *NME*,
 December 1983.

A Go-Betweens gallery (clockwise from top left): *Before Hollywood*; "Cattle And Cane" 7"; Man O'Sand To Girl O'Sea" 7"; "Hammer The Hammer" 7"; *Send Me A Lullaby*.

Was Smith fair in his assessment of Rough Trade's new breed as "clean and accommodating"? There was no doubt that groups like Aztec Camera, The Go-Betweens, Prefab Sprout, and The Pastels possessed a demonstrably different sound from the first generation of post-punk groups. The urgency and abrasiveness of the first wave was gradually giving way to a lighter, janglier tone and a more personal, whimsical romanticism in the lyrics. Australians The Go-Betweens, formed around the songwriting partnership of Grant McLennan and Robert Forster after they met at Queensland University, relocated to London in 1981 to try to make a success of their group. They developed a niche of evocative, almost Proustian autobiographical song. The 1983 single "Cattle And Cane" recalled McLennan's childhood in the Australian countryside, and eventually became officially designated as one of the ten best Australian songs. Newcastle-Upon-Tyne's Prefab Sprout aired their first songwriting efforts on Rough Trade, with the 1983 single "Lions In My Own Garden: Exit Someone", licensed from their own label Candle. Singer Paddy McAloon's tortuous but witty verse was set to a music that verged on saccharine, lite-jazz chord changes, with a sun drenched pastoral feel far from punk's three-chord woodcuts. Microdisney, an Irish outfit, specialised in similarly complex, lush song arrangements—by Sean O'Hagan, later of The High Llamas—to complement the vocals of Cathal Coughlan. Glaswegians The Pastels' "I Wonder Why" recalled the inspired amateurism of The Television Personalities but lacked the self-deprecating humour. Aztec Camera's trademark jangle, with Roddy Frame's catchy choruses accompanied by bouncy 12-string strumming on the trio of singles "Pillar To Post", "Oblivious" and "Walk Out To Winter", looked like the second most radio-friendly of all Rough Trade's new flagship acts, after The Smiths. Independent music was being recast as songs by/for sensitive, thoughtful, shy, starcrossed boys with a poetic bent.

Aztec Camera were signed up by Warners in late 1983, and the reissued version of "Oblivious" saw them finally make that long awaited *Top Of The Pops* appearance on 17 November. Having gained some insight into the workings of larger labels, and no doubt bristling after another of his discoveries had been cherry-picked by a corporation, Geoff Travis dipped a toe into major waters himself.

Back in the late 70s, Travis and Richard Scott had conceived the idea of setting up a publishing operation, and had approached the young managing director of Warners, Rob Dickins, for advice. Travis found that Dickins had similar music tastes to himself, and by 1983, the 32 year old Dickins had rapidly risen to become the chairman of UK music at WEA Records and Warner Music. It was Dickins who signed Aztec Camera from Rough Trade, one of a handful of other acts breaking through from the indie sector. He needed some underground credibility. Warners' British division was passive and uninspired, completely in thrall to the American side of the business and had so far demonstrated few imaginative A&R decisions. By 1983, he was keen to work with the man who had most impressed him with just such an imagination—Geoff Travis.

Coincidentally, Travis had also been having conversations with Mike Alway, a former partner in independent label Cherry Red, who had recently quit, after a series of disagreements with his business partner Ian McNay. Alway had had his fill of the independent sector and was keen to broker a collaborative venture with a major label, which was the plan he put to Travis. With a third partner, Michel Duval of the Belgian label Crepuscule, the new label, which they named Blanco Y Negro, was shopped around various major labels, but it was Rob Dickins at WEA who displayed the most keenness, and advanced them the cash to make their first signing, poached from Cherry Red: Ben Watt and Tracey Thorn's jazz-inflected pop duo, Everything But The Girl.

Above (clockwise from left): Roddy Frame of Aztec Camera; the group's "Pillar To Post" 7"; Everything But The Girl's "Each And Every One" 7"—the first release on Blanco Y Negro. Photograph by Peter Anderson.

Opposite: Morrissey. Photograph by Peter Anderson.

"Hand In Glove"
Gay porn star Leo Ford, from Margaret
Walter's *The Nude Male*.

"This Charming Man"
Jean Marais, from *Orphée*.

"What Difference Does It Make?"
Terence Stamp, from *The Collector*.

"Shakespeare's Sister"
Pat Phoenix, from the actress's
personal collection.

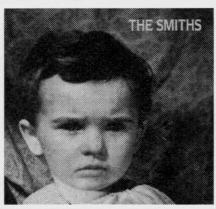

"That Joke Isn't Funny Anymore"
Unknown Italian child actor, from
Film And Filmmaking magazine.

"The Boy With The Thorn In His Side"
Truman Capote, photographed by
Cecil Beaton.

"Sheila Take A Bow"
Candy Darling, from Andy Warhol's
Women In Revolt.

"Girlfriend In A Coma"
Playwright Shelagh Delaney.

"I Started Something I Couldn't
Finish"
Avril Angers in *The Family Way*.

"Heaven Knows I'm Miserable Now"
Pools winner Viv Nicholson.

"William, It Was Really Nothing"
Original withdrawn sleeve featuring
unknown man in advert for speakers.

"How Soon Is Now?"
Sean Barrett in *Dunkirk*.

"Panic"
Richard Bradford, from TV series
Man In A Suitcase.

"Ask"
Yootha Joyce, on set of *Catch Us If
You Can*.

"Shoplifters Of The World"
The King, photographed by James
R Reid.

"Last Night I Dreamt That Somebody
Loved Me"
British rock 'n' roller Billy Fury.

Blanco Y Negro was trumpeted as a new deal for independent music in the UK. Essentially, the major label acted as a parental figure in the same way that Rough Trade itself had in 1978, advancing cash and allowing Blanco Y Negro to tap into its marketing and distribution forces. WEA received an "indie front of house", as Dickins put it; Travis was granted a channel for his own acts allowing him to retain control of their progress into a realm of bigger budgets and higher sales—receiving some payback for his own A&R discoveries. Blanco Y Negro ended up signing artists such as The Jesus & Mary Chain, The Dream Academy and, later, electronica duo Ultramarine. But in the immediate term, Travis's new freelance jaunt was causing serious disruption at Rough Trade HQ. For many, it was insult added to injury: Rough Trade's previously equal pay packets were a thing of the past; Richard Powell had introduced a pay structure that injected a clear hierarchy of responsibility into the company. On top of this, now, came Travis's pact with the old enemy: final confirmation, for some, that Rough Trade had sold its dreams upriver.

Not that anyone had much time to sit and brood on their fate. There was the distribution side, awash with units from big clients like Factory and Mute, as well as all the fiddly little labels they still handled. For Geoff Travis, the object of internal resentment up in his office at Collier Street, there was the vexed question of his relationship with Blanco Y Negro to resolve. And there was an increasingly fractious relationship with his golden goose, The Smiths, to deal with, even as they zoomed into the national consciousness through 1984 and 85 with hits such as "Heaven Knows I'm Miserable Now", "William, It Was Really Nothing", "How Soon Is Now?", "That Joke Isn't Funny Anymore" and "The Boy With The Thorn In His Side". Morrissey was accusing the label of a lack of confidence in promoting them, constantly disappointed with their chart placings and any number of small niggles regarding artwork, posters, etc. ("They released "Shakespeare's Sister" with a monstrous amount of defeatism", he commented to *NME*). Only too conscious of the fact that they had become a desirable proposition for a larger company, the group were becoming frustrated at their contract with Rough Trade, which tied them in for two further LPs.

In November 1985, the group assembled at Jacobs Studios in Farnham, Surrey, to kick off the sessions that would result in the album *The Queen Is Dead*. Like Rough Trade, the group were having internal communication issues of their own. Andy Rourke and Mike Joyce were coming to terms with the dawning realisation that they were, in effect, being treated as hired hands by Morrissey and Marr, at least in the way the group's finances were divvied up. Furthermore, Rourke was fighting a secret battle with a heroin addiction, and Morrissey had developed a dysfunctional communication style, using intermediaries such as Marr when he wanted to sack a lawyer or give difficult instructions to the other two members.

During their winter residency at Jacobs Studios, the group fielded calls from several interested labels, including EMI, Virgin and WEA. EMI's offer particularly impressed them, and the general feeling in The Smiths camp was that one way or another, they would soon be scuttling the good ship Rough Trade and sailing out of the sea of independence, emboldened by

Above (left to right): *The Queen Is Dead*'s cover star was Alain Delon; a still from Emile de Antonio's *In The Year Of The Pig* was doctored for the album cover of *Meat is Murder*—the helmet slogan originally read "Make war, not peace".

the appearance of "an absolute shark of a lawyer", as Marr once described him, although the individual has never been named. But Travis fought back. Catching wind of these backstage negotiations, he slapped an injunction on the group preventing them from releasing any new Smiths material on any other label. The wrangling only ceased midway through the following year, when the single "Bigmouth Strikes Again" was released in May 1986 as a preface to the unveiling of *The Queen Is Dead* in June. The stand-off meant that an unprecedented eight months elapsed with no new Smiths music since the previous September's "Ask" 45.

While the album was held up, things got seriously out of hand. Johnny Marr was stressed out by the recording sessions being constantly interrupted by their lawyer's visits, phone calls from van hire companies wanting payment, and his delicate position as intermediary between Morrissey, producer Stephen Street, and the rhythm section. In January, Marr bungled a 4am attempted raid on Jacobs Studios to steal the master tapes. Rourke was temporarily sacked (in the form of a note attached to his windscreen) in an attempt to force him to deal with his heroin problem; a week later he was actually arrested in a drugs raid, although let off with a suspended sentence and allowed back into the group in April.

The group's frustration with Rough Trade had turned into profound disillusionment, and one song on *The Queen Is Dead* made it personal. "Frankly Mr Shankly"'s jovial music-hall stomp belied a direct attack on Geoff Travis, couched in the form of a resignation speech by a disgruntled clerical worker. "I'd rather be famous/than righteous, or holy, any day" was directed at the label's right-on reputation, while the line "I didn't realise you wrote such bloody awful poetry" apparently refers to a humorous message Travis had sent Morrissey in the form of a poem. Morrissey didn't buy this attempt to communicate with him as one creative soul to another, and used it as one more weapon against the hand that fed them.

"I did feel a certain sense of betrayal", admits Travis today, of his reaction to the song. Hindsight has made him more magnanimous. "I think we learned that lesson that if musicians always think the grass is greener on the other side, they need to go and experience it. 'Why aren't we riding around in our own Boeing 747 with our name emblazoned on the side?' It's all that kind of mentality. 'We want a Peter Grant of our own, we want to be riding around in limousines, and if we're so great, why aren't these things happening?' That's a very easy way of displacing underlying problems, by focusing on that kind of rubbish. I think we did a good job with The Smiths and I don't have any regrets about that. I wish them nothing but well, but I don't think they could really say that they underachieved while they were with Rough Trade. In a conventional sense, they did very little, in the sense that they [only] toured American one and a half times. But they still sold about half a million copies of every record, which is pretty decent."

The Smiths finally achieved the much desired severance from their Rough Trade contract in July 1986, even as the album was basking in critical acclaim and achieving strong sales. The engineer of the new deal was Matthew Sztumpf, who had briefly managed the group in 1985 before being dismissed. He was now working with the group Madness, but had begun approaching The Smiths in December while they were recording the album, viewing it as a professional challenge to extricate them from their contract. He eventually reached the settlement that after one more album, they would be free to move from Rough Trade to EMI. The new contract was signed the day before the group flew to the US for a 27 date tour; the first public announcement was made just after they returned, in mid-September. It was a victory for the group, but a hollow one, because they were to split up even before their final Rough Trade LP was in the shops.

Meet me in the alley by the railway station: The Smiths in Manchester, 1984. Photograph by Paul Slattery.

1987–91
ON
FIRE

The Smiths commenced recording their contract-breaking LP as soon as possible, in January 1987. Beginning with "Sheila Take A Bow" and "Girlfriend In A Coma", the work at the Wool Hall in Bath produced what the group themselves subsequently considered their best music, and was reportedly conducted in an atmosphere of good humour, even hedonism (during the hours the teetotal Morrissey wasn't there, at least). Even so, soon after they had wrapped the *Strangeways, Here We Come* sessions in April, a great deal of bad feeling blew up between Marr and Morrissey. They had appointed yet another new manager, Ken Friedman, after ditching Matthew Sztumpf immediately after he had negotiated their EMI deal. But Friedman appears to have had a divisive effect on the group. Marr, desperate for someone else to shoulder the day-to-day burden of handling their business affairs, was in favour of Friedman, and a familiar pattern of behaviour emerged; as Marr got closer to the manager, so Morrissey grew to dislike him. Friedman would regularly interrupt Marr's carousing with Rourke and Joyce, calling the two principal songwriters in for long meetings and leaving the drummer and bassist to kick their heels for hours at a time. Marr realised that this situation was never likely to change, and he could see no way out of the predicament.

So it was that, in May, Marr gathered the group at a fish and chip shop in Notting Hill and informed them that he wanted to quit The Smiths. He was persuaded to stay on and record two further tracks for use as the B side to "Girlfriend In A Coma", but the brief taping at Firehouse Studios in south London were dogged by barely concealed hostility between the four group members, and an almost complete communication breakdown. 19 May 1987, the day "I Keep Mine Hidden" was completed, was also the last occasion Morrissey and Marr were in the same room for several years. In August, Marr officially confirmed the rumours that had already been circulating, that he had left The Smiths, in a press release sent to the *NME*. Rough Trade released *Strangeways, Here We Come* one month later. But instead of ushering in a brave new chapter in The Smiths' life, it turned out to be the last word. It contained one last kick in Geoff Travis's teeth: "Paint A Vulgar Picture" co-opted record company marketing speak and satirised the kind of language that Morrissey must have heard echoing round the meeting table at Collier Street; "Re-issue! Re-package! Re-package!/Re-evaluate the songs/Double pack with a photograph/Extra track (and a tacky badge)..."

Previous page: Harriet Wheeler and Dave Gavurin of The Sundays. Photograph by Nick Knight.

Above left: Re-issue! Re-package!: Smiths compilation *The World Won't Listen*.

Above right: By the time *Strangeways, Here We Come* was released in 1987, the group had split up.

Over the lifetime of The Smiths, Rough Trade expanded out of all recognition and was forced into the cut-throat aspects of the industry. The label was swept into the kind of tactics and industry games usually the preserve of majors. For Mayo Thompson, who worked as label manager during 1986–87, this new arena was a source of fascination. "By that time, the label was doing business around the world with licensees, there were a lot of interesting things going on. I had a ball, because I got to see how business is done in Britain. From the producer through the distributor to the wholesaler and high street retailers, and what kind of deals and trade-offs were going into making records hits, and the stuff it takes to get stuff on the radio. The mechanics of how long you've got to sustain a song on the radio before it drops.... I learned all those curves, that was a lot of fun.

"People used to say to me at the beginning, 'What are you going to do when you get to be a big record company like Virgin?' And I'd say, We *are* a big record company like Virgin, what are you talking about? But that was a time of particular turmoil in the industry, at all levels, not just the majors but all the way down to the grass roots."

With the continued growth of the Cartel and its associated network of retailers, The Chain With No Name, the notion of 'indie' music had become complicated. No longer was the independent chart a clearing-house for a ragbag of Goths, spiky post-punks and lo-fi racketeers, as it was in the early 1980s. The Cartel's market penetration meant that a label like PWL could dominate the upper reaches of the independent charts simultaneously with national Top Ten hits for the hit factory of Stock, Aitken & Waterman, and artists such as Kylie Minogue and Rick Astley. But in the wake of The Smiths and the host of lesser groups brandishing jangly guitars and snappy choruses, 'indie' was beginning to take on a specific definition, flagging up a particular kind of music, instead of the circumstances of its production and release.

The document that in many respects acted as the manifesto of late 80s UK indie music was *C86*, a cassette compilation made available via an offer in the *NME* in that year. *C86* came five years after *C81*, a similar collection of era-defining tracks that had been released as a joint promotion between the paper and Rough Trade as a showcase of Rough Trade Distribution's acts. In 1987, Rough Trade released a vinyl edition of *C86*, which took the record to an audience beyond the magazine's readership.

C86 is often represented as nothing but a compilation of 'twee' ditties — rewrites of The Ramones, The Buzzcocks and Orange Juice, etc. That image is partly true: groups such as Primal Scream, Mighty Mighty, The Soup Dragons, The Shop Assistants, Mighty Lemon Drops, Close Lobsters and The Bodines represented indie music as a bloodless whine, devoid of funk, a petulant and impotent alternative to the vacuous mainstream. In fact, of 22 tracks, at least nine didn't fit that template: Big Flame, Bogshed, The MacKenzies, Stump, The Shrubs, Age Of Chance and A Witness variously channelled harsher, more atonal and spiky styles with Captain Beefheart and The Fall as key touchstones, but these were too quirky and wilfully obscurantist to make any lasting impression. The most telling inclusion on *C86* was the apolitical scream of Half Man Half Biscuit's "I Hate Nerys Hughes": the Liverpool group's bile, laced with irony, was usually directed at trivial targets, such as 1970s British television. The political engagement and enlightened musical tastes of The Pop Group, Cabaret Voltaire and Robert Wyatt suddenly seemed to have been left a long way behind. By 1987, in fact, apart from Pere Ubu's David Thomas, all of Rough Trade's original artists had disbanded or moved on.

OUT ON YOUR OWN
WHISTLING IN THE DARK
NINETEEN SIXTY NINE
CARGO OF SOULS
LENIN IN EUROPE
GET BACK TO RUSSIA
TO LIVE LIKE THIS

EASTERHOUSE CONTENDERS

THE BOY CAN SING
ESTATES
INSPIRATION
JOHNNY I HARDLY KNEW YOU
EASTER RISING
AIN'T THAT ALWAYS THE WAY

Opposite (clockwise from top): The
Woodentops; Easterhouse's LP, *Contenders*;
the cover of the infamous *C86* tape.
Photograph by Peter Anderson.

Above: Camper Van Beethoven's eponymous
1986 album; a group shot of the band.
Photograph by Peter Anderson.

Far from its intended celebration of the state of indie, *C86* exposed the
problems of a watered down scene: in a post-Smiths world, there was
now a wave of imitators instead of a new inspiring breed. So Geoff Travis
changed gear. His other hopes of the mid-80s, Easterhouse (whose
guitarist Ivor Perry briefly replaced Johnny Marr in an aborted attempt
to keep The Smiths going after their breakup) and The Stars Of Heaven,
peddled worthy but dull, clean, crafted guitar music with none of Morrissey
and Marr's wit and sparkle. The high energy 'hypnobeat' and infectious
positivity of Northampton's Woodentops was popular with John Peel and
live audiences, and produced three LPs between 1986–89, although they
moved away from the label when they began connecting their repetitive
beats to the insistent pulse of electronic trance (singer Rollo went on to
produce a number of dance tracks under the name Pluto). There was also
a handful of American rock groups, who could be effectively administered
by Rough Trade's US office, based in San Francisco since the early 80s,
when Pete Walmsley had set up a shop and small distribution network
on Grant Street (the HQ relocated to New York in 1989). Camper Van
Beethoven's Jonathan Richman-style "Take The Skinheads Bowling" was
one of the most memorable tunes of 1985; Miracle Legion, Soul Asylum
and Opal (David Roback of Rain Parade and Kendra Smith of The Dream
Syndicate) represented the most interesting fallout from the mid-80s
'Paisley Underground', a rootsy and atmospheric blend of hardcore rock and
psychedelia. And in 1987 Rough Trade signed Beat Happening, an American
outfit from Olympia, Washington whose pop-naif would have fitted very
comfortably on *C86*.

The Sundays and a selection of their
records. Photograph by Renaud Monfourny,
courtesy of Rough Trade shop.

But Travis's stewardship of the Rough Trade label ensured that there was a seam of more eccentric and experimental artists brought on board in the second half of the 80s, sometimes for one-off deals: Dip In The Pool (Japanese synth-pop), Tirez Tirez and Arthur Russell (New York minimalism meets pop), AR Kane (oceanic avant pop), Band Of Holy Joy (starcrossed, bohemian *guignol*), and Sudden Sway (playfully conceptualist electro/art group). Straitjacket Fits and The Clean were two of the more prominent groups from a wave of New Zealand guitar groups that sought UK success in the late 1980s. Added to the country tinged rock of The Wygals, Lucinda and Victoria Williams, and Souled American, Rough Trade had become a mature yet determinedly eclectic label whose A&R policy still appeared broad, even if there was no representation of emerging black musics such as hiphop, or of the big movement of the late 80s, Acid House.

The two groups that attracted most critical attention in 1989 were The Sundays, from London, and Galaxie 500, a trio from Boston. The Sundays provoked a flurry of attempts to sign them after their first gig, at the Vertigo Club at Camden Falcon in north London. Songwriting couple David Gavurin and Harriet Wheeler had moved from Bristol University to London, and formed the group with Paul Brindley (bass) and Patrick Hanna (drums). They narrowed down the offers to three independents, and chose Rough Trade partly because "it was near our flat", as Gavurin recalls. When the group first met Travis, he was accompanied by his new assistant, Jeannette Lee, who had joined the company in 1987. Lee had been a member of John Lydon's Public Image Limited, assisting with the group's PR and videos, and was married to Gareth Sager of The Pop Group, so she had an insider's knowledge of Rough Trade's post-punk grounding. "First impressions of this incongruous duo were that he was very tall and introverted, and she was very small and extroverted", remembers Gavurin. "What appealed to us about the two of them was that they seemed incredibly straightforward, sat opposite each other at a desk in a little room on the top floor of this huge old warehouse in King's Cross. For us Rough Trade was this immensely cool and significant label, yet there was no arrogance about them. They basically came over as a couple of unassuming music fans." The couple handed over demo versions of "Can't Be Sure", released as a single in 1989, and "Here's Where The Story Ends", which ended up on their LP *Reading, Writing And Arithmetic*, 1990. Focused around the raucously ethereal voice of Wheeler, and her partner's crystalline guitar lines, The Sundays were a slightly funkier version of The Cocteau Twins, without the fluffy Gothic trappings, arranged with Smiths-style conciseness, a formula which took the album into the national Top Five. The group's memories of working with Rough Trade remain overwhelmingly positive. Effectively, the label provided a base providing all the facilities and support they needed to run their group in the way they wanted, from assembling their cover artwork (with the help of designers Jo Slee and Slim Smith) to conducting interviews and organising tours. "The culture seemed to be one of openness and co-operation", recalls Gavurin, "and we got on well with everyone there. That was the thing about Rough Trade, certainly for a band with no manager: you ended up working with virtually the entire staff, not just your A&R people. There was an exciting, un-flashy buzz about the place, from the netherworld of the ground floor warehouse with its anarcho

staff stuffing boxes while blasting out German Industrial music, to the white open-plan offices above, with records, tapes and artwork crammed into every available corner. We used to walk down Caledonian Road from our flat in Holloway, and it became a sort of home-from-home."

Galaxie 500's experience was not so rosy, however. Influenced by the Rough Trade group Young Marble Giants (they used to include a cover of "Final Day" in their early live sets), the group's languorous, skeletal songs were the product of a fully digested rock history, with The Velvet Underground's moody three-chord minimalism as year zero. Drummer/vocalist Dean Wareham, guitarist Damon Krukowski and bassist Naomi Yang met at Harvard College in Massachusetts, and cut their debut LP *Today* in 1988 with producer Kramer (himself a Rough Trade veteran through his work with Shockabilly). Released on tiny Boston label Aurora, the album was admired by Geoff Travis, who sent the group a proposal for a three-album deal. "They were unlike the other people we had met from labels", says Naomi Yang, "who were saying things to us like, 'We'll get your faces on a billboard on Sunset Boulevard'. Also, I was struck by Jeannette Lee's presence, she was absolutely wonderful: smart, funny and direct. I have the impression of Geoff and Jeannette working like two detectives in an old movie—on desks that were facing each other. Jeannette was always taking notes in these big notebooks." *On Fire*, 1989, was the group's peak, its wintry, desolate mood encapsulated in Wareham's awkward, straining vocals. It was followed by one more LP, *This Is Our Music*, in 1990. By this time, though, the group had become frustrated with their label's failure to pay any royalties on any of their records.

Below: Galaxie 500's *On Fire* and *This Is Our Music*.

Opposite: Staff at the warehouse in Collier Street, King's Cross. Photographs by Chris Ward (Sparks).

"They delayed and delayed", complains Krukowski, "telling us that our accountings were in the works, just be patient, there's a new computer system.... And then one morning the US office declared bankruptcy without warning, even shutting their own employees out with a padlock on the door." Their contracts were passed into the hands of a court in New York. "We turned to Geoff for help, of course, but he just said there was nothing he could do... and then he stopped taking my calls." Wareham left the group at that moment, in 1991, forming a new grop called Luna. Krukowski and Yang continued as Damon & Naomi. On their first album in that guise, they exorcised their feelings about Rough Trade in a song called "Little Red Record Co", a jibe at the label's socialist past: *Mother's close, father's close, but neither's close as Chairman Mao...*".

Galaxie 500 (left to right): Dean Wareham, Naomi Yang and Damon Krukowski.

For Rough Trade, the beginning of the endgame began in July 1990. The entire operation moved yet again, this time to a 31,000 square foot warehouse and five-storey office block in Finsbury Park. The upheaval was driven by the rapid growth of Rough Trade Distribution, which was on the verge of taking on an extra 15 label clients, swelling their roster from 55 to 70.

To keep track of the vast amount of money, transactions and stock traffic, a computer system was installed at a cost of around £750,000. Although other distributors were consulted to find out what system worked best, in the end someone decided to buy in one that had not been tried, to manage the distribution network. "That took a long time to get working", shudders Travis, "and caused huge problems." The lack of equipment also meant that the company's credit control was non-existent, and there were uncollected bad debts approaching £1 million. On top of this, a strike by UK Customs and Excise workers meant that VAT bills had not been payable for several months. "Of course", recalls Cathi Gibson of Rough Trade Publishing, "Rough Trade being Rough Trade, they didn't just put it aside: they just kind of spent the VAT and then when the VAT people came back, they said, 'Right, you owe us £5,000 million!' And they didn't have it."

Inevitably, the dominoes began to tumble. In the same month that Rough Trade installed their bug-riddled computers, and with hundreds of creditors unpaid, the Cartel expired, terminally overheated by staunched cash flow and bloated orders. Core labels such as Creation, Sleeping Bag and Gee Street, seeing their products simply languishing in Rough Trade's new warehouse, began closing their accounts with distribution. Staff were laid off in an emergency cull, but that only increased the burden on those that were left, making it almost impossible to clear the backlog. Several labels including Big Life and Rhythm King clung on in support, optimistic that the problems would be sorted out, but when April 1991 came round with no resolution in sight, even these last faithful finally deserted. In May, the Rough Trade group announced it was ceasing trading.

For his part, Geoff Travis believes the three factors that accelerated Rough Trade's downfall were the faulty computer system, the badly managed credit control, and the resentment that had grown up against him personally while he was running Blanco Y Negro. "They felt I had two jobs and that my allegiances weren't 100 per cent with Rough Trade. But it didn't really affect things—maybe that was a bigger emphasis for them to try to seize control of everything, and I never realised."

"I think they were trying to rein him in", confirms Jeannette Lee, one of Travis's loyal supporters through the crisis. "Not that he was spending ridiculous amounts of money, but in terms of the things he was committing to do. Everyone wanted to be in on it the whole time, and make decisions about what he was allowed to do and not allowed to do, and I don't think you can really work that way."

"Bad creditors, that's the job of the accounts department", adds Travis. "That's nothing to do with me, in a sense. I don't want to spend my week looking through the books to make sure the debts have been collected. It's just bad management."

Amazingly, Travis's altruism remained even as the wave washed over the company, liquidating it at a stroke. In legal terms, Rough Trade Records was a separate entity within the larger group of companies, and he would have been entitled to carry on independently of the rest of the group of companies. But, recognising that his name would forever be linked with the brand, he chose to toss his label into the whirlpool. "If I'd been a different person I would have said, 'Goodye, see you later', but we couldn't do that because it just wouldn't be fair to walk away when the distribution had money owing to [people] that we considered to be our friends ... so we just said, 'Take it'. We didn't have to do that, but it was morally the right thing to do. It was a horrible moment in time, really a bad ending."

Cathi Gibson and Pete Walmsley attempted to buy out the publishing division they had run, but instead it was tendered out to an outside company called Complete Music. Rough Trade Music had handled publishing rights for a huge range of independent artists—not only those signed to the label—and the brand's reputation took a blow. Gibson remembers: "Lee Ranaldo of Sonic Youth, when he found out—because we had some copyrights of theirs—he said, 'I just cannot believe that my songs have been sold without my permission to somebody I've never heard of! How can this happen? I thought you were a company that we could trust'. That was the sentiment across a lot of the writers. They felt that Rough Trade was a sort of safe haven and somebody who would be ethical and moral and all the rest of it and actually look after them, and suddenly it seemed like nothing mattered except money, and they'd just been flogged off." Gibson complains that the publishing operation was largely neglected by the rest of the company during its lifetime. Now, the decision to sign The Smiths' publishing rights to Warner Chappell instead of Rough Trade in 1983, came back to haunt them.

In the event, Complete was forbidden from using the name Rough Trade, even though they owned the publishing catalogue, and Gibson and Walmsley set up a new company called Rough Trade Publishing, which continues to work with a portfolio of independent and underground artists.

Following the black month of May, Rough Trade, the Cartel and all the structures that had been built up over the past 15 years had crumbled to nothing. It was a victim of its own success: the strength of the company—it had a turnover of £22 million by 1989—finally made it top heavy, while personality clashes rotted it away from the inside. Casualties included several of the smaller cogs in the Cartel, such as Probe and Fast Forward, who had gone bust, and more than 50 of the country's most significant independent labels left out of pocket and unable to shift their stock until the receivers had done their work. In the diaspora that followed, labels found that the alternative distributors—like Rough Trade's rival Pinnacle—were hardly any different from the big companies like PolyGram or BMG in their methods. The great collective dream that founded the shop in the punk era imploded into distrust, paranoia, redundancy, and a laying to waste of the landscape in which independent music had formerly thrived.

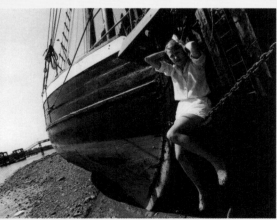

AR Kane (above left and right)
After taking part in the 1987
M/A/R/R/S hit "Pump Up The Volume",
London duo Alex Ayuli and Rudy
Tambala recorded 69, 1988, where they
rewrote the black sci-fi visions of
Sun Ra and Lee Perry, and the three-
chord distortion of The Jesus &
Mary Chain, as cavernous, Freudian
moonsong, dubbed and scrubbed down
to its bleached bones. With its mix
of power-pop, plastic soul and avant
noise, the double album follow-up,
i, 1989, was almost too eclectic
for its own good. Photograph by
Peter Anderson.

Virginia Astley (left)
The former Ravishing Beauty
produced a lost classic of English
pastoralism in From Gardens Where
We Feel Secure, 1983. Influenced
by English composers such as Vaughan
Williams and Delius, the Miss
Havisham of indie planted a secret
garden of delicate, tonal fronds
and hushed singing. Later in the
80s Astley composed music for
television documentary World Of
Herbs and planned a musical setting
of Thomas Hardy's The Woodlanders.
Photograph by Peter Anderson.

Dip In The Pool (above)
This duo of Japanese vocalist Miyako Koda and synth player Tatsuji Kim made a small splash with their collection of cut-glass Techno-pop in 1986. Produced by Seigen Ono, *Silence*'s frosty, po-faced exterior— Koda was a fashion model at the time —anticipated the Lynchian uncanny of Julee Cruise by several years.

Band Of Holy Joy (above)
Led by Newcastle's Johny Brown, this folky, nomadic seven piece troupe busked a bohemian mix of inner city *guignol*, Brechtian street song and soaring romanticism on a selection of junk shop instruments like fiddle, accordion, trombone, harmonium and marching drum. Photograph by Peter Anderson.

Ivor Cutler (right)
The eccentric harmonium songs and surrealist poetry of the grumpy old Scotsman are well known to John Peel listeners. He released three albums on Rough Trade, including two in one year: *Prince Ivor* and *Gruts*, 1986. But 1983's *Privilege*, co-released with poet Linda Hurst, was given a distinctive sound by producers by David Toop and Steve Beresford, adding keyboards, banjo, euphonium and alto flute to Cutler's potty recitations.

Daniel Figgis (below)
During his brief association with Dublin's Virgin Prunes (also signed to Rough Trade), Daniel Figgis was known as Bintii. After leaving the group in 1985, he returned with the transgressive glam-punk of Princess Tinymeat. But his real masterpiece is *Skipper*, an evocatively creaky organic ambient soundscape from 1994.

Arthur Russell (left)
The New York based composer was a true omni-musician, whose work merged downtown minimalism, dub-inflected songs utilising electronically enhanced cello, and his fascination with the city's burgeoning club scene. He produced legendary dance tracks such as "Go Bang", "Let's Go Swimming" and Dinosaur L's "Is It All Over My Face". His 1986 Rough Trade LP *World Of Echo* stands as his masterpiece, a serious and fluid attempt to "redefine songs from the point of view of instrumental music, in the hopes of liquefying a raw material where concert music and popular song can criss cross."

Sudden Sway (above and bottom right)
More of a conceptual art unit than a group, the trio of Mike McGuire, Peter Jostins and Simon Childs spent most of the 1980s creating eccentric artefacts such as "Let's Evolve", a keep fit record for evolving lifeforms; "Sing Song", recorded eight times and released on eight separate records; and *Spacemate*, a philosophical box set that included a double LP, interactive game, poster, cards and instruction manual. Their labcoat synth music was cut from the same cloth as Thomas Dolby, but their material was often a deconstruction of Thatcherite society and the banality of art in an enterprise culture, culminating in the spoof West End musical *76 Kids Forever*, transmitted over a telephone chatline, 1988, and their final release, *Ko-Opera*, a swansong for collectivist dreams. One of Rough Trade's most eccentric acts, they never performed conventionally 'live', but once played from 'a city in the future' installed inside a holographic jukebox, and devised a headphone-guided walk setting out from Rough Trade's Covent Garden shop. Photograph courtesy Rough Trade shop.

Unknown Cases

Launched as a spin-off project from German group Dunkelziffer, The Unknown Cases was an occasional group based around Helmut Zerlett and Stefan Krachten that was open to an array of floating members. Their 1983 single "Masimbabele" is a prescient slice of Fourth World funk, beefed up with Afrodelic percussion from Can's Reebop Kwaku Baah. Zerlett had been a keyboardist in Jaki Liebezeit's post-Can group Phantomband, and later became resident musician on the Harald Schmidt television show—Germany's equivalent of David Letterman.

Zounds (top and bottom right)

More than just anarchist punk thrash, Steve Lake and Lawrence Wood's outfit was described by themselves as "Velvet Underground meets white liberal guilt". Formed in the late 1970s, first in Reading, then Oxford, Zounds were closely connected to the traveller/hippy circuit and were associates, and later tenants, of anarchist collective Crass. But their broad music taste, which took in Krautrock and The Grateful Dead as well as punk, produced a distinctively paranoid and claustrophobic sonic crush that avoided formulaic protest song. Key works: "Demystification"/ "Great White Hunter" 7", and the 1981 LP *The Curse Of Zounds*.

1992–2000
THERE ARE STRINGS

Clockwise from top: Disco Inferno;
Second Language EP; "A Rock To Cling To".

In the aftermath of Rough Trade's collapse, much of the 1990s had an anticlimactic feel: a frustrating period of false starts. As a stopgap, Geoff Travis and Jeannette Lee rigged up a new, small-scale Rough Trade Records within a year, but for the first time, their A&R choices seemed out of step with the prevailing music culture, in which 'Madchester'-style indie/dance crossovers vied with a peaking Nirvana in the independent charts. Rough Trade's 1992 roster was respectable, with albums by Television's Tom Verlaine, Robert Wyatt's *Dondestan*, plus Cul De Sac, Giant Sand, Chicago's Shrimp Boat, Levitation (featuring a post-House Of Love Terry Bickers) and electronic duo Ultramarine, but music by The Mabuses, Shelleyan Orphan, The Bats and Sweet Jesus was forgettable and inconsequential. In 1993, medium sized independent label One Little Indian acquired the Rough Trade catalogue and employed Travis to run it. For a brief period, he signed a handful of experimental rock acts that provoked hyperbolic press coverage but sold in infinitesimal quantities: Disco Inferno, East Londoners who used rewired guitar and drums to trigger samples; Butterfly Child, purveyors of shimmering, oceanic rock; Irishman Daniel Figgis, former associate of the Virgin Prunes and Princess Tinymeat, with an idiosyncratic ambient project. By signing Sam Prekop's group Shrimp Boat and its successor, The Sea And Cake, Travis's ears were among the first in the UK to tune in to the expanding Chicago scene that would soon produce Tortoise, Chicago Underground Orchestra and Gastr Del Sol. From the previous Rough Trade company he kept The Boo Radleys on for one LP, and Dean Wareham's post-Galaxie 500 group Luna, as well as reissuing some vintage Raincoats and Robert Wyatt LPs.

Previous page: Robert Wyatt. Photograph by Peter Anderson.

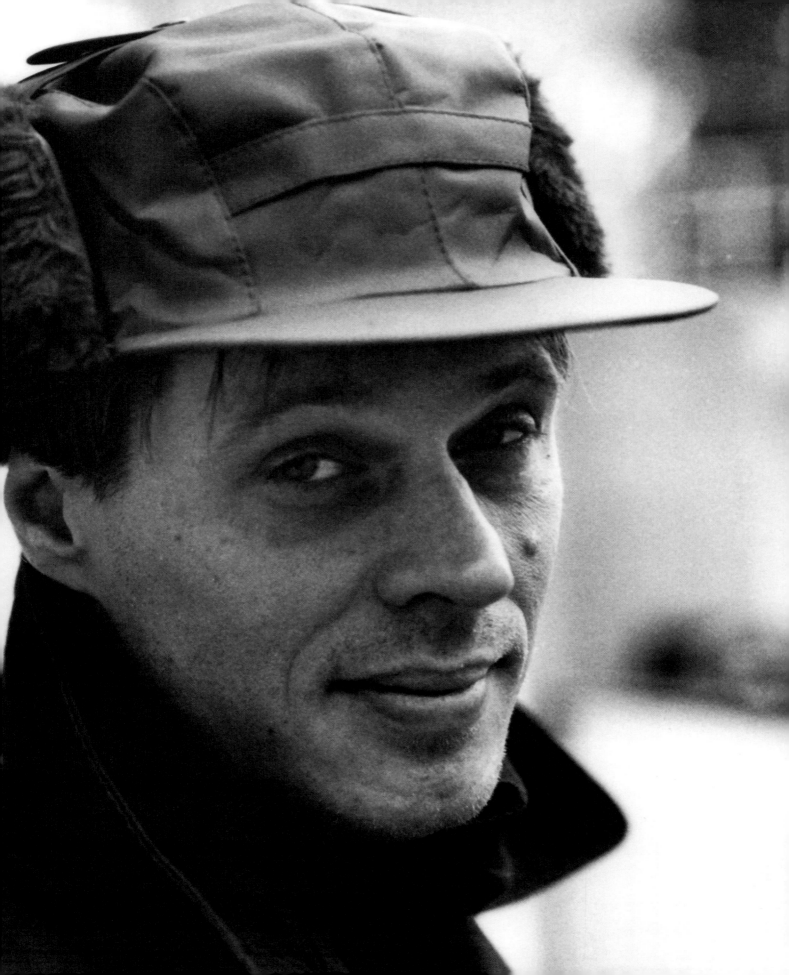

In 1993 Travis had a fortuitous meeting with a young producer called John Coxon in the foyer of WEA's London headquarters. Coxon had just been fired as producer of a female acoustic duo called Pooka, but Travis brought him on board to remix Everything But The Girl's hit single "Missing" on Blanco Y Negro. At the Strongroom, the East London studio where Coxon worked, he had been involved in a number of diverse projects, including some anonymous Hardcore Techno tracks, and a collaboration with a musician called Ashley Wales, helping him realise some composed scores. At the time he became involved with Travis, these two facets were just about to merge.

Ashley Wales had a background in underground post-punk, as a founder member of The Shockheaded Peters with Karl Blake, between 1982–85. Their single "I Bloodbrother Be (£4,000 Love Letter)" had been released on the eccentric Cherry Red spin-off imprint, él Records, in 1984. Wales was deeply interested in contemporary composers such as Xenakis and Ligeti, and was writing his own scored work. But working in their Shoreditch studio, they were well inside the reception area for London's Hardcore pirate radio stations, belting out the clanking, high velocity rhythm matrices of Jungle. Naming themselves Spring Heel Jack, the pair began combining Wales's feel for orchestration with the intricate sampling and programmed beats that was becoming known as 'intelligent' drum 'n' bass. For the rest of the decade, Travis faithfully released Spring Heel Jack's evolving music, beginning with the single "Where Do You Fit In?" in 1994, and the album *There Are Strings* the following year. Travis even kept them with him when he tired of working under the wing of One Little Indian in the summer of 1996.

Opposite: Tom Verlaine. Photograph by Peter Anderson.

Above (clockwise from top left): Butterfly Child's "Ghetto Speak"; a group shot of Butterfly Child; *Onomatopoeia*.

Above (clockwise from top left): Mazzy Star's *She Hangs Brightly*; Shrimp Boat's *Cavale*; Shrimp Boat's *Duende*; *The Sea And Cake* by The Sea And Cake.

Opposite: Shrimp Boat. Photograph by Arty Perez.

Unable to keep control of the Rough Trade name, he set up a subsidiary of Island Records, Trade 2. As a merger of independent and corporate methods, it was a pot-boiler, a comfort zone, rather than the exciting open door of Blanco Y Negro, but it gave Travis the opportunity to regroup and rethink. "We have a pretty stable financial structure", he told an interviewer in November 1996, just after the company had been launched. "We have the freedom to do what we want to do. We're not really in a position to do one-offs and experimental things that we'd like to. So that's the gap and that's what you're trying to change…. The same old thing applies—people that are doing innovative and creative things are what becomes commercial. You just have to let them do it in their own time and try to bring the public and the world around to it." [11]

11. Gross, Jason, Interview with Geoff Travis, *Perfect Sound Forever,* www.furious.com/perfect, November 1996.

In the event, Trade 2 only existed for two years, enough time to release three Spring Heel Jack LPs, a bunch of singles, and several releases by a now forgotten Britpop synth group called Tiger. "I guess it was a difficult time for them, because they weren't having any hits, and we weren't helping", comments John Coxon. But in any case, Travis and Lee had channelled their experience into full-time artist management, taking on a roster that included Pulp, Spiritualized, Mazzy Star and former Suede guitarist Bernard Butler. In doing so, they saw the business from a different angle. "It's very good to learn how every other label works", explains Travis. "Gives you confidence." Lee adds: "The bands we worked with through all the years haven't had managers, so we've ended up being quasi-managers anyway, and building personal relationships with a lot of our artists. But managing people is a lot more personal again. You really are doing everything together. We learned a lot from that point of view. It's a different role and you connect in different ways."

Spring Heel Jack's time with Trade 2 gave them the resources to develop and extend their activities in a way that few major labels allowed in a business that, during the 90s, was looking for quick returns and instant success. When Spiritualized were looking for a guitarist, Travis, acting as their manager, installed John Coxon in the group. Later, when the duo were becoming interested in creating an innovative fusion of electronics with live, improvising jazz musicians, he introduced the duo to Peter Gordon in New York, whose Thirsty Ear label provided the perfect outlet, and since 1998 they have been working exclusively with high calibre improvisors, eventually setting up their own, grassroots label Treader in the spirit of the very earliest incarnation of Rough Trade.

Above: David Roback and Hope Sandoval of Mazzy Star.

Opposite (clockwise from top): Spring Heel Jack's Ashley Wales (left) and John Coxon; "Lee Perry"; *Versions* (Trade 2); "Oceola"/ "Double Edge". Photograph by Iris Garrelfs.

Meanwhile, by 1999 Trade 2 had dried up, and so had the Rough Trade imprint, which One Little Indian had retained. Although it seemed like a good idea at the time to absorb the brand, no one at OLI had put much energy into keeping it viable. It had been run in a lacklustre fashion, with only seven releases between 1996–97, and afterwards lay dormant. In 1999, Travis was allowed to buy back the right to use the name. "It didn't work out", says Lee, "so by the time four years had passed, they let us have it back quite easily." "They were good about it in the end", adds Travis, "They have their own label, and it's a strong brand."

Rough Trade was once again free to steam ahead, with Travis and Lee at the helm. At the same time they floated a second imprint, Tugboat, featuring electronica acts like ISAN and Múm, and American Mormon slowcore rock group Low. For a while they even considered dropping the name Rough Trade altogether. "It seems madness to me now", exclaims Lee. "We decided we weren't going to use it", affirms Travis, "and then [in 2001] it was the 25th anniversary of the Rough Trade shop, and they had a big do at the V&A Museum and it was such a good occasion, it just made us realise how much Rough Trade meant to a lot of people, and it seemed foolish to throw it all away."

This was all very nice, but the events of the past eight years hardly compared with the rollercoaster ride of Rough Trade's first decade. The Travis and Lee team had made a success of their management venture, but musically, despite connecting with the energy of drum 'n' bass via their involvement with Spring Heel Jack, they had otherwise been pottering about. To make a success of the third flotation of Rough Trade, they needed something comparable to The Smiths that would give some momentum to their operation. And in August 2000, they got it. It was a package, sent from New York, containing a tape of three songs. It had been mailed by a man named Ryan Gentles, who announced himself as the manager of a new group called The Strokes.

Leaning on its own lift shaft, the Trellick Tower spreads its oblong shadow over the Golborne Road in Ladbroke Grove. Here, among a bustling mixture of secondhand furniture shops, Moroccan restaurants and coffee houses, one grey shopfront is conspicuous by its lack of a name sign. Is this some kind of living art installation, or a transparent business? The glass forms one wall of a scruffy office: desks and chairs compete for space with piles of paperwork, CDs and boxes, phones cower under desk clutter, and a handful of employees tuck themselves snugly into the gaps. A poster bearing a familiar logo gives the game away: this is the present headquarters of Rough Trade Records. Directors Geoff Travis and Jeannette Lee dwell in neighbouring offices at the rear of the space, and closer investigation reveals a hive of further activity in the lightless basement below.

The physical footprint of Rough Trade's base may not be large, but since regaining the right to use the name from One Little Indian at the end of the 1990s, Travis and Lee have re-established a firm course for the company without the distractions of legal wrangles, and financial mismanagement. The label was re-incorporated with the investment of the Sanctuary group, the independent distributor and label whose post-2000 growth in certain respects echoed the rise of Rough Trade in the 1980s.

Previous page: The Libertines (left to right); Carl Barat, Pete Doherty, Gary Powell and John Hassall.

Opposite: The Strokes (left to right); Albert Hammond Jr, Julian Casablancas, Fabrizio Moretti, Nick Valensi, Nikolai Fraiture. Photographs courtesy of Rough Trade Records.

The Strokes (clockwise from top left):
"12:51"; *The Modern Age*; *Is This It*.

It was The Strokes that gave them their flying start. Within a week of hearing the group's demo, Travis and Lee had flown to New York, watching them play in a small club in New Jersey to a handful of uninterested people, and later at a celebrated show at the city's Mercury Lounge. *The Modern Age* EP, released in January 2001, tapped into a new mood, and a rock scene that had been invigorated by the recent appearance of The White Stripes' raw, defiantly transistorised debut LP, *De Stijl*. The instant success of The Strokes—their first UK gig, in Portsmouth, played to a packed house— vastly helped Rough Trade's new relationship with Sanctuary: "It meant they had confidence in us", says Travis. Five months later, they signed The Libertines, an English four-piece that matched The Strokes' rock energy and added literate lyrics, tempestuous inter-band relationships and an intemperance that saw them brush with the police, and become hounded by the tabloid press (the first time Travis had to contend in that arena since The Smiths).

Babyshambles and an assortment of album covers from The Libertines and Babyshambles; *Down In Albion* (bottom left) looks back to the DIY aesthetic of earlier Rough Trade releases. Photograph courtesy of Rough Trade Records.

In five years, the newest incarnation of Rough Trade has assembled an enviable roster of several dozen artists, most notably Arcade Fire, Belle & Sebastian, British Sea Power, Sufjan Stevens, The Fiery Furnaces and Babyshambles—the group set up by Pete Doherty in the wake of The Libertines. They have retained some old friends: Jarvis Cocker's post-Pulp venture Relaxed Muscle, Mazzy Star's Hope Sandoval with her Warm Inventions group, Scritti Politti, Low, and reissues of the late Arthur Russell. And in 2005, the avantish torch song album *I Am A Bird Now*, by New York's Antony & The Johnsons, won the UK's Mercury Music Prize (on the strength of singer Antony Hegarty having been born in Britain). It is, broadly, a healthy selection of contemporary leftfield rock, the terrain Travis and Lee know best.

Opposite: Jarvis Cocker of Relaxed Muscle
and two of his Rough Trade releases. The
Pulp singer signed to the label after
being managed by Travis and Lee in the 90s.

Above: Belle and Sebastian and their
2003 single "Step Into My Office, Baby".
Photograph courtesy of Rough Trade Records.

Rough Trade in 2006 is a very different entity from the one instigated
in 1978—symptomatic of an entirely altered musical and cultural
landscape. It's unlikely many consumers would buy a record purely
on the strength of the Rough Trade logo, as they might have in the late
70s; instead the label plays a strong supporting role, propping up and
foregrounding its artists. In contrast to the early days, the label's story
is not so intimately connected to the fortunes and biographies of
its artists—it is a strong enough base to let them live out their own
narratives. "The whole definition of independence and having a part of
the marketplace is really different", explains Travis. "I mean, post-punk
had a massive audience—17,000 singles.... Chelsea's "Right To Work"
would sell about 7,000 copies. If that came out today, the equivalent
would sell about 70 copies. So it is a very different place. But we try to
keep it simple, not to clutter our heads too much. We try not to analyse
the trends and add up the numbers. The important thing is to keep up
to date with what is happening in music. That is key for me. If you don't
do that, how are you going to recognise something that is different or
exceptional—someone else may have done it the day before, and you're
ignorant of it."

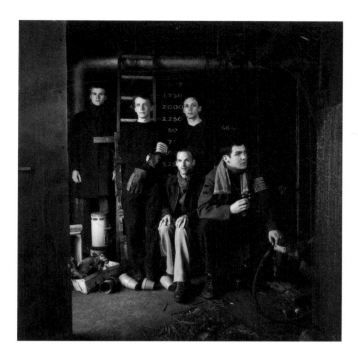

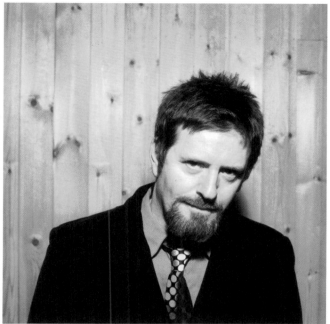

That passion for music, coupled with an unusually thick skin, are the twin
forces that have driven Geoff Travis through the 30 year adventure of Rough
Trade. In the beginning, the organisation was a bid to find and establish a
new business model for music, one built on altruism and respect for the
primacy of the artist. His equal handedness with artists' fees has become a
common practice in the independent sector, and his desire to provide the
best psychological conditions for musicians to create in is borne out by the
amount of goodwill he has retained among most of those who have been
associated with Rough Trade down the line. Right from the start, the Rough
Trade team fostered an experiment in inclusivity and collectivity, rejecting
the competitiveness of the music industry. The co-operative structure
extended out to the label's musicians, providing an artistic backup service,
helping to push the music out with logistics, encouragement and a
readymade community of likeminded groups. Almost without exception, the
artists and former employees interviewed for this book generously praised
Travis's achievements and fondly recollected their interactions with him.

The restructuring of the company in 1982 lost much of this first flush of
altruism. Rough Trade's reputation made it an institution—no longer
proudly on the margins, it became a central plank of the independent scene.
As the main HQ of the Cartel, it was also the scene's financial lifeline.
Continuing to support its large roster of artists required a hike in revenue
and a change in the company culture to rise to the demands of the new
workload and make it more efficient, but the laidback chain of command
was unable to impose these changes effectively.

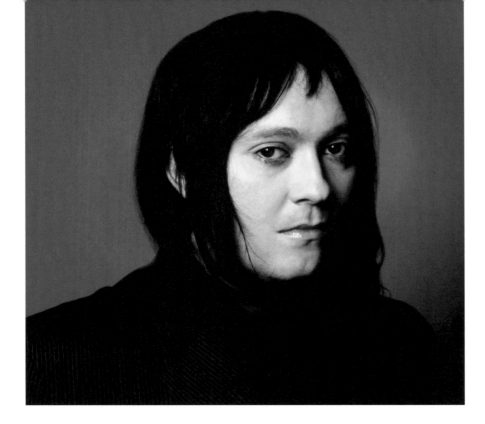

Rough Trade's problems leading to its demise were symptomatic of wider problems within Britain's political institutions. The harsh realities of the economic situation had brought the left firmly down to earth through repeated electoral failure. In a similar way, Rough Trade was forced to compromise its Marxist/utopian origins during the 80s as it delicately negotiated its own expansion. It needed to maintain its connections with the grassroots musical underground, while simultaneously servicing an international market when The Smiths took off in popularity. This shift to producing hits necessitated an engagement with the stratagems and business practices the label originally rebelled against.

At the same time, the role of music in public life changed. One example can been seen in the attitudes of the music press. The *NME* angered its publishers IPC by printing many overtly left-leaning stories in the early to mid-80s. It published interviews with the likes of Tony Benn and Militant leader Derek Hatton; Labour leader Neil Kinnock was the cover star on the eve of the 1987 general election. When an issue devoted to youth suicide sent the sales graph plummeting, IPC pulled the plug, installing new editor Alan Lewis in place of the departing Ian Pye, with a brief to bump up the sales and focus on pop music. One of Lewis's first cover stories featured Page 3 model-turned-pop singer Samantha Fox.

The longer Margaret Thatcher's Conservatives held onto power throughout the 1980s, the less defeatable they seemed. With the disillusionment of the third term victory in 1987, belief in the political force of music declined, and hedonism replaced protest via the decade's biggest underground movement, Acid House. Rough Trade's earnest political correctness began to look decidedly outmoded.

Above: Antony Hegarty of Antony & The Johnsons. Photograph courtesy of Rough Trade Records.

Opposite: Arcade Fire. Photograph courtesy of Rough Trade Records.

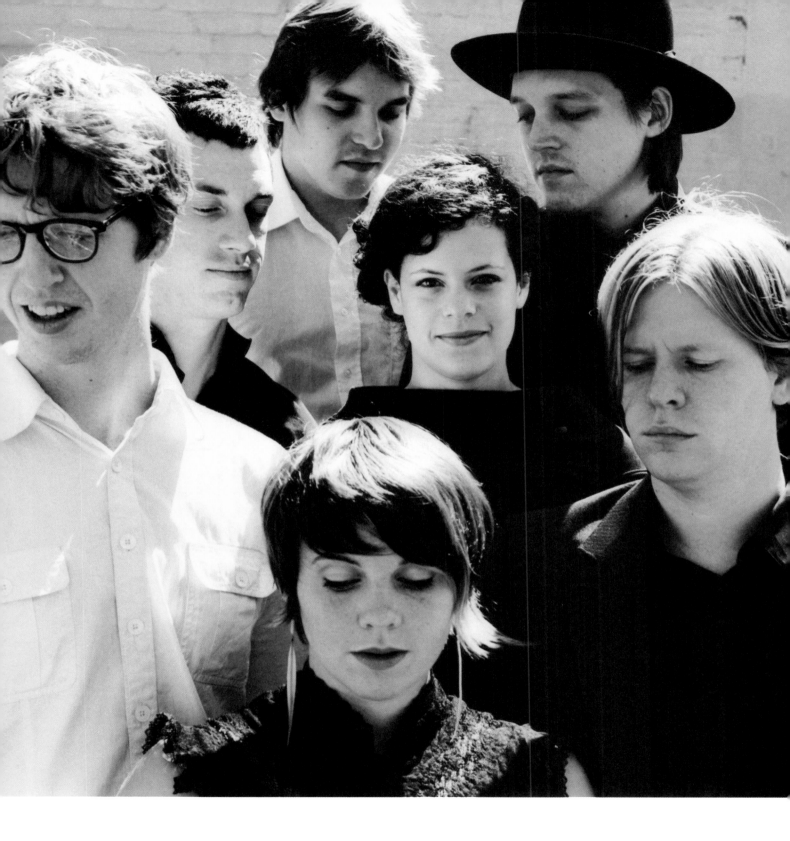

I Am A Bird Now 151

In the late 1980s, the *NME* was also the arena for a debate that divided pop music along racial lines. Rough Trade's first decade coincided with the growth of hiphop—a lightning ascent from the streets to the big time success of Run-DMC, Public Enemy, et al—and underground House and Techno in Chicago and Detroit. The polarisation had been simmering since around 1985, and The Smiths' single "Panic", with its insurrectionary lines "burn down the disco! Hang the blessed DJ!", was factored into the debate, although its bile was aimed at the general irrelevance of pop rather than specifically club music. Still, although the label continued releasing a handful of reggae records and African music throughout the 1980s, there was no question that Rough Trade had emphasised white guitar music and didn't invest in America's urban street sounds.

Rough Trade stands as an example of the model indie label. While it was lying relatively low during the 1990s, there was a population explosion of small labels, as majors began to neglect their role of building artists over long-term periods. The massive growth of the independent sector went relatively unremarked upon due to the failure of many releases to impact on the charts, and instead of the wide inclusiveness of a Rough Trade, Factory or Mute, there was a tendency towards specialisation. Independent labels have become boutique imprints catering to niche communities, often concentrating on a single particular (micro-)genre. It's significant that this trend reached its height in the late 1990s, while Rough Trade itself was at its lowest ebb.

But after 30 years, everything that bears the Rough Trade logo—the record company, the shops, the publishing company—is still seeded with the same essential mindset laid down in 1976. In this alternative universe, challenging music is nothing to be afraid of, and not the preserve of an informed elite, but an adventure to be shared by all. Wherever the label heads in the future under Geoff Travis and Jeannette Lee, the guiding principle is still centred on the exhilarating moment of discovering a musical thrill. "That's what it's all about", says Travis. "It feels like the beginning to us really. We haven't really had a Nirvana, so we're working with the expectation that that will happen, and I think we're due one."

Q&A
GEOFF
TRAVIS
&
JEANNETTE
LEE

Previous page: Geoff Travis in his office,
1978. Photograph by Jill Furmanovsky.

Above (top to bottom): Geoff Travis in
his office, 2006; Geoff Travis & Jeannette
Lee in the entrance to the current
Rough Trade label HQ, Golborne Road,
west London. Photographs courtesy of
Rough Trade Records.

Geoff Travis founded the Rough Trade shop in 1976,
and the record label in 1978. He has run the label
in partnership with Jeannette Lee since 1987.
Interviewed April 2006

Rob Young: I'd like to go right back to the
beginning, to the actual moment when the idea
for Rough Trade came into being—you were
travelling in America?

Geoff Travis: It was really wondering about what to do
with my life, because I had absolutely no idea.... I'd
graduated, I'd finished my degree and that was all good,
and I was wondering what to do next, really, weighing
up what options I had—whether I had any options.
So I decided to go to America for a year to see some
friends and travel around and do that whole bohemian
thing just for fun.

And you picked up a lot of records along the way?

Yeah, Ken Davidson, who started the shop with me, it was
his idea. He said, "What are you going to do with all
these records now?"—there were about 400. And he wanted
to do it with me and he got it started with me. That's
when it got going, really. It just seemed like a really
good idea. That was in 1975, at the tail end I think,
and then we just drove round trying to find the right
location. We made a false start up in Dollis Hill. We
actually paid some rent on a place, started sanding down
the walls.... Then we realised it probably wasn't the
best location, so we packed it in and just drove around
until we saw that wheel outside Kensington Park Road,
and we investigated and we discovered a shop in an old
print workshop, *the* big 'head shop' during the hippy era
in Ladbroke Grove, so it seemed appropriate.

The shop sounds chaotic and disorganised—
a shoplifters' paradise...

Well, the records weren't actually in the sleeves,
although secondhand ones were, they were probably

nicked. The worst thing was that Mick Rock gave us
these brilliant photographs of Iggy Pop and Lou Reed,
the originals that he'd taken, which he'd framed, and
gave them to us just because he liked the shop, which
was very sweet of him, and they all got nicked. That
was a bit of a shame. You know we were held up once?
I think it was knives. They didn't really get much.

Your father lent you start-up money...

Yeah, he lent us £4,000, which helped to pay for some
stock and to kit the shop out.

And was he involved in running it?

No, that was really his contribution. And being
encouraging, supportive about it.... So that was good.
Although he did want me to sell luggage as well! I
remember getting quite annoyed about it, but that's
probably a bit unfair.

Rough Trade was an unusual company. You made
up your own rules about how to do business in
the early days...

It was set up as a collective. And we all got nothing,
basically, for a long time. Then we all got next to
nothing for a long, long time. And then we got almost
next to nothing for the years after that! But it wasn't
really about money, it was about having fun, and having
a place to go and listen to music we wanted to and be
in an environment that you enjoyed. You know, we were
lucky, because the whole punk rock explosion was just
happening and was all around us and we were actually
in the right place.

When you decided to set up the label in 1978, were
you already looking beyond punk rock to what was
coming next?

That's right, the label was very much post-punk, wasn't
it? Metal Urbain was the first thing. We just did up the

shop, and we were more spectators and enthusiasts during punk... I suppose it was really stocking fanzines that was the biggest contribution. I mean, allowing Mark Perry to come and sell *Sniffin' Glue* and *Ripped And Torn* and Jon Savage's *London's Outrage* and Adrian Thrills... and *White Stuff*, lots of brilliant fanzines, really, that we encouraged.

I mean Subway Sect was punk to us... we were involved in those first records and we manufactured Vic [Godard]'s first record and we did a second one. The first wave of punk was just slightly forward and we had thought about becoming a label....

I think that whole thing about The Clash and The Sex Pistols signing to majors was partly the impetus of why we decided we should be doing that.... It seemed really stupid to sign to CBS and then start writing songs about how difficult it is to do a new record. Though we loved The Clash dearly, it just seemed that it wasn't really subject matter you could get excited about... It was that moment when we imported all of those Metal Urbain singles from Paris, and we really loved that record, it was called "Lady Coca Cola" and "Panik". And we just thought about supplying the shop. They all came over from Paris, one day, the whole group, five of them, and they gave me the tape of what they'd just recorded, which was "Paris Maquis", and said, "Can you help us do anything with this?". So that was really the moment... it was them asking us that made us do it really. I don't think we were kind of hatching a master plan to run a label.

> You were practically doing it anyway, manufacturing records on behalf of the labels you distributed...

I'm more interested in the idea of distribution. That was the 'big idea'. And that was important for us, because that helped to combine a network of shops around the country, and I think that was a good idea about regionalisation and distribution, try and get less dependent on London, and to encourage those people to take another step and become a distributor. That was the key thing really, because without that distribution network then the whole idea of being able to do justice to someone's music didn't exist. That was a lot of hard work and it probably took about five, six, seven years to make it really zoom along.

> It was four years until the Cartel was set up—so, culturally, things travelled a long way between 1978 and 82, in terms of what happened to music in that time.

It's not that long actually. I mean it was pretty intense, and of course for the label it was a perfect economy, because it meant that we were almost first port of call for anyone doing anything really interesting. People would just keep arriving with their records, which they'd just recorded. It was pretty exciting, and when people come to you as an A&R outfit then you're in a really lucky position. It was almost an embarrassment of riches really. Green came in the shop with [Scritti Politti's] "Skank Bloc Bologna" that he'd just recorded, and [The Normal's] Daniel [Miller] came into the shop with "Warm Leatherette". Dan Treacy came in with Television Personalities' first record. The Buzzcocks' Richard Boon came down with "Spiral Scratch", that was a mad moment. Crass came in with their records.... People were just coming in all day long with great stuff they were doing. I suppose once they'd recorded it, [they'd think] "What shall I do with it? Go down to Rough Trade and see if they like it."

> So did you have to listen to it in their presence?

Yeah, but that wasn't too terrible because most of them were great! The most persistent people are often the worst.... It wasn't like that.

> And you started attracting celebrities.

Actually, our first two in-store signings were The Ramones and Talking Heads. The Ramones one was packed with people and the Talking Heads one was completely empty! Nobody came except for the band, who were really happy, they were like, "This is great!" And they just stayed in the shop for a couple of hours and had some tea and looked at the records and chatted. They were lovely. And Patti Smith had one as well. She was off her head. She used to wear an aviator hat and always be trying to score. "You're asking the wrong person!"

> Although you say distribution was what you were most interested in, it turned out that your real vocation was handling the A&R side.

I was immersed constantly in the music itself, so I was excited by that whole thing. I used to pack boxes up with the best of them. But apparently my invoicing was a bit suspect, unreadable! Yeah, it was always the music that I was really interested in, and the musicians, but the music primarily. So, I mean doing A&R—being the filter for what we distributed—was my job really.

> But your choices had to be run past the collective?

There was probably a lot more musical discussion than you'd find in most places. But it wasn't really that caricature of everybody sitting round having a debate in a kind of Comintern way. That was just not true ... often, I would just be very autocratic and say, "This is great". I mean it was kind of common sense. You don't have to be a genius to say "Spiral Scratch" is great—everybody liked it. I remember a couple of people in the back of the yard saying that they thought Scritti's "Skank Bloc Bologna" was a bit long, and therefore slightly flawed.... That came out on St Pancras and it could have been a Rough Trade record, I always regretted that. The other record was that Dave Stewart record, with Colin Blunstone called "What Becomes Of The Broken Hearted", which I thought was fantastic, but nobody else liked! So I ended up missing that. It ended up being number four or something in the charts! [actually number 13]

There were some things that distribution refused to distribute, quite rightly. Things like Steve Albini's band called Rapeman, that's puerile to call your band that. People have the right to say what they want to say, but they can be wrong. You have to be able to include everybody, and you have to be rational. But at the end of the day, somebody's got to take responsibility. But there wasn't really a big debate about anything ... the thing is that I'm not aware of them. Maybe they were having debates when I wasn't there! It's quite possible!

> You mentioned the charts just now. At that time was that something that you set your sights on?

Not in the very beginning, not in a kind of conscious way, but then when our first album went into the charts [Stiff Little Fingers' *Inflammable Material*], we were very excited about that. So we were quickly seduced by the idea. And I think both of us were brought up with popular culture, we like to think of ourselves as pretty mainstream, in the sense that we're not snobs in terms of being cultural purists and "Oh, this is the only thing you can like and the rest of it's crap". You want things that you think are great to be heard.

> Around the time Rough Trade was developing, I feel there was this kind of split in pop music ... it became forked in a way. What was in the charts as 'pop music' was one thing. Then there's a whole range of stuff that fanzines would call 'perfect pop', especially as you get more into bands like The Smiths, Aztec Camera, that kind of attempt to write the ideal three minute pop song. There's a certain purism about it as well. There was a sense of the pop music that was in the charts having betrayed those qualities.

Well, when it comes into focus that that kind of music is popular, and then it goes out of fashion again, and then you get moments like The Strokes and The Libertines, where guitar music becomes commercial again for a moment, I don't know. I mean if you talk to Morrissey, he'll say The Smiths never got played on the radio. We didn't get a huge amount of radio in the early days, although they were having hit records just by the sheer numbers of their fans. They were getting on *Top Of The Pops* when it had more meaning. The highest a Smiths single ever got to was number ten, which always seemed a bit of a shame, really ... The Arctic Monkeys can get to number one in a different era. The Smiths now, perhaps they'd be more embraced by a bigger, mainstream audience, perhaps.... Or perhaps they'd just say, "What's that keening, miserabilist, moaning voice?"

The thing is, we weren't really set up to be a pop label in the fully competitive sense. I mean, that moment when Scritti went to Virgin and Aztecs went to Warners, they went with our blessing in the sense that we didn't have enough resources to compete. And we knew that. I think it was The Smiths that taught us how to market records. We didn't really want Johnny and Morrissey to be able to say to us anything other than "Well done, you've done a good job". Otherwise we would have felt really uneasy about it. And they were our first long-term signing. So we made that commitment to them in our minds in a much bigger way.

The thing is, we didn't have any big plans. We just didn't think, "Right, this is the five-year plan, this is what we're going to do." It was pretty much day-to-day.

> Are they mostly good memories from those days? Was it a lot of hard work?

Yeah, it is good memories. It wasn't really work. It was good up until the period when the distribution and the label started to get really separate in terms of those board meetings. And it's only really when it grew so big that there was a structure of middle management put into place that it felt like a really strange and alien place to be. Because then the people that came in felt that there was a career there for them, money to be made. The first flush of Rough Trade people were very much "Well, we're a bunch of misfits, what else are we going to do?" I don't think anybody was thinking, "Wow, this is great. I've found my place in the Civil Service, I'm going to be safe." You never knew what was going to happen next, and that was the exciting thing about it.

> That's always the really difficult thing, isn't it, with that kind of operation? What happens

when you grow, when you become an institution, when you've got some history behind you.

Yeah. I think that's why we're so keen now to try and stay at a relatively modest size. We are ambitious not to be entrepreneurs on a massive scale. You lose the enjoyment of not doing anything. We just like to sell lots of records.

You mentioned that you had a lot of female employees... you also signed a healthy amount of female groups too. Where did that egalitarianism come from? People recall it as unusual for a man in the music business to have a pro-feminist attitude.

I just think it was a very natural... there was lots of feminist debate at university in that period, and it was a serious thing at the time, so it was taken seriously by us. I think if you don't recognise that fact then you're missing out really.

We didn't make a big deal out of anyone's sexuality, it really wasn't important to us. So perhaps we were just a bit more inclusive than other people. And also, we weren't really trying to succeed in that kind of natural selection way. It wasn't like "We're going to succeed, and we're going to trample everybody else." It was more about how can we spread this out, open it up, become a kind of access point for people? That was much more the politics of it. It wasn't about how we can become rich and famous, it was more about what can we do to help people that are doing things and are putting something back into this community?

That inclusiveness is reflected in the music as well. It's really interesting, looking at the diversity of the first three singles that you put out: Metal Urbain, Augustus Pablo, Cabaret Voltaire. It's right there, in those three.

It is, yeah. We'd like it to be wider now than is happening. That's one of the things we'd like to do, we'd like to spread it out again. Yeah, that mixing of cultures is really important.

That's the kind of secret history of the label: us as personalities, we don't really exist in a sense, it's just filtered through our music. And that's a kind of idealised representation of all the things you'd want to say and do and be, but you don't really get the chance.

You weren't ever a musician yourself, were you?

Tone deaf!

No frustrated ambitions then?

Not really. I produced quite a few records in the old days. A lot with Mayo [Thompson], I enjoyed that a lot.

It seems to me like Scritti were the ideal Rough Trade band in 1979, with the whole deconstructing the process kind of thing they did on the sleeves... did they stand out for you?

That's true. Again, they were in their kind of Carol Street world. I went to [their squat in] Carol Street a couple of times but I wasn't really a big part of staying up all night and listening to Green talking about Gramsci.

There was one fantastic trip where Scritti and This Heat played a gig together in Holland. That was really quite wonderful. That was exciting and Green really played very well. Once, at Acklam Hall, they played five songs and they didn't have any more so they played them again!

After you moved the company's offices to Blenheim Crescent in 1979, relations between the label and distribution seemed to deteriorate rapidly. Was it a slow unravelling, or did what eventually happened come as a shock?

I think I felt that some of the new distribution people just weren't very friendly. They were just out for their own ends and were in fact quite jealous of the label— they saw it as the kind of irresponsible, glamour end of the business, and they wanted to organise things properly. I wasn't against organising things properly, but I suppose the inevitable personal politics started to play a part in it. That was the problem really, I think. Then people started to divide into camps, and it was horrible to come in. I didn't feel like it was my job to be worrying about all the distribution issues after a certain point. I just wanted to get on with the label. I always felt that the label was helping to keep distribution going. We always made a profit, we weren't a drain, we were total positive. OK, it reached a point where we were no longer really being the conduit for everyone we were distributing, but we were still helping, I mean we were helping to bring [Creation Records boss] Alan McGee into distribution, and all those kinds of things. So I think it was a bit sad that it just... it's that old-fashioned power struggle that people just can't accept.

Was the argument largely over business or did it also impact on the music, do you think? Did people factionalise around what you should listen to?

No, I think people felt resentful that I was doing Blanco Y Negro. I think that was a big part of it. They felt I was having two jobs and that my allegiances weren't 100 per cent with Rough Trade. I'm sure that caused a lot of disquiet amongst distribution hierarchy.... Maybe that was a bigger impetus for them to try and seize control of everything than I realised at the time... I mean, the distribution issues which brought the company down were all things that should have been dealt with, things like credit control. Parkfield were a creditor owing about three quarters of a million pounds, and that's the job of the accounts department: to chase bad creditors, and that's nothing to do with me in a sense. I don't want to spend my week looking through the books to make sure all the debts have been collected.

And then moving distribution warehouse [to Finsbury Park], taking on two leases... they got a computer. They came and said to me, "What computer should we get?" I said, "I don't know, why don't you see with the other distributors what computers they've got and talk to them?" They went and did that, and then they got a computer that no one else was using. That seemed pretty strange. I don't know anything about computers, I don't want to take responsibility for that, but that took a long time to get working and caused huge problems. Those were the three things that caused the distribution to go bankrupt.

It couldn't have been a worse time really. It seemed like nearly everything just came crashing down like a house of cards... although legally Rough Trade Records was a separate entity to the whole co-operative structure. I'm sure if I'd been a different person I would have said, "Goodbye, see you later", but we couldn't do that because it just wouldn't be fair to walk away when distribution had money owing to Daniel Miller [of Mute] and to Ivo [Watts-Russell of 4AD] and everybody that we considered to be our friends, so we just said, "Take it". We didn't have to do that, but it was morally the right thing to do. So, really a bad ending... and I guess you can blame me for not keeping control of it.... But I didn't think of it as my job to keep control of those things.

In a way it was a victim of the strength of the original idea.

I just think it's bad management. I always say that. I think it's classic: British people seem to have a very poor record of managing things properly, when you look at the number of things that go bankrupt, the number of enterprises that are hit. It just seems that it's not something that we're very good at. It's a national characteristic!

Geoff Travis, 1979. Still taken from *The South Bank Show*.

I just think it grew too big and, people being human, they weren't capable of dealing with it, and they weren't willing to admit they couldn't deal with it. I think if people had put their hands up and said, "God, this is a disaster, everything's getting out of control. The accounts department is out of control, I don't know what the hell's going on anymore", then we could have done something about it. But people don't say that. Everybody soldiers on, trying to make it work.

By the end was there a complete communication breakdown between you and the rest of the company?

I remember having a terrible time with Richard Powell, who I just thought talked absolute rubbish, and I really couldn't stand him.

I think people always see me as being financially irresponsible: "Why are you putting out another record when you could be... counting Smiths royalties or something!"

Did it feel different anyway, after 1982 when it was converted into a trust and you had surrendered your ownership of the company?

Well, you feel pretty conflicted. On one hand you feel good about that; that you tried to make something work as a co-op. On the other hand, you feel really stupid that you just gave it all away! I think that's a feeling I had.

Lee: It didn't actually work, did it? Let's face it.

Travis: It worked for a long time. I think it almost worked until certain characters strolled onto the scene, then I think it all turned. But also it didn't work because perhaps it grew so big; running a huge enterprise is not something that interests me.

That was also the moment when The Smiths appeared... they must have been the thing that really helped Rough Trade to grow.

It did. It was our first long-term signing, it was our first serious commitment to making a commercial project work, and to see how far we could take somebody, as opposed to just putting out a record. There was a different mindset.

Was it a case of needing a chart act at that time?

It was a necessity... what we always say is, we like to work with people. We like to work with the best people we possibly can and the ones we're most excited about. So I think we reached a point where we wanted to try and work for a longer term. We were going to commit all our resources to The Smiths and we wanted to have some kind of security. We don't often think like that— we would still make stupid one-off deals all the time.

Did they pester you in your kitchen with their first demo?

That was Johnny walking in and dropping off "Hand In Glove". They didn't have to work very hard—they just had to take a train ride down from Manchester! After that it was a merry dance trying to sign them, but they'd been turned down by EMI, that's the incredible thing.

The first time you saw them play?

That was amazing. Yeah, they were great. Seeing Morrissey on stage was pretty much a revelation at the Rock Garden. He was fully formed then. Dancing about, it was great. Then again, I remember some people at Rough Trade were saying, "I'm not sure about this lot." You have to think, "OK, fine, well don't worry, soon you'll be convinced". You have to have that kind of ridiculous belief. Same with the band. If you take a consensus of opinion, I think you've had it... you end up signing Shed Seven!

How did the relationship work? Again, measured in years, it's quite a short period. That must have been very intense...

It was a hurricane, yeah. Joe [Moss] was the manager at the beginning, but he didn't last very long. I think he felt they became unmanageable. He decided he'd rather remain Johnny's friend... I think Morrissey found it very hard to have a manager that was skewed more towards one than the other. And I don't think they ever found that perfect manager who was able to balance the two together, which is part of their tragedy really. Had they done that, they would have probably lasted. But it was fine, because Morrissey took care of business and Johnny took care of the music—it was the perfect combination. Morrissey was awake in the daytime and Johnny was awake at night. So Morrissey would do everything, talk to us almost every day, Jo Slee would do the sleeves....

For a record label, it was a dream, because they were so fully formed and they knew what they wanted to do, and they were so fast. If they had a John Peel session to do on Tuesday, they'd write four songs over the weekend. They saw it very much as their job. It's a wonderful attitude.

Lee: It wasn't just Johnny's philosophy?

Travis: No, both of them had that 60s thing of "This is what we're doing". And their musical knowledge was just unbelievable... insatiable, huge,

oceanic knowledge of all music, well, a particular type of music... Morrissey knew more about girl groups than anybody that I'd ever met. He still has that love for music, Morrissey... and that's the side of him you want to know!

It was good fun, but everything was on the run. I made decisions about singles in about three minutes. "That's a great track, why don't we do that as a single?" "OK, sounds good to us. We'll do it next week!" Or "Tomorrow—what's happening tomorrow? Do it tomorrow!"

Were you their surrogate manager?

In a way, yeah. I mean, Rough Trade people were surrogate managers. Not only me... people like Jo, and Scott Piering, he was quite close to them.

Do you think it worked because you weren't officially the manager?

Yeah, I think so... I mean, they had their lawyers, and they had their advisers and their producers, so it wasn't as if they were exploited in a naive way. You know, we helped and got them signed to Sire in America...

Wasn't there a 12" of disco mixes of "This Charming Man", which they objected to?

Yeah, François Kevorkian. Which they disavowed at the time, and now I think Johnny's really into it! I asked if I could do it. To be fair, they didn't really say much, but at the same time they said OK. But Johnny was really into dance music, it's just that Morrissey wasn't—at least in his public persona.

They obviously developed reservations about the way the label handled some issues. Some single choices they didn't agree with... was this disputed at the time?

No, I think it's the other way round... they wanted "That Joke Isn't Funny Anymore" to be the single and I thought that was a good B side. No, we would never have released a track that they didn't want as a single—that would never have happened. So I think it's with the benefit of hindsight that they're saying that now. Morrissey absolutely insisted on that being the single. And that was really a poor choice.
Lee: I know that would have been the end of your relationship if you'd released something they didn't want.
Travis: Exactly, of course.
Lee: With any artist, that's the thing. If you release a record they're not happy with, then that's the end of it.

Travis: You'd never do that with anybody. We wouldn't do it now, we wouldn't do it then. We'd never put out a track as a single that they didn't want. The problem with them was that they'd been so impeccable in their judgment that you almost had to give them the benefit of the doubt in situations like that. But then when they didn't do as well, then it was our fault, of course... That's the dynamic. What was the other one?

"Shakespeare's Sister"?

Yeah, but that did pretty well. It got to about 14 [it was actually 26], and that's a great track. I think "Last Night I Dreamt That Somebody Loved Me" was a bad choice, that was the only other one. So that's not too terrible a track record, considering their first seven singles are about as good as it gets!

So was it a shock to find yourself in a legal stand-off over The Queen Is Dead?

I just think it's all down to that thing of the grass is greener. "Why aren't we riding around in our own Boeing 747 with our name emblazoned on the side?" It's all that kind of mentality.
Lee: It's like, "If we were with another label, this is what we'd have."
Travis: Exactly. And also, "We want a Peter Grant of our own, we want to be riding around in limousines, and if we're so great, then why aren't these things happening?" That's just not reality.... But it's a very easy way of displacing your internal problems, by focusing on that kind of rubbish.

When the record emerged, with the barely veiled attack on you and Rough Trade in "Frankly Mr Shankly", how did that feel?

I don't really care too much. I mean, everyone has their moods! I felt a certain sense of betrayal, yeah. I felt betrayed at the end.... When they signed to EMI and then never actually gave EMI a record, I thought there was a certain poetry to that.

I think we did a good job with The Smiths and I don't have any regrets about that. Did Johnny and Morrissey go on to sell millions and millions of records after they left Rough Trade? I don't think so... I wish them nothing but well, but I think they realise that, if you talk to them now, I don't think they could really say that they underachieved while they were with Rough Trade. And also, in a conventional sense, they did very little, in the sense that they [only] toured America about one and a half times. But they still sold about half a million copies of every record, which is pretty decent.

Could things have turned out differently?

It probably would have been much, much better for Johnny if there'd been a stronger organisation around him. Then on the other hand, you've got the paradox of Morrissey wanting to be in control of everything, and how would he accept an organisation that had any strength to it? So you've got a dynamic that doesn't really work. He's just a paradox. He needs to be in control of what he does and it's part of what makes him weird really. It doesn't really make for a concerted campaign in a normal kind of sense. And you have to accept that—comes with the territory. But of course, the characters that are involved don't accept that.

One of the things we would be mortified about, is if we felt we had sort of been responsible for them highly underachieving in anything that deserved to do better or well. I think we take that really seriously. I mean, we're not frivolous about it or anything.

When was the last contact you had with any of them?

Well, I still talk to Morrissey. He rings me up every once in a while for advice ... and Johnny is always charming when I see him. I mean, Morrissey knows that I don't think his band are as good as The Smiths, but then they're not, so what can I do! He's always like, "Why are you talking about The Smiths? What about what I've been doing?" And I think that's fair, isn't it? I do admire the fact that he's kept that group together for so long, I think that shows a lot of loyalty. I mean, Elvis Presley once had a crap band—I don't see why Morrissey can't! He's still pretty magnificent really.

Jeannette, how did you become a part of Rough Trade?

Lee: I'd been off having a baby, I hadn't done anything for 18 months. And then I got this call from a mutual friend of ours saying, "Geoff Travis has had this idea maybe you'd fancy coming to work with him." We went to Vivien Goldman's birthday party, and Geoff and I sat next to each other, and we just started talking about music and people. And Geoff said, "Come and work with me". I was saying, "I don't have any office skills at all, can't do anything like that." He was saying, "It doesn't matter, just come and work with me, it'll be great fun!" I remember thinking, maybe I'll just do it for a month or something. That was 20 years ago! [When I started in 1987] everything at Rough Trade reeked of The Smiths. It was all conspiratorial and everyone wanted Morrissey's attention, and it was all a bit weird

Travis: I just wanted to have a partner in crime, really! You know, someone who understood, which is hard to find.

Did the culture of the company change from that point?

A horrible series of terrible things happened, it was kind of a miracle we managed to stay together during that period. Going to Finsbury Park and all the rest of it. It was just one nightmare after another for about three years.

Lee: I'm sure it did change at that point because everything went upside down really quickly—we just became a team. It was definitely 'us and them' for a while, in a nasty scrum. We had a really good roster at that time, though—The Sundays, Mazzy Star Lots of great music, even though I think everyone at Rough Trade was just mourning The Smiths.

In the wake of The Smiths, to what extent did you start looking to different areas of music to fill the hole?

Travis: You don't think, "I've got to make "Planet Rock" because no one else is." You couldn't pre-plan it or second-guess it. There's a set of circumstances that lead up to that point It's a magical moment. And as a record label, you just hope to be lucky enough to be around for some of those moments. You just have to keep your eyes and ears open.

We tried to sign Run-DMC. And we tried to licence De La Soul's first album, but we failed. But at least we tried ... And we tried to sign Prince. There's lots of things we would like to have done that we never quite managed. Releasing Run-DMC's first album would have been good We were always talking about NWA, weren't we, as well? Those are the things we should have done. That's the missing part of our history that we really should be more involved in. That will be the future.

Lee: Yeah, I agree. More black music, generally.

Travis: It's partly to do with not being in America and having a real relationship with the people you work with—it's quite hard to do if you're not in the culture. You don't really want to be a tourist. It's tricky.

After Rough Trade crashed in 1991, it didn't take you that long to get a new label back up and running.

We made loads of false starts, didn't we? We went and did a deal with One Little Indian and we did one with Island Records and that took a lot of years ... which

were kind of wasted years, in a sense that ... perhaps the disillusionment with Rough Trade was so horrible that it kind of put the idea of Rough Trade to the fringes of things for a long time.

Lee: I don't think they were wasted years, because in those years, that's when we developed a management company. Again, we weren't intending to be managers, but people came to us and asked us to manage them. We managed The Cranberries at first, and then we managed Pulp, and we still manage Jarvis Cocker. I don't think of it as wasted time, just slightly sidetracked. We were still working with bands that we loved. Then at the end of that period [in 1999], we started talking to Sanctuary and got some reinvestment and discovered The Strokes, practically all at the same time.

Travis: And within probably five months, The Libertines came along. We got off to a really, really great start. A lot of momentum. I think that momentum has carried on until now. I feel we've been on a roll for the last five years really.

Lee: I've enjoyed it. I mean we've had a good relationship with the two of them [The Libertines' Pete Doherty and Carl Barat], and we're really fond of them. Sometimes you just want to strangle them, obviously. You can't get on with anything without some ridiculous drama. But they have been absolutely great to work with.

Travis: They were as good as any band we've ever worked with in the early stages.

Lee: We think they've been underestimated as songwriters. There's so much fuss about everything that they do, and because they're noisy and punky, people don't really realise how good the words are, and what a great collaboration they were as songwriters.

Were they equal to the Morrissey and Marr partnership?

Travis: Yeah. Definitely, yes.

Lee: They reminded me a bit of Mick Jones, and that's one of the reasons we put them together with Mick [the former Clash member produced the group's albums *Up The Bracket* and *The Libertines*, plus *Down In Albion* by Doherty's subsequent group Babyshambles]. The relationships were similar. I agree that they've been underestimated as songwriters. Hopefully that will come out eventually. It's been the heat of the moment for the last three or four years ... such an exciting time. We had The Strokes, and The Libertines were getting into trouble every single day of the week. It was a little bit annoying in some respects, because you couldn't get on with work, but on another level, it was really fun and exciting.

You're reliant on the time being right for your decisions as well, aren't you? There was something interesting going on in the early 90s with Disco Inferno and Butterfly Child, but it was drowned out by Grunge.

Travis: We spent a long time trying to make a record with Disco Inferno actually. All those things started up in a burst of brilliance, and then lost their way quite quickly.

Lee: We put a lot of love into Disco Inferno particularly, I think. There was a lot of redoing it. We kept going back and back, trying to make it work.

Travis: But yeah, it wasn't really the right time for what people wanted, but that never bothers us. They could have changed the terrain. So although it's true that what they did fell on fallow ground, it wouldn't necessarily have remained the same if they had kept doing it. Quite often things like the Young Marble Giants come out with something completely different and a bit old school, and everyone stops in their tracks and thinks, "well, this is interesting". There was a time when we were just mad about drum 'n' bass. That was a very exciting time. And in a way, working with Spring Heel Jack was an attempt to put out a drum 'n' bass record.

Lee: That was when we went to [Talvin Singh's club] Anokha every Monday night, non-stop.

Travis: We don't seem capable of signing an act that we don't really like—even if it might be hugely successful. And I debate with myself whether that may be a fault. We've turned down so many things that turned out to be huge. It's probably a strength.

Lee: I don't think it's a fault at all. If you don't understand, don't love something for whatever reason, for me personally, I don't want to be involved with it. Sometimes when you see something huge, you think "Oh God, that could have been us", but I still wouldn't want to have done it for that reason.

When you regained the use of the Rough Trade name from One Little Indian at the turn of the century, how did your deal with Sanctuary come about?

Lee: There was a guy called Dai Davies, who used to manage Levitation, who was involved for a long time. Really nice Welshman, who's been in business for a long time, and was originally with the people who did David Bowie. One day he just called up and said to Geoff, "Sanctuary have money to invest and your name came up, why don't we try and do something together?" And that's pretty much how it started.

Travis: We'd never heard of them at that point. But once we met them it seemed to make sense, and the first couple of years were great.

Back in the 70s, you said you wanted the label to provide the psychological conditions for artists to make their best work. Is that still true?

Travis: It's still true. We have really good artists and I think it makes a huge difference to the standard of work that the other artists are producing, because everyone competes with each other to be the best. I think that's healthy. We don't accept things that are less than the artists are capable of. If you're in a Rough Trade band and you listen to Arcade Fire, you think, "That's the standard that's been set. I want to do that too. I want to have that effect on the world." I think it does work like that. I mean, if you're on a huge label with hundreds of artists, it doesn't inspire you in the same way. We encourage artists to get to know each other—I think that's a healthy thing to do. That's what inspires creativity.

If Rough Trade was a person, how would you describe its character?

[Long silence]

Travis: It's an aggregation of the artists, like a colony of bees ... Tiny Tim with talent.

Opposite: Horace Andy. Photograph by Peter Anderson.

A—Z

Horace Andy

Born Horace Hinds in 1951 in Kingston, Jamaica, Horace Andy's characteristic falsetto vocal style first came to prominence in the late 1960s. In 1970 he recorded for Coxsone Dodd's Studio One label and sang on many classic productions for reggae producers, including King Tubby, Prince Jammy and Bullwackies. He emigrated to London in 1985, where he signed to Rough Trade and released the dancehall-tinged "Elementary", followed by an album of the same name in 1986. He later became a regular collaborator with Massive Attack.

The Apartments

The Apartments were formed in 1978 by Peter Milton Walsh (vocals/guitar), Peter Whitby (bass), Peter Martin (drums) and Michael O'Connor (guitar). Only after breaking up in 1979 did they release their debut EP, *Return Of The Hypnotist*. Walsh, the band's chief songwriter, briefly joined The Go-Betweens, a tour of duty commemorated on their track "Don't Let Him Come Back". The Apartments reformed in 1984 and signed to Rough Trade the following year to release their debut LP *The Evening Visits ... And Stays For Years*, which featured a cameo appearance by Ben Watt of Everything But The Girl. After Rough Trade's demise, *Drift* was released in 1992 in France, followed by three more LPs in quick succession; *A Life Full Of Farewells*, 1995, *Fête Foraine*, 1996, and *Apart*, 1997.

AR Kane

AR Kane were Alex Ayuli (A) and Rudy Tambala (R). As part of M/A/R/R/S, with members of Colourbox, they had a surprise number one hit with 1987's "Pump Up The Volume". AR Kane's early singles—"When You're Sad" (One Little Indian) and "Lollita" (4AD) pitched them as a noise pop outfit in the wake of The Jesus & Mary Chain. They put out their "Up Home" 12" and critically acclaimed album *69* in 1988 on Rough Trade. This was followed by *i*, 1989, a more polished and diverse album than its predecessor.

Ayuli moved to California but the duo released one more LP, *New Clear Child*, in 1994. Tambala continued as Sufi, while Ayuli currently runs the Dreampop label.

Virginia Astley

Born in 1959 in Cheshire, Astley's career stretches back to 1980 when she played keyboards for The Victims Of Pleasure. Before her solo career blossomed, she also composed and sang for The Ravishing Beauties alongside two fellow students from The Royal College of Music, Kate St John and Nicola Holland. She also worked with Prefab Sprout, Fairground Attraction, Dave Stewart, David Sylvian, The Semionics, and poet Anne Clark. From the start of her career her strongest influence was her father, Edwin Astley, a composer who wrote theme tunes for such 60s TV series as *Dangerman* and *The Saint*. She signed with Why-Fi in 1982 and released *A Bao A Qu*, which laid her classical music influences bare. *Love's A Lonely Place To Be* was released on her own label, Happy Valley, and distributed in August 1983 by Rough Trade, who have since reissued it. Rough Trade has also recently reissued her ambient pastoralia record *From Gardens Where We Feel Secure*, 1983, produced by John Foxx. Despite great fame in Japan, Astley remains a cult artist in her own country.

Aztec Camera

The Glaswegian semi-acoustic group made their name with 1981's "Just Like Gold" single on Postcard before sliding over to Rough Trade for a string of hit singles, including "Pillar To Post", "Oblivious" and "Walk Out To Winter", 1982. Over the years, the group's line-up has changed several times, but songwriter Roddy Frame (guitarist/vocalist) has remained constant. Campbell Owens (bass) and Dave Mulholland (drums) were other founding members who subsequently left prior to the release of their debut album, *High Land, Hard Rain*, 1983. They were signed by WEA, who re-promoted "Oblivious" to better effect. Six albums later, with the release of *Frestonia*, 1995, Frame dissolved the group to go solo.

Band Of Holy Joy

Formed in New Cross, London, in 1984. The line-up of Johnny Brown (vocals), Adrian Bailey (trombone), Bill Lewington (keyboards/banjo), Karel Van Bergen (violin), Alf Thomas (accordion) and Mark Cavener (double-bass) heralded an acoustic, guitar-free, English urban folk sound. Brown's songs were rousing and optimistic, a backlash against hard-right policy signifying a generation's discontent with an oppressive Thatcher government. The group debuted with the EP *The Big Ship Sails*, 1986, followed by *More Tales From The City*, 1987, both distributed through the small indie label, Flim Flam. Rough Trade issued the acclaimed *Manic, Magic, Majestic* in 1988, but despite a promotional tour of the Soviet Union, the follow-up *Positively Spooked*, 1990, failed to deliver the expected commercial returns, and the collapse of Rough Trade in 1991 further slowed the group's impetus. A year after their final album, *Tracksuit Vendetta*, 1992, they disbanded, although they have made sporadic reappearances since.

Beat Happening

Based in Olympia, Washington, Beat Happening recorded their first EP *Three Tea Breakfast* while on a trip to Tokyo in 1983. Calvin Johnson (guitarist/vocalist) alongside Brett Lunsford (guitarist), and Heather Lewis (drummer/vocalist) helped found the indie label K Records, through which their work has been released. The albums *Beat Happening*, 1985, *Jamboree*, 1988, and *Dreamy*, 1991 established Beat Happening's popularity with fans of *C86*-style whimsy and lo-fi aesthetics. The group reconvened after a lapse of eight years to release the single "Angel Gone" in 2000.

The Blue Orchids

Founder members of The Fall, Mancunians Una Baines (keyboards/vocals) and Martin Bramah (guitar/vocals) fell out with Mark E Smith and formed The Blue Orchids in 1979. Along with Rick Goldstar (guitar), Steve Toyne (bass) and Joe Kin (drums), The Blue Orchids signed with Rough Trade in 1980 to release their first single "The Flood"/"Disney Boys". The group's debut album a year later, *The Greatest Hit (Money Mountain)*, met with outstanding reviews for their punk-infused sound of half-spoken/half-sung lyrics, psychedelic Hammond organ and punchy guitars. The group disbanded shortly after recording the EP *Agents Of Change*, 1982, regrouped in 1985 with Baines and Bramah at the core before splitting up once more following a string of performances in Germany and Austria. In 1991, after outside collaborations, Bramah reformed The Blue Orchids—this time without Baines and with all new musicians. A retrospective of their work from 1980 to the early 1990s, *A Darker Bloom*, was released by Cherry Red in 2002.

Butterfly Child

Led by Belfast native Joe Cassidy, cosmic post-rock outfit Butterfly Child appeared in 1991 with two well-received EPs on AR Kane's H.ark! label. Signing to Rough Trade in 1993, Butterfly Child released the Ghetto Speak EP and the sparkling *Onomatopoeia* album before Cassidy relocated to Chicago, maintaining a low profile ever since.

Cabaret Voltaire

Cabaret Voltaire began in Sheffield in the early 70s, as bedroom tape and noise experimentation by Stephen Mallinder, Richard H Kirk and Chris Watson. The group's early experiments with dada/*Clockwork Orange*-inspired performance art morphed into punishing electronic tirades infused with punk energy. The group signed to Rough Trade in 1978 and released a string of highly regarded singles, incuding "Do The Mussolini (Headkick)" and *The Mix-Up* EP. Their debut album *The Voice Of America*, 1980, was followed by the acclaimed *Red Mecca*, 1981. The punk influences of these first two albums were less prevalent on their third release, *The Crackdown*, Virgin Records, 1983, which focused the sound into a cleaner version that pointed the way towards developments in House and Techno, which they themselves pursued on subsequent recordings. All three have now separated; Mallinder lives in Australia; Kirk releases Techno under his own name and Sandoz; Watson is a sound artist and award winning recordist for BBC wildlife programmes.

Camper Van Beethoven

David Lowery's Santa Cruz outfit took their cue from the goof-off chug-rock of Jonathan Richman and the Modern Lovers, with a dash of countrified violin and lyrical surrealism. Although they put out eight albums in all, "Take The Skinheads Bowling" is the one song they'll be remembered for, and it appeared prominently in the Michael Moore film *Bowling For Columbine*.

Chris & Cosey

After the split of Throbbing Gristle in 1981, founder members Chris Carter and Cosey Fanni Tutti signed to Rough Trade and embarked on a duo career that found them anticipating the repetitive beats and sampling of later Techno and electronica, with Tutti's vocals to the fore. Their first single, "October (Love Song)", was released in 1982, following 1981's *Heartbeart* LP. Other work for the label includes the albums, *Trance*, 1982, *Songs Of Love And Lust*, 1984, *Techno Primitiv*, 1985, and Carter's solo album, *Mondo Beat*, 1985. The couple currently record and perform under the name Carter Tutti for their own CTI imprint.

The Clean

Formed in New Zealand in 1978 by brothers Hamish and David Kilgour, The Clean were one of the raft of export NZ indie groups on the Flying Nun label. They broke up around 1983 before reuniting in 1989 for a show in London, which led to their first and only recording for Rough Trade, *Vehicle*. Since then, they have regrouped intermittently, and worked on separate and solo work, including bassist Robert Scott's other Rough Trade group, The Bats.

Ivor Cutler

Glaswegian poet, humourist, raconteur, musician—Cutler was known for his surreal, idiosyncratic, and sometimes melancholic songs about the minutiae of everyday life, delivered in a lugubrious Scottish brogue. Born into a middle class Jewish family in 1923, he began writing songs at the age of 34 and soon became a popular fixture on the BBC's Home Service. Being a favourite of the late John Peel, and appearing in The Beatles' 1967 film *Magical Mystery Tour*, brought Cutler to a new audience, and he went on to release music on Virgin and Harvest before recording three albums for Rough Trade: *Privilege* (with Linda Hurst) in 1983, *Gruts* (with Phyllis King) in 1986, and *Prince Ivor*, also in 1986. Rough Trade also released Robert Wyatt's cover version of Cutler's "Grass" as a single in the mid-80s. Cutler died in March 2006.

Disco Inferno

Disco Inferno formed in Essex in the late 1980s by Ian Crause (guitar & vocals), Paul Wilmott (bass), Rob Whatley (drums) and Daniel Gish (keyboards). Their first releases on Che betrayed the influence of late 1970s post-punk doom-mongers such as Joy Division, but the trio's methods were ahead of their time: Crause's guitar and Whatley's drums were hotwired to allow them to play samples instead of their expected sounds. Nevertheless, their innovation never translated into sales, and the group split before their final album *Technicolour* was released in 1996.

Dislocation Dance

Spiky post-punk/jazz crossover from the four piece which came through on Richard Boon's New Hormones label with 1981's *Music Music Music*. Voted 'band most likely to make it' in the 1983 *Smash Hits Annual*, they packed it in after a second LP, *Midnight Shift*, on Rough Trade in 1984. Trumpeter Andy Diagram went on to work with Pere Ubu's David Thomas in Two Pale Boys.

The Dream Syndicate

Guitar-driven outfit from LA that existed from 1981–89, originally associated with the Paisley Underground collision of psychedelia and country rock. Despite a classic album, *Days Of Wine And Roses*, released on Rough Trade, 1982, the group's founders Steve Wynn and Kendra Smith eventually tired of the project. Wynn formed Gutterball; Smith went on to work with David Roback in a duo that eventually became Opal.

Easterhouse

British mid-80s rock group known for jangly guitars and leftist political leanings. *Contenders*, Easterhouse's abortive shot at American success, almost made good on the group's lofty goals. Songs like "Out On Your Own", "To Live Like This" and "Cargo Of Souls" vilified various institutions (including the British Labour party) without losing sight of the human cost of governmental oppression. Shortly after *Contenders* was released, the internal contradictions broke the group apart. Frontman Ivor Perry briefly replaced Johnny Marr as guitarist in an attempt to reform The Smiths in 1987, with no success.

Essential Logic

The core of this group was Lora Logic (née Susan Whitby), teenage saxophonist with punk legends X-Ray Spex. The group also consisted of Ashley Buff (Philip Legg/Phil Lip) on guitar, Mark Turner (Base) on bass, Rich Tee (Tea) on drums and Dave Wright on tenor sax, and formed in 1978 after Lora's departure from her former group. Essential Logic began by releasing the single "Aerosol Burns" on their own Cells label, in association with Rough Trade, before recording an EP for Virgin the following year, and then returning to Rough Trade in 1979 for their second album, *Beat Rhythm News*.

After Essential Logic disbanded, Logic continued to record for Rough Trade as a solo artist, with the EP *Wonderful Offer* in 1981, and the album *Pedigree Charm* the following year. The urgency of earlier Essential Logic compositions was replaced by a more funk-flavoured confection, which featured some of her old bandmates and reflected her newfound contentment after joining the Hare Krishna movement. Logic also collaborated with fellow Rough Trade artists The Raincoats, Scritti Politti, Swell Maps and Red Crayola. The Essential Logic compilation, *Fanfare in the Garden*, was released on the US label, Kill Rock Stars, in 2003.

The Fall

Still recording and performing nearly 30 years after being formed in Manchester by the inimitable Mark E Smith, the group has become an independent music institution, albeit a chaotic and unstable one, celebrated for its riotous, ramshackle sound. Named after Albert Camus's novel, *La Chute*, the group is notorious for its line-up changes, based around the core of Smith, and has previously included Una Baines on keyboards and Martin Bramah on guitar, who went

on to co-found The Blue Orchids in 1978, as well as Mark E Smith's former wife, Brix Smith, on guitar, and his current wife, Elenor Poulou on keyboards. The group released some of their finest work while signed to Rough Trade, including *Totale's Turns (Live)*, 1980, *Grotesque (After The Gramme)*, 1981, and *Perverted By Language*, 1984. They left after Smith became disgruntled with Rough Trade's politically correct stance, and the implication that they were favouring another younger Manchester group, The Smiths.

The Feelies
New Jersey outfit formed in 1976 by Glen Mercer & Bill Million (guitars), Keith Clayton (bass), Vinnie DeNunzio (drums) and Dave Weckerman (percussion). In 1980, the group released their first single, "Fa Ce La", on Rough Trade, and the same year, after a line-up change, they signed to Stiff Records and released the album *Crazy Rhythms*. This record, which was reportedly extremely influential on the formative REM, served as a contrast to the punk/new wave musical environment at the time, and perhaps this contributed to the fact that the album was not a commercial success. The following years brought a separation from Stiff, several line-up changes, a second album (produced by REM's Peter Buck), a cameo appearance in Jonathan Demme's *Something Wild*, and several side-projects (such as The Tyde, Speed The Plough and The Yung Wu).

Float Up CP
Notable for the presence of a young Neneh Cherry, the group was formed in 1984 out of the ashes of her previous jazz and funk influenced unit, Rip, Rig & Panic. Like that group, Float Up CP was formed in association with Bruce Smith and Gary Sager of The Pop Group, with Sean Oliver. Float Up CP had a more commercial flavour and intent but they only released one LP, *Kill Me In The Morning*, 1985, before Cherry departed for a lucrative solo career.

Galaxie 500
Blissful, dreamy 'slowcore' from the USA, courtesy of guitarist and singer Dean Wareham, drummer Damon Krukowski and bassist Naomi Yang, who formed the group in 1987 after meeting at Harvard University. Influenced by groups such as The Velvet Underground, Joy Division and early New Order, they signed to Rough Trade and achieved underground success in the UK, recording two sessions for John Peel. The group disbanded in 1991 after the sudden departure of Wareham, who went on to form Luna (initially supported by Travis's reformed Rough Trade). Krukowski and Yang went on to release an EP under the name Pierre Etoile, but now record and perform simply as Damon & Naomi. The group's distinctive,

slow, atmospheric style (cultivated with producer Kramer) anticipated the crawl of future Rough Trade act Low. The group's back catalogue was reissued by Rykodisc in the 1990s. Wareham has teamed up with singer Britta Phillips; Damon & Naomi are still a going concern, and Krukowski runs Exact Change, a niche publishing imprint specialising in avant-garde and surrealist writing.

Giant Sand
Overseen by singer-songwriter/guitarist/pianist Howe Gelb, Giant Sand's membership has shifted over the years to include members of Calexico, Green On Red and The Go-Gos. The group's desert blues/rock has amassed a huge discography; their association with Rough Trade occurred with the early 90s LP *Ramp*.

The Go-Betweens
Grant McLennan and Robert Forster met at Queensland University and began writing songs as The Go-Betweens in 1978, influenced by New York new wave artists like Television and Patti Smith. They were later joined by Lindy Morrison on drums, Robert Vickers on bass, Amanda Brown on violin and oboe, and John Wilsteed on bass. Their songs were literate, emotional yet restrained in tone; Rough Trade released the singles "Hammer The Hammer", "Cattle And Cane", and "Man O'Sand To Girl O'Sea", and the band's debut album *Send Me a Lullaby* in 1981. They went on to sign with Beggars Banquet for their late 80s peaks *Liberty Belle And The Black Diamond Express* and *Tallulah*; and after splitting up, reformed in 2000, finally achieving the recognition and success in their home country that had previously eluded them. McLennan died suddenly in 2006.

Gregory Isaacs
Jamaican reggae singer Gregory Isaacs released a number of self-produced singles on his African Museum label, formed in 1973 with Errol Dunkley. Rough Trade issued *Live At The Brixton Academy*, 1985.

Jah Shaka
Jah Shaka is one of the UK's most uncompromising and powerful dub warriors, active since the early 70s. *Revelation Songs*, 1983—engineered by a young Mad Professor—is the pinnacle of Rough Trade's reggae releases, a conscious and deeply felt statement of Rastafarian values.

Kleenex
This Swiss all-girl punk band formed in Zurich in 1978 and were known as the Swiss Slits. In 1980 the group changed their name to Liliput (following the threat of legal action from the Kimberly-Clark company) and remained under that name until they broke up in 1983.

Their thrashy sound combined husky vocals, lyrics in both English and German, and crashing drums and guitar, and it proved a success with John Peel. Their debut 45, *The Kleenex* EP and the follow up *Ain't You* reached Number One in the alternative charts.

Bill Laswell
The American bassist and producer draws upon a myriad of musical genres, including funk, trance, world music, dub, ambient and jazz. A key player in Massacre and later Material, Laswell released his *Baselines* LP on Rough Trade in 1984. More recently, Laswell has remixed the works of Bob Marley (*Dreams of Freedom*), Miles Davis (*Panthalassa*), and Carlos Santana, and played with the likes of John Zorn as well as his new group Methods Of Defiance.

Levitation
English psychedelic post-rock outfit fronted by ex-House Of Love guitarist Terry Bickers and featuring Dave Francolini (drums) and Christian Hayes (The Cardiacs, guitar) amongst others. Levitation's music and attitude challenged an early 90s UK alternative music scene dominated by shoegazing and Madchester. Rough Trade released their third EP *World Around* and studio album *Need For Not* in 1992, but the group's intensity caused them to burn out the following year, with Bickers announcing his departure from a London stage.

Los Lobos
The American Tex-Mex/country/folk outfit, who made the bigtime with their Ritchie Valens covers for the soundtrack to the film *La Bamba*, were picked up by Rough Trade in 1984 with the LP *And A Time To Dance*.

Luna
Luna was formed in 1991 by Dean Wareham after the breakup of Galaxie 500, with Stanley Demeski and Justin Harwood (Demeski formerly of The Feelies and Harwood formerly of New Zealand band The Chills). Wareham continued until their final concert in New York in 2005.

Thomas Mapfumo & Blacks Unlimited
'The Lion of Zimbabwe' achieved immense popularity through the politics of his music, which addressed issues of poverty and social problems in his homeland. Mapfumo released his classic *Chimuranga For Justice* LP on Rough Trade in 1986; as a political exile resident in the US he continues to tour internationally, and still sings and speaks out about the problems of Zimbabwe.

Mazzy Star
Caustic, country-influenced alternative rock unit formed in 1989 from Opal, a collaboration of Rain Parade guitarist David Roback and bassist Kendra Smith (see The Dream Syndicate). They were later joined by Smith's friend Hope Sandoval on vocals. Smith soon left the group. The song "Fade Into You" brought the group some success in the mid-90s, but their best moment was the album *She Hangs Brightly*, 1989. Although they never officially broke up (the group is officially dormant), Sandoval went on to found The Warm Inventions, and is still signed to Rough Trade.

Metal Urbain
Rough Trade's first release in 1977 was Metal Urbain's "Panik"/"Lady Coca Cola". With vocals by Clode Panik and Erik Debris, Rikki Darling, Hermann Schwartz and Pat Lüger on guitar, and Zip Zinc, Eric Débris, Charlie H on synths, the group has been eternalized as the first to use synthetic percussion in a punk-rock context. Their unique medley of influences (The Clash, The Sex Pistols and Lou Reed to name a few) and the relentless aggression of their sound made them a hit in England, although that popularity never transferred itself to their home country. The group broke up in 1979, with Eric Debris, Hermann Schwartz and Pat Lüger continuing their careers with the groups Metal Boys and Doctor Mix & the Remix, both of which released records on Rough Trade.

Microdisney
Irish musical duo formed in 1980 by Cathal Coughlan (keyboards, vocals) and Sean O'Hagan (guitar). Their two Rough Trade albums are *Everybody Is Fantastic*, 1984, and *The Clock Comes Down The Stairs*, 1985. After two further LPs for Virgin, who financed an increasingly lush sound, the group disbanded in 1988, with Coughlan forming Fatima Mansions and O'Hagan The High Llamas.

Miracle Legion
Connecticut based jangle pop group begun in 1984, consisting of singer Mark Mulcahy, guitarist Mr Ray Neal, drummer Jeff Wiederschall, and bassist Steven West. Often compared with REM, their first album, *Surprise Surprise Surprise*, was released in 1987 on Rough Trade.

The Monochrome Set
The London group was an amalgam of school friends Andy Warren and Bid, and art school punks Adam Ant and Lester Square. Ant left in 1977, and The Monochrome Set began their wayward path the following year with driving, conceptual post-punk songs such as "He's Frank" and "Symphonie Des Grauens". They cultivated an arty, aloof image, and played gigs that included eccentric video

back projections and shades of performance art. After
three Rough Trade singles they cut the *Strange Boutique*
LP for DinDisc and went on to record at least ten further
albums, with varying line-ups, by the end of the
century, many on the Cherry Red imprint.

The Normal
The Normal was the alias used by Daniel Miller, best
known as the founder of Mute Records. In fact The Normal
only ever released two records under that name: the
post-punk electro classic "Warm Leatherette"/"TVOD"
in 1978, and a live collaborative 12" with Robert Rental
on Rough Trade. The lyrics for "Warm Leatherette"
referenced JG Ballard's novel Crash, and the song has
since been covered by Grace Jones and Chicks On Speed.

Panther Burns
The brainchild of cult figure Gustavo 'Tav' Falco, who
started the group in 1979 after becoming involved in the
Memphis alternative performance, film and photography
scene. The group was also co-founded by Alex Chilton,
of seminal power pop act Big Star, and the duo turned
their influences of blues, rockabilly, tango, samba and
mambo into a self-styled "southern Gothic, psychedelic
country band". The group's first album, *Behind The
Magnolia Curtain*, was released in 1981 on Rough Trade,
featuring a marching drum band and cameos by veteran
blues singer Jessie Mae Hemphill.

Pere Ubu
A volatile mix of proto-punk guitars, synthesizers
and singer David Thomas's apocalyptic lyrics, Pere Ubu
was formed in 1975 in Cleveland, Ohio by Thomas, who
named the group after Alfred Jarry's surrealist play
Ubu Roi. The line-up also featured Tony Maimone, Allen
Ravenstine, Scott Kraus and Tom Herman. In 1979 the
group had released *Dub Housing* and *New Picnic Time*
on Radar, and was joined by Mayo Thompson of The Red
Crayola, who was working as a producer for many Rough
Trade artists. The connection led to the label issuing
The Art Of Walking, 1980, *390° Of Simulated Stereo*, 1981,
Song Of The Bailing Man, 1982, and the singles collection
Terminal Tower, 1985. The relationship with the label
continued through to the group's 1989 live anthology,
One Man Drives While The Other Man Screams.

 Thomas has conducted a prolific parallel career
alongside Ubu. During the 1980s he released five LPs on
Rough Trade, solo and with his groups The Pedestrians
and The Woodenbirds—all recently collected on the box
set *Monster* (Cooking Vinyl).

The Pop Group
The Bristolian quintet—Mark Stewart (vocals), Gareth
Sager (guitar), Jon Waddington (guitar), Simon Underwood
(bass) and Bruce Smith (drums)—formed in 1978 and
supported Pere Ubu on their summer tour the same year.
The group inspired devotion for their passionate,
politicised lyrics and claustrophobic, combustive fusion
of punk rock, free jazz and dub spatialization. Their
debut album, *Y*, was released on Radarscope, impressing
Rough Trade enough to release the single "We Are All
Prostitutes", featuring improv cellist Tristan Honsinger,
and LP *For How Much Longer Do We Tolerate Mass Murder?*,
1980, with a guest appearance from The Last Poets. With
new bassist Dan Catsis, they toured as part of a label
package with The Slits, with whom they also co-released
the single "Where There's A Will". After splitting up due
to internal tensions in 1981, Stewart went on to form Mark
Stewart & The Maffia, recording with the dub organisation
On-U Sound; Sager and Smith formed Rip, Rig & Panic with
singer Neneh Cherry; Underwood founded Pigbag.

The Raincoats
Art school students Gina Birch and Ana da Silva began
writing songs together in 1977, inspired by punk's
anti-virtuosic DIY ethics. They were joined by violinist
Vicky Aspinall, and after a succession of male drummers
they recruited Palmolive, formerly of The Slits. Their
Rough Trade debut was the *Fairytale In The Supermarket*
EP, 1979, and their self-titled album came out in
the same year. Palmolive left in 1980, and was replaced
by Ingrid Weiss for *Odyshape*, 1981, whose unique
improvisatory, exploratory quality was aided by guests
Robert Wyatt, Charles Hayward and Richard Dudanski.
Although they split after 1984's *Moving*, they were fondly
remembered by Nirvana's Kurt Cobain, who sought out
da Silva after a visit to the Rough Trade shop in 1992
and brokered the reissue of the group's back catalogue
through Rough Trade/DGC. The group's indian summer
rode the wave of the burgeoning early 90s Riot Grrrl
movement, and a reformed version went out on tour,
without Aspinall and with Sonic Youth's Steve Shelley
on drums. Although a planned tour supporting Nirvana
was cancelled following Cobain's death in 1994, the
Raincoats recorded the new LP *Looking In The Shadows*
in 1996. Da Silva is still actively writing music and
released *The Lighthouse* on Chicks On Speed Records
in 2005. Birch followed a stint with The Red Crayola
by forming Dorothy with Vicky Aspinall and then The
Hangovers in the late 90s; she has directed videos
for groups including The Libertines, New Order, Beth
Orton and The Pogues. Aspinall set up dance label
Fresh Records in 1992.

The Red Crayola
Mayo Thompson formed The Red Crayola as a leftfield
psychedelic garage rock group in Houston, Texas, in
the late 1960s. The group recorded one album, *The Parable*

Of Arable Land, for International Artists in 1967; but even then the group's loose structures and non-conformist lyrics did not fit squarely into the garage rock template of their contemporaries. Thompson went on to join conceptual art organisation Art & Language, and involved them in later musical projects with a reformed Crayola including the records *Corrected Slogans*, 1976, *Kangaroo?*, 1981, and *Black Snakes*, 1983. Thompson moved to London in the late 1970s and, while playing guitar in Pere Ubu, developed a close relationship with Rough Trade, acting as in-house producer and, in the later 80s, as label manager and spokesman. He reconstituted The Red Krayola in 1981 (the name change due to threat of legal action from the American pencil manufacturer), utilising Rough Trade musicians Gina Birch (The Raincoats), Epic Soundtracks (Swell Maps) and Lora Logic (Essential Logic) and Allen Ravenstine (Pere Ubu). He went on to run the short-lived Blue Guitar label and has consistently released Krayola records throughout the 1990s and 2000s, drawing on such musicians as George Hurley, Stephen Prina, John McEntire, Jim O'Rourke and David Grubbs. He divides his time between his home in Edinburgh, Scotland and teaching at the Pasadena Art Center College of Design in California.

Jonathan Richman & The Modern Lovers
Born in Massachusetts, Richman moved to New York at the end of the 1960s and formed his Modern Lovers with Jerry Harrison (later of Talking Heads) and David Robinson (The Cars). Their 1972 single "Roadrunner" has become a classic slice of pre-punk lunkage. Beginning with 1984's *Jonathan Sings!*, Rough Trade began licensing his albums including *Rockin' And Romance*, 1985, and *It's Time For Jonathan*, 1986. He has remained prolific since; releasing albums in a country style and sung in Spanish, and making a cameo appearance in the film *There's Something About Mary*.

Arthur Russell
Iowa born Arthur Russell was a sonic polymath: cellist, contemporary composer, singer and sometime disco producer. Classically trained on the cello, he studied with Ali Akbar Khan at the Ali Akbar Khan School in San Francisco in the early 1970s. In the mid-1970s he moved to New York and became a regular performer at avant-garde venue, The Kitchen, often with his group The Flying Hearts. His 1987 LP *World Of Echo* introduced his oceanic, effects-laden solo music, while at the same time he had become seduced by the sounds he encountered at NYC clubs such as the Loft and the Gallery, and worked with dance producers Nicky Siano, Walter Gibbons and Larry Levan on eccentric 1980s grooves such as Dinosaur L's "Go Bang", "Loose Joints", "Is It All Over My Face" and "Pop Your Funk", and his own "Treehouse"/"School

Bell" and "Let's Go Swimming" (the latter released by Rough Trade). Russell died of AIDS in 1992, before a second planned LP could materialise, but his connection with Rough Trade continues, as the label has issued collections of his unreleased music, *Calling Out Of Context* and *First Thought/Best Thought*.

Sandie Shaw
Sandie Shaw was one of the most successful British female singers of the 1960s, thanks to hits such as "Puppet On a String". After a request from Morrissey, a besotted fan, Rough Trade persuaded her out of retirement to record a version of their first single "Hand In Glove" in 1984. The single sold 20,000 copies in its first three days, and peaked just inside the UK Top 30. It was accompanied by a legendary performance on the BBC's *Top Of The Pops* with Shaw lying on the floor kicking her feet in the air, backed by a barefooted Smiths. Energised by the experience, Shaw recorded the comeback album *Hello Angel*, released by Rough Trade in 1988.

Scritti Politti
Scritti Politti began as a collective of anarchists, Marxists and intellectual slummers living in a Camden squat. The musical fulcrum of the collective was Green Gartside (guitar, vocals), Tom Morley (drums) and Niall Jinks (bass), plus manager Matthew Kay. At first their unpolished music and self-reflexive lyrics interrogated the process of creating musical artefacts. Their "Skank Bloc Bologna" 7", on their own St Pancras label, drew the attention of Geoff Travis, who released the subsequent EPs *4 A Sides* and *2nd Peel Session*. The group's short live sets often included songs written on the spot, although Gartside developed a fear of playing live which drove him to a nervous illness in 1980. After recuperating at his parents' Welsh home, he conceived a new blueprint for the group based on pop, soul and funk, a strategy put into practice on "The 'Sweetest Girl'" and 1982's *Songs To Remember* album. By this time the concept of Scritti had moved on from its collectivist roots, and Green hooked up with NYC producer David Gamson, signed to Virgin and achieved international hits with "Wood Beez", "Absolute" and "The Word 'Girl'". In 2004, Green re-signed to Rough Trade, who issued *Early*, a collection of the first singles, and a new LP *White Bread, Black Beer* in 2006.

The Sea And Cake
Pop/rock group with a jazzy edge, formed in the mid-90s in Chicago, Illinois. The group's name is lifted from the Gastr Del Sol track "The C In Cake". Singer Sam Prekop was formerly in post-hardcore/jazz group Shrimp Boat, also on Rough Trade in the early 90s. Both Prekop

and guitarist Archer Prewitt (The Coctails) have also released solo albums on Thrill Jockey.

Shelleyan Orphan
Goth popsters with a Pre-Raphaelite fetish, Caroline Crawley and Jemaur Tayle hailed from the seaside town of Bournemouth. They signed to Rough Trade in 1986 and released the singles "Cavalry Of Cloud" and "Anatomy Of Love". 1987's *Helleborine* LP featured Kate Bush's drummer Stuart Elliott, and Bush's brother Paddy. *Century Flower*, 1989, paved the way for the group to support The Cure on their worldwide *Disintegration* tour, after which they moved to 4AD for their third and final LP, *Humroot*.

Shockabilly
This acid-tinged avant punk/jazz/bluegrass outfit featured Eugene Chadbourne (guitar/vocals), Kramer (bass/organ) and David Licht (drums). Active between 1982—85, the group released two EPs and an album of inspired mayhem on Rough Trade, including the *Earth Vs Shockabilly* 12". Chadbourne has become a notoriously eclectic improviser while Kramer went on to form Bongwater as well as becoming one of the US indie scene's most sought-after producers.

The Slits
Formed in 1976, The Slits was comprised of female members of the bands The Flowers of Romance and the Catrators; Ari Up (vocals), Palmolive (drums), Kate Korris (guitar) and Suzi Gutsi (bass). Kate and Suzi left the band in 1977 and were replaced by Viv Albertine and Tessa Pollitt. They supported the Clash during their 1977 White Riot Tour with the Buzzcocks and Subway Sect, and acquired a violent image, which was backed up by their raw and raucous sound and an uncompromising stage presence. Their image and sound was polished up by the time they released their 1979 album, the dub inflected *Cut*. The Slits split up in 1981 following the release of their record *Return of the Slits* on CBS. Tessa Pollitt and Ari Up have recently reformed the band with new members, and are planning to release an EP in the near future.

The Smiths
Rough Trade's reputation was extended by the popularity of Manchester's The Smiths, but at the same time their success was catalytic in precipitating the company into overreach. Morrissey (vocals), Johnny Marr (guitar), Andy Rourke (bass) and Mike Joyce (drums) arrived on the scene at exactly the right moment, as Rough Trade were looking for a bankable act and as the independent sector was ripe for a fresh sound. Unquestionably one of the greatest songwriting partnerships of the 1980s, Morrissey and Marr kept up a string of singles throughout the group's life, 1983—87, defining a new, much imitated 'indie' guitar sound while remaining one step ahead of it. Morrissey's lyrics, often characterised as dour, are in fact laced with black humour, a waspish mixture of adolescent angst and Alan Bennett-style self-deprecation. They compensated for the weak sound of their self-titled debut album with *Meat Is Murder*, 1985, and the superb *The Queen Is Dead*, 1986, whose changing moods flipped through anger, loss, wistful deathwish and acerbic attacks on Little England. Easily the Rough Trade act with most *Top Of The Pops* appearances to their name, the group became increasingly dissatisfied with a perceived failure of the label to maximise the group's promotion and sales and, after a legal injunction had held up the release of *The Queen Is Dead*, they secured a long desired move to major label EMI. But before they had the chance to take up that offer, they were torn apart by a series of internal politics and personality clashes, not before leaving a final studio album, *Strangeways, Here We Come*, 1987. Rough Trade continued to capitalise on their cash cow, with *The World Won't Listen* compilation and a live LP *Rank*, 1988. Morrissey pursued a musically varied solo career; Marr worked with New Order's Bernard Sumner in Electronic, played guitar in The The, and formed The Healers in 2000. Rourke and Joyce have had less successful post-Smiths careers, with Joyce pursuing a court case against the group's two songwriters in 1996 for an equal share of recording and performance royalties. Rourke has drifted between working with The Pretenders, Killing Joke and others. His Great Northern Productions company organised a cancer benefit in 2006 at which Marr and Joyce were reunited on stage to play "How Soon Is Now"—the closest to a Smiths reunion anyone is likely to hear in the foreseeable future.

Souled American
Chicagoans Chris Grigoroff (guitar/vocals) and Joe Adduci (bass/vocals) began Souled American in 1987. Touring mates of Camper Van Beethoven, their music is a dark, droney and occasionally comic take on country rock and Americana. They quickly formed a connection with Rough Trade and proceeded to release three albums: *Fe*, 1988, *Flubber*, 1989, and *Around The Horn*, 1990. The group stuck with the label after its 1991 demise, releasing *Sonny* on Travis's relaunched imprint in 1992, before moving to German label Moll Tonträger for two further LPs, *Frozen*, 1996, and *Notes Campfire*, 1999. They are still active today.

Spring Heel Jack
The Spring Heel Jack project was launched in 1994 by the duo of John Coxon, sometime guitarist for Spiritualized, and Ashley Wales, former member of post-punks Shockheaded Peters. The duo produced a

colourful version of ambient jungle, a melodic and atmospheric take on drum 'n' bass.

Stars Of Heaven
Nurtured in the mid-80s Dublin music scene, Stars Of Heaven were a quartet featuring Bernard Walsh (drums), Stephen Ryan (guitar/vocals), Peter O'Sullivan (bass/vocals) and Stanley Erraught (guitars). Their Rough Trade mini-LPs *Sacred Heart Hotel*, 1986, and *Holyhead*, 1987, displayed crafted songwriting in a gentle, Celtic country mode that echoed the pastoral side of The Byrds.

Stiff Little Fingers
Fronted by vocalist/guitarist Jake Burns, alongside Henry Cluney (guitar), Ali McMordie (bass) and Brian Falloon (drums), Belfast punk quartet Stiff Little Fingers had the honour of releasing the first Rough Trade album—*Inflammable Material*, 1979. Singles such as "Alternative Ulster", "Suspect Device" and "Gotta Gettaway" supplied a pithy, vituperative commentary on the political troubles in Northern Ireland from the perspective of a citizen on the front line. The success of the debut album prompted the group to relocate to London, and they signed to Chrysalis in summer 1979 to put out their second LP, *Nobody's Heroes*. Since then the group has gone through eight different line-up changes and as many subsequent albums, with Burns the only constant member (former Jam bassist Bruce Foxton was a temporary member in the mid-90s).

Straitjacket Fits
The Dunedin guitar group were one of several New Zealand outfits to make it onto Rough Trade during the late 1980s with their debut album *Hail*, 1989. Shayne Carter, John Collie, Andrew Brough and David Wood had already gained a reputation following a successful EP, *Life In One Chord*, 1987, but two 90s LPs failed to significantly advance their sonic blueprint. Carter has had the most interesting subsequent career, as founder of the space-rock unit Dimmer.

Subway Sect
Londoner Vic Godard initiated Subway Sect during punk rock's first explosive wave in 1976, but much of their enduring reputation is based solely on the two singles the original group released in 1978: "Nobody's Scared"/"Don't Split It" (Braik) and "Ambition"/"Different Story" (Rough Trade). That initial line-up (including Paul Packham, Paul Millie Myers and Barry 'Baker' Auguste) reportedly recorded an album's worth of material, which was suppressed by manager Bernie Rhodes, who also looked after The Clash. The album remains unreleased, and afterwards Rhodes sacked everyone apart from Godard. The singer embarked on an eccentric career that veered from the rockabilly and vintage rock 'n' roll twang of *What's The Matter Boy?* (by a second incarnation of Subway Sect, released on Oddball 1980) to the cocktail lounge swing/schmaltz of solo pieces like *TROUBLE*, Rough Trade, 1986. Godard legendarily made a living as a postman during the 1980s and 90s, but has made sporadic, low-key returns to music since.

Sudden Sway
Conceptual art unit formed by Mike McGuire, Peter Jostins and Simon Childs in the aftermath of Cambridgeshire punk group The Now. Influenced by the arch-commodity satire of Devo and The Residents, the group's output included records, satirical operas, a board game, performances inside a living jukebox and in a shopping centre, and a headphone-guided walk in Central London. Rough Trade releases such as "Autumn Cutback Joblot Offer", 1986, *76 Kids Forever*, 1988, and *Ko-opera*, 1990, nailed the banalisation and suburbanisation of culture in Thatcher's Britain during the 1980s. Apart from a Cherry Red reissue of *76 Kids*, nothing has been heard of the group in the interim.

The Sundays
Singer Harriet Wheeler and guitarist David Gavurin formed The Sundays at Bristol University, adding bassist Paul Brindley and drummer Patrick Hannan. First single "Can't Be Sure" drew comparisons with The Cocteau Twins and The Smiths, influences consolidated on 1990's *Reading, Writing, And Arithmetic*. Subsequent albums *Blind*, 1992, and *Static And Silence*, 1997, went gold in the US. The group is currently in suspension, although Wheeler and Gavurin, who have raised two children together, claim to be slowly writing new material again.

Swell Maps
Formed in Solihull around brothers Nicholas and Kevin Godfrey (a.k.a. Nikki Sudden and Epic Soundtracks), along with schoolfriends Jowe Head, Richard Earl and others, Swell Maps harnessed disparate influences from T-Rex to Can, shaping a quintessentially post-punk sound. The brothers worked at the Rough Trade shop in the mid-70s and their exuberant "Read About Seymour" single was licensed from their own Rather Records in 1978. As well as two LPs, *A Trip To Marineville*, 1979, and *Jane From Occupied Europe*, 1980, the Maps released a string of singles on the label. Epic Soundtracks was co-opted into the reformed Red Crayola by Mayo Thompson, drummed for Crime & The City Solution and These Immortal Souls, and released sporadic solo albums, including the Rough Trade LP *Rise Above*, 1992. He died in 1997. Nikki Sudden formed The Jacobites with Rowland S Howard in 1984 and released 14 solo LPs between 1982–2004; he died backstage at New York's Knitting Factory in 2006 midway

through an international tour. Jowe Head joined The Television Personalities in 1984 and has played in The Palookas, The Househunters and current group, Angel Racing Food.

They Might Be Giants
American alternative rock duo consisting of John Linnell and John Flansburgh. Their 'nerd rock' proved popular on college campuses; the road to 1990's hit single "Birdhouse In Your Soul" began with the debut *They Might Be Giants*, released by Rough Trade in 1987.

This Heat
The South London based experimental rock trio were formed in late 1975 by multi-instrumentalists Charles Bullen (guitar, clarinet, viola, vocals, tapes), Charles Hayward (drums/percussion, keyboards, vocals, tapes) and Gareth Williams (keyboard, guitar, bass, vocals, tapes). Often confrontational and freeform, their music was a product of studio processing of many hours of acoustic research and exploratory jamming at their self-built Cold Storage studio in Brixton. *Deceit*, 1981, was their lone Rough Trade contribution. Hayward briefly collaborated with The Raincoats, and was also a contributor to Regular Music, a collective of British contemporary composers (including Orlando Gough, Jeremy Peyton Jones and Andrew Poppy), who released one LP on Rough Trade in 1985.

Tirez Tirez
American rock unit led by composer/performer Mikel Rouse, strongly influenced by contemporary minimalism and the New York downtown scene. 1987's *Social Responsibility* (Rough Trade) featured Rouse alone, playing drums, guitar and keyboards.

Television Personalities
Dan Treacy and Ed Ball's ambivalent relationship to punk rock was expressed in the enduring single "Part-Time Punks", included on the EP *Where's Bill Grundy Now?*, Rough Trade, 1980. Treacy, Ball and cohorts Jowe Head and Joe Foster (whose solo project Missing Scientists released the "Big City Bright Lights" 7" on Rough Trade) were obsessed with the imagery of 60s pop and 'Swinging London', and decked the LP *And Don't The Kids Just Love It*, 1981, containing the classic 'twee' anthem "I Know Where Syd Barrett Lives", with photos of Twiggy and Patrick McNee of *The Avengers*. When Foster and Ball quit—both later involved in various degrees with the fledgling Creation Records—Treacy carried on, setting up his Whaam! label and releasing a string of albums including *Mummy Your Not Watching Me*, 1982, *They Could Have Been Bigger Than The Beatles*, 1982, *The Painted Word*, 1985. After a spell in prison,

Treacy re-emerged in 2006 with a new TVP line-up on the album *My Dark Places* (Domino).

James 'Blood' Ulmer
Ulmer's harmolodic guitar was heard to devastating effect in Ornette Coleman's Prime Time group in the mid-70s. Something of an anomaly in the Rough Trade catalogue, his *Are You Glad To Be In America?* LP, 1980, is a unique fusion of free jazz, fiery blues and funk rock. He also released the *Part Time* album in 1984 along with a 12" single, "Eye Level".

Ultramarine
After a false start as A Primary Industry, Paul Hammond and Ian Cooper's 'progressive', pastoral dance duo emerged at the beginning of the 90s. Their early live appearances were augmented with live drums and occasional guest slots by free-jazz saxophonist Lol Coxhill. *Every Man And Woman Is A Star*, 1992, was a hubbub of warm analogue synthesizers and bubbling drum machines; they went on to record *United Kingdoms* for Geoff Travis's Blanco Y Negro imprint in 1993 and continued to record and perform throughout the 1990s.

Tom Verlaine
The legendary guitarist of New York's Television released a slow-burning instrumental LP for Rough Trade in 1992, *Warm And Cool*.

Violent Femmes
A trio from Milwaukee, Wisconsin, Brian Ritchie, Victor DeLorenzo and Gordon Gano recorded their iconoclastic 'folk punk' debut album *Violent Femmes* in 1982. Two years later Rough Trade licensed it for UK release, and it went on to become one of the best selling independent albums of all time. Via later LPs such as *Hallowed Ground*, 1984, and *The Blind Leading The Naked*, 1986, they went on to become that peculiar phenomenon, a cult act with a wide following.

Virgin Prunes
The Virgin Prunes—one part Industrial grind to one part garage punk thrash—formed in Dublin in the late 70s, coming out of the infamous Lypton Village scene which also spawned U2. The group was fronted by Gavin Friday and fellow Dubliners Guggi, Dave-id Busaras Scott (vocals), Strongman (bass), Dik Evans (guitar), Mary D'Nellon (drums) and (temporarily) drummer Bintii, a.k.a. Daniel Figgis (who remained associated with Rough Trade via the mid-80s group Princess Tinymeat and his folk-ambient release *Skipper*, 1994. In all they released six singles and one LP on Rough Trade during the early 80s, including "A New Form Of Beauty", a single in four parts, and the album *If I Die, I Die*, 1982. Friday left the group in 1986 for a solo career.

Lucinda Williams

When Rough Trade released the Texas based country rock singer's self-titled third album in 1988, it drew high praise from Tom Petty, who covered her song "Changed The Locks".

Victoria Williams

One of Rough Trade's last signings before going bust, Victoria Williams put out her *Swing The Statue* LP in 1990. She was born in Louisiana and has lived in California for most of her professional life.

Wire

Terse art rockers Graham Lewis (bass, vocals), Bruce Gilbert (guitar), Colin Newman (vocals, guitar) and Robert Gotobed (drums) released their rare *Document And Eye Witness* album on Rough Trade in 1981, a live addendum to their distinguished late 70s trilogy of post-punk LPs for Harvest, *Pink Flag*, *Chairs Missing* and *154*.

The Woodentops

Named after a 60s children's animated TV series (and a nickname for the police), The Woodentops were formed in Northampton, England, in 1983. Signed to Rough Trade, the five-piece, led by singer Rollo McGinty and featuring Alice Thompson, now a successful novelist, released a series of energetic singles midway through the 80s leading up to 1986's *Giant*, a melange of chugging acoustic guitars, accordion, marimba, strings and horns. The band then became more experimental, using more electric guitar and electronic sounds. Live shows tilted towards trance beats, evidenced on the live *Hypno Beat*, 1987, recorded in Los Angeles, and explored further on the disappointing *Wooden Foot Cops On The Highway*, 1988. The group disbanded in 1992, with Rollo producing Techno under the name Pluto.

Robert Wyatt

The drummer left the Canterbury progressive group Soft Machine in 1970, after three LPs, and became involved in various leftfield rock projects and collaborations, including the solo album *The End Of An Ear*, and the group Matching Mole (a pun on the french words *machine molle*, meaning 'soft machine'). After an accident that left him paralysed from the waist down in 1973, Wyatt released the classic album *Rock Bottom* and guested with the likes of Henry Cow, Hatfield And The North, Carla Bley and Michael Mantler. After several years of musical inactivity, he returned to the fray as a committed Communist under Rough Trade's wing, with a newly invigorated interest in political song—*Nothing Can Stop Us*, 1981, featured cover versions of protest music from around the world, with a focus on Latin America. This phase reached its apex with the anti-Falklands War song "Shipbuilding", 1983, written by Elvis Costello, which entered the UK Top 40. Wyatt released two further albums on the label, and guested with early 90s electronica act Ultramarine on their Blanco Y Negro LP *United Kingdoms* in 1994. The intervening years have seen an intermittent release schedule of perfectly formed, jazz-inflected song albums for Rykodisc, including *Shleep*, 1997, and *Cuckooland*, 2003. All his record sleeves since he joined Rough Trade have been designed by his wife and co-writer Alfreda Benge.

Young Marble Giants

This Cardiff post-punk trio formed in 1978. Their style featured minimal, unmistakable instrumentation provided by brothers Philip and Stuart Moxham, buoying up the cool, dispassionate voice of Alison Statton. YMG's barely-there sound was defined by the Moxham brothers' steel-hawser bass, haunting organ and staccato-picked rhythm guitar, while Statton provided expressionless, insouciant vocals. While signed to Rough Trade, the group released two EPs, and the influential album *Colossal Youth*, 1980. After YMG split in 1981, Stuart Moxham formed a new group, The Gist, who remained with Rough Trade for a handful of releases including the *Embrace The Herd* LP, while Statton formed the cool jazz/pop crossover group Weekend. Philip Moxham ended up playing with The Communards and Everything But The Girl.

Zounds

Originally part of the cassette culture movement, releasing material on the Fuck Off tape label, Zounds—a Reading based outfit fronted by bassist/singer Steve Lake—were involved in the squatting and free festival scene and were associated with the Crass collective. They released their first album *The Curse Of Zounds* on Rough Trade in 1981. The cover art, by anarchist artist Clifford Harper, featured a painting of the group as fire-fighters 'dousing' a blaze at the Houses of Parliament with a secret supply of petrol. The band split up in late 1982.

<u>Opposite:</u> The Raincoats. Photograph by Shirley O'Loughlin.

Rough Trade Records 1978–90
Singles

RT001	**Metal Urbain** Paris Maquis 1978	
RT002	**Augustus Pablo** Pablo Meets Mr Bassie 1978	
RT003	**Cabaret Voltaire** Do The Mussollini (Headkick) 1978	
RT004	**Stiff Little Fingers** Alternative Ulster 1978	
RT005	**The Monochrome Set** He's Frank 1978	
RT006	**Stiff Little Fingers** Suspect Device 1978	
RT007	**Subway Sect** Ambition 1978	
RT008	**Electric Eels** Agitated 1978	
RT009	**Kleenex** Ain't You 1978	
RT010	**Swell Maps** Read About Seymour 1978	
RT011	**File Under Pop** Heathrow 1978	
RT012	**Swell Maps** Dresden Style 1978	
RT013	**The Raincoats** Fairy Tale In The Supermarket 1979	
RT014	**Kleenex** You 1979	
RT015	**Stiff Little Fingers** Gotta Gettaway 1979	
RT016	**Metal Boys** Sweet Marylin 1979	
RT017	**Dr Mix** No Fun 1979	
RT018	**Cabaret Voltaire** Nag Nag Nag 1979	
RT019	**The Monochrome Set** Eine Symphonie Des Grauens 1979	
RT020	**Cult Figures** Zip Nolan 1979	
RT021	**Swell Maps** Real Shocks 1979	
RT022	**The Last Word** Animal World 1979	
RT023	**The Pop Group** We Are All Prostitutes 1979	
RT024	**The Feelies** Fa Ce La 1979	
RT025	**The Pack** King Of Kings 1979	
RT026	**The Red Crayola** Micro Chips And Fish 1979	
RT027	**Scritti Politti** 4 A Sides 1979	
RT028	**The Monochrome Set** The Monochrome Set 1979	
RT029	**Essential Logic** Popcorn Boy 1979	
RT030	**Plastics** Copy 1979	
RT031	**Delta Five** Mind Your Own Business 1979	
RT032	**Dr Mix** I Can't Control Myself 1979	
RT033	**TV Personalities** Part Time Punks 1980	
RT034	**Scritti Politti** 2nd Peel Session 1980	
RT035	**Cabaret Voltaire** Silent Command 1980	
RT036	**Swell Maps** Let's Build A Car 1980	
RT037	**Robert Wyatt** Arauco 1980	
RT038	**Cabaret Voltaire** Three Mantras 1980	
RT039	**Slits/Pop Group** In The Beginning There Was Rhythm 1980	
RT040	**The Prefects** Going Through The Motions 1980	
RT041	**Delta Five** You 1980	
RT042	**The Prats** 1990's Pop EP 1980	
RT043	**Young Marble Giants** Final Day 1980	
RT044	**Slits** Man Next Door 1980	

RT045	**James Blood Ulmer** Are You Glad To Be In America 1980
RT046	**Robert Wyatt** Stalin Wasn't Stallin 1980
RT047	**Liliput** Split 1980
RT048	**The Fall** How I Wrote "Elastic Man" 1980
RT049	**Pere Ubu** Final Solution 1980
RT050	**Essential Logic** Eugene 1980
RT051	**TV Personalities** King And Country 1980
RT052	**Robert Wyatt** At Last I Am Free 1980
RT053	**Essential Logic** Music Is A Better Noise 1980
RT054	**The Red Crayola** Born In Flames 1981
RT055	**Girls At Our Best** Politics 1981
RT056	**The Fall** Totally Wired 1981
RT057	**Missing Scientists** Big City Bright Lights 1981
RT058	**The Gist** This Is Love 1981
RT059	**Young Marble Giants** Testcard EP 1981
RT060	**Cabaret Voltaire** Seconds Too Late 1981
RT061	**Delta Five** Try 1981
RT062	**Liliput** Eisiger Wind 1981
RT063	**TV Personalities** Where's Syd Barrett Now? 1981
RTT064	**Furious Pig** I Don't Like Your Face 1981
RT065	**Blue Orchids** Disney Boys 1981
RT066	**Pere Ubu** Not Happy 1981
RT067	**Blue Orchids** Work 1981
RT068	**Vic Godard & Subway Sect** Stop That Girl 1981
RT069	**Zounds** Demystification 1981
RT070	**Mark Beer** Pretty 1981
RT071	**The Fall** Slates EP 10" 1981
RT072	**The Virgin Prunes** War 1981
RT073	**The Red Crayola** An Old Man's Dream 1981
RT074	**Essential Logic** Fanfare In The Garden 1981
RT075	**The Nightingales** Idiot Strength 1981
RT076	**Tan Tan** Theme From A Summer Place 1981
RT077	**Panther Burns** Train Kept A Rollin' 1981
RT(T)078	**Chris & Cosey** October Love Song 1981
RT079	**Wire** Our Swimmer 1981
RT080	**The Prats** General Davis 1981
RT081	**Robert Wyatt** Trade Union 1981
RT082	**Jackie Mittoo** These Eyes 1981
RT083	**Bunny Wailer** Riding 1981
RT084	**Epic Soundtracks** Jelly Babies 1981
RT085	**The Gist** Love at First Sight 1981
RT086	**DNA** A Taste of DNA 1981
RT(T)087	**Lora Logic** Wonderful Offer 1981
RT(T)088	**David Gamson** Sugar, Sugar 1982
RT089	**Virgin Prunes** A New Form Of Beauty 1 1982
RTT090	**Virgin Prunes** A New Form Of Beauty 2 10" 1982

RT(T)091	**Scritti Politti** The 'Sweetest Girl' 1981
RT092	**Martin Pig** Lovely Rita 1982
RT093	**The Raincoats** No One's Little Girl 1983
RT094	**Zounds** Dancing 1982
RT095	**Cabaret Voltaire** Jazz In The Glass 1981
RTT096	**Cabaret Voltaire** Eddie's Out 1982
RTT097	**Weekend** The View From Her Room 1981
RT098	**Zounds** More Trouble Coming Every Day 1982
RTT099	**Virgin Prunes** The Slow Children 1982
RT100	**Mighty Diamonds** Pass The Kouchie 1982
RT(T)101	**Scritti Politti** Faithless 1982
RT(T)102	**Cosmetic** Cosmetics 1982
RT103	**Mofungo** El Salvador 1982
RTT104	**Epic Soundtracks & Jowe Head** Rain Rain Rain 1982
RTT105	**Brilliant** Colours 1982
RT(T)106	**Virgin Prunes** Pagan Lovesong 1982
R(T)T107	**Weekend** Past Meets Present 1982
RT108	**The Go-Betweens** Hammer The Hammer 1982
RT109	**TV Personalities** A Sense Of Belonging 1983
RT110	**Konk** Master Cylinder Jam 1982
RT(T)111	**Scritti Politti** Jacques Derrida 1982
RT112	**Aztec Camera** Pillar To Post 1982
RT(T)113	**Cosmetic** Get Ready 1983
RTT114	**Panther Burns** I'm On This Rocket 1984
RT(T)115	**Robert Wyatt** Shipbuilding 1982
RT(T)116	**Weekend** Drumbeat For Baby 1982
RT117	**Blue Orchids** Release 1983
RT118	**World Service** Celebration Town 1983
RT(T)119	**Virgin Prunes** Baby Turns Blue 1982
RT(T)120	**Shockabilly** The Dawn Of Shockabilly EP 1983
RTT121	**Dream Syndicate** Tell Me When It's Over 1982
RT(T)122	**Aztec Camera** Oblivious 1983
RTT123	**Wire** Crazy About Love 1983
RT124	**The Go-Betweens** Cattle And Cane 1983
RT125	**The Gist** Fool For A Valentine 1983
RTT126	**Unknown Cases** Masimbabele 1983
RT127	**Shockabilly** 19th Nervous Breakdown 1983
RTT128	**James Blood Ulmer** Eye Level 1984
RTT129	**Kendra Smith & David Roback** Fell From The Sun 1984
RT(T)130	**Sandie Shaw** Hand In Glove 1984
RT131	**The Smiths** Hand In Glove 1983
RT(T)132	**Aztec Camera** Walk Out To Winter 1983
RT133	**The Fall** The Man Whose Head Expanded 1983
RT(T)134	**Troy Tate** Love Is 1983
RT(T)135	**Microdisney** Dolly 1983
RT(T)136	**The Smiths** This Charming Man 1983

RT136NY	**The Smiths** This Charming Man (NY Mix) 1983
RT137	**The Pastels** I Wonder Why 1983
RT138	**Jazzateers** 16 Reasons 1983
RTM139LP	**Weekend** Live At Ronnie Scott's LP 1983
RT140	**Rainy Day** I'll Keep It With Mine 1984
RT141	**Prefab Sprout** Lions In My Own Garden (Exit Someone) 1983
RTT142	**Dislocation Dance** Show Me 1982
RT143	**The Fall** Kicker Conspiracy 1983
RT144	**The Go-Betweens** Man O'Sand To Girl O'Sea 1983
RT145	**Ivor Cutler** Women Of The World 1984
RT146	**The Smiths** What Difference Does It Make 1984
RT147	**Violent Femmes** Ugly 1984
RTT148	**Chris & Cosey** Sweet Surprise 1985
RTT149	**Robert Wyatt** Work In Progress 1984
RT(T)150	**Float Up CP** Joy's Address 1984
RTT151	**The Enemy** Within Strike 1984
RT(T)152	**Jonathan Richman** That Summer Feeling 1984
RTT153	**The Raincoats** Animal Rhapsody 1984
RT(T)154	**Jonathan Richman** I'm Just Beginning To Live 1985
RTM155	**Microdisney** We Hate You South African Bastards 1984
RT(T)156	**The Smiths** Heaven Knows I'm Miserable Now 1984
RTT157	**Fats Comet** Don't Forget That Beat 1985
RTT158	**Virginia Astley** Melt The Snow 1985
RTT159	**Fats Comet** Stormy Weather 1985
RTT160	**Princess Tinymeat** Sloblands 1985
RT(T)161	**Camper Van Beethoven** Take The Skinheads Bowling 1985
RTT162	**Horace Andy** Elementary 1985
RT163	**Princess Tinymeat** Bun In The Oven 1985
RT(T)164	**Easterhouse** Whistling In The Dark 1985
RT(T)165	**The Woodentops** Move Me 1985
RT(T)166	**The Smiths** William, It Was Really Nothing 1984
RT(T)167	**The Woodentops** Well, Well, Well 1985
RT(T)168	**Robert Wyatt & Swapo Singers** Wind Of Change 1985
RTT169	**The Woodentops** It Will Come 1985
RT(T)170	**Shelleyan Orphan** Cavalry Of Cloud 1986
RTT171CD	**The Smiths** Barbarism Begins At Home 1988
RTT172	**Horace Andy** Get Down 1986
RTM173LP	**Stars Of Heaven** Sacred Heart Hotel 1986
RT(T)174	**Easterhouse** Inspiration 1986
RTT175	**Microdisney** In The World 1985
RT(T)176	**The Smiths How** Soon Is Now 1985
RT(T)177	**The Woodentops** Good Thing 1986
RT(T)178	**The Woodentops** (Love Affair With) Everyday Living 1986
RT(T)179	**The Woodentops** You Make Me Feel 1988
RTT180	**The Feelies** No One Knows 1986
RT(T)181	**The Smiths** Shakespeare's Sister 1985

RT(T)182 **The Seers** Lightning Strikes 1988

RT183 **Sudden Sway** Autumn Cutback Joblot Offer 1986

RTT184 **Arthur Russell** Let's Go Swimming 1985

RT(T)185 **Microdisney** Birthday Girl 1985

RT(T)186 **The Smiths** That Joke Isn't Funny Anymore 1985

RT(T)187 **Princess Tinymeat** Angels In Pain 1985

RT(T)188 **The Apartments** All You Wanted 1986

RTM189LP **Richard H Kirk** Ugly Spirit 1986

RTT190 **Thomas Mapfumo & Blacks Unlimited** Hupenya Wangu 1986

RT(T)191 **The Smiths** The Boy With The Thorn In His Side 1985

RT(T)192 **The Smiths** Bigmouth Strikes Again 1986

RT(T)193 **The Smiths** Panic 1986

RT(T)194 **The Smiths** Ask 1986

RT(T)195 **The Smiths** Shoplifters Of The World Unite 1987

RT(T)196 **The Smiths** Sheila Take A Bow 1987

RT(T)197 **The Smiths** Girlfriend In A Coma 1987

RT(T)198 **The Smiths** I Started Something I Couldn't Finish 1987

RTT199 **Richard H Kirk** Hipnotic 1986

RT(T)200 **The Smiths** Last Night I Dreamt That Somebody Loved Me 1987

RTT201 **AR Kane** Up Home 1988

RT(T)202 **The Cradle** It's Too High 1987

RT(T)203 **Stars Of Heaven** Holyhead 1987

RT(T)204 **Easterhouse** Come Out Fighting 1989

RTM205LP **Camper Van Beethoven** Good Guys Bad Guys EP 1987

RTT206 **Thirst** Let Go 1987

RT(T)207 **Shelleyan Orphan** Anatomy Of Love 1987

RT(T)208 **Stepping Razor** Latin Tears (Uncle Sam Is Coming) 1987

RTT209 **Brother D** Clapper's Power 1987

RT(T)210 **Motorcycle Boy** Big Rock Candy Mountain 1987

RTT211 **The Heart Throbs** Bang 1987

RTT212 **Craig Davies** I Don't Want It 1987

RTT213 **Sudden Sway** The Barmy Army 1987

RTT214 **The Wygals** Passion 1987

RTT215CD **The Smiths** The Headmaster Ritual 1988

RT(T)216 **Gene & Jim** Shake 1988

RT(T)217 **Shelleyan Orphan** Shatter 1989

RT(T)218 **The Sundays** Can't Be Sure 1989

RT(T)219 **SOB** Make Me Wonder 1989

RT(T)220 **Sandie Shaw** Please Help The Cause Against Loneliness 1988

RT(T)221 **The Heart Throbs** Too Many Shadows 1988

RT(T)222 **Craig Davies** Jennifer Holiday 1988

RT(T)223 **Band Of Holy Joy** Tactless 1988

RT(T)224 **Lucinda Williams** I Just Wanted To See You So Bad 1989

RT(T)225 **James** Sit Down 1989

RT(T)226 **Miracle Legion** You're The One Lee 1989

RTT227 **The Assassins** Where's Joey Gone 1990

RT(T)228 **My Jealous God** Everything About You 1990

RT(T)229 **AR Kane** Listen Up 1988

RT(T)230 **Sandie Shaw** Nothing Less Than Brilliant 1988

RT(T)231 **AR Kane** Love Sick 1988

RT(T)232 **Lucinda Williams** Passionate Kisses 1989

RTT233 **Band Of Holy Joy** Evening World Holiday Show 1989

RTM235LP **Two Nice Girls** Like A Version 1990

RT(T)236 **Helter Skelter** Last Train 1989

RT(T)237 **This Picture** Naked Rain 1989

RT(T)238 **My Jealous God** Pray 1989

RT(T)239 **AR Kane** Pop 1989

RT(T)240 **The Butthole Surfers** Hurdy Gurdy Man 1990

RTT243 **Band Of Holy Joy** Real Beauty Passed Through 1990

RT(T)245 **James** Come Home 1989

RTT246 **Galaxie 500** Blue Thunder 1990

RTT247 **Galaxie 500** Fourth Of July 1990

Albums

Rough 1 **Stiff Little Fingers** Inflammable Material 1979

Rough 2 **Swell Maps** A Trip To Marineville 1979

Rough 3 **The Raincoats** The Raincoats 1979

Rough 4 **Cabaret Voltaire** Mix Up 1979

Rough 5 **Essential Logic** Beat Rhythm Mews 1979

Rough 6 **Dr Mix & The Remix** Wall Of Noise 1979

Rough 7 **Cabaret Voltaire** Live At The YMCA 1979

Rough 8 **Young Marble Giants** Colossal Youth 1980

Rough 9 **The Pop Group** For How Much Longer Do We Tolerate Mass Murder? 1980

Rough 10 **The Fall** Totale's Turns (Live) 1980

Rough 11 **Cabaret Voltaire** The Voice Of America 1980

Rough 12 **The Pop Group** We Are Time 1980

Rough 13 **The Raincoats** Odyshape 1980

Rough 14 **Pere Ubu** The Art Of Walking 1980

Rough 15 **Swell Maps** Jane From Occupied Europe 1980

Rough 16 **James Blood Ulmer** Are You Glad To Be In America? 1980

Rough 17 **The Normal & Robert Rental** Live At West Runton 1980

Rough 18 **The Fall** Grotesque 1981

Rough 19 **The Red Crayola** Kangaroo? 1981

Rough 20 **Scritti Politti** Songs To Remember 1982

Rough 21 **Swell Maps** Whatever Happens Next... 1980

Rough 22 **Pere Ubu** The Modern Dance 1980

Rough 23 **Pere Ubu** 390 Degrees Of Simulated Stereo 1981

Rough 24 **TV Personalities** And Don't The Kids Just Love It 1981

Rough 25 **The Gist** Embrace The Herd 1980

Rough 26 **This Heat** Deceit 1981

Rough 27 **Cabaret Voltaire** Red Mecca 1981

Rough 28 **Lora Logic** Pedigree Charm 1980

Rough 29 **Wire** Document & Eye Witness 1981

Rough 30 **David Thomas & The Pedestrians** The Sound Of The Sand 1981

Rough 31 **Zounds** The Curse Of The Zounds 1981

Rough 32 **Panther Burns** Behind The Magnolia Curtain 1981

Rough 33 **Pere Ubu** Song Of The Bailing Man 1981

Rough 34 **Chris & Cosey** Heartbeat 1981

Rough 35 **Robert Wyatt** Nothing Can Stop Us 1981

Rough 36 **The Blue Orchids** The Greatest Hits 1982

Rough 37 **Various** Soweto: A Compilation 1982

Rough 38 **The Mighty Diamonds** Changes 1982

Rough 39 **Weekend** La Variete 1982

Rough 40 **Robert Wyatt** Animals, Soundtrack To Film 1982

Rough 41 **Swell Maps** Collision Time 1982

Rough 42 **Cabaret Voltaire** 25×45 1982

Rough 43 **Liliput** Liliput 1982

Rough 44 **Chris & Cosey** Trance 1982

Rough 45 **The Go-Betweens** Send Me A Lullaby 1982

Rough 46 **Jazzateers** Jazzateers 1983

Rough 47 **Aztec Camera** High Land, Hard Rain 1983

Rough 48 **Shockabilly** Earth Vs Shockabilly 1983

Rough 49 **Virgin Prunes** If I Die, I Die 1982

Rough 50 **Jah Shaka** Revelation Songs 1982

Rough 51 **Bill Laswell** Baselines 1984

Rough 52 **Jonathan Richman & The Modern Lovers** Jonathan Sings! 1984

Rough 53 **The Dream Syndicate** The Days Of Wine & Roses 1984

Rough 54 **Go-Betweens** Before Hollywood 1984

Rough 55 **Violent Femmes** Violent Femmes 1984

Rough 56 **Vic Godard & The Subway Sect** Retrospective 1984

Rough 57 **Young Marble Giants/Weekend/Gist** Nipped In The Bud 1984

Rough 58 **Virginia Astley** From Gardens Where We Feel Secure 1983

Rough 59 **Ivor Cutler & Linda Hurst** Privilege 1983

Rough 60 **David Thomas & The Pedestrians** Variations on A Theme 1984

Rough 61 **The Smiths** The Smiths 1983

Rough 62 **The Fall** Perverted By Language 1984

Rough 63 **Dislocation Dance** Midnight Shift 1983

Rough 64 **Chris & Cosey** Songs Of Love & Lust 1984

Rough 65 **James Blood Ulmer** Part-Time 1984

Rough 66 **The Raincoats** Moving 1983

Rough 67 **Rank And File** Sundown 1983

Rough 68 **Shockabilly** Colosseum 1984

Rough 69 **Robert Wyatt** Old Rottenhat 1984

Rough 70 **Rainy Day** Rainy Day 1984

Rough 71 **Los Lobos** And A Time To Dance 1984

Rough 72 **Jonathan Richman & The Modern Lovers** Rockin' And Romance 1985

Rough 73 **Regular Music** Regular Music 1985

Rough 74 **Gregory Isaacs** Live At The Brixton Academy 1985

Rough 75 **Microdisney** Everybody Is Fantastic 1984

Rough 76 **The Smiths** Hatful Of Hollow 1984

Rough 77 **Float Up CP** Kill Me In The Morning 1985

Rough 78 **Linton Kwesi Johnson** In Concert /MC/DA 1985

Rough 79 **Del Fuegos** The Longest Day 1984

Rough 80 **David Thomas & The Pedestrians** More Places Forever 1985

Rough 81 **The Smiths** Meat Is Murder /MC 1985

Rough 82 **Horace Andy** Elementary 1985

Rough 83 **Pere Ubu** Terminal Tower 1985

Rough 84 **Chris & Cosey** Techno-Primitiv 1986

Rough 85 **Microdisney** The Clock Comes Down The Stairs 1985

Rough 86 **Vic Godard** TROUBLE 1986

Rough 87 **The Woodentops** Giant 1986

Rough 88 **The Apartments** The Evening Visits 1985

Rough 89 **Ivor Cutler** Prince Ivor 1986

Rough 90 **David Thomas & The Woodenbirds** Monster Walks The Winter Lake 1986

Rough 91 **Thomas Mapfumo & Blacks Unlimited** Chimuranga For Justice 1986

Rough 92 **Jonathan Richman & The Modern Lovers** It's Time For Jonathan 1986

Rough 93 **Pere Ubu** Live Vol II 1986

Rough 94 **Easterhouse** Contenders 1986

Rough 95 **Camper Van Beethoven** Telephone Free Landslide Victory 1986

Rough 96 **The Smiths** The Queen Is Dead 1986

Rough 97 **Shelleyan Orphan** Helleborine 1987

Rough 98 **Ivor Cutler** Gruts 1986

Rough 99 **Richard H Kirk** Black Jesus Voice 1986

Rough 100 **Various** NME C86 1986

Rough 101 **The Smiths** The World Won't Listen 1987

Rough 102 **Soul Asylum** Made To Be Broken 1986

Rough 103 **Various** Luxury Condos Coming To Your Neighbourhood Soon 1986

Rough 104 **The Feelies** The Good Earth 1986

Rough 105 **Beat Happening** Beat Happening 1986

Rough 106 **The Smiths** Strangeways Here We Come /MC 1987

Rough 107 **Dip In The Pool** Silence 1986

Rough 108 **Princess Tinymeat** Herstory 1987

Rough 109 **Camper Van Beethoven** Camper Van Beethoven 1986

Rough 110 **Sandie Shaw** Hello Angel 1988

Rough 111 **Tirez Tirez** Social Responsibility 1987

Rough 112 **Miracle Legion** Surprise Surprise Surprise 1987

Rough 113 **Stars Of Heaven** Rain On The Sea (Export) 1987

Rough 114 **Arthur Russell** World Of Echo 1987

Rough 115 **They Might Be Giants** Don't Let's Start 1987

Rough 116 **Opal** Happy Nightmare Baby 1987

Rough 117 **The Woodentops** Live Hypnobeat Live 1987

Rough 118 **The Yung Wu** The Yung Wu 1987

Rough 119 **AR Kane** 69 1985

Rough 120 **David Thomas** Blame The Messenger 1987

Rough 121 **Stars Of Heaven** Speak Slowly 1988

Rough 122 **Craig Davies** Like Narcissus 1988

Rough 123 **Camper Van Beethoven** II & III 1987

Rough 124 **Easterhouse** Waiting For The Red Bird 1989

Rough 125 **Band Of Holy Joy** Manic, Magic, Majestic 1989

Rough 126 **The Smiths** Rank 1988

Rough 127 **The Woodentops** Woodenfoot Cops On The Highway 1989

Rough 128 **Opal** Early Recordings 1989

Rough 129 **Distant Voices, Still Lives** OST 1989

Rough 130 **Lucinda Williams** Lucinda Williams 1989

Rough 131 **Souled American** Fe 1989

Rough 132 **Craig Davies** Groovin' On A Shaft Cycle 1990

Rough 133 **Sudden Sway** 76 Kids Forever 1988

Rough 134 **Wygals Honyocks** In The Whithersoever 1989

Rough 135 **Two Nice Girls** Two Nice Girls 1989

Rough 136 **Miracle Legion** Me & Mr Roy 1989

Rough 137 **Shelleyan Orphan** Century Flower 1989

Rough 138 **Scrawl** He's Drunk 1989

Rough 139 **AR Kane** AR Kane 1989

Rough 140 **Victoria Williams** Swing The Statue 1990

Rough 141 **Souled American** Flubber 1979

Rough 142 **Sudden Sway** Ko-Opera 1990

Rough 143 **The Clean** Vehicle 1990

Rough 144 **Walter Salas** Humara Logartija 1990

Rough 145 **Beat Happening** Black Comedy 1990

Rough 146 **Galaxie 500** On Fire 1989

Rough 147 **Straitjacket Fits** Hail 1989

Rough 148 **The Sundays** Reading, Writing And Arithmetic 1990

Rough 149 **Pussy Galore** Historia De La Musica Rock 1990

Rough 150 **Scrawl** Smallmouth 1990

Rough 151 **Souled American** Around The Horn 1990

Rough 152 **Dave Ray & Tony Glover** Ashes In My Whiskey 1990

Rough 155 **Band Of Holy Joy** Positively Spooked 1990

Rough 156 **Galaxie 500** This Is Our Music 1990

Rough 158 **Mazzy Star** She Hangs Brightly 1990

Rough 255 **The Smiths** Louder Than Bombs 1988

RCD6001 **Cabaret Voltaire** The Golden Moments Of Cabaret 1990

RCD6002 **Pere Ubu** Dub Housing 1989

RCD6003 **Pere Ubu** New Picnic Time 1989

RCD6004 **Various** A Constant Source Of Interruption 1989

OneMan1 **James** One Man Clapping 1989

Rough Trade 1991—97
Singles

PELL0027 **Giant Sand** Solomans Ride 1992

R282 **Liberty Horses** Believe 1992

R284 **Sweet Jesus** Phonefreak Honey 1992

R285 **Levitation** World Around 1992

R291 **Sweet Jesus** Real Babe 1992

R295 **Ultramarine** Nightfall In Sweetleaf 1992

R297 **Luna** Indian Summer 1992

R298 **Disco Inferno** A Rock To Cling To 1993

R299 **Butterfly Child** Ghetto Child 1993

R303 **Disco Inferno** The Last Dance 1993

RT319 **Marion** Violent Men 1993

R320 **Puppy Love Bomb** Not Listening 1993

R322 **Swallow** Hush EP 1994

R324 **Spring Heel Jack** The Sea Lettuce 1994

R334 **Puppy Love Bomb** Bobby Milk EP 1994

R335 **Disco Inferno** It's A Kid's World 1994

R351 **Spring Heel Jack** Where Do You Fit In? 1994

R352 **Spring Heel Jack** Oceola 1994

R355 **Spring Heel Jack** Lee Perry 1995

R379 **60FT Dolls** No 1 Pure Alcohol 1995

Under One Little Indian

R407 **Pooka** The Insect 1996

R404 **The Raincoats** Don't Be Mean 1996

Singles Club

45REV1 **Levitation** Squirrel 1991

45REV2 **Sweet Jesus** Honey Loving Honey 1991

45REV3 **Inrain** Grow 1991

45REV4 **Liberty Horses** This Town 1991

45REV5 **The Nails** 88 Lines About 44 Women 1992

45REV6 **Mercury Rev** If You Want Me To Stay 1992

45REV7 **Ultramarine** Saratoga 1992

45REV8 **Butterfly Child** Juice 1992

45REV9 **Puressence** Siamese 1992

45REV10 **Jacob's Mouse** Company News 1992

45REV11 **Holy Joy** It's Lovebite City 1992

45REV12 **Vic Godard** Johnny Thunders 1992

45REV13 **Flower Sermon** (Sugar) Lullaby 1993

45REV14	**Papa Sprain** Tech Yes 1993	R287	**Freedy Johnston** Can You Fly? 1992
45REV15	**The Auteurs** Housebreaker 1993	R288	**Tom Verlaine** Warm And Cool 1992
45REV16	**Tindersticks** A Marriage Made 1993	R289	**Ultramarine** Every Man And Woman Is A Star 1992
45REV17	**Harmony Ambulance** Nature's Way 1993	R290	**Various** Lipstick Traces 1993
45REV18	**Strangelove** Zoo'd Out 1993	R292	**Liberty Horses** Joyland 1993
45REV19	**Mazzy Star** Five String Serenade 1993	R293	**Epic Soundtracks** Rise Above 1993
45REV20	**Star Power** Turn My World 1993	R295	**Robert Wyatt** Mid-Eighties 1993
45REV21	**St Johnny** Unclean 1993	R206	**St Johnny** High As A Kite 1993
45REV22	**Silver** Ten Seconds 1993	R300	**Shrimp Boat** Cavale 1993
45REV23	**Steven Roback** Brightside 1993	R301	**The Boo Radleys** Learning To Walk 1993
45REV24	**Drugstore** Modern Pleasure 1993	R302	**The Raincoats** The Raincoats 1993
45REV25	**Blessed Ethel** Blue Plastic 1993	R304	**The Raincoats** Odyshape 1993
45REV26	**Milf** No Name 1993	R306	**The Raincoats** Moving 1993
45REV27	**Blameless** All The Signs Were There 1994	R307	**Disco Inferno** DI Go Pop 1994
45REV28	**Puppy Love Bomb** Too Busy Thinking 1994	R308	**Butterfly Child** Onomatopoeia 1994
45REV29	**God Is My Co-Pilot** Childhood Dreams 1994	R309	**Robert Wyatt** Nothing Can Stop Us 1994
45REV30	**Swimming** Cut Her Out 1994	R310	**The Sea And Cake** The Sea And Cake 1994
45REV31	**Terry Edwards** Well You Needn't 1994	R311	**Robert Wyatt** Flotsam Jetsam 1994
45REV32	**Fruit** Queen Of Old Compton St 1994	R312	**Daniel Figgis** Skipper 1995
45REV33	**Catatonia** Whale 1994	R313	**The Mabuses** Melbourne Method 1995
45REV34	**Lida Husik** Star 1994	R314	**Timber** Parts And Labour 1995
45REV35	**Catherine** Songs About Girls 1994	R317	**Robert Wyatt** Animals 1995
45REV36	**Blonde Redhead** Flying Douglas 1995	R353	**Spring Heel Jack** There Are Strings 1995
45REV37	**Pooka** Sweet Butterfly 1995	R357	**Milk And Honey** Band Round The Sun 1995
		R358	**PEZ** Waiting 1995

Under One Little Indian 1996—97

45REV40	**Nub** Fall Guy 1996
45REV39	**Des Man** Deablo Fever 1996
45REV41	**Snowpony** The Little Girls Understand 1996
45REV42	**The Hangovers** Soho 1997
45REV43	**Butterfield** Cool Blue 1997
45REV44	**The Spectators** tba 1997

Under One Little Indian 1996—97

R4102	**Disco Inferno** Technicolour 1996
R4052	**Bedhead** Bedheaded 1996
R4111	**American Analogue Set** Fun Of Watching Fireworks 1997
R4121	**Simon Warner** Waiting Rooms 1997

Albums

PELL001	**Cul-De-Sac** Ecim 1992
R272	**Pierre Etoile** Pierre Etoile 1991
R274	**Robert Wyatt** Dondestan 1991
R276	**Giant Sand** Ramp 1991
R277	**The Mabuses** The Mabuses 1991
R278	**Shrimp Boat** Duende 1991
R279	**Shelleyan Orphan** Humroot 1992
R280	**Souled American** Sonny 1992
R281	**Vulgar Boatmen** Please Panic 1992
R283	**The Bats** Fear Of God 1992
R286	**Levitation** Need For Not 1992

Rough Trade 2000—
Singles

RTRADESCD001	**Terris** The Time is Now 2000
RTRADESCD002	**Birthday** Welcome To Life 2000
RTRADESCD003	**Cadallaca** Out West 2000
RTRADESCD008	**Hope Sandoval & The Warm Inventions** Around My Smile 2000
RTRADESCD009	**Ooberman** Dolphin Blue 2000
RTRADESCD010	**The Strokes** The Modern Age 2001
RTRADESCD013	**Eileen Rose** Party Dress EP 2001
RTRADES016	**The Moldy Peaches** Who's Got The Crack?/ NYC's Like A Graveyard 2001
RTRADESCD017	**Baxter Dury** Oscar Brown 2001

RTRADES020	**Jeffrey Lewis** The Chelsea Hotel Oral Sex Song 2001
RTRADESCD021	**Mull Historical Society** Animal Cannabus 2001
RTRADESCD022	**ARE Weapons** Street Gang 2001
RTRADESCD023	**The Strokes** Hard To Explain/New York City Cops 2001
RTRADESCD028	**Queen Adreena** Pretty Like Drugs 2002
RTRADECSD032	**British Sea Power** Remember Me 2001
RTRADESCD035	**Beachwood Sparks** By Your Side 2001
RTRADESCD037	**ARE Weapons** New York Muscle 2001
RTRADESCD041	**The Strokes** Last Nite 2001
RTRADECSD045	**Sunstorm** The Comeongohigher EP 2002
RTRADESCD046	**Eastern Lane** The Last Excerpt EP 2002
RTRADESCD047	**The Moldy Peaches** County Fair/Rainbows 2002
RTRADECSD048	**British Sea Power** The Spirit Of St Louis/The Lonely 2002
RTRADESCD049	**Jacob Golden** Come On Over 2002
RTRADECSD053	**The Strokes** Hard To Explain (Ireland-only release) 2002
RTRADESCD054	**The Libertines** What A Waster 2002
RTRADESCD055	**Jeffrey Lewis** Back When I Was 4 2002
RTRADESCD056	**The Tyde** Blood Brothers EP 2002
RTRADESCD057	**Beachwood Sparks** Make The Robot Cowboys Cry 2002
RTRADESCD058	**Low** Canada 2002
RTRADESCD059	**Hope Sandoval & The Warm Inventions** Suzanne 2002
RTRADESCD062	**Adam Green** Dance With Me 2002
RTRADESCD063	**The Strokes** Someday 2002
RTRADESCD064	**The Libertines** Up The Bracket 2002
RTRADESCD066	**Baxter Dury** Gingham Smalls 2/Lucifer's Grain 2002
RTRADESCD069	**British Sea Power** Childhood Memories 2002
RTRADESCD070	**Detroit Cobras** Seven Easy Pieces 2003
RTRADESCD071	**Queen Adreena** FM Doll 2003
RTRADESCD073	**Relaxed Muscle** The Heavy EP 2003
RTRADESCD074	**The Libertines** Time For Heroes 2003
RTRADESCD075	**The Hidden** Cameras Ban Marriage 2003
RTRADESCD085	**Delays** Nearer The Heaven 2003
RTRADESCD087	**The Sun** Back In The Summer Of 72 2003
RTRADES091	**The Tyde** Go Ask Yer Dad/Henry VIII 2003
RTRADESCD092	**British Sea Power** Carrion 2003
RTRADES096	**Eastern Lane** Dead July/Portrait Of July 2003
RTRADESCD098	**Eddi Reader** Ae Fond Kiss 2003
RTRADESCD103	**The Delays** Hey Girl 2003
RTRADESCD105	**The Hidden** Cameras Miracle 2003
RTRADESCD106	**Relaxed Muscle** Billy Jack / Sexualize 2003
RTRADESCD111	**The Veils** Guiding Light 2003
RTRADESCD112	**Adam Green** Jessica Simpson / Kokomo 2004
RTRADESCD115	**The Veils** Lavinia 2003
RTRADESCD119	**The Libertines** Don't Look Back Into The Sun 2003
RTRADESCD124	**The Fiery Furnaces** Crystal Clear 2003
RTRADESCD125	**British Sea Power** Remember Me 2003

RTRADESCD128	**Belle & Sebastian** Step Into My Office 2003
RTRADESCD132	**Eastern Lane** Feed YourAddiction 2003
RTRADES139	**Oneida** Caeser's Column 2004
RTRADESCD140	**The Strokes** 12:51 2003
RTRADESCD152	**The Fiery Furnaces** Tropical Iceland 2004
RTRADES153	**The Delays/The Veils** Ride It On/Lions After Slumber 2003
RTRADESCD154	**The Veils** Wild Son 2004
RTRADESCD155	**The Strokes** Reptilia 2004
RTRADSCD156	**Eastern Lane** Saffron 2004
RTRADSDVD157	**Belle & Sebastian** I'm A Cuckoo 2004
RTRADSCDE163	**The Libertines** Can't Stand Me Now 2004
RTRADSCD164	**The Veils** The Tide That Left & Never Came 2004
RTRADST167	**Arthur Russell** You And Me Both 2004
RTRADS168	**Cornershop** Topknot/Natch 2004
RTRADS169	**Sufjan Stevens** That Dress Looks Nice On You 2004
RTRADSCD171	**Adam Green** Friends Of Mine/Born To Run 2004
RTRADSCD172	**Hal** Worry About The Wind 2004
RTRADSCD174	**Art Brut** Formed A Band 2004
RTRADSDVD175	**Delays** Nearer Than Heaven 2004
RTRADSCD177	**Wolfman feat Pete Doherty** For Lovers 2004
RTRADSDVD180	**Belle & Sebastian** Wrapped Up In Books 2004
RTRADSCD183	**Aberfeldy** Vegetarian Restaurant 2004
RTRADSCDX186	**The Hidden Cameras** I Believe In The Good Of Life 2004
RTRADS187	**Phantom Buffalo** A Hilly Town 2004
RTRADSCD189	**The Detroit Cobras** Cha Cha Twist 2004
RTRADSCD190	**The Fiery Furnaces** Single Again 2004
RTRADSCD192	**Aberfeldy** Heliopolis By Night 2004
RTRADST196	**Emiliana Torrini** Sunny Road 2005
RTRADSTP197	**Delays** Lost In A Melody 2004
RTRADSCD199	**Eastern Lane** I Said Pig On Friday 2004
RTRADSCD201	**Babyshambles** Killamangiro 2004
RTRADSCD203	**Emiliana Torrini** Lifesaver 2004
RTRADSCD205	**The Strokes** The End Has No End 2004
RTRADSCD212	**Hal** What A Lovely Dance 2005
RTRADSCD213	**Adam Green** Emily 2005
RTRADSCDX215	**The Libertines** What Became Of The Likely Lads 2004
RTRADSCD216	**David Kitt** Dancing In The Moonlight 2005
RTRADSCD218	**Aberfeldy** Love Is An Arrow 2005
RTRADSCDX220	**British Sea Power** It Ended On An Oily Stage 2005
RTRADSCD221	**Low** California 2005
RTRADSTP222	**Arcade Fire** Laika/Power Out Promo 2005
RTRADSTP207	**Cornershop** Topknot Remix feat MIA Promo 2005
RTRADSCD224	**Emiliana Torrini** Heartstopper 2005
RTRADSCD225	**Arcade Fire** Laika 2005
RTRADSCDX226	**Hal** Play The Hits 2005
RTRADST229	**Antony & The Johnsons** Hope There's Someone 2005

RTRADSX232	**Arcade Fire** Power Out 2005
RTRADSTP209	**Baxter Dury** Francesca's Party 2005
RTRADSCD238	**Be Your Own Pet** Fire Department 2005
RTRADSCD241	**Brakes** All Night Disco Party 2005
RTRADSCDX242	**British Sea Power** Please Stand Up 2005
RTRADCD330	**The Strokes** First Impressions of Earth 2006
RTRADSCD283	**Belle & Sebastian** Funny Little Frog 2006
RTRADSCD273	**Cornershop** Feat. Rowetta 2006
RTRADSCD265	**Delays** Valentine 2006
RTRADSCD303	**Jenny Lewis** Rise Up With Fists!! 2006
RTRADSCD305	**The Strokes** Heart In a Cage 2006
RTRADSCD313	**Belle & Sebastian** The Blues Are Still Blue 2006
RTRADSCD311	**Island** Rough Gem 2006
RTRADSCD339	**Brakes** All Night Disco Party 2006
RTRADSCD328	**Nobody & The Mystic Chords of Memory** Broaden a New Sound 2006
RTRADSCD337	**Jenny Lewis** You are What You Love 2006
RTRADSCD308	**Adam Green** Nat King Cole 2006
RTRADSCD336	**Delays** Hideaway 2006
RTRADSCD344	**Fiery Furnaces** Benton Harbour Blues 2006
RTRADS329	**1990's** You Made Me Like It 2006
RTRADSCD349	**Scissors For Lefty** Ghetto Ways 2006
RTRADSCD341	**Aberfeldy** Hypnotize 2006
RTRADSCD345	**Scritti Politti** Boom Boom Bap 2006
RTRADSCD351	**The Long Blondes** Weekend Without Makeup 2006
RTRADSCD355	**Belle & Sebastian** White Collar Boy 2006
RTRADSCD312	**The Strokes** You Only Live Once 2006
RTRADSCD347	**Jakobinarina** His Lyrics Are Disastrous 2006
RTRADSCD357	**Cerys Matthews** Open Roads 2006
RTRADSCD367	**The Veils** Advice For Young Mathers To Be 2006
RTRADS307	**The Hidden Cameras** Awoo—Single 2006

Albums

RTRADECD004	**Eileen Rose** Shine Like it Does 2000
RCD10605	**Jeb Loy Nichols** Just What Time It Is 2000
RTRADECD006	**David Kitt** Small Moments 2000
RTRADECD007	**Spring Heel Jack** Disappeared 2000
RTRADECD011	**Eddi Reader** Simple Soul 2001
RTRADECD012	**Pooka** Shift 2001
RTRADECD014	**The Moldy Peaches** The Moldy Peaches 2001
RTRADECD015	**Kevin Tihista's Red Terror** Kevin Tihista's Red Terror 2001
RTRADECD018	**Jacob Golden** Jacob Golden 2001
RTRADECD019	**Cara Dillon** Cara Dillon 2001
RTRADECD026	**Jacob Golden** Hallelujah World 2002
RTRADECD027	**Jeffrey Lewis** The Last Time I Did Acid I Went Insane & Other Favorites 2001

RTRADECD029	**Ray First** Light 2001
RTRADECD030	**The Strokes** Is This It 2001
RTRADECD031	**Hope Sandoval & the Warm Inventions** Bavarian Fruit Bread 2001
RTRADECD036	**Beachwood Sparks** Once We Were Trees 2001
RTRADECD038	**Richard Parfitt** Highlights In Slow Motion 2002
RTRADECD040	**Eileen Rose** Long Shot Novena 2002
RTRADECD043	**Queen Adreena** Drink Me 2002
RTRADECD044	**Band of Holy Joy** Love Never Fails 2002
RTRADECD050	**Baxter Dury** Len Parrot's Memorial Lift 2002
RTRADECD051	**Adam Green** Adam Green 2002
RTRADECD052	**Kimya Dawson** I'm Sorry That Sometimes I'm Mean 2002
RTRADECD060	**Various Artists** Anti-Folk Vol 1 2002
RTRADECD061	**Low** Trust 2002
RTRADECD065	**The Libertines** Up The Bracket 2002
RTRADECD076	**The Moldy Peaches** Unreleased Cutz & Live Jamz 1994–2002 2003
RTRADECD077	**The Hidden Cameras** The Smell Of Our Own 2003
RTRADECD078	**ARE Weapons** ARE Weapons 2003
RTRADECD083	**Equation** Return To Me 2003
RTRADECD086	**Eastern Lane** Shades Of Black 2003
RTRADECD088	**The Tyde** Twice 2003
RTRADECD089	**Royal City** Alone At The Microphone 2003
RTRADECD090	**British Sea Power** The Decline Of British Sea Power 2003
RTRADECD094	**Alasdair Roberts** Farewell Sorrow 2003
RTRADECD097	**Eddi Reader** Eddi Reader Sings The Songs Of Robert Burns 2003
RTRADECD099	**Jeffrey Lewis** It's The Ones Who've Cracked That The Light Shines Through 2003
RETRADECD001	**Virginia Astley** From Gardens Where We Feel Secure 2003
RTRADCD067	**The Detroit Cobras** Mink, Rat Or Rabbit 2004
RTRADCD068	**The Detroit Cobras** Life, Love And Leaving 2004
RTRADECD100	**Various** Stop Me If You Think That You've Heard This One Before 2003
RTRADECD104	**Children's Hour** SOS JFK 2003
RTRADELP107	**Adam Green** Friends Of Mine 2003
RTRADELP122	**The Fiery Furnaces** Gallowsbird's Bark 2003
RTRADECD123	**Cara Dillon** Sweet Liberty 2003
RTRADELP130	**The Strokes** Room On Fire 2003
RTRADECD131	**Relaxed Muscle** A Heavy Nite With… 2003
RTRADECD135	**The Veils** The Runaway Found 2004
RTRADLP138	**Oneida** Secret Wars 2004
RTRADDVCD114	**Delays** Faded Seaside Glamour 2004
RTRADCD151	**Royal City** Little Hearts Ease 2004
RTRADLP158	**The Hidden Cameras** Mississauga Goddam 2004
RTRADCD161	**Arthur Russell** Calling Out Of Context 2004
RTRADCD162	**Sufjan Stevens** Seven Swans 2004

RTRADCD165	**Mystic Chords Of Memory** Mystic Chords Of Memory 2004	
RTRADCDX166	**The Libertines** The Libertines 2004	
RTRADLP170	**Sufjan Stevens** Michigan 2004	
RTRADLP181	**Aberfeldy** Young Forever 2004	
RTRADCD182	**The Fiery Furnaces** Blueberry Boat 2004	
RTRADCD184	**Eastern Lane** Article 2004	
RTRADLP193	**The Detroit Cobras** Baby 2004	
RTRADCD204	**David Kitt** The Black And Red Notebook 2004	
RTRADCDX195	**Low** A Lifetime Of Temporary Relief (Boxset) 2004	
RTRADCD202	**The Unicorns** Who Will Cut Our Hair When We're Gone? 2004	
RTRADCD217	**Gruff Rhys** Yr Atal Genhedlaeth 2004	
RTRADCD185	**Emiliana Torrini** Fisherman's Woman 2005	
RTRADCD188	**Scritti Politti** Early 2005	
RTRADCD191	**Phantom Buffalo** Shishimumu 2005	
RTRADLP194	**Adam Green** Gemstones 2005	
RTRADLP200	**British Sea Power** Open Season 2005	
RTRADLP206	**Low** The Great Destroyer 2005	
RTRADCD208	**Arthur Russell** World Of Echo 2005	
RTRADCD211	**The Fiery Furnaces** EP 2005	
RTRADLP219	**Arcade Fire** Funeral 2005	
RTRADLP223	**Antony & The Johnsons** I Am A Bird Now 2005	
RTRADLP231	**Oneida** The Wedding 2005	
RTRADCD160	**Hal** Hal 2005	
RTRADCD248	**Arcade Fire** EP 2005	
RTRADLP330	**The Strokes** First Impressions Of Earth 2006	
RTRADCD291	**Jenny Lewis** Rabbit Fur Coat 2006	
RTRADCD287	**Sun Kil Moon** Tiny Cities 2006	
RTRADCD280	**Belle & Sebastian** The Life Pursuit 2006	
RTRADCD198	**Cara Dillon** After The Morning 2006	
RTRADCD214	**Delays** You See Colours 2006	
RTRADCD310	**Arthur Russell** First Thought Best Thought 2006	
RTRADCD293	**Adam Green** Jacket Full of Danger 2006	
RTRADCD245	**Nobody and the Mystic Chords of Memory** Tree Coloured Sea 2006	
RTRADCD288	**The Tyde** Threes Co. 2006	
RTRADCD297	**Islands** Return To The Sea 2006	
RTRADCD270	**Scritti Politti** White Bread Black Beer 2006	
RTRADCD381	**Aberfeldy** Do Whatever Turns You On 2006	
RTRADCD350	**Sufjan Stevens** Avalanche 2006	
RTRADCD352	**Oneida** Happy New Year 2006	
RTRADCD227	**Cerys Matthews** Never Said Goodbye 2006	
RTRADCD358	**V/A** Colours Are Brighter 2006	
RTRADCD295	**The Hidden Cameras** Awoo 2006	